THIRD EDITION

New York
Institute
of Finance
Guide to
Investing

MICHAEL STEINBERG

D1539426

NEW YORK INSTITUTE OF FINANCE

NEW YORK • TORONTO • SYDNEY • TOKYO • SINGAPORE

Library of Congress Cataloging-in-Publication Data

Steinberg, Michael.
 New York Institute of Finance guide to investing. —3rd ed. / Michael Steinberg.
 p. cm.
 ISBN 0-7352-0117-X
 1. Investments—United States. 2. Securities—United States. 3. Stockbrokers—
United States. I. New York Institute of Finance. II. Title.
HG4921 .N53 2000
332.67'8—dc21 00-023071
 CIP

Acquisitions Editor: *Ellen Schneid Coleman*
Production Editor: *Eve Mossman*
Formatting/Interior Design: *Robyn Beckerman*

Printed in the United States of America

10 9 8 7 6 5 4 3 2 1

This publication is designed to provide accurate and authoritative information in regard to the subject mat-
ter covered. It is sold with the understanding that the publisher is not engaged in rendering legal, account-
ing, or other professional service. If legal advice or other expert assistance is required, the services of a
competent professional person should be sought.

> . . . *From the Declaration of Principles jointly adopted by a Committee of the
> American Bar Association and a Committee of Publishers and Associations.*

ISBN 0-7352-0117-X

ATTENTION: CORPORATIONS AND SCHOOLS

Prentice Hall books are available at quantity discounts with bulk purchase for edu-
cational, business, or sales promotional use. For information, please write to:
Prentice Hall Special Sales, 240 Frisch Court, Paramus, New Jersey 07652. Please
supply: title of book, ISBN, quantity, how the book will be used, date needed.

 NEW YORK INSTITUTE OF FINANCE
An Imprint of Prentice Hall Press
Paramus, NJ 07652

Visit us at www.phdirect.com/business

NYIF and NEW YORK INSTITUTE OF FINANCE are trademarks of Executive Tax
Reports, Inc. used under license by Prentice Hall Direct, Inc.

To my daughter, Shaina,
with the hope that she will read it.

ACKNOWLEDGMENTS

Special thanks to my friend and editor, Ellen Schneid Coleman, for keeping me firmly within the Guide format and to our production editor, Eve Mossman, for doing everything a good production editor is supposed to do.

I also wish to express my appreciation to *Investor's Business Daily,* Morningstar, Inc., and Standard & Poor's for allowing me to use their materials in the preparation of this book.

CONTENTS

Chapter 3

There's More Than One Way to Invest *38*

Chapter 4

Mutual Funds *67*

Chapter 5

There's More Than One Market *84*

Chapter 6

Implementing Your Investment Goals *98*

Chapter 7

The Brokerage Firm and You *117*

Chapter 8

Opening an Account *134*

Chapter 9

The Mechanics of Trading *153*

Chapter 10

Fundamental Analysis *162*

Chapter 11

Technical Analysis *192*

Chapter 12

Your Rights As an Investor *223*

Chapter 13

Computers and the Internet *241*

Glossary *251*

Appendix 1

Recommended Reading *277*

Appendix 2

Sources for Additional Information
on Brokerage Firms *279*

Appendix 3

Recommended Websites *283*

Index *289*

INTRODUCTION

Most people think of investing as synonymous with putting money into the stock market. Those with a slightly broader view might also think of buying income real estate. Properly defined, investing is the placing of capital in business with the expectation of profit or income, which covers a much larger universe of possible investments. The *New York Institute of Finance Guide to Investing* will introduce you to some of the other possibilities, while retaining its original emphasis on the mechanics of the stock market.

There have been monumental changes in the various markets since the last edition was published in 1992. Mutual funds have come to dominate the stock and bond markets and accordingly coverage in this guide has been expanded. Ninety percent of the mutual funds currently operating did not exist when this book was last revised. The effect of derivatives on the various markets was just beginning to demonstrate volatility and the extraordinary inflows of funds from savings accounts, current earnings, and retirement plan contributions has become a flood of capital seeking a home. During this same period, the number of mutual fund managers has grown by over 900 percent and the vast majority have never experienced a down market. This same period has seen a shrinking of the number of shares of large capitalization companies on the NYSE through mergers and buybacks. As this is happening, there is a greater and greater reliance upon the S&P 500 companies to absorb the incredible liquidity that money managers demand in order to be able to place all the cash.

Try to picture it this way. In 1982, there were less than 300 mutual funds operating in the United States. This number had grown to about 900 by 1990 and by 1999 is over 10,500 mutual funds. Admittedly only about 4,000 are equity mutual funds, or more than

the 3,400 individual companies trading on the NYSE. Now add in the fact that in 1982, 60 percent of equities were owned by individuals with the balance owned by banks and mutual funds. Today mutual funds dominate 60 percent of the trading on the NYSE and the money pot is ten times larger. The judgment of a relative handful of mutual fund managers, all listening to the same drummer marching down Wall Street, has been substituted for the common sense and patience of millions of individual investors. It does not take any great insight to understand that when the elephants all head for the door at the same time, the small investor is likely to get trampled. (I should mention here that I am given to clichés and aphorisms, believing that they became such through time, truth, and common sense.)

I would also note that the figures and percentages stated above and throughout this book are what have been commonly reported in the investment media and should be deemed reliable only for relative example or as Mark Twain said, "There are lies, damn lies, and statistics."

Major changes are accelerating global macroeconomic interaction and integration. The end of the Cold War heralded increasing free-market competition and the movement toward American-style transparent accounting standards that offer investors an ever growing global smorgasbord of investment opportunities. These changes have brought a certain natural degree of chaos as formerly autocratic nations move to adjust to the speed and competitive nature of the free market. Europe hopes a common currency (the Euro) will foster economic growth and offset the reserve currency status of the U.S. dollar and the market opportunities created by the North American Free Trade Agreement.

Virtually every working household in the United States has some direct or indirect interest in the fortunes of the stock and bond markets. The number of investors has skyrocketed because of individual retirement accounts, company sponsored-401(K) plans, and the increasing participation of variable return insurance products tied to stock market performance. Consumer and mortgage interest

rates are affected by what happens on the greater macroeconomic scale and technology has made the world a much smaller and more interconnected place to do business. The daily global transfers of currency and bond futures dwarf the total value of all issues on all exchanges operating in the United States and money chases money from market to market around the globe 24 hours a day just by pressing the Enter key on a computer.

As the speed of technology increases, it becomes more important to slow down the information overload and sift out that which is useful from hype and deliberate disinformation. As never before, the responsibility for your financial well-being is falling to you, the individual.

This book is intended as a starting point for you, the individual investor. It covers the basic concepts of investing, including types of investments, fundamental, and technical investing; terminology, strategies, and pitfalls; and resources available. It can help you determine what kind of an investor you are and what kind of investments you should buy. It cannot instill in anyone the two most important factors for investing: *self-awareness* and *discipline*. These you must find within yourself.

As we start, I offer you the following thoughts to keep in mind and which I will attempt to justify in the text:

- Greed and Fear rule the markets.
- There is no substitute for self-discipline.
- The markets will do whatever is necessary to confound the greatest number of investors.
- The markets are always right.
- The majority is always wrong.
- The more things change, the more they stay the same.
- Classics always remain in fashion.
- Bears make money, Bulls make money, hogs get slaughtered.

Foremost is the first rule of investing, *Investigate before you invest*. As you read through the *New York Institute of Finance Guide to Investing*, incorporate that which you find most suitable to your investment goals and remember that you are making a strong start to a lifelong endeavor.

Michael Steinberg

Determining Your

Investment

Goals

Congratulations! By beginning to read this book you are obeying the first rule of investing. You have begun to investigate. As with any endeavor, education and preparation are critical. Preparation begins with an awareness of your current financial situation and your anticipated future needs.

INVESTMENT PREPARATION

There is no single cookie-cutter approach toward investing. Each individual has different assets, different needs and goals, and most of all a different tolerance for risk. The first step is to coordinate your assets and liabilities.

To develop your own road map for financial success, you must know what your assets and liabilities are: *How much money do you have available to work with? How much risk can you take with how much of this money? What debts or moral obligations do you have?* For example, you may have no legal obligation to take care of your mother-in-law or to educate your cousin, but if you want to do these things, then they become goals of yours as well as moral obligations.

Your assets and liabilities are invariably interrelated and eventually they affect each other. The illustration in Figure 1–1 shows this interrelationship. As you coordinate your assets and liabilities,

1

with the help of suitable advisors, you must understand how your assets and liabilities are related in order to match your assets and investments to your resources and liabilities and to accomplish your financial goals.

Figure 1–1. Investing Is Only One Aspect of Your Overall Financial Situation.

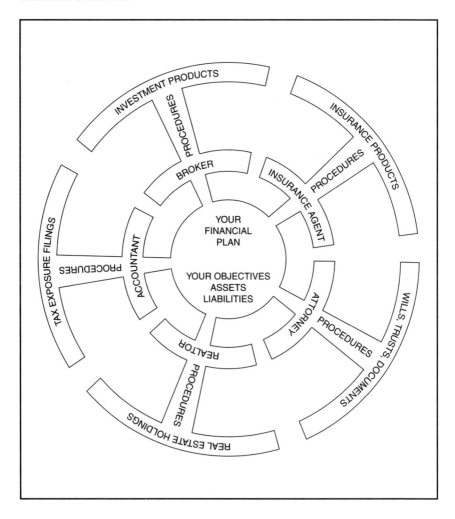

Reprinted from Victor L. Harper, *Handbook of Investment Products and Services,* 2nd ed. (New York: New York Institute of Finance, 1986), p. 13.

Develop Your Net Worth Statement

To develop a suitable investment program, you must complete a net worth statement. This process enables you and your financial advisor(s) to fully understand your present financial circumstances and to design an appropriate map to your financial success.

Figure 1–2 shows an example of a simplified net worth statement. It lists assets and liabilities in a way similar to that required for a financial statement you submit to a bank when applying for a loan. However, your net worth statement should be more detailed than is a financial statement to a banker.

Figure 1–2. Simplified Net Worth Statement.

TOTAL ASSETS

Current Assets

Cash
 On hand and in checking account
 Savings accounts
 Regular
 Certificates of deposit
 Savings bonds
 Treasury bills, notes, and bonds
 Marketable securities including stocks, corporate bonds, municipal
 bonds, mutual funds, etc.

Noncurrent Assets

 Real estate (residence)
 Real estate (investment property)
 Pension plans—vested
 IRA/Keogh plan contributions
 Life insurance
 Tax shelters—liquidation value
 Annuities & inheritances
 Personal effects
 Miscellaneous

Figure 1–2, *cont'd.*

TOTAL LIABILITIES

Current Liabilities

 Credit cards
 Bank lines
 Auto loans
 Home improvement loans
 Miscellaneous loans

Noncurrent Liabilities

 Mortgage
 Children's college expenses

RECAPITULATION

 Total Assets
 Total Liabilities
 Net Worth

DEVELOP YOUR CASH FLOW STATEMENT

Your cash flow statement should list all your income and expenses. Depending on your profession and the number of people in your family who work, you may find it difficult to project all income and expenses. If you can make a reasonable estimate, however, you should have a fairly good idea of where you stand. If you are like most people, you had no idea of your real worth until you calculated it: You probably had no idea how your assets are distributed or what your liabilities are. For this reason you *must* calculate your net worth *before* you invest in financial vehicles such as stocks, bonds, mutual funds, and so on, or before you add to such investments you have already made.

This is not an idle exercise. It forces you to evaluate how your assets are distributed and enables you to focus on your future needs and what degree of risk will be necessary to achieve your goals.

FIRST THINGS FIRST

After examining your cash flow statement, you will have an idea of what you can invest. But what about life preparations for all those unexpected events that occur while you are making and working toward your goals?

DRAW UP A WILL

One thing that should be mandatory in any financial planning program is *drawing up a will*. Many people, even today, are hesitant to draw up a will because doing so arouses fears that they are growing old or that death is imminent. But a will is a "living document"—a way of planning and managing your assets to protect your loved ones and reduce tax liability. For these reasons, consider having an attorney draft a will for you at the time you are calculating your net worth, when you are thinking in terms of acquiring financial assets. You should also review your will periodically to decide what, if any, changes should be made. A note of caution: Using the services of an attorney to draft a will is preferable to purchasing one of the "will-drafting kits" that are extensively advertised. An attorney is able to advise you about your personal situation including trust and tax considerations.

EVALUATE YOUR LIFE AND DISABILITY INSURANCE NEEDS

In connection with any financial-planning program you should examine *the adequacy of your life insurance and disability coverage*. In today's world it is not out of line for the head of a family to carry $500,000 or more in life insurance; in a two-income family this figure may approach $1,000,000. For families with young children, most attorneys and financial planners advise insurance coverage on a nonworking spouse sufficient to provide for substitute child care.

For the person starting out, *term life insurance,* a "pure" form of insurance that does not accumulate any cash value in the policy, offers the best buy. As you grow older, the cost of term insurance grows, and for this reason most term policies offer the option of converting to whole life or some other form of insurance. The universal life or variable life policy is a relatively recent product that is being offered by more and more insurance companies. This policy offers the insured a combination of life insurance and participation in the debt and equity markets. Certain tax rules allow the owner of such a policy to borrow against the equity built up in the policy without incurring any capital gains liability. Before you purchase any life insurance policy, you should compare the costs and benefits of different policies offered by a number of insurance companies.

Disability coverage is another area you should review before implementing any financial plan. Actuarial tables indicate that you are six times more likely to be disabled for a period of six months or longer than that you will die accidentally. Most employers provide some form of disability insurance for their employees, either as a fringe benefit or under the terms of a union contract. However, the coverage provided under such plans should be reviewed before the need for it arises. If the coverage seems inadequate for your circumstances, individual disability insurance is available. Because the commissions paid on such policies are relatively low, many insurance agents do not actively sell them; however, they are available. If purchased, an individual disability policy should include a clause that makes it noncancellable and renewable. Take time to compare the cost and coverage of different policies offered by various insurance companies. Be sure you understand the coverage provided by the policy you purchase.

ESTABLISH AN EMERGENCY FUND

One last step before you put any financial plan into effect is to *set up an emergency fund.* An emergency fund consists of savings bonds

or money set aside in a savings account or money market fund that is available to you to meet emergencies such as the loss of your job, a sudden illness, or any unplanned expense. For most people, such an emergency fund should contain enough to cover three months' normal living expenses, although wealthier individuals may require the equivalent of six months to a year of net earnings.

Even if your net worth statement shows an accumulation of financial assets, do not neglect these steps when embarking on any financial plan. Only after you have adequately provided for your economic health by drafting a will, obtaining adequate life and disability insurance coverage, and setting up an emergency fund are you ready to take the first step in forming a financial plan or program.

YOUR FINANCIAL PROFILE

The first step in any financial plan or program is the selection of a goal—a reason for accumulating financial assets. Examples of such goals range from the accumulation of financial assets for their own sake, to the accumulation of assets in order to make a down payment on a house, start a business, provide for a child's education, or prepare for retirement. Once you clearly define your reason or purpose for accumulating financial assets, you can use your net worth statement to help you reach your goal(s).

When you work up your net worth statement, you create a snapshot of your financial profile. Your financial profile will change over time just as the subject of any snapshot does. A young person's assets are usually concentrated in the category of current assets; that is, cash, savings accounts, and certificates of deposit (CD). As people grow older and marry and raise their families, the concentration of assets may shift from current assets to noncurrent assets—principally, homes or condominiums. The inflation of the past few years, together with a demand for housing as the "baby boomers" came of age, resulted in substantial appreciation of the value of most residential property. For most individuals in their forties and fifties,

home ownership has contributed the largest increase in net worth, followed by increases in the value of their retirement assets. For middle-aged and older persons, with most home-buying and child-rearing expenses behind them, the placement of financial assets generally shifts from the noncurrent back to the current category, as these individuals become able to accumulate capital for investment and prepare for retirement. While every reader does not fit this pattern, it can serve as a guideline or benchmark in discussing how particular financial assets fit into your lifestyle and stage of life.

The net worth statement tells you a number of things about your financial profile. In particular, the net worth statement tells you how much capital with which you have to work. If you know how much capital you have, and if you have an approximate time frame for reaching your dollar goal, you can determine what rate of return you must obtain from the capital you invest. The rate of return you need largely dictates the types of investment (for example, blue chips vs. new issues) you should make, and highlights the amount of risk you must be willing to accept in order to reach your goal. By calculating your net worth on an annual basis, you can judge your progress toward your goal. Finally, your age and personality (your psychological profile) should be considered with your net worth statement and investment goals to determine whether the investment program you have selected is appropriate for your needs and resources.

YOUR PSYCHOLOGICAL PROFILE

It is equally important to your investing success to develop a personal psychological profile that requires an honest self-examination to determine your own comfort level. Typically, a conservative investor is less concerned about the rate of return than the possibility of loss, and tends to invest in highly rated fixed-income investments such as long-term government bonds. An aggressive investor

seeks higher reward, and therefore is willing to assume higher risk and, accordingly, might have a portfolio consisting only of growth stocks. A moderate-risk investor seeks a balanced portfolio, typically consisting of a percentage of bonds (equal to 100 less your age), with the balance of the portfolio invested two thirds in large capitalization stocks and one third in growth issues in an attempt to balance risk and reward.

Regardless of what type of an investor you decide you are, one of the oldest adages states that if you are worried about your investments, sell down until you can get a good night's sleep.

Some considerations may help you determine what kind of an investor you are. The first is a matter of time. Simply, what is the time frame for each investment? When will the funds be needed for another purpose, or are retirement and estate planning the long-term goals? Understanding your time goals is important, especially in light of time compounding. For example, $25,000 invested at 6% compound interest will grow to $44,770 in 10 years, $80,180 in 20 years, and $143,590 in 30 years. At a 10% rate of return, the figures are $64,845 in 10 years, $168,190 in 20 years, and $436,235 in 30 years.

Legendary stock speculator Jesse Livermore was an advocate of timing the market and maintained that the average investor should be in the market only three or four times a year. Livermore made and lost six fortunes and died broke in 1941.

Historical data indicates that the risks of trying to time the ups and downs of the market have greater risk to your investments than a long-term buy-and-hold strategy. The most recent studies indicate that if an investor had been sitting on the sidelines during the 40 best trading days in the period from 1982–1998, his or her gains would have been reduced by nearly 80 percent compared with the performance of the Standard & Poor's 500.

Superinvestor Warren Buffett, who practices fundamental value investing as developed by the late Benjamin Graham, believes the ideal holding period of a good investment is forever—and his-

torical market studies support this view. During the 70-year period
from 1926–1996, the return on the 20-year U.S. Government bond
outperformed a market portfolio of common stocks in only one
decade. The average return for common stocks during these seven
decades was in excess of 11% compared to a 5.2% yield on a port-
folio of 20-year bonds and an average inflation rate of 3.1%. Time
also reduces the risks inherent in market fluctuations. The likelihood
of loss associated with trading during a one-year period is 24%.
This risk factor drops to 1% at 10 years and 0% at 20 years.

Numerous studies of investors across the spectrum of age and
wealth conducted by various markets and self-regulatory agencies
indicate that most successful investors tend to concentrate their
investments in a few areas or stocks. Thus, concentration, not diver-
sification, was a more likely road to investment success, but entailed
a degree of risk much higher than the average investor was com-
fortably willing to accept. Successful investors adhered to a buy-
and-hold philosophy, only occasionally adjusting their investments.
Because they did not follow the market closely, they were more
likely to let their profits run rather than sell out too early, and
refused to be influenced by short-term market swings.

Another common factor among successful investors was invest-
ments in industries in which they were employed or with which they
were familiar. Peter Lynch, the well-respected former manager of
Fidelity's Magellan fund, has long been an advocate of investigating
products and services that you use and like as a good starting point
for choosing a stock investment.

There is no guarantee that following any one particular
approach will bring investing success. Whether you determine your-
self to be an aggressive, moderate, or conservative investor, you
must develop the personal discipline to ignore the noise of the crowd
and stay with your particular style of investing unless or until there
is a fundamental reason to change your investment strategy. Greed
and fear are the predominant emotions that rule all markets as so
amply demonstrated in John Mackay's classic 1841 work *Popular*

The *Education IRA* need not be established by a parent, but there is a nondeductible contribution limit of $500 per year per beneficiary. Distributions are not subject to income taxation if used for post high school educational expenses and may be used in addition to other IRAs. However, the educational IRA is not available if the "modified" adjusted gross income exceeds $110,000 ($150,000 for couples). The intended goal is the long-term tax-free accumulation of funds for a specific purpose.

The new kid on the block is the *Roth IRA*. Contributions are not deductible and are not available to individuals with an adjusted gross income in excess of $100,000 ($150,000 for couples). The major benefit of this type of IRA is that it results in the tax-free accumulation of assets that may never be subject to income tax, as withdrawals are *not* subject to a 10% penalty *or* income tax if the contribution was made more than five years prior to the withdrawal and

(a) the depositor is over 59-1/2 years old; or

(b) withdrawal is used to buy a first home; or

(c) withdrawal is after the death or disability of the depositor.

401(K) PLANS

For many individual investors *401(K) plans* remain the only avenue for sheltering income. Many employers established such plans to encourage their employees to save and to provide an added tax-sheltered fringe benefit. In the typical plan, an employee would authorize a given amount of money to be deducted from salary, the employer would match or contribute on a sliding scale, and the employee would be able to reduce adjusted gross income by the amount of the contribution to the 401(K) plan. The employee was also allowed to borrow against the contributions to a 401(K) plan.

The new tax law allows the 401(K) to continue as a tax-sheltering device. For this reason, the plans have become a major

employee benefit. The maximum contribution and tax deduction are gauged to and increase with inflation, but are capped at a maximum of 15% of the employee's pre-tax income.

Before you make any decisions about IRA and 401(K) plans, consult with your tax advisor. Each situation is different, and the laws are always subject to change.

CAPITAL GAINS

Recent tax law changes have once again reduced the maximum tax on long-term capital gains to 20%. Current tax law defines long term as any asset held for over a period of 12 months.

UNIFORM GIFT TO MINORS ACT

The new tax law radically changes the rules governing the gift of financial assets to minor children. The changes were directed at eliminating "generation-skipping" loopholes in the tax laws that allowed wealthy individuals to pass on their accumulated or inherited wealth with little or no tax liability.

How does the Uniform Gift to Minors Act (UGMA) help the small investor? The act allows an investor to shift assets—whether long-term growth investments or interest-generating assets such as savings accounts or certificates of deposit—to minor children. While the new tax law places limits on the amount of assets that can be transferred to a minor child, such limits will not have much impact on the average investor. Such interest income and capital gains must be reported on a tax return filed for the minor child, and net unearned income is taxed at the parent's rate if the child is under age 14.

What are the negative aspects of the UGMA? Once such a gift to a minor child is given, the transaction cannot be reversed. In effect, ownership passes from the adult to the minor. For this reason, before any such transfer is made, the parent should consider carefully whether the assets will be needed in the future. In addition, spe-

cial consideration must be given to such gifts if there is an expectation that the child will need financial assistance for college, since assets in the child's name are weighted more heavily toward college expenses than assets belonging to the parents when application is made for scholarship assistance.

SELF-EMPLOYMENT

One last area that many small investors overlook when considering ways of sheltering income is to start their own business.

While starting your own business on a full-time basis may be difficult if not impossible, for many small investors the possibility of turning a hobby into a part-time business is a worthwhile idea. Even under the new tax law, a number of advantages exist in being self-employed even on a part-time basis. Certain business-related expenses can be deducted and self-employment income is eligible for retirement plans that can shelter up to 15 percent of your self-employment income regardless of other retirement plans. Talk to your tax advisor about the benefits and possible drawbacks to becoming self-employed.

What Is a Stock?

Everyone has heard of stocks and the stock market. But what exactly is a stock? A stock represents a *share* of the ownership of a business. A stockholder or shareholder—an owner of stock—actually owns a percentage of the company. The more stock people own, the larger their share in the ownership. For example, a person who owns 5% or more of a company's stock is said to be a *major stockholder* and must file as such with the SEC.

The term *share* also refers to an actual stock certificate; that is, a piece of paper. Someone owning 30 shares of a company is issued one certificate representing 30 shares. Though most stocks can be issued in certificate form, generally shares are held in street name, i.e., the name of the brokerage house, and attributed to segregated individual client accounts.

The rise and fall of a stock's price (value) is fundamentally determined by the company's success or failure. If the company's management earns a profit, then the company's value increases, and so in turn, does the value attached to ownership of the company (its stock). When the company's value increases, your position as an investor can be very profitable.

But be cautious; many investment professionals maintain that to succeed in investing, you have to understand how business operates, that such knowledge is essential for success in selecting the

investments most appropriate to your needs and goals. The following discussion gives some insight into the organization and capitalization of corporations—the businesses that issue stock.

TYPES OF BUSINESS ORGANIZATIONS

Three basic forms of business organization exist in the United States—the proprietorship, the partnership, and the corporation. Only the corporation can issue stocks to investors, but to better understand the distinctive features of the corporation, we also discuss the proprietorship (sole ownership) and partnership.

SOLE PROPRIETORSHIPS AND PARTNERSHIPS

Did you ever wonder why you can't invest in your local restaurant, dry cleaner, or grocery store? The reason is that such enterprises are in most cases set up as *sole proprietorships* or *partnerships,* not as *publicly traded corporations.* As a matter of fact, the number of sole proprietorships and partnerships existing in the United States far exceeds the number of publicly traded corporations.

Your neighborhood dry cleaner provides a good example of a sole proprietorship. Whether such a venture succeeds or fails depends almost exclusively on the skill and efforts of its owner and/or family members. "Sweat equity" is a key ingredient here, as most such ventures entail long hours of work and a willingness on the part of all family members to sacrifice.

The owner of a dry cleaning shop is required to wear a number of hats. Dealing with the general public in a courteous and friendly manner is but one responsibility. The proprietor must also be familiar with all the technical aspects of the business and be able to direct the work of others in the actual cleaning process. The owner must deal with suppliers; maintain the financial, employee-benefit, and tax records on a day-to-day basis; and have a working knowledge of

real estate and site location. In addition, the owner has unlimited liability; that is, liability extends to the owner's personal assets, not just to the assets committed to the business. In effect, the sole proprietor is like a one-man band, marching to its own beat.

As time passes and business grows, many sole proprietorships evolve into partnerships. (Or a business may also start up in the partnership form.) The partnership form of doing business has a number of advantages over the sole proprietorship, although it too entails unlimited liability. A partnership brings with it other sets of hands as well as a different perspective on the whole business. It is hoped that the personalities and skills of the partners complement each other. Also, the partner most likely brings additional capital. The typical sources of capital for sole proprietorships and partnerships are the owners, family and friends, and the local bank. Lack of capital is a prime reason why a number of sole proprietorships and partnerships fail, and it may be the reason for a change from sole ownership to partnership. Many owners look to partnership for the mechanical and financial resources needed for the business to grow and expand.

CORPORATIONS

Our neighborhood dry cleaner successfully conducted business as a sole proprietorship, perhaps later as a partnership. Business is good. Why, then, should incorporation be considered?

First, a corporation provides its owners with *limited liability*, that is, the owners' losses are limited to the assets that were committed to the venture. Creditors of the corporation cannot lay claim to any other assets of the owners. Limited liability also insulates owners of a corporation and their assets from suits brought against it. Even the owners of a small business such as a dry cleaning store might expect to be sued at some time. Operating as a corporation serves to protect the owners' personal assets from debts and legal battles. (Although limited liability is very important, in many cases

a bank requires the owners to personally guarantee the debts of the corporation before it will make a loan to a small corporation. However, by personally guaranteeing the corporation's debts, the owner forgoes the benefit of limited liability and allows the bank to attach all the owner's assets, if necessary, to settle the corporation's debts.)

Another important feature of the corporate form of business is its *unlimited life*. If a sole proprietor dies or if partners die or separate, the business legally ceases to exist. A corporation, on the other hand, requires an act of law for its dissolution, so it can survive the death or disagreements of its owners. The unlimited-life feature of a corporation makes it easier for the owners to formulate plans for the disposition of their estates and to pass control to their heirs.

Further, a corporation can raise capital much more easily than a sole proprietorship or partnership can. Lenders are more familiar and comfortable with a corporate borrower. The corporate form of doing business is more acceptable to them because of its limited liability and unlimited life. Although a bank may ask for the personal guarantee of the owners of a small corporation, the decision to make the loan is based on the corporation's assets, sales, and earnings record.

CAPITALIZATION OF CORPORATIONS

While sole proprietorships and partnerships typically have to look to internally generated funds and bank borrowings to finance business expansion, operating as a corporation offers a number of alternative sources of capital for growth and expansion.

A corporation can "go public" and raise capital in the equity markets through stock offerings (covered in this chapter). A corporation can raise money by selling bonds to the public as well. This is covered in Chapter 3.

More than 100,000 corporations conduct business in the United States today. They range in size from local businesses with

sales of less than $1 million per year to giant corporations with sales of $1 billion or more; some of them have been in existence since Revolutionary War days.

PRIVATE CORPORATIONS

The vast majority of the nation's corporations are privately owned by a few large shareholders who in most instances are the founders of the corporation or their descendants. The manner in which they conduct their affairs closely parallels the approach used by sole proprietors and partners. Growth and expansion are financed primarily by internally generated funds or by bank borrowing. In the case of many of these private corporations, management does not wish to relinquish absolute control over the corporation's direction. Therefore, they do not offer their stock to the public. Instead, the company sells stock directly to the individual shareholder, who is generally expected to hold the stock as a long-term investment, rather than trade it in the secondary market. (Because this process involves no underwriter or investment broker as middleman—and therefore no commissions or other sales-related fees—the overall cost of this type of transaction is low.)

PUBLICLY TRADED CORPORATIONS

Some corporate managements—over 25,000 in the United States—have elected to *go public* by offering the investing public an opportunity to buy their shares. A decision to go public is made for one of several reasons. First and foremost, going public is an excellent way of raising large amounts of capital to finance expansion. The exclusive use of internally generated funds and bank borrowings limits the type of projects that can be undertaken. The demand for large amounts of capital may be particularly intense if the company is in an industry experiencing rapid growth, and such a company is likely to find an investing public eager to buy its shares. Current examples

are myriad in technology, communications, and Internet-related Initial Public Offerings (IPO).

Second, many corporate officers view going public as a way of "cashing in" on the value of their holdings—whether for personal use or for estate-planning purposes. Holdings in a private corporation are often difficult to convert to cold hard cash, and valuing a private corporation for estate-tax purposes is also difficult. Going public solves both these problems. Companies may also choose to go public to retain key employees and reward them for their contributions to the growth of the company. By granting stock options to such employees, the company links their personal wealth and fringe benefits to the performance of the company.

THE PROCESS OF GOING PUBLIC

As an investor, you should be aware that the agreement of the underwriting firm to take a company public can take one of two forms. In the case of a start-up company, the underwriter (the investment banking/brokerage firm that handles the public offering of the company's common stock from beginning to end) typically offers to distribute the company's stock on a *best efforts/all-or-none* basis, meaning that the underwriting firm gives no guarantee that it will succeed in distributing the stock; if it is unable to distribute all the shares, it will not distribute any. Further, none of the underwriter's own capital is committed to the offering. (This type of agreement is commonly offered by small *over-the-counter firms*—organizations that buy and sell stocks in the over-the-counter market, as discussed in Chapter 5.) If the company seeking to go public has substantial assets and/or is enjoying rapid growth, it might be able to obtain a firm commitment from an underwriter. With a *firm commitment,* the underwriting firm obligates itself and its own capital to take the company public. Obviously, this type of agreement offers the company a much better basis for going public.

Once the underwriting firm and the company agree on their respective responsibilities, the next step is *registration*. The registration process defines the legal requirements and standards a company must meet before it can offer its shares to the investing public. The registration process is administered by the Securities & Exchange Commission (SEC), the federal agency established by act of Congress to oversee the nation's financial markets. As a result of the abuses uncovered during investigations into the causes of the Market Crash of 1929, Congress mandated that "full disclosure" be a key element in all public stock transactions. *Full disclosure* means simply that all available pertinent data must be provided to investors so that they can base their decisions whether or not to make a particular investment on the most complete and accurate information. The laws of the state in which the company is incorporated also require certain information to be filed with the state authorities. These state laws afford additional protection to the company's shareholders.

In a public offering, the *prospectus* or *offering circular* is the basic disclosure document. For a public offering of more than $5 million worth of stock, a prospectus is required. SEC regulations spell out the information required for inclusion in the prospectus— such as management aims and goals, the use to which the proceeds of the public offering will be put, financials, and management background. If a company wants to raise $5 million or less in its initial public offering, an offering circular (as opposed to a full prospectus) is prepared and submitted to the Securities & Exchange Commission. Referred to as a "Regulation A offering," such filings are designed so that small companies can easily gain access to the capital markets. The emphasis is to simplify the normal disclosure process. While a company must still describe the same type of information in its offering circular, a less sophisticated and detailed treatment of the information is required for a Regulation A filing.

During the registration process, the underwriter's employees organize the selling effort. In the case of a small offering, the under-

writing firm may be the sole seller of the stock. If the offering is for a substantial number of shares, a *syndicate* may be organized that consists of a number of brokerage firms under the direction of the major underwriting firm. Account executives involved in the selling effort (also referred to as registered representatives) are furnished with copies of a *preliminary prospectus* (also known as a "red herring"), but sales cannot be consummated until the buyers receive copies of the final prospectus. At this stage of the underwriting process, brokers and account executives solicit indications of interest in buying shares from prospective investors. From the response to this solicitation, conclusions are drawn as to whether the offering should proceed. In the case of a best-efforts offering, the underwriting firm may withdraw from the offering at this point, whereas with a firm commitment, withdrawal is generally not possible.

The last step in a public offering is essentially to bring together the registration and selling effort. With approval obtained from the SEC, the final prospectus is printed and arrangements are made for its distribution. Funds received from customers for the purchase of shares are held in an *escrow account,* separated from the underwriting firm's other accounts. When the full number of shares offered is sold and the money is received by the underwriting firm, the offering is closed. The proceeds, less fees and charges, are turned over to the company issuing the stock, and at the same time, the company authorizes the *transfer agent*—who handles the physical distribution and recording of ownership of the stock—to release the shares to the underwriter for distribution to the buyers. The SEC is advised that the offering is completed and the company moves from the status of a private company to a publicly traded corporation.

Once the public offering is completed, the underwriting firm does not disappear from the scene. The underwriting firm continues to "make a market" in the company's shares and advises management regarding the responsibilities that come with public ownership, including periodically furnishing financial information to the SEC and shareholders and holding the annual meeting of shareholders.

HOW DO YOU GO ABOUT INVESTING?

Now that you know how a company becomes a publicly traded cor-
poration, you're probably asking yourself, "How can I invest in a
publicly traded corporation?" The question can be answered in two
ways. One approach is through an *equity investment:* You could
purchase common stock or preferred stock if it is available.
Alternatively, you could make a *debt investment* by investing in the
bonds of the public corporation. (Bonds are discussed in Chapter 3.)

COMMON STOCK

When you hear people discussing stocks and the stock market, they
are for the most part talking about common stock.

Earlier in this chapter, it was explained what a corporation is
and how it acquires public status. When a company goes public, it
offers the investing public the opportunity to own a part of itself by
purchasing shares of its common stock. The bulk of the trading on
the various exchanges is in common stock.

When you, the investor, purchase the common stock of a public
corporation, you make an equity investment: You are buying a "piece
of the action." If the company prospers, this should be reflected in
the higher price its common stock commands in the marketplace.
Alternatively, if the company's fortunes wane, the price of its com-
mon stock will most likely decline. In purchasing common stock you
make a bet on the company's future growth and profitability.

The return on your investment comes principally in the form of
price appreciation, referred to as *capital gains.* You also receive a
return on your investment in the form of dividends paid by the com-
pany on its stock. Companies are not obliged to pay dividends to
common stockholders, and in the case of a company that is enjoy-
ing rapid growth in sales and earnings, investors probably prefer
that the earnings be retained in the business to fuel further growth.
Hence, rapid-growth companies typically pay few, small, or no div-

idends, or they may offer stock dividends. (When dividends are paid in the form of stock, the common shareholders receive additional stock but each shareholder's percentage of ownership in the company remains the same.) Only in the case of mature companies or companies in regulated industries, such as utilities, do investors concentrate their attention on the value of cash dividends paid out by the company. Even this time-honored tradition, however, is being tested as government deregulation turns staid conservative utilities into takeover targets and potential growth stocks.

Certain rights and privileges come with ownership of common stock. The federal securities laws require a public company to supply its stockholders with timely reports (quarterly and annually) of the company's financial condition and progress. Shareholders must also be promptly informed of any significant event affecting the company, such as the destruction of a plant, the resignation of a senior officer, or an offer to buy the corporation.

In addition, a company's management must solicit the votes of its shareholders on a yearly basis. This solicitation is in the form of a *proxy* statement, which requests that stockholders vote to approve the continuation of existing management; provides information about the stockholdings of all company officers, directors, and 5% stockholders; and discloses the remuneration paid to management. Any change in the corporation's charter must be approved by the stockholders. A public corporation is required to have an annual meeting of shareholders, which provides an open forum for management and shareholders to meet and exchange views and opinions.

Common stocks have other characteristics important to you as an investor. For the most part, common stocks are *easily transferable;* that is, ownership can readily be passed from and between individual and corporate owners. Because ownership of common stocks is readily transferable, an active and dynamic market generally exists for them. Common stocks are one of the most liquid forms of investment an individual can make. Be aware, however, that in the case of a corporation's bankruptcy, the claims of common

stockholders are subordinate to the claims of debt and preferred shareholders. This fact should remind you that as a common stockholder you own a "piece of the action" and stand to gain or lose according to the company's good or bad fortune.

As an investor, you should be familiar with certain key terms and concepts relating to common stocks.

In today's world, par value has little significance. Most corporations assign a nominal par value to their stock. Many years ago, it was customary for the initial public offering price of a corporation's common stock to be known as its *par value*. Nowadays, par value has no real significance, and it is utilized only for bookkeeping purposes. The par value of common stock is not related to its book value or market value. Most major corporations assign a par value to their common stock of one to ten cents. Some common stock has *no* par!

When a business is incorporated, management decides how many shares it will authorize the company to issue. Typically, management authorizes a greater number of shares than it plans to offer initially so that additional shares can be offered in the future. These shares are called *authorized-but-unissued shares;* with stockholder approval, management can increase the number of authorized shares at any time. *Issued-and-outstanding shares* represent the number of authorized shares distributed among investors.

To make a new stock more attractive, the corporation may attach a *warrant* to the authorized-but-unissued stock. This gives the shareholder a long-term privilege to *subscribe* to common stock (agree to buy a new issue), usually at a fixed price. Even though the subscription price of a warrant is higher at the time of the offering than the market price of the underlying stock, warrants are appealing to investors because of the possibility of a high-percentage gain.

At some point after a corporation has become publicly held, management may decide to buy back or repurchase some of its common stock. Shares that are reacquired, or in some instances acquired by donation, are called *treasury stock*. A company may buy back its

own stock if the stock is selling at an extremely low price or if management is trying to prevent an unfriendly takeover, to provide stock for acquisition of other companies, or to fulfill stock option commitments. Reacquired stock is called treasury stock because it is thought of as held in the corporation's treasury, as part of its assets.

Treasury stock can be a two-edged sword in the hands of a corporation's management. On the one hand, an organized program by a company to repurchase its own shares provides a floor for the price of the stock because the company probably represents the most important and wealthy buyer obtainable. On the other hand, such a program makes the stock less liquid and inhibits a takeover, possibly perpetuating incompetent management.

The term *float* is frequently used in discussing common stock. The float equals the number of shares outstanding less the number of shares held by corporate insiders, institutions, or in the treasury. Thus, the float represents the number of shares available for trading in the public marketplace. You might be surprised at how few shares of a particular company's common stock are available for trading. The calculation of the float brings into focus the extent to which institutions and insiders dominate and control a company's fortunes. The float also tells you as an investor how difficult or easy it would be to "accumulate a position," that is, to purchase or sell a large amount of the company's common stock.

The reasons for investing in common stock are as diverse as the categories of common stock in which to invest. Those investors concerned with preservation of capital and a fixed dividend rate typically concentrate their attention in the area of utility stocks and blue chips (companies with a long record of steady growth and uninterrupted dividend payments). At the other extreme, investors willing to risk losing all the money they commit to the stock market in return for the possibility, however remote, of finding the next IBM or Xerox, concentrate their attention primarily in the area of over-the-counter stocks and new issues. Because of the diversity and liquidity common stocks offer, they are by far the most popular investment vehicle.

PREFERRED STOCK

Preferred stock is another type of equity investment, which first became popular during the 1920s and 1930s as a hybrid form of equity investment possessing some characteristics of common stock and some of bonds.

As an investor, you should understand the important characteristics of preferred stocks. Preferred stock represents equity ownership in a corporation, but to a limited degree. Preferred stockholders have no voice in selecting a company's officers and directors, but owners of preferred stocks are guaranteed a fixed dividend payment that takes precedence over any dividend payment to common stockholders. Preferred stockholders also have a more senior claim on the company's assets in the event of liquidation or bankruptcy. Only bondholders (and other creditors) come before preferred stockholders in such cases.

In spite of the apparent advantages of senior claims to dividends and company assets, preferred stocks also have some negative features of which you should be aware. While the common stockholder can look forward to dividend increases as the fortunes of the company improve and to possible stock dividends or stock splits, preferred stockholders generally do not enjoy any of the benefits of growth and expansion. Because investors typically look to preferred stock for current income rather than for growth (capital gains), they are particularly concerned about the dividends paid on such stocks. Hence, any increase in the prevailing interest rate has a greater impact on the price of preferred stocks than on common stocks.

For the knowledgeable and astute investor, cumulative preferred stock and convertible preferred stock offer the possibility of significant capital gains. *Cumulative preferred* simply means that the dividend accumulates and becomes a debt of the company in those years in which the company is unable to pay the preferred dividend. Also, no dividend can be paid on the company's common stock while the preferred dividend is owed. For the shrewd investor who

recognizes a turnaround in the company's business, the purchase of the cumulative preferred stock with a substantial dividend owed may represent a potential windfall profit when the company "cleans up" all the outstanding preferred dividends before resuming payment of dividends on its common stock.

Convertible preferred stock (preferred stock that is convertible into common stock) can also offer special opportunities to the knowledgeable investor. An investor who feels that some time may pass before a company achieves recognition in the marketplace as a "growth" company may purchase convertible preferred stock if the company has such an issue outstanding. By purchasing convertible preferred, the investor is assured of a fixed dividend payment while providing the option of converting from preferred to common stock if and when the company is recognized in the marketplace and its common stock appreciates. Generally, convertible preferreds are more volatile than straight preferreds because their price is affected by the market performance of the common stock to which they can be converted.

What are the characteristics of the investor who purchases preferred stocks? Buyers of preferred stocks are characteristically cautious in their approach to investing and concerned for current income. Federal tax law allows many corporations and institutional investors to shelter a portion of the dividends they obtain from their stock holdings, and this provides an added incentive for these investors to purchase preferred stocks.

READING STOCK TABLES IN THE FINANCIAL NEWS

Since the previous revision of this book, there has been as much change in the publishing of financial news as there has been in new products offered. Though the major change has been the advent of the Internet and the near instant access to information, I will defer this discussion to Chapter 13.

Newspapers such as *The Wall Street Journal* and *The New York Times* were the primary purveyors of stock tables that appear daily in the financial pages. Things change. Upstart *Investor's Business Daily* has come on strong with many innovations such as technical charts, reports of technical indicators, and proprietary sentiment indicators. These innovations and the demand by investors for information in turn forced *The Wall Street Journal* to copy such innovations, even as the *IDB* softened its front page to cover in-depth articles. (Bond tables and mutual fund quotations also appear in the financial news to be discussed in Chapters 3 and 4.) The ability to read, understand, and extract information from these tables is of vital importance for successful investing. Figure 2–1 is an example of such a stock table.

Figure 2–1. NYSE Stock Quotations.

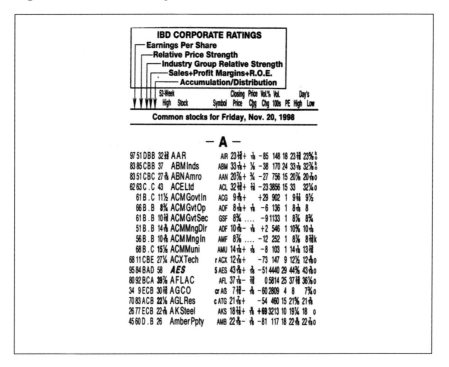

What information can you obtain from the stock tables and what significance should you attach to it? The five columns on the left are proprietary technical indicators developed by *IBD*. The first column on the far left in Figure 2–1 gives you a percentage ratings of the earnings of the company relative to other companies in the same industry. For example, AAR Corporation's earnings are in the 97th percentile of earnings reported by its industry group. The next column from the left is a percentage ratings of the stock's price strength relative to its group. Here, AAR is only in the 51st percentile. The next column is an indicator of the stock's strength within its group, the D rating indicating relative weakness. The fourth column from the left rates the sales plus profits margins plus return on equity; the B rating indicates strength. The fifth column is the *accumulation/distribution rating* which is an indicator of whether the stock is being accumulated by investors—considered bullish, or being distributed to investors—considered bearish. The B rating here would be considered bullish. The next column is the 52-week high. (In most papers the 52-week high and low are given. *IBD* gives up the yearly low for another proprietary column.) From the 52-week high and low you can determine if the stock is selling close to its yearly high or yearly low. Many investors are hesitant to buy a stock selling close to its yearly high because they feel that it may be *fully priced;* that is, its price already reflects the positive factors of the company's future growth and prospects. Many investors also believe that when a company's stock is selling at its yearly high, any further price rise may encounter "resistance" as analysts and investors question whether the company's prospects warrant such a price for its stock. Many technicians believe, however, that a breakout to a new high price on heavy volume is a bullish signal indicating much higher prices to come. As an investor you should give special consideration to the present price of a stock compared with its yearly high and low.

The first column to the right of the company's name gives the company's trading symbol followed in order by the daily closing

price; then the price change from the prior day's trading; the change in daily percentage volume, i.e., were more or less shares traded than during the previous session; followed by the actual volume of shares in 100-share blocks. As an investor, you should focus your attention on the prevailing trend in volume and price rather than concern yourself with the details of what occurred on a particular day. Develop a feeling for what is the normal volume of trading in the particular stock and the normal price variation. If something occurs that does not seem quite right, think twice before you invest.

The next column is the price earnings *(P/E)* ratio, which is calculated by dividing the price of the company's stock by its current year's earnings per share. Price/earnings ratios vary, ranging from a low of 5 to 50 or more. Detailed studies have been conducted to determine whether investors should invest in low or high P/E stocks. Such studies seem to indicate that low P/E stocks may ultimately become high P/E stocks and are therefore a better investment. One reason given for this pattern is that low P/E stocks tend to be in industries followed by few, if any, analysts. When their growth is finally recognized, these stocks enjoy a rapid rise in price.

On the other hand, high P/E stocks tend to be the so-called institutional favorites. Stocks favored by a large number of institutional investors and followed by many analysts are subject to wide price swings as their holders review their investments and react rapidly to changes in company prospects and/or earnings. Thus, in purchasing any stock, the current P/E ratio should be considered and compared with the P/E ratios of similar companies in the same or similar industries. If the P/E ratio deviates from the norm, you should ask questions.

The last two columns are the daily high and low prices indicating the day's trading range. The small k indicates earnings are to be reported within four weeks and the small o indicates that options are traded on the stock. Other newspapers may also list the annual dividend and the indicated *percentage dividend yield.* These two

items are of particular importance to the investor seeking current income as opposed to capital gains. Such an investor typically concentrates on utilities and blue chips. The percentage-yield column enables the investor to compare specific stocks in terms of the yields they offer.

Over-the-counter stock information consists of two lists: (a) the NASDAQ (now merged with the American Stock Exchange) National Market Issues and (b) the NASDAQ Bid and Asked Quotations. The NASDAQ–AMEX National Market Issues listing is for the more actively traded stocks on the National Association of Securities Dealers Automated Quotation System (NASDAQ). The same information is provided for these stocks as for the NYSE stocks. (See Figure 2–2.) Each trade must be reported to the National Association of Securities Dealers (NASD) within a minute and a half, so that up-to-date trading information about those securities is always available.

The second list for OTC stocks is the NASDAQ Bid and Asked Quotations, which describes less actively traded stocks. Because there is no central reporting of these trades, no up-to-date transaction prices are provided.

The stock pages also provide an analysis of the overall pattern of the market. Under the listing General Market and Sectors, you can find a summary of the Dow Jones most active stocks and those stocks in the Dow Jones Average whose prices rose or fell the greatest percentage. This section highlights the overall direction of the market and what particular stocks and categories (NYSE and NASDAQ–AMEX) of stocks are of greatest interest to investors at this time. This section is intended as a gauge for measuring market sentiment, and you should use it for that purpose, rather than for choosing the most active stock or the industry currently in vogue.

In addition, the "Earnings Digest"—published daily in *Investor's Business Daily* as well as *The Wall Street Journal*—reflects the value of securities. A typical earnings report gives the previous

Figure 2–2. Over-the-Counter Quotations.

NASDAQ Tables

52-Week High	Stock	Symbol	Closing Price	Price Chg	Vol.% Chg	Vol. 100s	Dvd Yld	Day's High	Low

Common stocks for Wednesday, Dec. 2, 1998

– A –

79 73 E B C 11¾	AAON	AAON	9	–98	2..	9	9
45 37 D C C 22¼	ABCRailPrd	ABCR	12⅜– ⅜	+29	290..	12⅞	11⅝	
99 32 E A D 32¾	ABRInfoSvc	r ABRX	16⅞– ⅞	–50	1737..	16¾	16⅞ o	
59 33 D C B 18%	ABTBldgPrd	ABTC	10⅜+ ⅛	–71	140..	10⅜	9⅞	
69 30 . A . 10⅛	ACLNLtd	ACLNF	7½ ..	+75	110..	7¾	7	
51 8 B B D 19⅝	ACMooreArt	ACMR	7⅛⅛+ ⅛	+108	663..	8	7¼	
36 65 A E B 18⅛	ACTMfrg	ACTM	8⅛⅛– ⅛⅛	+175	1156..	9⅞	8⅛⅛	
30 97 A E A 15¼	ACTNetwrks	c ANET	12 +1⅛	+377	7356..	12⅛	10% o	
94 60 A A C 43%	ADCTele	r ADCT	26⅞– 1%	+16	2.2m..	28⅛	26¼ o	
62 54 A C B 26	ADE	ADEX	13 +1⅛	–28	293..	13¼	11½ o	
91 68 A A B 40¼	AFCCable	AFCX	29¾– ⅞	+4	406..	30⅛	29¼ o	
98 88 E B B 42¾	AHLSvcs	AHLS	32⅛⅛+ ⅛	–58	169..	33	32⅛	
75 85 A B A 11%	AMX	c AMXX	7⅛⅛+ ⅛	–41	121..	7⅛⅛	7%	
82 67 A B A 16¼	APACTelesv	APAC	6 – ⅛	–32	1028..	6%	5⅞ o	
94 83 A A B 63¾	ArmHldgs	ARMHY	54½+1½	–83	54..	55%	53¾	
74 65 D A D 51	ASAHldgs	r ASAI	35⅞+1	–69	780	1.2	36%	34½ o
86 74 A A B 56½	ASETestLtd`	ASTSF	32 + ⅛	+286	1651..	32⅞	31¼ o	
99 39 A A C 11⅜	ASISolutions	ASIS	7⅛⅛+ ⅛	–90	21..	7⅛⅛	7	
76 72 A A A 49⅛	ASMLitho	ASMLF	28¼ ..	+65	1.4m..	28⅛	26 o	
99 61 B A D 26¾	ASV	ASVI	18¼– ¼	+39	494.,	18%	16	
75 30 D B B 10%	ATG	ATGC	6¼– ¼	–40	299..	6%	6¼	
99 89 A A B 17¼	ATITechn	ATYTF	10⅛⅛+ ⅛	–95	670..	11	10%	
33 73 A B A 33¾	ATMI	ATMI	19⅛⅛+ ⅛	–48	952..	19½	18¾ o	
88 89 A A B 26⅛	AVT	AVTC	22¾– 1%	+31	1517..	24%	21½ o	
85 73 A A B 36¾	AavidTherm	AATT	16½– 1	–51	525..	17%	16½ o	
98 86 A A A 58¾	AbacusDir	ABDR	55⅛– 2⅛	–33	993..	57¾	54% o	
19 36 A E B 18%	Abiomed	ABMD	10%+ ½	–20	110..	10%	9¾	
76 91 A A D 20⅛⅛	AbleTelcom	c ABTE	7⅛⅛+ ⅛	+205	8118..	8⅛	6⅛⅛ o	
96 91 B A B 39⅛⅛	AccessHlth	c ACCS	36⅜– ⅛	–79	981..	36%	35⅛⅛ o	
63 70 A . A 16%	AccssWldwd	AWWC	8⅛– ¼	–82	142..	8%	7%	
76 96 A . A 10¼	AcclaimEnt	AKLM	9 – ⅛	–28	8487..	9⅛⅛	8⅛⅛ o	
94 68 B B C 20½	AceCashEx	AACE	13⅛⅛+ %	–25	125..	13⅛⅛	13¼	
81 15 E B C 20½	Acsys	ACSY	7⅛	–73	104..	7%	7⅛	
60 95 A C A NH	Actel	ACTL	18⅛⅛+ ⅛	+41	4013..	18⅛	17 o	
99 80 B A C 39¼	ActionPerf	r ACTN	33⅞– ⅛	+26	4655..	34½	33 o	
27 82 A C A 18%	Activision	ATVI	13⅝⅛– ⅛	0	2417..	13%	13% o	
97 56 B A B 29%	ActradeIntl	r ACRT	12⅛⅛+ ⅛	–75	183..	13¼	12%	
26 22 A . B 23	ActuateSftw	ACTU	10 +1⅛	+356	2278..	10½	8¾	
94 84 A . B 28¼	Acxiom	ACXM	23½– ¾	–40	3005..	24¼	22% o	
74 67 A A C 31%	Adac Labs	c ADAC	24⅛– ⅛	+51	3739..	25	24% o	
27 72 A B A 50½	Adaptec	r ADPT	16⅛⅛– ¼	–24	1.7m..	17¼	16% o	
31 94 A . B 44	Adelphia	ADLAC	35% ...	+149	2753..	36⅛	35⅛	
16 40 A D A 15¾	AdeptTech	r ADTK	7⅛⅛+ ⅛	+15	381..	7½	7¼ o	
16 61 A D A 23⅛	ADFlexSolut	AFLX	7½+ ½	–9	1562..	7⅛⅛	7 o	
7 51 D B B 11	AdmirltyBnc	AAABB	10¼– ¼	–94	8..	10½	10¼	
31 91 A B A 51%	AdobeSys	5 ADBE	45 – ⅛	–8	8961	0.4	46%	43⅛⅛
87 52 A A B 37%	Adtran	ADTN	24¼– ½	–62	893..	25	24% o	
99 87 B A B 43½	AdvPardgm	ADVP	31⅞– %	+11	1034..	31¾	31% o	
96 78 B A A 14⅛⅛	AdvComm	ACSC	11⅛– %	–53	247..	12	11%	
57 95 A B A 20½	AdvDigital	r ADIC	16⅛⅛+1⅛⅛	–12	907..	16%	14% o	

44 27 C A B 31%	Ambassadr	AMIE	17 + ⅛	–80	62..	17	16⅛⅛	
59 75 B D B 19%	AmcorLtd	AMCRY	17¼– ⅛	–74	515.0	17%	17¼	
80 61 C C B 27¾	AmcoreFinl	r AMFI	23⅛⅛+ ⅛	–63	160	2.3	23⅛	23½ x
58 47 E D D 33%	Amerco	UHAL	24⅛⅛+1⅛⅛	–49	71..	24⅛⅛	22%	
76 40 B B B 17⅛⅛	AmerSvcGp	c ASGR	9¼– ¼	–68	25..	9¼	9¼	
78 37 E A C 34¾	AmerBldgs	ABCO	23⅛⅛– ⅛	–57	124..	24%	23¾	
93 17 D A A 27½	AmerBusFinl	r ABFI	13%+ ⅛	–32	104	1.5	13⅛⅛	13⅛
77 42 D D C 24%	AmerCapStr	r ACAS	15 – ¼	+50	1707	9.9	15%	14⅛⅛ o
28 56 C D B 24%	AmerClassic	AMCV	15⅛⅛+1	–32	229..	15⅛	15⅛	
78 9 C B D 23½	AmerCoin	AMCN	8⅛⅛– ⅛	–45	542..	9	8¾	
76 52 C B A 19%	AmerDental	ADPI	12⅛⅛– ¼	–9	315..	13¼	12¾	
76 98 A A B 61	AmerEagleO	AEOS	57%+1	–54	2300..	57¼	55¾ o	
35 47 D C B 16¼	AmerFreight	r AFWY	9 ...	–69	292..	9	8⅛⅛ o	
53 89 B D B 12%	AmerHlthcp	r AMHC	10⅛– ⅛	–26	145..	10%	10% k	
94 18 C B B 26%	AmerHomest	HSTR	11⅛⅛–4⅛⅛	+999	1.4m..	16¼	11¾%	
83 83 A C A 34½	AmerMgtSys	r AMSY	31⅞+ %	–43	1657..	32	31 o	
94 65 C B A 19	AmerOnclgy	AORI	11¾– ¾	–32	1666..	12	11¾ o	
90 92 A A B 46¼	AmerPwCon	APCC	40½+ ¼	–35	5988..	41%	40% o	
82 30 C A B 15⅛	AmerSafelns	AMSFF	9¼+ ⅛	–85	22..	9¼	9	
37 44 C B B 23¼	AmerSafRazr	ASR	12 ...	–98	7..	12	11½ o	
19 74 B E B 18¼	AmerSuprcn	AMSC	10¼+ ⅛	–57	264..	10¼	9¾ o	
93 87 D A B 32¾	AmerWdmrk	AMWD	29¾– ⅛⅛	+161	515	0.5	30%	29¾
96 28 A B B 14%	AmerXtalTec	AXTI	7⅛ + ⅛	+102	1141..	7%	7	
33 15 A C C 33⅛⅛	Amerilink	r ALNK	7¾+ %	–93	17..	7¾	7¾	
95 54 C A B 33%	Amerin	AMRN	24⅛– ⅛	–47	1604..	24⅛⅛	23% o	
98 1 C A E 19%	Ameripath	PATH	4⅛⅛+ %	+4	3700..	4⅛⅛	4 o	
41 91 B A A 26%	AmeriTrade	AMTD	20⅛⅛–1%	+71	4729..	21½	20% o	
61 90 E B B 29%	AmesDeptSt	r AMES	23⅛⅛– %	+13	9971..	23½	22% o	
87 91 A A C 84%	Amgen	r5 AMGN	79⅛+2½	+13	3.0m..	79⅛⅛	76⅛⅛ o	
1 18 C . C 14¾	AmrescoCap	c AMCT	8½+ ¼	–72	280.11	8½	8¼	
28 2 B B C 39¾	Amresco	AMMB	7⅛⅛– %	–85	2863..	7⅛⅛	7¼ o	
77 95 D D B 30	Amtran	AMTR	–22⅛⅛+ ⅛	–49	144..	22⅛⅛	21¼	
17 65 A E B 24%	Anacomp	c ANCO	14⅛– %	+20	582..	15½	14%	
31 40 A . B 35½	Anadigics	c ANAD	12⅛⅛+ ⅛	–64	985..	12½	11% o	
57 51 A B B 48	Analogic	ALOG	36 + ⅛	–41	1240.7	36¾	35%	
91 11 A A D 36½	AnalystsIntl	ANLY	16⅛– ⅛	+54	3164	2.4	16¾	15¾ o
99 73 A A B 54½	AnalyticalSur	ANLT	27⅛⅛– ⅛	–47	620..	28	27%	
45 80 A . A 25¾	AnarenMicr	cr ANEN	16¾– ¼	–46	195..	16%	16%	
91 70 E A B 24	AnchorBpWl	r ABCW	21¼+ ⅛	–25	302	0.9	21¼	20½
96 22 C A C 94¾	AnchorGamg	r SLOT	50⅛+ %	–60	622..	50¼	48% o	
91 60 E B C 40¼	AndoverBcp	ADB	30⅛– %	+16	290	2.4	31%	29%
69 42 A B B 30⅛	Andrew	5 ANDW	16⅛+ ⅛	+96	1.3m..	16½	15% o	
58 88 A D B 43	Andrx	ADRX	39¾+ ⅛	+16	784..	40%	39% o	
7 91 A D B 24½	Anesta	c NSTA	21⅛	–57	595..	21⅛⅛	20% o	
98 28 A C A 18%	Anicom	ANIC	10⅞+ ⅛	–60	814..	10⅛	9¾ o	
1 86 B . A 26%	Annuity&Life	ALREF	25¾	–24	1297	0.2	25%	25% o
76 88 A . B 28½	AnswerThink	ANSR	20%+1⅛⅛	+41086..	20%	17%		
60 88 A A A 12¾	Ansys	ANSS	9%– ⅛	–79	126..	9¾	9⅛⅛	
76 87 A E C 25	Antec	r ANTC	19¾+ ¾	–29	3324..	20	18¾ o	
99 86 A . B 35¼	ApexPCSolu	APEX	26⅛⅛+ ⅛	+3	2635..	27%	24% o	
16 86 A D B 18%	Aphton	APHT	13%+ ⅛	+5	432..	13%	13 k	
17 60 D E D 23¾	ApogeeEnt	cr APOG	11⅛⅛– ⅛	+6	547	1.8	12	11¾ k
97 52 B A C 43¾	ApolloGrpA	r APOL	31⅛⅛–2⅛⅛	+110	1.5m..	31¾	28% k	
76 93 A E D 43¾	AppleCmptr	5 AAPL	36 +1%	+78	8.6m..	36%	33½ o	

year's and the current year's net sales (revenues), net income (or loss), per-share earnings, and any extraordinary items taken into consideration during these fiscal periods. This report would certainly be worth a look if you have any doubts regarding the history of a particular stock.

Major daily newspapers can give you basic stock prices and earnings of local companies, but this information pales in comparison to what is freely available on the Internet as I will discuss in Chapter 13.

There's More Than One Way to Invest

In Chapter 2 you were introduced to the world of stock investing and the procedure a company must follow to change from a privately held corporation to a publicly traded company. Common and preferred stocks were discussed and it was explained in some detail why individuals find stocks and the stock market attractive places to invest their savings. However, as an investor you should be aware of and familiar with another world—the world of debt and the bond market.

CORPORATE BONDS

What is the key difference between the stock and bond markets? The purchase of common or preferred stock represents an equity investment in the particular publicly traded company. As a stockholder, you are an owner of the company; how you fare as an investor depends on the company's success or failure. When you purchase a bond of the same publicly traded company, you acquire a debt instrument and you become a creditor of that company. The only claim you have against the company is for the face amount of the bond itself plus the interest the company has promised to pay for the use of your money.

In general, if you buy a bond, a debt is owed you by the bond's issuer. As a bond owner, you are promised a fixed payment in the form of interest, usually paid on a semiannual basis over the life of the bond. The price of the bond varies, depending on whether interest rates rise or fall. For example, if interest rates rise after you purchase a particular bond, the price of the bond you bought must fall to bring the yield (the interest payment divided by the price) into line with the prevailing yield of similar bonds. The price of a bond maturing in 30 years reacts to changes in prevailing interest rates to a greater degree than the price of a bond coming due in a year or two. This disparity is due to the fact that the owner of a 30-year bond is exposed to the impact of the higher interest rates for a much longer time.

For the most part, bonds are extremely liquid investment vehicles because an active marketplace exists for such investments.

Why would a publicly traded company issue bonds instead of stock? A company that goes public raises capital by offering its stock through an underwriter to the investing public. When additional capital is needed, management considers a number of factors in choosing a method for raising those funds. The condition of the company, the condition of the marketplace, the nature of the project for which the funds are needed, and the internal characteristics of the particular company are some of the factors that play a role in management's decision to offer stocks or bonds.

As a company grows in size and earning power, its bonds typically become more marketable, because the principal players in the bond market are large institutional investors or wealthy individuals whose major concern is to preserve their capital and to provide a predictable and adequate return for their assets. Such investors focus their attention on the company's assets and earning power rather than on future prospects. They rely on rating services such as Moody's Investor Service Inc. and Standard & Poor's Corporation in deciding whether to purchase a particular bond or not. Thus, the majority of newer, smaller companies are excluded completely from the bond market.

Market conditions also play a major role in determining whether a company will raise capital through a bond or a stock offering. If the stock market is rising and the particular company's stock is performing well, the company's underwriter will most likely suggest a stock offering. Obviously, if the price of the company's stock is higher than normal, relatively few shares will have to be sold to raise the needed dollar amount, and the company's equity will be diluted to a lesser degree. Expressed another way, the assets behind each share of common stock will be reduced by a lesser amount. In a declining market, a stock offering may be extremely difficult, if not impossible, and a bond offering may be the only route available. Also, a stock offering in a declining stock market would result in a substantial dilution in the company's equity base. The current level of interest rates also plays a significant role in determining whether a stock offering or bond issue should be undertaken. If interest rates are rising or unusually high, the rate on a new bond issue (which represents interest expense to the issuing corporation) will be elevated. In such cases, a stock issue *might* be preferable.

The nature of the project also has a bearing on the way it will be financed. If the money to be raised is designated for a specific project, such as new plant construction or an existing plant's modernization, management and its investment banker will most likely select a bond issue because costs and returns can be specifically projected. However, if the funds are for general corporate purposes, rather than for a specific project, and if the stock market is particularly strong, an equity offering may be a more appropriate selection.

The peculiar characteristics of the company also influence the selection of financing alternatives. Management policy may dictate that the company carry very little debt and that the bulk of funds for financing growth and expansion come from internally generated funds and equity offerings. On the other hand, some corporate managements believe in the extensive use of debt and are willing to

leverage (that is, borrow heavily against) corporate assets. The use of leverage has a dramatic effect because it magnifies corporate results, whether positive (increase in earnings) or negative (decline in earnings).

You as an investor should be familiar with some terms and concepts used by management and investors when describing debt and equity financing. The *debt-to-equity ratio* comes into play whenever a decision between debt and equity financing must be made. This ratio expresses in numerical terms what percentage of a company's capital structure is represented by debt, and what percentage is represented by equity. Managements seek to maintain a balance between the debt and equity components of their capital structure. For the investor, the debt-to-equity ratio gives a clue as to whether the company is excessively leveraged or is diluting its equity base by issuing too many shares. *Trading on the equity* (another term with which you should be familiar) means that a company is earning a higher rate of return in the business (equity side) than it is paying as the cost of the money it borrows (debt side). Expressed another way, trading on the equity means that the rate of return a company can earn in its business exceeds the rate of interest it has to pay to borrow the funds. In this case, it makes sense for a company to have a debt offering because it is able to earn a high rate of return on the borrowed funds.

SPECIAL CHARACTERISTICS OF DEBT OFFERINGS

The bond *indenture* contains a description of the key elements of any bond. For example, the indenture describes what items, if any, of the company's plant or equipment will secure the bond; which bank will act as trustee to represent the interests of the bondholders; what authority the trustee has to force the company into bankruptcy if it fails to comply with the terms contained in the indenture; what rate of interest will be paid to the bondholders; and how the payments will be made. Rather than examine the indenture

itself, most investors rely on their financial advisors to inform them about the terms it contains. Only in the event of a *default* do bond-holders focus their attention on the indenture (although many bonds sold and traded today are *debentures,* secured only by the "full faith and credit" of the borrower rather than by a particular asset of the company).

Bonds used to be issued in two forms—bearer and registered. *Bearer bonds* are easily transferable from one individual or institution to any other individual or institution because the company assumes no responsibility for identifying or keeping track of the owners of its bonds. But in recent years only registered bonds have been issued due to governmental pressure to identify the holders of financial assets so that the income derived from these sources can be taxed. *Registered bonds* oblige the company to identify its bond-holders, to pay to the registered owners all interest payments as they come due, and to advise the registered owners of any upcoming developments, such as redemption calls.

PAR VALUE

Most bonds are issued in denominations of $1,000, and a bond sell-ing at $1,000 is referred to as selling at par. The bond tables in the financial news would list a bond selling at par, or $1,000, as 100 (100% of its face value). A bond selling at $1,200 (at a *premium* above par) would be shown as 120. A bond selling at $780 (below par or at a *discount)* would be shown as 78. While stocks are now quoted in thirty-seconds, corporate bonds trade at fractional prices in increments of eighths, but this is expected to change to a decimal system after the year 2000. Bonds issued by the federal government trade in a similar manner but the increments are expressed in thirty-seconds. For example, a government bond listed at 80.12 means 80-12/32, which translates into 80-3/8 or $803.75. (More information on how to read and understand bond tables in the financial pages can be found later in this chapter.)

RATINGS

Bonds are given ratings by investors' services such as Moody's and Standard & Poor's. The rating assigned can play a crucial role in determining both the price at which the bond sells and its marketability. The rating of **Aaa** is the highest grade assigned by Moody's and indicates that the company selling the bond has an extremely strong capacity to pay principal and interest. At the other extreme, if a bond is rated by Moody's as **D**, the issuer is in default of the principal and/or interest payments. The rating scale utilized by Standard & Poor's is similar, and both services generally track each other. Ratings are important because few investors have the time or the capability to arrive at their own conclusions about a company's ability to meet its financial commitments. Investors look to the rating services to perform this function. Further, many institutional investors, particularly pension funds and bank trust departments, are prevented by law or policy from investing in bonds rated below the **A** category. Many bond mutual funds are willing to invest in grades down to **BB,** while a similar market exists for even lower rated bonds in what is called the high yield, or "junk bond" category. In large part, low-rated bonds are cut off from a major segment of the bond-investing community.

It should be noted that this rating service is paid for by a fee from the bond issuer and many smaller issues of bonds forego a rating to conserve the expense.

CONVERTIBLE BONDS

The discussion thus far has focused in some detail on the characteristics and trading patterns of straight (nonconvertible) corporate bonds. Convertible bonds represent another area you should be familiar with—a special category of corporate debt. In essence, they combine some elements of both debt and equity offerings. The purchaser of a convertible bond is able to convert the bond from a debt

of the issuing company into shares of the issuing company's common stock according to a formula provided in the terms of the convertible bond offering. In return for this privilege, the company is able to pay a lower rate of interest on the bond. The investor receives a "piece of the action" via the convertible feature. At the same time, the investor enjoys the status of a debtor and the protection that status affords in the form of a fixed interest rate and protection in the event of default or bankruptcy.

To analyze a convertible bond issue, you must isolate the value of the bond as a straight debt offering and determine how much you are paying for the convertible feature. A number of financial advisory services, such as "Value Line," provide detailed information and advice on particular convertible bonds. While convertible bonds appear to provide the best of both worlds, individual investors should thoroughly examine them and seek competent advice and counsel before investing.

CALL AND SINKING FUND FEATURES

As an investor, you should be aware of call and sinking fund features of bond offerings, because such features can have a significant impact on the total return (capital gains or losses plus interest).

A *call feature* requires a company seeking to refinance its debt, that is, "call" its bonds, to pay its bondholders not only principal and accrued interest, but also a premium. In the early years of a bond's existence, this sum can be fairly substantial. From the investor's point of view, a call on bonds means the forced reinvestment of money at a time when interest rates have declined from previous levels; for this reason the call feature provides for the payment of a premium over the face value of the bond.

Not all bond offerings have a call feature. To determine if a particular bond has such a feature, examine the bond's indenture or consult one of the standard reference sources such as Moody's or Standard & Poor's. Through their bond-buying patterns, investors

have increasingly indicated that they prefer bonds without call features. This preference is principally a reaction to the volatile interest rates of recent years. Many investors saw high-yielding bonds "called away" from them as interest rates declined. In some instances they suffered a loss on their investments. If you own bonds in registered form, you will receive notice of any impending calls, but if the bonds are held in bearer form, you or your financial advisor must keep track of calls through the financial press and publications.

In the past, bond investors placed an emphasis on whether or not a particular bond had a *sinking fund* feature attached to it. A sinking fund provision means that the company is required to allocate a specific amount of its current earnings toward *retiring* the bond, that is, pay off a given amount of the bond each year. Investors like the sinking fund feature because it gives them some assurance that the company is working off its debt loan from current earnings rather than waiting until the bonds come due to meet its commitments. Such a provision also has an impact on the issue's market price. Because the company is under an obligation to retire a portion of its bonds on an annual basis, a floor is created for the price of the bond. Such demand by the company for its own bonds tends to smooth out adverse changes in interest rates and the bond market in general, and provides greater asset protection for the remaining bondholders.

In recent years, however, most investors have placed less emphasis on the sinking fund feature and more emphasis on the company's earnings and cash flow—the company's ability to service its debt. The rating services also have shifted their emphasis, focusing more on the ability of the company to service its debt and to show earnings and positive cash flow, and less on the terms of the indenture itself.

JUNK BONDS

Junk bonds came to prominence in the area of corporate bonds and debt financing in the 1980s. Drexel Burnham & Co., Inc., now

bankrupt in the aftermath of the Milken–Boesky scandal, pioneered the concept of junk bonds as a way to provide financing for merger and acquisition activity. Junk bonds get their name because of their low rating (Moody's and Standard & Poor's rate them **BB** or lower).

The most common method of acquisition financing was to use the assets of the corporation being acquired as collateral for the junk bonds being sold in order to purchase the company. The low rating came from the fact that the new corporation had a lot of debt and the certainty of interest payments was low. In fact, many junk bonds make interest payments "in kind" and not in cash. While there is greater risk in holding these bonds compared with better-rated securities, there is also the potential of a higher return.

The universe of high-yield securities is quite large and varied in quality. The best approach for individual investors is to maintain diversified portfolios based upon their own thorough research, or through a mutual fund.

READING CORPORATE BOND TABLES IN THE FINANCIAL NEWS

The format for corporate bond tables in the financial news is shown in Figure 3–1. For purposes of this discussion, focus your attention on the first listed AT&T bond 8.200 02/05 in these tables. The first column to the left of the corporate name gives the S&P rating of the bond issue. The first column to the right of the name gives the exchange on which the bond is traded. The next column to the right gives the coupon rate of the bond. In this particular case AT&T offered to pay 8.2% when it offered for sale bonds that will come due and be payable in 2005.

Undoubtedly 8.2% was the prevailing rate on similar bonds when AT&T marketed these bonds, but changes in the pattern of interest rates now dictate a current yield of 7.9%. To understand the figures in the tables, you should be familiar with the following

Figure 3–1. New York Stock Exchange Bond Listings.

NYSE & Amex Bonds With More Key Data

For Wednesday, December 16, 1998

Dow Jones Bond Averages

	1997 High	Low	Today's Close	Change
20 Bonds	107.17	101.09	106.59	-0.13
Utilities	104.71	97.64	104.31	-0.25
Industrials	109.81	104.54 ½	108.87	-0.02

Bonds Summary

	Domestic Wed	Domestic Tue	All Issues Wed	All Issues Tue
Issues Traded	220	205	230	215
Advances	84	69	87	74
Declines	82	87	86	91
Unchanged	54	49	57	50
New highs	3	8	3	8
New lows	7	8	7	8

Total NY Bond Volume $20,523,000
Total Amex Bond Volume $866,000

S&P Rates	Bond	Ex	Coupon Rate	Mat-ures	Yld. Cur.	Yld.to Mat.	Vol.	Bond Close	Chg
NR	AamesFncl	NY	10.500	02/02	18.8	34.6	115	56	- 2
A	AldCorp	NY	ZrCpn	08/09	...	6.5	30	50⅞	...
NR	Amresco	NY	10.000	01/03	13.7	20.0	50	72⅝	+ ⅜
B	Amresco	NY	1.000	03/04	1.4	7.3	108	73	+ 1
NR	Amresco	NY	8.750	07/99	9.0	14.3	25	97	...
B-	AnnTaylr	NY	8.750	06/00	8.6	7.8	15	101⅜	+ ⅜
CCC	Arch Com	Am	10.875	03/08	18.1	20.8	57	60	+ 5
B+	ArgsyGm	NY	13.250	06/04	11.9	10.5	28	111	+ ⅞
BB+	AMR Cp	NY	9.000	09/16	7.4	6.9	5	121¾	...
AA	AON Corp	NY	6.875	10/99	6.8	6.2	25	100½	...
NR	APP FIN VI	NY	ZrCpn	11/12	...	14.1	34	15	- 3
AA	AT&T	NY	8.200	02/05	7.9	7.4	66	104	- ⅛
AA-	AT&T	NY	7.000	05/05	6.5	5.4	10	108½	- ¼
AA-	AT&T	NY	8.125	07/24	7.5	7.3	22	109	...
AA-	AT&T	NY	6.750	04/04	6.3	5.1	20	107⅜	+ ¼
AA-	AT&T	NY	5.125	04/01	5.1	5.2	45	99¾	...
AA-	AT&T	NY	8.125	01/22	7.5	7.3	43	109	- ½
AA-	AT&T	NY	7.125	01/02	6.8	5.3	63	105⅛	...
AAA	BellSoTel	NY	6.750	10/33	6.5	6.5	102	103½	- ⅛
AAA	BellSoTel	NY	7.500	06/33	6.8	6.8	15	109⅜	...
AAA	BellSoTel	NY	6.375	06/04	6.0	5.2	35	105½	+ ¼
AAA	BellSoTel	NY	7.875	08/32	7.2	7.1	75	109½	...
AA	BellTelPa	NY	7.125	01/12	7.0	7.0	15	101¼	- ¼
B+	BethStel	NY	8.450	03/05	8.5	8.5	94	100	- ¼
NR	BeverlyE	NY	9.000	02/06	8.7	8.4	40	103⅛	+ ¼

S&P Rates	Bond	Ex	Coupon Rate	Mat-ures	Yld. Cur.	Yld.to Mat.	Vol.	Bond Close	Chg
BB	BrownGp	NY	9.500	10/06	9.0	8.5	69	105⅝	+ ⅛
NR	BstnCltcs	NY	6.000	06/66	10.0	10.0	104	60	+ ½
BBB	BurNtnRR	NY	3.200	01/45	6.1	6.4	3	52¾	- ⅛
A	Catpilr	NY	6.000	05/07	6.0	6.1	16	99½	+ ⅛
A	Catpilr	NY	9.750	06/19	9.1	9.0	11	107¼	...
A-	ChaseM	NY	6.750	08/08	6.4	5.9	5	106	- 1⅛
A-	ChaseM	NY	8.000	05/04	7.9	7.6	20	101¾	+ 1
AA+	ChespWV	NY	7.250	02/43	7.1	7.0	2	102¼	+ ⅝
BB-	ChesPkEn	NY	9.125	04/06	12.0	14.5	115	76¼	- 3⅝
BB	ClarkOil	NY	9.500	09/04	9.3	9.1	57	101¾	+ ⅜
CCC	ClrdgHotl	NY	11.750	02/02	16.3	25.2	100	72	+ ½
BBB-	CmwEd	NY	7.625	02/03	7.5	7.3	8	101¼	- 1½
NR	CnsmrPor	NY	n.a.	01/06	80	70	...
CCC+	CoeurD A	NY	7.250	10/05	12.1	17.5	40	59⅞	...
B+	CompUSA	NY	9.500	06/00	9.3	8.1	226	101⅞	+ ⅛
NR	ContlHms	NY	10.000	04/06	9.4	8.9	6	106	- ⅛
B	DataGnl	NY	6.000	05/04	6.1	6.4	1	98	- 1
B+	DelcoRmy	NY	8.625	12/07	8.5	8.3	5	102	...
NR	DelWebb	NY	9.375	01/28	9.6	9.6	319	98	- ⅛
B-	DelWebb	NY	9.750	03/03	9.5	9.0	20	102½	+ ¼
B-	DelWebb	NY	9.750	01/08	9.5	9.4	20	102⅜	+ ⅞
A+	DukePwr	NY	8.000	11/99	7.9	5.9	20	101¾	...
A+	DukePwr	NY	6.375	03/08	6.3	6.3	20	100⅝	- ⅝
A+	DukePwr	NY	6.625	02/03	6.3	5.1	13	105½	+ ¾
A+	DukePwr	NY	5.875	06/01	5.8	5.5	10	100¾	- ⅞
A+	DukePwr	NY	6.250	05/04	6.2	6.0	10	101⅛	- ⅜
NR	DVI Inc	NY	7.500	02/04	7.6	7.8	15	98⅞	- ⅛
A+	FordMtrCr	NY	6.375	11/08	6.1	5.8	15	104⅛	...
BB+	FruitL	Am	7.000	03/11	7.5	7.8	24	93½	- 2½
AAA	GenElEc	NY	7.875	12/06	7.1	6.0	15	111⅝	+ ¼
A	GenMtrAc	NY	ZrCpn	06/15	3	333	+ ¼
A	GenMtrAc	NY	ZrCpn	12/12	44	398½	+ 2⅞
A	GenMtrAc	NY	6.000	04/11	6.0	6.1	32	99½	+ 1½
A	GenMtrAc	NY	5.875	01/03	5.9	5.8	3	100¼	...
A	GenMtrAc	NY	7.000	03/00	6.9	5.5	45	101¾	- ⅛
A	GenMtrAc	NY	8.400	10/99	8.3	6.2	2	101¾	- ⅝
A	GenMtrAc	NY	5.620	02/99	5.6	7.4	12	99.25	...
A	GenMtrAc	NY	9.375	04/00	9.0	6.3	5	103¾	- ⅞
A	GenMtrAc	NY	5.500	12/01	5.5	5.6	35	99¾	+ ⅛
A	GenMtrAc	NY	7.000	09/02	6.7	5.8	6	104	+ ⅛
A	GenMtrAc	NY	6.625	10/02	6.4	5.7	5	103¼	- ½
A	GenMtrAc	NY	8.500	01/03	7.7	5.7	5	110	+ ⅞
CALL	GnsisHth	NY	9.750	06/05	9.9	10.2	20	98⅛	- 1⅞
BBB-	GreenTr	NY	10.250	06/02	9.4	7.3	5	109	+ 1½
NR	GBCBanc	NY	8.375	08/07	8.4	8.4	14	100	+ ¼
NR	HillStrs	NY	12.500	07/03	24.0	34.0	608	52	+ 2
BB-	Hollngr	NY	8.625	03/05	8.1	7.4	5	106	...
BB-	Hollngr	NY	9.250	02/06	8.9	8.5	17	103¾	- 1¼

terms. *Nominal yield* (coupon rate) is simply the rate of interest the bond carries on its face. The next column gives the *maturity date,* February of 2005 (02/05). The next column gives the *current yield,* which is obtained by dividing the annual interest (8.2% x 1000) dollars by the current market price. Obviously, current yield varies as the price of the bond changes. A principal factor influencing bond prices (and, hence, current yields) is change in the prevailing level of interest rates—or even the perception in the market place that such changes are imminent. The next column is *yield-to-maturity.* Yield-to-maturity is an average rate of return that involves collective consideration of a bond's interest rate, current price, and number of years remaining to maturity. It includes the effect of any premium or discount to par value in the bond's price. In this particular case, AT&T offered to pay 8.2% when it offered for sale bonds that will come due and be payable in 2005.

Yield-to-maturity comes into play when you are seeking to determine what the total yield of the bond would be if held to maturity. It is of greater significance to the professional investor than to the individual. For purposes of determining the yield-to-maturity, both bond tables and computer programs have been developed, eliminating the need for detailed manual calculations.

The next column to the right *(Vol)* gives the number of bonds (66) of the particular issue traded on this day. This means that bonds with a total par value of $66,000 were traded on the day in question. The number of bonds traded gives you an idea of how liquid the market for this bond is (how easy or difficult it would be to buy or sell this bond). Certain bonds can be very illiquid, and the small investor may pay a heavy penalty if an attempt is made to sell them before maturity date. Small orders (five bonds or less) can also present a problem at the time of sale. For this reason, many small investors are best served by investing in bonds via a bond fund.

The last two columns to the right describe the events that occurred during the trading day. In this particular case, the close for the day was 103, and the price of the bond fell 1/8 of a point for the day.

From this same trading table, you can see that AT&T has a number of bonds outstanding with different maturity dates and different nominal yields. In addition to the influence of interest rates, the time remaining until the bond matures and becomes payable affects the current yield.

U.S. GOVERNMENT-ISSUED SECURITIES

The Treasury Department issues U.S. government securities to pay for running the government. Interest payments are partially tax-free; free from state but *not* from federal income taxes.

As an investor, you are probably familiar with one form of treasury offering—the *savings bond*—which is sold directly to the public. Patriotism and safety of principal were the reasons most people purchased savings bonds, however, and few financial advisors recommended savings bonds as a means of investment. But in recent years, declining interest rates and tax law changes have made savings bonds more desirable. For one thing, the interest rate paid on savings bonds is no longer fixed for extended periods of time, but is adjusted to prevailing market rates on a periodic basis. Also, the tax laws allow the owners of savings bonds to decide whether to pay tax on the interest earned as it is accrued, or to postpone all tax on interest earned until the bonds are cashed in. For these reasons, savings bonds offer an attractive investment vehicle for the portion of assets the investor wants to set aside as a security umbrella.

In recent years, many investors have become familiar with another important category of government debt: Treasury bills, notes, and bonds.

Treasury bills, or T bills as they are called, are generally sold in multiples of $5,000 with a minimum face value of $10,000, and in maturities of 91 days, 182 days, and 52 weeks. However, a recent Federal program aimed at the small investor provides for increments of $1,000 if purchased directly from a branch of the Federal Reserve

Bank. All purchases of T bills are recorded in *book entry form*—the receipt given at the time of purchase is the only evidence of the purchase. For all practical purposes, T bills are the equivalent of cash. While institutions dominate the market, many small investors purchase T bills because they are available in relatively small dollar amounts. T bills do not pay interest on a semiannual basis as do Treasury notes and bonds. Instead, they are sold to investors at a discount from par value—in effect, at a dollar price that is less than the redemption value at maturity.

All categories of treasury offerings have certain common characteristics: ready marketability, excellent liquidity, and the safety of the full faith and credit of the U.S. government. In most instances, the spread between the bid and asked prices of Treasury notes and bonds shows that an active secondary market exists for these securities. Transaction costs, and thus brokerage fees, are fairly low. Probably the most important characteristic of treasury offerings is their exemption from state and city income taxes, which makes them more attractive than most conventional bank CDs (certificates of deposit), subject as they are to such taxes.

A significant difference between T bills and Treasury notes and bonds is in the length of time to maturity. Treasury notes mature in one to ten years, while Treasury bonds are issued in maturities ranging from ten to thirty years. Because they have a longer life span, Treasury notes, and Treasury bonds in particular, are more likely than T bills to fluctuate violently at the mere indication of a change in interest rates.

Treasury notes and bonds typically require a minimum investment of $5,000 for maturities within one to five years and $1,000 minimums for longer term notes. The development of *zero-coupon bonds* has allowed the small investor to readily invest in these instruments. Zero-coupon bonds, or stripped securities, are simply Treasury notes or bonds that are sold to investors with their coupons "stripped," or detached. Such notes and bonds are especially suitable for long-range goals such as providing for retirement

or a child's education, because you can determine ahead of time the actual dollars you will receive when the security matures. As an investor, you must report annually the interest you earn on a zero-coupon bond, even though you do not receive it until the bond matures. For this reason, zero-coupon bonds are considered most appropriate for Keogh (Defined Contribution Retirement Plans) and IRA accounts.

The newest type of government debt available to the average investor is the *Treasury Inflation-Protection Securities (TIPS)* which has a fixed par value or principal amount, with a fixed interest rate, and which pays interest every six months. The principal amount, however, is adjusted up or down according to the changes in the Consumer Price Index. At maturity, the investor receives the face value or the face value plus inflation adjusted increases.

MUNICIPAL BONDS

State, county, and local governments, like corporations, may issue bonds. Funds from municipal bond issues may be spent on the government's general financing or on special projects. The key characteristic of municipal bonds, or "muni's," is that the interest on certain types of them is exempt from federal taxation. Whether the bond is tax-exempt depends on how the funds are spent by the issuing government. Be certain, if you are purchasing a municipal bond because you wish tax-exempt income, that the bond you buy is indeed tax-exempt. In some cases, interest on a muni can also be exempt from state and city taxation if the bondholder resides in the same jurisdiction where the bond was issued.

Let's take a look at some characteristics of municipal securities.

As with corporate bonds, municipal bonds cover a wide range of safety and liquidity. Muni's can be highly rated or can be very speculative, depending upon what is used to back the payment of interest. There are two basic types of municipal bonds. *General*

Obligation bonds are secured by the "full faith and credit" of the issuer, or in simpler terms, by the full taxing authority of the issuer. General Obligation bonds tend to have a higher creditworthiness. *Revenue Bonds* are issued by agencies of a governmental body in order to build a specific public works project such as an airport, water and sewer district, or a highway. Such bonds have a lower creditworthiness because they are backed only by the revenue generated by the specific project in order to pay off principal and interest.

While most bonds of large, well-known state and local authorities are fairly safe investments, local economic conditions have impacted the creditworthiness of many well-known issuers. To increase their bonds' ratings, the majority of issuers today insure the payment of principal and interest through a number of municipal bond insurers including MBIA, FGIC, and BIA.

At one time, municipal bonds did not fluctuate much in price and few questions were raised about their creditworthiness, but several factors led to a change. The near bankruptcy of the City of New York in the early 1970s and the similar problems of Orange County, California, in the 1980s highlighted the need to scrutinize the finances of all issuing authorities. Second, the volatile pattern of interest-rate changes caused major upward and downward movements in the prices of municipal bonds as they tried to adjust to the prevailing rates.

The Tax Reform Act of 1986 and subsequent "fixes" made changes that render municipal bonds one of the last remaining tax shelters available to the small investor. The first significant change is the lower top bracket called for by the tax overhaul (39% vs. 50%). This lower top bracket makes the tax-exempt feature worth less to the individual investor. But the prices of many municipal bonds have already adjusted to take this change into account. Second, the bill eliminates the incentives for financial institutions to invest in municipals. Historically, banks and other financial institutions dominated the market for intermediate-term—7 to 20 years—tax-exempt issues.

With the principal players "out of the ball park," the individual investor may perhaps find some real buys in this category of tax-exempt issue. The impact of these factors is already reflected in the marketplace.

The area of tax-exempt securities is fairly complex. For many individual investors the best route to investments in municipal bonds may be through the selection of a well-managed mutual fund specializing in these securities.

U.S. GOVERNMENT-SPONSORED SECURITIES

Price information for most U.S. government (Figure 3–2), govern-ment-agency, and quasi-governmental debt securities (Figure 3–3) can be found in the daily newspaper. Some papers, however, publish this information only weekly. The listings are categorized by issue: U.S. government bills, notes, and bonds comprise one list, and gov-ernment-agency and miscellaneous securities comprise another. Each list is arranged in order of maturity; the earliest maturation dates are first. Bid and asked prices are shown in increments as small as 1/32% of the issue's par value. Bid changes *(Chg.)* are given for Treasury issues. These figures are also expressed in thirty-seconds. The figure in the Yield column *(AskYld.)* is a yield-to-maturity, not a current yield, and is based on the "Asked" quote. Yield-to-matu-rity gives a more relevant number for institutional investors, for whom these securities have greatest appeal.

Government-sponsored securities and agency obligations usu-ally offer a slightly higher rate of return than the previously described direct obligations of the Treasury. In spite of this fact, they are usu-ally viewed as a step down from Treasury offerings because they are neither so safe nor so liquid as Treasury offerings.

Just what are federal agency securities? They are usually not direct obligations of the U.S. government but are considered moral

Figure 3–2. U.S. Treasury Listings.

T-Bills, Bonds & Notes

STRIPPED SECURITIES

Mat. Date	Bid	Asked	Chg.	Yield
Feb 00 a	98.31	98.31	+0.01	5.18
Feb 00 c	98.30	98.30	...	5.28
May 00 a	97.20	97.20	...	5.37
May 00 c	97.20	97.20	...	5.39
Aug 00 a	96.08	96.08	...	5.52
Aug 00 c	96.03	96.03	...	5.76
Nov 00 a	94.23	94.24	−0.01	5.76
Nov 00 c	94.21	94.21	...	5.85
Feb 01 a	93.09	93.09	...	5.87
Feb 01 c	93.05	93.06	−0.01	5.97
May 01 a	91.27	91.27	...	5.94
May 01 c	91.25	91.26	−0.01	5.98
Aug 01 a	90.14	90.15	−0.01	5.98
Aug 01 c	90.11	90.12	−0.01	6.04
Nov 01 a	89.02	89.03	−0.01	6.01
Feb 02 a	87.22	87.23	−0.02	6.03
May 02 a	86.13	86.14	−0.02	6.03
May 02 c	86.08	86.10	−0.02	6.11
Aug 02 a	85.06	85.08	−0.02	6.05
Aug 02 c	84.31	85.00	−0.02	6.11
Nov 02 a	83.26	83.28	−0.02	6.05
Feb 03 a	82.09	82.11	−0.02	6.16
Feb 03 b	82.08	82.10	−0.02	6.17
Feb 03 c	80.31	81.02	−0.02	6.18
May 03 a	79.23	79.25	−0.02	6.19
Aug 03 a	78.17	78.20	−0.02	6.18
Nov 03 a	78.17	78.20	−0.03	6.18

Mat. Date	Bid	Asked	Chg.	Yield
Aug 06 a	65.14	65.19	−0.04	6.40
Nov 06 a	64.15	64.19	−0.03	6.39
Feb 07 a	63.08	63.12	−0.02	6.43
May 07 a	62.06	62.11	−0.04	6.45
Aug 07 a	61.06	61.10	−0.03	6.45
Nov 07 a	60.11	60.16	−0.03	6.42
Feb 08 a	59.01	59.05	−0.04	6.50
May 08 a	58.01	58.06	−0.04	6.51
Aug 08 a	57.03	57.07	−0.04	6.52
Nov 08 a	56.10	56.10	−0.04	6.52
Feb 09 a	55.03	55.07	−0.03	6.56
May 09 a	54.05	54.10	−0.04	6.57
Aug 09 a	53.08	53.13	−0.04	6.57
Nov 09 a	52.12	52.17	−0.03	6.58
Feb 10 a	51.13	51.17	−0.03	6.60
May 10 a	50.17	50.22	−0.04	6.61
Aug 10 a	49.21	49.26	−0.04	6.62
Nov 10 a	48.27	49.00	−0.04	6.62
Feb 11 a	47.30	48.03	−0.04	6.65
May 11 a	47.30	48.03	−0.03	6.66
Aug 11 a	46.09	46.14	−0.01	6.67
Nov 11 a	45.15	45.20	−0.04	6.67
Feb 12 a	44.21	44.27	−0.01	6.68
May 12 a	43.05	43.10	−0.01	6.69
Nov 12 a	43.09	43.10	−0.01	6.70
Feb 13 a	42.13	42.18	−0.02	6.70
Feb 13 b	42.22	42.27	−0.01	6.71
May 13 a	40.31	41.04	−0.01	6.72
Aug 13 a	40.07	40.13	−0.01	6.73

Mat. Date	Bid	Asked	Chg.	Yield
May 16 b	33.26	33.31	−0.03	6.67
Aug 16 a	32.27	33.00	−0.02	6.75
Nov 16 a	32.10	32.15	−0.03	6.74
Nov 16 b	32.19	32.24	−0.03	6.70
Feb 17 a	31.24	31.29	−0.06	6.75
Feb 17 b	31.08	31.13	−0.06	6.75
May 17 b	31.11	31.16	−0.05	6.73
Aug 17 a	30.24	30.29	−0.06	6.74
Aug 17 b	30.26	30.31	−0.06	6.73
Nov 17 a	30.14	30.19	−0.04	6.71
Feb 18 a	29.27	30.00	−0.04	6.73
May 18 a	29.11	29.16	−0.04	6.72
May 18 b	29.13	29.18	−0.04	6.72
Aug 18 a	28.27	29.01	−0.05	6.73
Nov 18 b	28.13	28.18	−0.05	6.72
Feb 19 a	27.31	28.04	−0.05	6.72
Feb 19 b	28.01	28.06	−0.05	6.70
May 19 a	27.17	27.22	−0.04	6.72
Aug 19 b	27.06	27.09	−0.04	6.70
Nov 19 a	26.21	26.26	−0.04	6.71
Feb 20 a	26.09	26.14	−0.03	6.70
Feb 20 b	26.12	26.17	−0.03	6.68
May 20 a	25.29	26.02	−0.02	6.68
May 20 b	25.29	26.02	−0.03	6.68
Aug 20 a	25.15	25.20	−0.03	6.68
Aug 20 b	25.17	25.22	−0.02	6.68
Nov 20 a	25.04	25.09	−0.03	6.68

T-BILLS

Mat. Date	Bid	Asked	Chg.	Yield
Aug 25 b	19.14	19.19	−0.05	6.45
Dec 09 99	4.37	4.35	+0.02	4.43
Dec 16 99	2.97	2.95	+0.02	3.00
Dec 23 99	4.02	4.00	+0.02	4.08
Dec 30 99	4.48	4.46	+0.02	4.56
Jan 06 00	4.76	4.73	−0.04	4.81
Jan 13 00	5.25	5.23	−0.04	5.35
Jan 20 00	5.02	5.00	−0.03	5.25
Jan 27 00	5.15	5.13	−0.05	5.12
Feb 03 00	5.02	5.00	−0.04	5.11
Feb 10 00	5.06	5.04	−0.03	5.18
Feb 17 00	5.10	4.98	−0.04	5.13
Feb 24 00	5.10	5.08	−0.03	5.23
Mar 02 00	5.11	5.09	−0.03	5.24
Mar 09 00	5.12	5.10	−0.01	5.25
Mar 16 00	5.11	5.09	−0.01	5.26
Mar 23 00	5.12	5.10	−0.04	5.27
Mar 30 00	5.15	5.13	−0.05	5.27
Apr 06 00	5.15	5.13	−0.05	5.31
Apr 13 00	5.19	5.17	−0.03	5.36
Apr 20 00	5.22	5.20	−0.04	5.44
Apr 27 00	5.26	5.24	−0.04	5.49
May 04 00	5.31	5.29	−0.03	5.49
May 11 00	5.31	5.29	+0.01	5.51
May 18 00	5.32	5.30	−0.01	5.53
May 25 00	5.33	5.31	+0.01	5.54
Jun 01 00	5.35	5.33	+0.01	5.55
Jun 15 00	5.35	5.33	+0.01	5.57
Jul 20 00	5.37	5.35	+0.02	5.60
Aug 17 00	5.40	5.38	+0.02	5.64

Mat. Date	Bid	Asked	Chg.	Yield
7.75 Dec 99	100.05	100.07	...	4.71
6.38 Jan 00	100.02	100.04	...	5.04
5.38 Jan 00	100.00	100.02	+0.01	4.89
7.75 Jan 00	100.12	100.14	...	4.87
5.88 Feb 00	100.23	100.25	−0.02	5.93
8.50 Feb 00	100.99	100.99	−0.02	5.97
5.50 Feb 00	100.28	100.30	−0.02	5.98
7.13 Feb 00	100.01	100.03	+0.01	5.04
5.50 Mar 00	100.11	100.13	...	5.97
5.50 Mar 00	100.00	100.02	...	5.21
6.88 Mar 00	100.14	100.16	...	5.20
5.50 Apr 00	99.31	100.01	...	5.33
5.63 Apr 00	100.00	100.02	...	5.40
6.75 Apr 00	100.15	100.17	...	5.39
6.38 May 00	100.11	100.13	...	5.43
8.88 May 00	100.19	101.21 +0.02	...	5.09
6.25 May 00	99.30	100.00	...	5.50
5.38 Jun 00	99.29	100.31	...	5.50
5.88 Jun 00	99.24	99.26	...	5.63
6.13 Dec 00	100.07	100.09 −0.01	...	5.65
6.00 Aug 00	100.05	100.07	...	5.66
8.75 Aug 00	99.16	99.18 −0.01	...	5.70
5.13 Aug 00	100.10	100.12	...	5.69
6.25 Aug 00	99.29	99.31	...	5.80
4.50 Sep 00	99.29	99.31	...	5.51
6.13 Sep 00	100.06	100.08	...	5.78
4.00 Oct 00	99.23	99.07 −0.01	...	3.93
5.75 Oct 00	99.29	99.30	...	5.82
8.50 Nov 00	102.13	102.15 −0.01	...	5.79
4.63 Nov 00	99.25	99.27 −0.01	...	5.84

Mat. Date	Bid	Asked	Chg.	Yield
8.00 May 01	102.24	102.26 −0.02	...	5.93
13.13 May 01	109.24	109.26 −0.02	...	5.95
5.25 May 01	100.23	100.25 −0.02	...	5.93
5.75 Jun 01	99.19	99.21 −0.02	...	5.97
6.63 Jun 01	100.28	100.30 −0.02	...	5.98
5.50 Jul 01	99.06	99.08 −0.02	...	5.97
6.63 Jul 01	100.30	101.00 −0.02	...	5.97
7.88 Aug 01	100.29	102.31 −0.02	...	6.00
13.38 Aug 01	111.21	111.23 −0.02	...	6.00
5.50 Aug 01	99.04	99.06 −0.01	...	5.99
6.50 Aug 01	100.24	100.26 −0.02	...	5.99
5.63 Sep 01	99.09	99.11 −0.01	...	6.00
13.75 Aug 01	100.17	100.19 −0.01	...	6.00
7.89 Nov 01	99.22	99.24 −0.02	...	6.00
5.88 Oct 01	100.11	100.13 −0.02	...	6.01
6.25 Oct 01	100.19	100.21 −0.02	...	6.03
7.50 Nov 01	102.19	117.22 +0.03	...	6.01
13.75 Nov 01	117.20	117.22 +0.03	...	6.00
5.88 Nov 01	99.22	99.24 −0.02	...	6.00
6.13 Dec 01	100.04	100.06 −0.02	...	6.02
6.25 Jan 02	100.12	100.14 −0.02	...	6.02
14.25 Feb 02	116.21	116.23 −0.03	...	6.01
6.25 Feb 02	100.13	100.15 −0.02	...	6.03
6.63 Mar 02	101.06	101.08 −0.02	...	6.03
6.63 Apr 02	101.08	101.10 −0.02	...	6.03
7.50 May 02	103.07	103.09 −0.03	...	6.04
6.50 May 02	100.07	100.02 −0.02	...	6.03
6.25 Jun 02	100.14	100.16 −0.02	...	6.03
6.38 Aug 02	100.21	100.24 −0.03	...	6.06
6.25 Aug 02	100.12	100.14 −0.03	...	6.06

Mat. Date	Bid	Asked	Chg.	Yield
5.25 Aug 03 p	97.02	97.04 −0.03	...	6.12
5.75 Aug 03 p	98.22	98.24 −0.03	...	6.13
11.13 Aug 03	115.26	115.28 −0.03	...	6.25
4.25 Nov 03 p	93.17	93.19 −0.03	...	6.09
11.88 Nov 03	119.08	119.10 −0.05	...	6.27
4.75 Feb 04 p	95.00	95.02 −0.04	...	6.10
5.88 Feb 04 p	99.05	99.07 −0.04	...	6.09
12.38 May 04	123.07	123.09 −0.06	...	6.29
5.25 May 04 p	96.16	96.18 −0.03	...	6.14
7.25 May 04 p	103.31	104.01 −0.05	...	6.20
6.00 Aug 04 p	99.09	99.11 −0.05	...	6.16
7.25 Aug 04 p	104.05	104.07 −0.04	...	6.20
13.75 Aug 04	125.25	129.26 −0.06	...	6.31
7.88 Nov 04 p	98.28	98.30 −0.05	...	6.23
7.88 Nov 04 p	106.27	106.29 −0.05	...	6.23
11.63 Nov 04	105.14	105.16 −0.06	...	6.24
7.50 Feb 05 p	105.34	105.34 −0.05 05	...	5.70
6.50 May 05 p	101.05	101.07 −0.04	...	6.23
6.50 May 05 p	125.35	125.37 −0.06	...	6.32
12.00 May 05 p	100.05	101.07 −0.04	...	6.24
6.50 Aug 05 p	100.05	101.07 −0.04	...	6.35
10.75 Aug 05	100.22	100.24 −0.07	...	6.35
5.88 Nov 05 p	98.07	98.09 −0.05	...	6.22
5.63 Feb 06 p	96.26	96.28 −0.05	...	6.24
9.38 Feb 06	115.14	115.16 −0.07	...	6.31
6.88 May 06 p	103.00	103.02 −0.06	...	6.29
7.00 Jul 06 p	103.23	103.25 −0.05	...	6.29
6.50 Oct 06 p	100.14	100.16 −0.02	...	6.30
3.38 Jan 07	95.05	95.07	...	4.16
6.25 Feb 07 p	99.21	99.23 −0.05	...	6.29
7.63 Feb 02 −07	102.15	102.19 −0.04	...	6.33
6.63 May 07 p	101.24	101.26 −0.05	...	6.31

Mat. Date	Bid	Asked	Chg.	Yield
12.75 Nov 05 −10	130.23	130.25 −0.05	...	6.44
13.88 May 06 −11	138.06	138.18 −0.06	...	6.47
14.00 Nov 06 −11	141.15	141.17 −0.07	...	6.48
10.38 Nov 07 −12	123.11	123.13 −0.07	...	6.55
12.00 Aug 08 −13	135.19	135.21 −0.08	...	6.55
13.25 May 09 −14	146.15	146.17 −0.09	...	6.55
12.50 Aug 09 −14k				
11.75 Nov 09 −14k	141.30	142.00 −0.09	...	6.51
11.25 Feb 15 k	137.12	137.14 −0.10	...	6.56
10.63 Aug 15 k	143.17	143.19	...	6.65
9.88 Nov 15 k	138.08	138.10	...	6.65
9.25 Feb 16 k	131.11	131.13 −0.02	...	6.65
7.25 May 16 k	124.13	125.16 −0.05	...	6.65
7.50 Nov 16 k	106.06	106.08 −0.06	...	6.62
8.75 May 17 k	108.22	108.24 −0.06	...	6.63
8.88 Aug 17 k	124.14	124.16 −0.06	...	6.65
9.13 May 18 k	122.27	122.29 −0.07	...	6.65
9.00 Nov 18 k	125.01	125.03 −0.09	...	6.65
8.88 Feb 19 k	123.28	123.30 −0.09	...	6.65
8.13 Aug 19 k	116.01	116.03 −0.08	...	6.64
8.50 Feb 20 k	120.12	120.14 −0.10	...	6.64
8.75 May 20 k	123.11	123.13 −0.10	...	6.64
8.75 Aug 20 k	123.14	123.16 −0.10	...	6.64
7.88 Feb 21 k	114.04	114.06 −0.08	...	6.62
8.13 May 21 k	117.00	117.02 −0.09	...	6.62
8.13 Aug 21 k	117.02	117.04 −0.09	...	6.62
8.00 Nov 21 k	115.27	115.29 −0.09	...	6.62
7.25 Aug 22 k	107.18	107.20 −0.06	...	6.60
7.63 Nov 22 k	111.31	112.01 −0.05	...	6.60
7.13 Feb 23 k	106.09	106.11 −0.10	...	6.59

obligations and carry an implied guarantee. Approved amounts of these securities are issued and payable through the Federal Reserve Bank, thereby enjoying federal sponsorship, but not necessarily strong guarantees of safety.

Some agency securities include:

1. Government National Mortgage Association (GNMA, or "Ginnie Mae")

2. Federal National Mortgage Association (FNMA, or "Fannie Mae")

3. Federal Home Loan Banks (FHLB, or "Freddie Mac")

4. U.S. Postal Service (USPS)

5. Tennessee Valley Authority (TVA)

Is there a place for agency securities in the portfolio of an individual investor? The answer to this question is yes because, like Treasury offerings, agency securities provide a safe haven for the portion of an individual's portfolio designated to provide a security umbrella. While agency securities are not directly guaranteed by the federal government, none have ever been allowed to fail.

MORTGAGE-BACKED SECURITIES

One of the most popular forms of agency securities is *mortgage-backed securities.* In recent years, you have probably heard and read about Ginnie Mae, Freddie Mac, and their various stepchildren such as Sallie Mae (Student Loan Mortgage Corp.). In this section, it is explained what these securities offer the individual investor and why they have become increasingly popular in recent years.

Ginnie Mae, Freddie Mac, and their stepchildren are referred to as *pass-through securities.* When you purchase a Freddie Mac or a Ginnie Mae bond or invest in a mutual fund consisting of such securities, you are purchasing an undivided interest in a pool of

Figure 3–3 Miscellaneous Debt Securities.

Misc. Debt Securities

Rate	Mat. Date	Bid	Ask	Bid Chg	Yld

FEDERAL FARM CREDIT

Rate	Mat. Date	Bid	Ask	Bid Chg	Yld
8.65	Oct 99	103.00	103.03	+0.01	4.55
6.75	Jun 07	112.09	112.15	-0.11	4.94
8.45	Jul 99	101.31	102.02	+0.01	4.70
6.35	Aug 99	100.30	101.01	...	4.66
8.55	Aug 99	102.14	102.17	...	4.78
5.81	Oct 99	100.22	100.25	+0.02	4.94
6.07	Oct 99	101.00	101.03	...	4.69

FEDERAL HOME LOAN

Rate	Mat. Date	Bid	Ask	Bid Chg	Yld
8.35	Nov 99	103.01	103.04	+0.01	4.72
6.44	Apr 99	100.18	100.21	...	4.36
8.60	Jun 99	101.28	101.31	+0.01	4.73
8.45	Jul 99	102.04	102.07	+0.01	4.69
6.26	Aug 99	100.26	100.29	...	4.77
8.60	Aug 99	102.14	102.17	...	4.76
8.38	Oct 99	102.28	102.31	+0.02	4.78
8.60	Jan 00	104.03	104.06	+0.02	4.65
5.56	Jan 03	100.15	103.21	+0.07	4.66
6.07	Jan 00	100.03	100.09	+0.01	3.50
6.03	May 03	102.18	102.24	+0.04	4.80
9.50	Feb 04	122.08	122.14	+0.10	4.59
6.79	Jun 04	109.26	110.00	+0.10	4.69
7.00	Jul 07	102.00	102.06	+0.02	5.54
7.00	Aug 07	102.08	102.14	+0.02	5.43
5.83	Dec 99	100.18	101.11	+0.02	4.74
6.10	Feb 00	101.08	101.11	+0.02	4.86
9.05	Apr 00	105.04	105.07	+0.02	4.88
6.41	May 00	102.18	102.21	+0.04	4.48
8.90	Jun 00	105.20	105.23	+0.04	4.84
9.20	Sep 00	107.07	107.10	+0.03	4.74
5.97	Oct 00	102.08	102.11	+0.04	4.59
6.03	Oct 00	102.15	102.18	+0.04	4.56
8.25	Dec 00	106.16	106.19	+0.04	4.75
5.72	Jan 01	102.02	102.05	+0.04	4.61
5.55	Jan 01	101.18	101.21	+0.04	4.69
5.50	Feb 01	101.16	101.20	+0.05	4.69
5.60	Mar 01	101.24	101.28	+0.04	4.73
6.16	Apr 01	102.15	102.19	+0.04	4.94
6.63	Apr 01	103.18	103.20	+0.04	4.95

FNMA ISSUES

Rate	Mat. Date	Bid	Ask	Bid Chg	Yld
9.55	Mar 99	101.02	101.05	...	4.38
6.00	Mar 99	100.08	100.11	...	4.66
5.65	May 99	100.12	100.15	+0.01	4.55
6.60	Jun 99	100.24	100.27	...	4.92
6.59	May 01	103.18	103.22	+0.04	4.95
6.67	Aug 01	104.24	104.28	+0.05	4.67
6.38	Aug 01	103.12	103.16	+0.05	4.95
6.58	Oct 01	104.22	104.26	+0.06	4.72
6.44	Nov 01	101.11	101.15	+0.01	4.76
7.50	Feb 02	107.01	107.05	+0.07	5.01
6.23	Mar 02	104.14	104.18	+0.06	4.68
6.49	Mar 02	105.16	105.20	+0.06	4.61
7.55	Apr 02	108.22	108.26	+0.06	4.67
6.70	May 02	106.06	106.10	+0.06	4.66
6.59	May 02	105.26	105.30	+0.06	4.69
6.09	Sep 02	104.21	104.25	+0.07	4.69
6.06	Oct 02	103.28	104.00	+0.06	4.89
6.40	Oct 02	102.12	102.16	+0.04	4.97
0.00	Nov 02	108.00	108.06	+0.08	4.73
6.80	Jan 03	106.23	106.29	+0.07	4.90
5.25	Jan 03	101.08	101.14	+0.08	4.66
5.78	Feb 03	101.22	101.28	+0.04	4.84
5.75	Apr 03	103.10	103.16	+0.04	4.84
6.71	May 03	107.26	108.00	+0.08	4.69
6.06	May 03	102.16	102.22	+0.04	4.86
5.45	Oct 03	103.00	103.06	+0.10	4.70
5.80	Dec 03	102.26	103.00	+0.09	5.11
6.65	Apr 04	108.20	108.26	+0.10	4.94
7.55	Jun 04	101.00	101.06	+0.02	5.00
7.40	Jul 04	111.04	111.10	+0.11	5.04
7.70	Aug 04	101.18	101.24	...	4.88
7.85	Sep 04	102.02	102.08	...	4.65
8.25	Oct 04	102.20	102.26	+0.02	4.70
8.40	Oct 04	102.22	102.28	+0.02	4.92
8.63	Nov 04	103.19	103.25	...	4.26
6.00	Jan 05	102.13	102.19	+0.06	5.08
7.88	Feb 05	103.30	104.04	-0.03	4.68
8.50	Feb 05	116.00	116.06	+0.08	4.81
6.25	Feb 05	100.28	101.02	+0.02	5.30
7.65	Mar 05	113.21	113.27	+0.09	5.03
6.35	Jun 05	106.18	106.24	+0.08	5.11
5.75	Jun 05	103.30	104.04	+0.08	5.00
6.55	Sep 05	109.00	109.06	+0.09	4.93
6.85	Sep 05	102.17	102.23	-0.03	5.18
6.70	Nov 05	102.10	102.16	-0.02	5.28
5.94	Dec 05	106.12	106.18	+0.11	4.82
5.88	Feb 06	104.03	104.09	+0.08	5.15
6.41	Jan 06	108.08	108.14	+0.10	5.00
6.22	Mar 06	107.06	107.12	-0.09	4.99
6.89	Apr 06	111.01	111.07	-0.11	5.04
7.90	Jun 06	101.07	101.13	+0.01	5.15
7.07	Jul 06	111.14	111.20	-0.11	5.20
7.93	Sep 06	102.01	102.07	-0.11	4.89
7.59	Oct 06	101.22	101.28	...	5.13
7.50	Nov 06	101.24	101.30	+0.02	5.30
6.88	Nov 06	103.20	103.26	-0.06	5.44
6.96	Apr 07	111.14	111.20	-0.11	5.21
6.64	Jul 07	108.26	109.00	+0.08	5.31
6.52	Jul 07	110.16	110.22	+0.12	4.97
6.54	Sep 07	110.19	110.25	-0.11	5.00
7.13	Sep 07	102.06	102.12	-0.10	5.74
6.59	Sep 07	102.02	102.08	+0.02	5.32
6.39	Sep 07	109.04	109.10	-0.11	5.06
6.87	Oct 07	102.18	102.24	+0.04	6.45
6.83	Oct 07	102.14	102.20	-0.04	5.28
6.34	Oct 07	109.00	109.06	-0.12	5.04
6.94	Oct 07	102.02	102.08	+0.02	5.63
6.97	Oct 07	102.03	102.09	+0.03	5.66
6.65	Nov 07	101.24	101.30	+0.03	5.56
6.15	Dec 07	108.00	108.06	+0.12	5.01
6.56	Dec 07	104.00	104.06	+0.06	5.37
6.16	Dec 07	107.30	108.06	+0.12	5.02
5.48	Dec 07	103.20	103.28	+0.06	5.39
6.40	Dec 07	103.06	103.14	+0.06	5.44
6.17	Jan 08	102.18	102.26	+0.06	5.39
6.41	Jan 08	101.00	101.08	+0.10	5.75
6.24	Jan 08	102.31	103.07	+0.06	5.36
6.27	Feb 08	103.00	103.08	+0.07	5.38
6.43	Feb 08	101.23	101.31	-0.11	5.44
6.42	Feb 08	103.26	104.02	+0.09	5.43
6.38	Feb 08	101.20	101.28	-0.03	5.19
6.00	May 08	105.28	106.04	+0.09	5.17
6.20	Aug 08	102.30	103.06	+0.07	5.42
0.00	Jul 14	42.00	42.08	-0.06	5.62
6.75	Dec 15	148.00	148.06	-4.03	5.83
8.20	Mar 16	128.02	128.10	-0.13	5.61
8.95	Feb 18	137.10	137.17	+0.14	5.70
8.10	Aug 19	128.31	129.07	+0.14	5.68
0.00	Oct 19	30.02	30.10	-0.29	5.82
7.13	Apr 26	121.24	121.30	-0.18	5.53
6.09	Sep 27	102.17	102.25	+0.15	5.89
6.03	Oct 27	108.06	108.14	+0.14	5.45
6.75	Feb 28	102.20	102.28	-0.03	5.95

GNMA ISSUES

STUDENT LOAN MKT.

Rate	Mat. Date	Bid	Ask	Bid Chg	Yld
6.50	30 y	101.04	101.06	+0.06	6.35
7.00	30 y	102.10	102.12	+0.04	6.53
7.50	30 y	103.04	103.06	+0.03	6.54
8.00	30 y	103.30	104.00	...	6.30
8.50	30 y	106.00	106.02	-0.03	5.77
9.00	30 y	106.23	106.25	...	6.08
9.50	30 y	107.06	107.08	+0.01	6.92

WORLD BANK BONDS

Rate	Mat. Date	Bid	Ask	Bid Chg	Yld
6.05	Sep 00	102.07	102.10	+0.03	4.64
7.00	Dec 02	107.26	108.00	+0.08	4.76
7.30	Aug 12	120.17	120.25	+0.17	5.16
0.00	Oct 22	25.04	25.12	+0.05	5.85
7.13	Sep 99	101.27	101.30	+0.01	4.53
8.38	Oct 99	103.00	103.03	+0.02	4.33
8.13	Mar 01	107.26	108.00	+0.04	4.28
6.75	Jan 02	105.15	105.19	+0.05	4.77
12.38	Oct 22	124.21	124.27	+0.07	5.13
5.25	Sep 03	103.02	103.08	-0.08	4.48
6.38	Jul 05	108.16	108.22	+0.08	4.82
6.63	Aug 06	111.02	111.10	+0.10	4.64
6.63	Mar 07	111.04	111.10	+0.11	4.93
8.25	Sep 16	128.05	128.13	+0.13	5.68
6.63	Oct 16	132.10	132.17	+0.14	5.69
9.25	Jul 17	140.10	140.17	+0.14	5.68
7.63	Jan 23	127.07	127.15	-0.15	5.54
8.88	Mar 26	142.06	142.14	+0.18	5.77

mortgages. As an owner of such an interest, you are entitled to receive on a monthly basis a pro rata share of the interest and principal payments collected on the particular pool or mortgages.

The creation of pass-through securities such as Freddie Macs and Ginnie Maes has helped the federal government and the nation's citizens by providing a medium through which the federal government can market the mortgages it guarantees. Hence, the government can expand its efforts to provide all its citizens with decent housing at a reasonable price.

You as an individual investor might find pass-through securities an attractive investment vehicle for a number of reasons. The first reason stems from the role of the federal government in the issuance of such securities. Second, an attractive feature for many people is that payments from such investments are received on a monthly basis, making it easier to balance income and expenses. Such securities also provide a high degree of liquidity, as well as a slightly higher yield than other Treasury offerings.

But as an investor you should be more than a little cautious when you see newspaper ads and other advertisements offering you what appear to be exceptional yields on Ginnie Maes. Such high yields may be the result of a fluke in the system. Because a Ginnie Mae represents a participation in a pool of mortgages, a particular pool might have a very high speed. *Speed* is professional jargon for the rate at which the pool of mortgages is liquidated. A pool has a high speed if by chance a number of mortgagees die or decide to liquidate their mortgages for various other reasons. This high speed is temporary, and eventually the speed of liquidation reverts to normal. So yields that are advertised as substantially above the prevailing rate will hold for only a short time. Such advertisers usually note somewhere that the rate shown in the ad is good only as of the date of the ad's placement.

Although there are some pitfalls to mortgage-backed securities, you should realize that such securities can be a valuable part of an individual investor's portfolio.

OPTIONS AND OTHER DERIVATIVES

Since 1973 when the Chicago Board of Options was created from the Chicago Board of Trade, options and other derivatives have come to play a greater and greater role in the financial marketplace. Simply, a *derivative* is defined as a financial contract that derives its value from changes in price of an underlying stock, financial instrument, or commodity, i.e., stock options, interest rate (bond) options, index options, currency options, and, of course, commodity futures.

Options are used in a variety of ways depending upon the investor's intent. Typically, a conservative investor or institution will use options as a form of portfolio insurance and to enhance income from the portfolio. A speculator will take an options position in hopes of a quick and large percentage profit created by rapid and sharp movement in the price of the item from which the option is derived. For the purposes of this discussion, I will concentrate on stock options.

The buyer of an option obtains, for a set period of time, the right (but not the obligation) to buy 100 shares of a company's common stock at a fixed price or to sell 100 shares at a fixed price, depending upon the type of option the individual purchases. An option does not confer ownership, however, merely the ability to control a specified number of shares for a designated period of time.

Option contracts are of two basic types. The buyer of a *call* option has the right to call (acquire) 100 shares of a company's common stock at a specified price for a limited period of time. The buyer of a *put* option has the right to put (sell) 100 shares of a company's common stock at a specified price for a limited time.

If you believe that the price of a company's common stock will rise in the future, you would want to buy call options on the stock. This will give you the right to purchase the stock at a set price in the future. Of course, you would want to exercise your option to buy at a lower price only in the future when the stock is selling at a higher price.

Conversely, if you believe that the price of a company's common stock will decline in the future, you would want to purchase put options on the stock. Puts enable you to sell the stock at a set higher price for a specific limited amount of time. The option would be exercised only when the stock can be purchased at a lower price.

The concept of *leverage* (which is discussed in more detail in Chapter 6) is at the cornerstone of the development of options as an investment vehicle. It would cost you $3,000 to acquire 100 shares of a stock selling at $30 per share ($30 per share times 100 shares), but for that same $3,000 you might be able to purchase 10 call options that are selling for $300 each. This purchase would allow you to purchase 1,000 shares for a specified time (typically 3 to 9 months, though active stocks may have options available in each of the nearest months) at a specified price per share (typically the price of the stock at the time you buy the option). Before you run out and buy options, though, be aware that if you have not exercised your option by a date specified in the contract (referred to as the *expiration date),* the contract loses all its value and any money you committed to the investment is lost, which is why options are referred to as *wasting* assets. When you purchase an option, you are gambling that your prediction—whether for a rise or a decline in the stock's price—will occur within the time specified in the option contract.

This principle works in favor of the investor when he or she is using a conservative investment strategy known as covered call writing. This practice requires owning a stock and simultaneously selling the call option on that particular stock. For stocks that do not generate a lot of gain or dividends throughout the year, this can be a method to increase cash flow. *Put options* are often purchased to provide insurance against a decline in the market. *Long options* of up to two years—called *LEAPs*—are another alternative. In addition, options may also be used to create artificial stock positions allowing an investor to control a large position through leverage.

Options are traded on the Chicago Board of Options Exchange (CBOE) as well as on most of the leading stock exchanges; thus, options are among the most liquid investment vehicles.

Option investments can carry a high degree of risk depending upon the type of strategy an investor pursues. While they can be very useful, you should take the time to understand options and fundamental option strategies before using options as an investment tool. It is a requirement of most brokerage firms that a separate agreement be executed in order to trade options. An investor must be supplied with a booklet entitled "Characteristics and Risks of Standardized Options," which is published through the CBOE, and explains the basic concepts and risks of options trading.

COMMODITIES/FUTURES

Up to this point, the investment vehicles that have been discussed probably present the average investor with some degree of familiarity and comfort. Commodities may present a totally different picture.

Just what are commodities? How and under what circumstances do commodities fit into an individual's financial planning? When someone speaks of commodities, you may think of wheat, corn, soybeans, and other farm products. Commodities also include such things as financial futures, gold, silver, platinum, lumber, gasoline, heating oil, and even pollution credits, to name just a few.

Originally, farmers simply sold their crops as they were harvested and had to be content with whatever they earned from their labors. Some of the nation's produce is still sold on this basis in the cash (actual) market.

When people speak of commodities as investment vehicles, however, they are referring to *commodity futures contracts.* Large grain dealers and end-users of grain products (for example, food processors and manufacturers) use futures contracts to assure themselves of a given supply of a particular commodity on a specified

future date at a fixed price. Many of the nation's farmers liked the idea of selling their crops ahead of harvest time at a given price. Commodity futures contracts came into being as a third participant—investors and speculators—entered the marketplace created by farmers and grain dealers and provided liquidity.

To understand what commodity futures contracts represent, you must understand that a contract gives the holder the right to buy or sell a given amount of a specific commodity at a set price on a fixed date. A contract represents only the right to buy or sell—it does not represent ownership. For example, if you as an investor feel that a certain commodity will rise in price in the future, you would "go long" a futures contract; that is, purchase a futures contract that entitles you to buy the commodity in question at a set price on a fixed day. If you feel that a certain commodity will decline in price in the future, you would "go short" a futures contract; that is, sell a futures contract at the current price in the expectation that you will be able to buy back your obligation to sell before the contract expiration date.

Because an active market exists for them, commodity futures contracts are a liquid form of investment. Beginning with the formation of the Chicago Board of Trade (CBT), the marketplace for futures contracts has continued to expand and now includes more than eleven exchanges around the country as well as trading locations in the major financial centers of the world.

Likewise, futures contracts have developed far beyond agricultural and industrial commodities to include financial futures, that is, Treasury bonds, bills, and notes; foreign currencies; and stock index futures, as well as a variety of different tangibles and intangibles such as pollution credits.

Although futures contracts get a plus for their liquidity, you should be aware that they carry a high degree of risk because of the high leverage factor. It is possible to lose many times your original margin investment. The risk exists because weather, world economics, and political conditions are unpredictable and can lead to either an

excess of a commodity or a shortage of it. Radical price movements in futures contracts are the norm rather than the exception.

SAVINGS ACCOUNTS

Have you ever considered that a market exists for your savings? Probably not. But commercial banks, savings and loan associations, and money market funds all compete for your savings. This market does not exist at any specifically designated location, such as Wall Street; the marketplace is national in scope.

A market for your savings exists because financial institutions actively compete for your deposits and stand ready to pay them out on demand. Thus, your savings deposits have liquidity—a key characteristic of any marketplace.

Liquidity is an important concept for first-time investors to grasp because the presence or absence of liquidity in a particular investment vehicle in most instances determines what, if any, money should be committed there. By definition, liquidity is simply the ease or difficulty one experiences in purchasing or selling a particular investment. Because an active and highly competitive marketplace exists for savings accounts, they are considered the most liquid form of investment.

At the outset of any investment program, you should set aside a given amount of money in a savings or money market account to provide for unexpected emergencies. Likewise, you should actively shop around for the bank offering the best rate of interest for a specified period of time. Many investors seek to have their CD/savings accounts come due between March 1 and April 15 because banks seeking to obtain IRA deposits often engage in rate wars during this time. It should also be noted that for the first time in U.S. history, since November of 1996, there has been more money in mutual funds than in bank deposits as the rates paid on savings dropped to minuscule compared with the returns to be obtained in the stock market.

INSURANCE

Once you have set up a savings account to meet unexpected emergencies, you are ready to consider another investment vehicle: insurance.

Insurance should be at the core of any financial planning program. The purpose of insurance is to provide protection for an individual or, in the case of death, a financial safety net for survivors. You should purchase insurance policies for the protection they offer, *not,* as most insurance agents recommend, as a tool for savings. For most individuals, term insurance is the best choice because it provides maximum coverage at the lowest cost.

Remember that insurance is a relatively illiquid investment vehicle. No central marketplace exists and it is difficult to compare the policies issued by one insurance company with those issued by other companies.

REAL ESTATE

The most significant investment you make in your lifetime may be the purchase of the home in which you live. After savings and insurance, most people look to the purchase of their own home as a core element of long-range financial planning. Besides providing shelter and a pleasant living environment, traditionally the family home has been a contributing factor to growth in personal net worth. During the period from 1973 through 1983, residential real estate proved to be the single best investment as baby boomers drove up the price of housing. Recent tax changes have altered the landscape, allowing homeowners to build equity and cash in any growth in equity tax free if the home has been a primary residence for at least two years and the gain is less than $250,000 for a single person or $500,000 for a married couple.

The purchase of rental property, whether a single condo unit or a multiunit dwelling, may also be a suitable investment vehicle. Such

properties generate returns that are largely dependent on the price buyers pay as well as on the amount of time and "sweat equity" they are willing to invest in management and upkeep of the properties. The nature, interests, and characteristics of the potential investor—not simply an analysis of earnings and appreciation potential—determine whether rental property is a suitable investment vehicle for a particular individual. The primary benefits are viewed as capital appreciation and tax deductions.

Real estate is basically an illiquid investment vehicle because each property is unique. You cannot determine how much time it will take to sell a property or at what price it can be sold. Further, no central marketplace exists where buyer and seller can easily and quickly be brought together.

COLLECTIBLES

Collectibles consist of any tangible asset—whether jewelry, paintings, stamps, coins, furniture, Star Wars™ toys, Beanie Babies®, sports cards, and so forth—that a person acquires with an expectation of appreciation in its value. The best investments in collectibles are usually made by individuals who purchase a particular article because they like it and enjoy it. Individuals with an expert knowledge of and familiarity with a particular category of collectibles have a substantial advantage over the investor who lacks such knowledge.

Appreciation of collectibles is closely linked to the rate of inflation and scarcity or uniqueness of the particular item. The extremely high rate of inflation that characterized the mid-1970s encouraged many individuals for the first time to look at collectibles as possible investment vehicles. During this period, financial publications developed various indexes and averages—much like the stock tables—to record the rise or fall in the price of collectibles. A number of investment managers formed partnerships to invest in various categories of collectibles. Within a few years collectibles gained a reputation as

legitimate investment vehicles and, for some investors, replaced stocks and bonds as core elements of their overall financial plans.

In their enthusiasm for collectibles, however, investors lost sight of the fact that the marketplace for collectibles is extremely illiquid. Because each work of art or piece of jewelry is one of a kind and must be bought and sold as such, no one can predict how easy or difficult the disposition of a particular item will be. Also, because each collectible is one of a kind, a central marketplace has been impossible to develop despite the efforts of auction houses and dealers to achieve one. Further, collectibles, as opposed to stocks and bonds, are creatures of fashion and thus experience radical changes in value and price.

When the Reagan administration succeeded in controlling the rate of inflation, the prices of a number of collectible items, as well as investor interest in collectibles in general, declined sharply only to be rekindled again in the mid-1990s. This fact should remind you that investments in collectibles, like investments in commodities and options, require a high degree of knowledge and expertise and should perhaps be left to the professional dealer and expert.

PRECIOUS METALS

Precious metals form an asset category that has had a traditional place in most investment portfolios for a variety of reasons and in a variety of forms. For most conservative investors, a small percentage of their assets held in a precious metal investment has represented a tangible hedge against inflation. But studies indicate that precious metals also are a storehouse of wealth during deflationary times as well. Most of the precious metals are also industrial commodities used in manufacturing processes, which creates a demand factor reflective of economic times.

Gold, silver, and platinum are typically held as jewelry, coinage, numismatic coinage, bullion, and depository receipts for bullion

held by a bank. Speculators participate through futures contracts and stock investors through the purchase of mining shares, which tend to move at a greater velocity than the price of the underlying metal.

While precious metals represent a form of security against disaster, as an asset class they tend to underperform most other types of assets except in times of extreme political or economic turmoil.

Mutual Funds

As I noted in the introduction, the single most pervasive change in stock market investing has been the rapid growth of the mutual fund industry. The constant flow of money is in large part funded by retirement account deposits from baby boomers who have reached their peak earnings years and are worried that the social security system will either collapse or be insufficient to provide for their needs. Out of fear or greed, money is being tossed into mutual funds without much consideration as to whether the funds selected are suitable to the investor's needs and goals. Often more time is given to choosing a video rental than to investigating retirement investments. The mutual funds know this and target their marketing accordingly, appealing to claims of security or outstanding growth or simplicity of investment. The average investor would be hard pressed to describe the investment philosophy of any of the mutual funds held in a typical retirement portfolio.

SELECTING A MUTUAL FUND

The primary concepts influencing the choice of mutual funds by the individual investor are *diversification* and *expertise*. By investing in a mutual fund, the individual adds his or her money to a large pool

of funds that is managed professionally. Since a fund has a large amount of money to work with, it is possible for it to invest in a number of companies in order to spread its risk. An individual investor with limited assets may not have access to highly skilled investment analysts and managers, but by combining assets with those of other small investors in a mutual fund, access to skilled professional management becomes available.

There are currently over 10,400 mutual funds operating in the United States, a rise of 900% in eight years. When the average investor speaks of a mutual fund, he or she is thinking of an *open-end equity* fund of which there are approximately 4,000, or more than the number of individual stock issues traded on the NYSE. The variety of funds is a supermarket of choices, each promising something slightly different, or claiming to be better than another fund that has the same investment policy. Long-term statistical data indicate that only 15 percent of these 4,000 funds will consistently outperform the Standard and Poor's 500 Index which is used as a benchmark.

So how does the investor know which funds to choose? A good starting point is learning the terminology and basic concepts of the product, and make no mistake, mutual funds are a product—developed, packaged, and sold like any other product. As the brokerage industry notes, 65 percent of mutual funds are *sold,* not *bought.* Investors are sold *benefits,* not *information.*

Mutual funds come in all shapes and sizes and one size does not fit all. Funds are organized by whether they are closed or open end, load, no load, or back-end load, by sector, country, and investment class to name but a few criteria. So what does it all mean?

EQUITY FUNDS

When a broker speaks to an investor about a mutual fund, he is usually directing his attention to what is described as an open-end equity fund. Open end means that the issuing company is constantly

issuing new shares and redeeming shares for investors. The sponsoring company is the only market for the shares of its mutual fund. Since the potential number of shares is unlimited, and each new sale is the issuance of new shares, mutual funds are considered over-the-counter stocks and the SEC requires that each new sale must be accompanied by a *prospectus*. The prospectus contains information intended to allow an investor to make an intelligent and informed decision. Typical information provided are the fund's goals, risks, and history, as well as a breakdown of expenses and charges.

The value of the shares of a mutual fund is calculated at the end of business each day based on the *Net Asset Value (NAV)* of the mutual funds holdings. New sales and redemptions are based on the end of the day's NAV. *Equity* means that the fund invests in common and preferred stocks in order to participate in the anticipated capital gains. Equity funds typically have a charter that defines their investment philosophy. For example, sector funds might invest only in technology companies, or utilities, or biotech firms, or financial institutions, whereas a fund that indexes would be obligated to invest only in S&P 500 companies. A single country fund would invest only in corporations based in a particular country such as Japan, Korea, Mexico, or Russia, or any number of variations on these examples.

DEBT INSTRUMENTS

Mutual funds come in other "flavors" than just equities. Almost as great a number of funds are devoted to debt instruments. Investors seeking a very high degree of security may select funds that invest only in U.S. Government bonds or obligations that are backed by the moral authority of the U.S. Government, such as government-backed mortgage obligations, Ginnie Maes. Those seeking a higher rate of return might select a fund investing in corporate bonds or even a high-yield fund of junk bonds which bears a higher degree of risk. For those seeking tax-free income, there are funds that invest

only in municipal bond offerings which are free of federal taxation
and in some cases state taxation as well. In today's smorgasbord of
offerings there is something for every type of investor.

OPEN-END FUNDS

Open-end mutual funds are further categorized by what kinds of
sales charges and fees are attached. There's no such thing as a free
lunch and someone is going to pay the fund manager's fees, the office
expenses, sales, and advertising. Most operating expenses are calcu-
lated into the manager's fees, but some items—such as sales charges
and trail fees—are additional deductions that detract from your
actual return on investment and should be carefully explored when
choosing a fund for purchase. For sales purposes, funds are subdi-
vided into: load, no load, and back-end load funds. *Load funds* carry
an upfront sales charge ranging from 3.0% to the maximum allowed
by law of 8.5% of the initial investment. *No-load funds* are usually
sold directly by the issuer's captive sales force without any form of
added sales charge though most do have trail fees. *Back-end load*
funds carry a sales charge of 4.5% to 7.0% that is reduced by 1% for
each year the fund is held, typically disappearing in the sixth year.

Nowhere is Mark Twain's adage about statistics more apt than
in trying to compare the performance claims of various mutual funds;
but the most reliable data indicates that for long-term investors (i.e.,
those holding a fund over five years), there is virtually no difference
in performance between loaded and unloaded funds. Morningstar
Inc., which tracks the performance of mutual funds, reports that
approximately 4,250 funds are no load, approximately 2,930 are
front loaded, and approximately 3,230 are back-end loaded.

Most also carry a trail fee called a 12-b-1 which is another con-
tinuing form of compensation to brokerages to keep them interested
in promoting the funds. No-load funds are allowed to charge up to
0.25% per year, part of which is used to compensate discount bro-
kerages for selling the funds. Back-end loaded funds, which use the

12-b-1 fees to recoup the commissions paid to brokers for selling the funds, may charge up to 1% per year.

CLOSED-END FUNDS

Perhaps the most ignored and misunderstood form of mutual fund is the *closed-end* mutual fund. Like open-end funds, closed-end funds come in virtually every flavor and like most open-end funds, they are actively managed. Unlike an open-end fund, however, a closed-end fund is issued like a stock through registration and issues a *limited* number of shares. Once the initial underwriting is completed, the shares of the fund trade like a stock on a major exchange such as the NYSE or AMEX where the price is set by the auction market, rather than calculated against the NAV. As the price is set by market opinion, shares may trade at a premium or a discount to the NAV. Though on occasion such funds will trade at a premium depending on investor interest in a region, sector, or the reputation of the manager, most tend to trade at a discount to the actual value of the portfolio held by the fund. This market discounting mechanism will sometimes allow the astute investor to buy assets at substantial discounts ranging from an average discount of 7% up to 50% in extreme circumstances.

Investors using this investment vehicle are seeking capital appreciation not merely from growth in the value of the underlying assets, but also from the possible narrowing of the discount. In a rare move, a closed-end fund may decide to change its charter and become an open-end fund. When this happens, investors are treated to an immediate windfall as the discount disappears and the fund's shares are valued at the NAV. Though the price of closed-end funds tends to rise more slowly in an up market, they also tend to lose value more slowly in a down market. Since managers are not forced into a position of liquidating assets to meet possible redemptions from shareholders, they are better able to withstand the vacillations of the market and are less prone to hair-trigger sales.

Figure 4–1. Leading Funds Table.

Leading Funds Over Last 5 Years /
The funds below are among those with strong five-year performance

LEXINGTON CORPORATE LEADERS
36 Mos. Results A–
Obj: GROWTH AND CURRENT INCOME
Yield: 11.2% Avg. PE 22
Median Mkt Cap. $12.17 Bil. Assets 10/1998 $452 Mil Volatility 4
PH (800)526–0056 Avg. EPS Rating 55 # of stocks 55 2 worst drops (5 yrs) 16%, 10%
Mgr. Lawrence Kantor (et. al.) since 1988 Alpha: –0.52 Beta: 0.78
Min. Investment: 1000 Cash 9/1998: 0.40% 5 yr after tax return of $10,000 = $17,644

10 LARGEST U.S. HOLDINGS
% (AS OF 9/30/1998)

N	%		EPS	RS
543,850	7.3	ColumblGas	41	87
355,600	6.8	Chevron	38	71
355,600	6.4	GeneralElect	82	84
355,600	6.2	East Kodak	85	77
355,600	6.1	Mobil	34	73
355,600	5.8	Procter&Gm	80	84
355,600	5.7	Exxon	41	79
743,342	5.5	BurlNthSFe	79	73
355,600	4.7	A T & T	85	81
355,600	4.5	Dupont Nmrs	53	59

TOP NEW BUYS
543,850	ColumblGas
355,600	A T & T
355,600	USX Mara
355,600	Allied Signal
176,860	Lucent Tech
355,600	Praxair
314,367	UnlonPcRe

TOP SELLS
17,900	Chevron
17,900	GeneralElect
17,900	East Kodak
17,900	Mobil
17,900	Procter&Gm
17,900	Exxon
38,500	BurlNthSFe
17,900	Dupont Nmrs
17,900	ConsolidEdls
17,900	Sears
17,900	Union Carb

Year	FUND	S&P 500
1994	–0.8%	+1.3%
1995	+39.2%	+37.6%
1996	+22.4%	+23.0%
1997	+23.1%	+33.4%
1998	+9.0%	+23.6%

NEW ENGLAND GROWTH FUND A
36 Mos. Results A–
Obj: LONG TERM GROWTH OF CAPITAL
Yield: 0.1% 6/1998 T/O Rate: 214.0% Avg. PE 28
Median Mkt Cap. $16.81 Bil. Assets 10/1998 $1.6 Bil Volatility 5
PH (800)888–4823 Avg. EPS Rating 76 # of stocks 19 2 worst drops (5 yrs) 28%, 16%
Mgr. G. Kennneth Heebner since 1977 Alpha: 0.75 Beta: 1.31
Min. Investment: 2500 Cash 6/1998: 0.40% 5 yr after tax return of $10,000 = $16,646

10 LARGEST U.S. HOLDINGS
% (AS OF 6/30/1998)

	%		EPS	RS
–1,650,000	8.1	Nokia Pl A	96	98
–1,680,000	7.9	WarnerLam	86	94
+1,720,000	7.5	ComputrSci	89	94
+1,740,000	7.2	Wal–Mart	88	95
–1,312,000	6.7	ChaseMan	66	66
–1,160,000	6.7	Phillips Elec	38	52
–1,360,000	6.4	Hershey	70	74
+2,175,000	6.2	Mattel	57	54
N4,740,000	6.2	Kmart Corp	76	66
+2,275,000	6.1	Phillp Morris	67	94

TOP NEW BUYS
4,740,000	Kmart Corp
1,190,000	Gap
1,140,000	Carnival
300,000	BurlNthSFe

TOP SELLS
1,105,000	BnkAmerica
885,000	Xerox
1,049,000	A M R
675,000	Delta Air
651,400	US Airways
1,085,000	Mirage Rsrts
170,000	ColgatePlmlv
150,000	WarnerLam
90,000	ChaseMan
45,000	Hershey
15,000	Amer Intl Gp

Year	FUND	S&P 500
1994	–7.1%	+1.3%
1995	+38.1%	+37.6%
1996	+20.9%	+23.0%
1997	+23.5%	+33.4%
1996	+26.0%	+23.6%

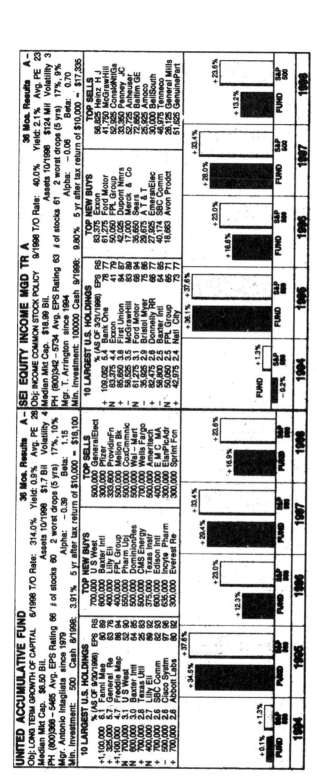

UNITED ACCUMULATIVE FUND
Obj: LONG TERM GROWTH OF CAPITAL 6/1998 T/O Rate: 314.0% Yield: 0.9% Avg. PE 28 36 Mos. Results A-
Median Mkt Cap. $6.50 Bil. Assets 10/1998 $1.7 Bil Volatility 4
PH (800)366-5465 Avg. EPS Rating 66 # of stocks 60 2 worst drops (5 yrs) 17%, 10%
Mgr. Antonio Intagliata since 1979 Alpha: -0.39 Beta: 1.15
Min. Investment: 500 Cash 6/1998: 3.91% 5 yr after tax return of $10,000 = $18,100

10 LARGEST U.S. HOLDINGS

	% (AS OF 9/30/1998)	EPS	RS
+1,100,000	Fanni Mae 6.1	80	89
+ 325,000	General Re 5.7	83	76
+1,100,000	Freddie Mac 4.7	98	94
N 700,000	U S West 3.1	52	90
N 600,000	Baxter Intl 3.0	64	85
+ 700,000	Texas Util 2.8	25	83
+ 400,000	Lilly Eli 2.7	89	92
N 700,000	SBC Comm 2.6	82	93
- 500,000	Cisco System 2.6	97	96
+ 700,000	Abbott Labs 2.6	80	92

TOP NEW BUYS

700,000	U S West
600,000	Baxter Intl
400,000	Lilly Eli
400,000	FPL Group
550,000	Pharm Upj
500,000	DominionRes
500,000	CMS Energy
375,000	Texas Instr
600,000	Edison Intl
635,000	Incyte Pharm
300,000	Everest Re

TOP SELLS

500,000	GeneralElect
300,000	Pfizer
333,600	ProvidinFn
500,000	Mellon Bk
500,000	CoxCmmnic
700,000	Wal-Mart
700,000	Wells Fargo
500,000	Ameritech
400,000	E M C MA
300,000	ElanPlcAdr
300,000	Sprint Fon

Performance bars:
- 1994: FUND +0.1%, S&P 500 +1.3%
- 1995: FUND +34.5%, S&P 500 +37.6%
- 1996: FUND +12.3%, S&P 500 +23.0%
- 1997: FUND +29.4%, S&P 500 +33.4%
- 1998: FUND +16.9%, S&P 500 +23.6%

SEI EQUITY INCOME MGD TR A
Obj: INCOME COMMON STOCK POLICY 9/1998 T/O Rate: 40.0% Yield: 2.1% Avg. PE 23 36 Mos. Results A-
Median Mkt Cap. $18.99 Bil. Assets 10/1998 $124 Mil Volatility 3
PH (800)342-5734 Avg. EPS Rating 63 # of stocks 61 2 worst drops (5 yrs) 17%, 9%
Mgr. T. Arrington since 1994 Alpha: -0.08 Beta: 0.70
Min. Investment: 100000 Cash 9/1998: 9.80% 5 yr after tax return of $10,000 = $17,335

10 LARGEST U.S. HOLDINGS

	% (AS OF 3/31/1998)	EPS	RS
+ 109,082	Bank One 5.4	78	77
N 83,375	Exxon 4.4	41	79
+ 85,660	First Union 3.8	84	87
+ 58,525	McGrawHill 3.5	83	89
N 61,275	Ford Motor 3.1	68	94
I 35,925	Bristol Myer 2.9	75	86
+ 82,475	Donnelly RR 2.6	77	66
I 56,800	Baxter Intl 2.5	64	85
N 50,060	FPL Group 2.5	65	71
+ 42,975	Natl City 2.4	73	77

TOP NEW BUYS

83,375	Exxon
61,275	Ford Motor
50,060	FPL Group
42,025	Dupont Nmrs
17,000	Merck & Co
35,660	Sears
29,675	A T & T
27,925	EmersnElec
40,174	SBC Comm
18,663	Avon Prodct

TOP SELLS

56,825	Heinz H J
41,750	McGrawHill
52,925	ConsolNtlGs
33,350	Penney JC
52,725	Anheuser
72,660	Baltim GE
25,925	Amoco
30,000	BellSouth
46,975	Tenneco
28,125	General Mills
51,625	GenuinePart

Performance bars:
- 1994: FUND -0.2%, S&P 500 +1.3%
- 1995: FUND +36.1%, S&P 500 +37.6%
- 1996: FUND +16.6%, S&P 500 +23.0%
- 1997: FUND +28.0%, S&P 500 +33.4%
- 1998: FUND +13.2%, S&P 500 +23.6%

Courtesy of *Investor's Business Daily.* All rights reserved.

WHICH FUNDS ARE BEST FOR YOU

Virtually everyone in America who has an IRA, Keogh, SEP, 401(K), employer-sponsored pension plan, variable annuity, or a variable life insurance policy has some holdings in at least one mutual fund. In most sponsored plans there is a limited choice, i.e., to one family of funds, but a choice of asset allocation to bond funds, growth funds, blue chip funds, or money market funds. The choice is much greater for individual investors. Brokers can be of some help in the selection of the appropriate funds, but remember that their view will be biased by the commission they receive from the sale. As with any other investment, investigate before you invest. Luckily there are information sources readily at hand that can provide you with an abundance of information. Internet sources are discussed in Chapter 13, but substantial information is available from a variety of printed media including *The Wall Street Journal, Investor's Business Daily,* and specialized reporting services such as Morningstar and Value Line. An example is shown in Figure 4–1.

READING MUTUAL FUND TABLES

The information available from Figure 4–1 gives you a quick picture of the five-year performance of each fund. From the information supplied, you can determine the following:

- the fund's investment objective
- the median market capitalization of all stocks that the fund owns
- the number of stocks owned by the fund
- the annualized turnover rate of the fund's trading activity
- the total assets under management
- the yield on the fund's portfolio

Figure 4–2. How to Read a Mutual Fund Chart.

Fund's investment objective.

Median Mkt. Cap:
Median market capitalization of all stocks that fund owns.

Turnover rate - Annualized measure of fund's trading activity.

of stocks - Total number of stocks the fund owns.

Yields of fund's portfolio.

36 Mos. Results - 36 month performance rank, versus all other mutual funds. All dividends and capital gains are included. A+ = top 5% of all funds. A = top 10% of all funds, A− = top 15% of all funds, etc.

Avg. PE: Average price-earnings ratio of funds' portfolio.

Volatility: Fund's price volatility (1 to 5 with 1 being the least volatile).

2 worst drops: Two worst % price declines fund had during last 5 years.

Alpha: shows % stocks would have changed per month in latest year if the S&P 500 was unchanged.

Beta: 1.50 means portfolio tends to be 50% more volatile than S&P 500. 1.00 means volatility tends to = S&P 500.

Avg. EPS Rank: Average Earnings Per Share Rank of all stocks in the fund (99 is the highest).

Name of portfolio manager and length of service.

Minimum Investment: Minimum amount of money needed to start an account with fund.

Cash: Percentage of fund assets in cash.

N Indicates a new position for the fund.
+ Shows fund added to holdings in last reporting period.
− Shows fund reduced its holdings in stock from previous reporting period.

Top New Buys ↓ Largest new buys (in order of dollar amount) in latest reported time period.

5 yr. after tax return: Shows amount of money that $10,000 grew to, over last 5 years after taxes, and if dividends were reinvested.

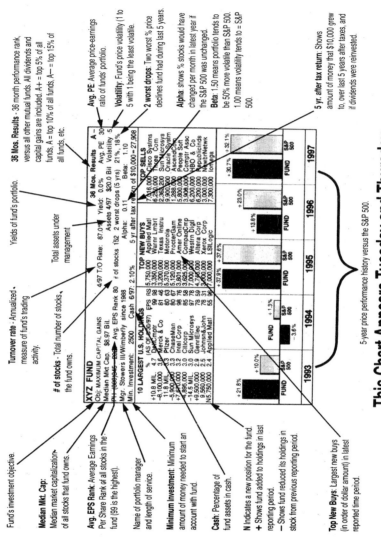

XYZ FUND
Obj: MAXIMUM CAPITAL GAINS
Median Mkt. Cap: $8.97 Bil.
Avg. EPS Rank 80
Mgr. Stowers III/Wimberly since 1988
Min. Investment: 2500 Cash: 6/97: 2.10%

4/97 T/O Rate: 87.0% Yield: 0.0%

36 Mos. Results A−
Avg. PE 30 Volatility: 5
Assets 4/97 $20.0 Bil 21%, 18%
of stocks 152 2 worst drops (5 yrs)
Alpha: 0.1 Beta: 1.10
5 yr after tax return of $10,000 = 27,908

10 LARGEST U.S. HOLDINGS (AS OF 2-30/97)

	%		EPS	RS
+10.6 MIL.	4.7	DellCmptr	99	98
−8,100,000	3.5	Merck & Co	81	46
11.8 MIL	3.3	Pfizer	80	63
−5,900,000	3.2	ChaseMan	98	76
+7,570,000	3.2	Intel Corp	98	67
4,895,000	3.0	Citicorp	85	58
−14.5 MIL.	3.0	Sun Microsys	97	78
+9,500,000	2.9	GenrlElec	78	59
9,560,000	2.5	Johnsn&John	78	31
N5,750,000	2.4	Applied Matl	55	96

TOP NEW BUYS
5,750,000	Applied Matl
3,350,000	Warnr Lmbrt
3,200,000	Texas Instru
5,370,000	Motorola
3,801,000	ProcterGam
3,625,000	Amer Online
7,090,000	CompacCmp
4,740,000	Westn Digtl
3,600,000	Altera Corp
3,000,000	Xerox Corp
	LSI Logic

TOP SELLS
7,016,000	Cisco Systms
6,230,000	Applied Matl
2,363,200	Tllabs Com
9,900,000	Sun Microsys
1,256,000	Oracle
6,200,000	AscendCom
3,906,000	People Sft
6,200,000	Centre Asc
6,200,000	HBO & Co
7,300,000	Republicinds
	NwbrkNetwk
	Iorkgra

1993	1994	1995	1996	1997
FUND +10.0% / S&P 500 +21.8%	FUND +1.3% / S&P 500 −3.6%	FUND +37.9% / S&P 500 +37.6%	FUND +13.6% / S&P 500 +23.0%	FUND +36.7% / S&P 500 +32.1%

5-year price performance history versus the S&P 500.

This Chart Appears Tuesday and Thursday

Figure 4–3. Morningstar Chart of Oakmark.

Oakmark I

Ticker	OAKMX
Load	None
NAV	$36.45
Yield	1.2%
Total Assets	$5,620.3 mil
Mstar Category	Large Value

Investment Style: Equity — Average Stock %

Prospectus Objective: Growth

Oakmark fund seeks long-term capital appreciation; income is a consideration.

The fund invests primarily in common stocks and convertibles. To select individual securities, the fund uses several qualitative and quantitative methods to determine economic value. The primary determinant of value is a company's ability to generate cash. other key factors include the quality of management and amount of management's stock ownership. The fund especially seeks securities that are priced significantly lower than their long-term value. The fund may invest up to 25% of assets in foreign securities. it may invest up to 5% in emerging markets.

Historical Profile

Return	Average
Risk	Average
Rating	★★★ Neutral

Fund Performance vs. Category Average
- ■ Quarterly Fund Return
- +/- Category Average
- – Category Baseline

Portfolio Manager(s)

Robert J. Sanborn, CFA. Since 8-91. BA'80 Dartmouth C; MBA'83 U of Chicago. Sanborn is an executive vice president and portfolio manager with Harris Associates L.P.. his employer since January 1988. From 1983 to 1987 he was a portfolio manager and analyst for the State Teachers' Retirement System of Ohio. Other funds currently managed: New England Star Adv. New England Star World. Masters' Select Equity.

Performance 08-31-99

	1st Qtr	2nd Qtr	3rd Qtr	4th Qtr	Total
1995	9.19	6.18	8.37	6.98	34.42
1996	3.56	3.51	0.75	7.60	16.21
1997	3.99	15.22	6.32	4.08	32.59
1998	9.95	-2.70	-13.83	12.53	3.73
1999	-0.47	11.53	—	—	—

Trailing	Total Return%	+/- S&P 500	+/- Russ Top 200 Val	%Rank All	%Rank Cat	Growth of $10,000
3 Mo	-5.55	-7.29	-2.14	96	88	9,445
6 Mo	3.82	-3.51	-2.32	51	74	10,382
1 Yr	18.72	-21.09	-15.48	48	85	11,872
3 Yr Avg	16.16	-12.41	-10.54	27	76	15,673
5 Yr Avg	16.23	-8.87	-7.43	24	78	21,211
10 Yr Avg	—					
15 Yr Avg	—					

Tax Analysis	Tax Adj Ret%	%Rank Cat	%Pretax Ret	%Rank Cat
3 Yr Avg	13.49	71	83.5	53
5 Yr Avg	13.79	68	85.0	44
10 Yr Avg	—			

Potential Capital Gain Exposure: 21% of assets

Risk Analysis

Time Period	Load-Adj Return%	Risk %Rank All	Cat	Morningstar Return Risk		Morningstar Risk-Adj Rating
1 Yr	18.72					
3 Yr	16.16	67	61	0.88	0.88	★★★
5 Yr	16.23	68	59	0.89	0.86	★★★
Incept	24.08					

Average Historical Rating (61 months): 4.6★s

Category Rating (3 Yr): Worst 1 2 3 4 5 Best

Other Measures	Standard Index S&P 500	Best Fit Index S&P 500
Alpha	-5.6	-5.6
Beta	0.78	0.78
R-Squared	67	67
Standard Deviation	18.40	
Mean	16.16	
Sharpe Ratio	0.69	

Return: Below Avg
Risk: Average

Portfolio Analysis 08-31-99

Share change since 07-99 Total Stocks: 27

Stock	Sector	PE	YTD Ret%	% Assets
⊕ Philip Morris	Staples	15.0	-28.50	7.07
⊕ H & R Block	Services	27.5	24.86	6.46
Boeing	Industrials	21.8	40.31	6.05
Knight-Ridder	Services	18.3	6.83	5.63
Black & Decker	Durables	19.7	-5.70	5.07
Mattel	Staples	28.5	-8.40	4.78
Lockheed Martin	Industrials	45.1	-11.10	4.77
⊕ Dun & Bradstreet (New)	Services			4.34
Nike	Durables	29.8	15.75	4.33
Washington Mutual	Financials	11.5	-15.70	4.23
⊕ Eaton	Industrials	20.9	40.88	3.69
⊕ Columbia/HCA Healthcare	Health	29.3	5.07	3.48
Brunswick	Industrials	13.0	4.92	3.31
Bank One	Financials	14.0	-20.20	3.28
Cooper Inds	Industrials	13.8	10.29	3.26
Fortune Brands	Staples		20.66	3.24
First Data	Technology	31.2	38.16	2.25

Performance Quartile (within Category)

History	1988	1989	1990	1991	1992	1993	1994	1995	1996	1997	1998	08-99
NAV	—	—	—	13.02	19.13	23.93	22.97	29.75	32.35	40.41	35.82	36.45
Total Return %	—	—	—	30.20	48.90	30.50	2.00	34.42	16.21	32.59	3.73	1.76
+/- S&P 500	—	—	—	20.32	41.28	20.45	2.00	-3.12	-6.74	-0.77	-24.85	-6.58
+/- Russ Top 200 Val	—	—	—	—	39.83	10.74	5.63	-5.62	-6.11	-2.90	-17.51	-5.72
Income Return %	—	—	—	0.00	0.31	1.20	0.97	1.24	1.16	1.24	1.21	1.76
Capital Return %	—	—	—	30.20	48.59	29.30	1.04	33.18	15.05	31.35	2.52	.70
Total Rtn % Rank Cat	—	—	—	—	1	2	13	39	86	11	93	70
Income $	—	—	—	0.00	0.04	0.23	0.13	0.28	0.34	0.40	0.44	0.00
Capital Gains $	—	—	—	0.00	0.21	0.77	1.47	0.84	1.87	1.98	5.63	0.00
Expense Ratio %	—	—	—	2.50	1.70	1.32	1.22	1.17	1.18	1.08	1.08	—
Income Ratio %	—	—	—	-0.66	-0.24	0.94	1.19	1.27	1.13	1.19	1.22	—
Turnover Rate %	—	—	—	34	34	18	29	18	24	—	43	—
Net Assets $mil	—	—	—	8.3	328.8	1,214.1	1,626.9	3,301.6	4,195.0	7,301.4	7,667.9	5,620.3

No one can argue that style inconsistency is at the root of Oakmark Fund's problems.

Manager Robert Sanborn has lately caught a little flak because this portfolio hasn't kept up with sibling Oakmark Select. On the surface, that has been surprising, as both managers pick from a list of approved stocks maintained by the Oakmark funds' advisor, Harris Associates. But Sanborn's conservatism with respect to valuations and franchise value has held back the fund in a roaring bull market. For example, Select scored big gains on biotech giant Amgen, but Sanborn thought the stock wasn't all that cheap, given the firm's dependence on the sale of just two drugs. Moreover, Sanborn has been a lot quicker than Nygren to trim his winners. Sanborn sold cable and media stocks, including Cablevision and AT&T–Liberty Media, when they still had room to appreciate, while Nygren let them run. Don't expect Sanborn to change his approach. While the market has usually

favored bigger, more richly valued firms in recent years, this fund's holdings have gotten smaller and cheaper (relative to the group). Attractive valuations have led Sanborn to hike the fund's stake in mid-caps, and the fund's median market cap has dropped by nearly half in the past two years. He says most tech stocks still don't meet his valuation criteria, and the fund continues to sport big stakes in the less-glamorous industrials and durables areas.

For those seeking a pure value fund, Sanborn's approach can make a lot of sense. The fund has only scant exposure to the big names that dominate the S&P 500, so it should provide some diversification away from the bogy. Sanborn's long-term record is still good, though he put up his best numbers when the fund's asset base was smaller. Moreover, the fund rallied sharply when cyclicals surged in the second quarter. That suggests that when value makes a sustained comeback—as it will at some point—this fund should perform well.

Address:	Two N LaSalle Street	Minimum Purchase:	$1000	Add: $100	IRA: $1000
	Chicago, IL 60602–3790	Min Auto Inv Plan:	$500	Add: $100	
	800–625–6275	Sales Fees:	No-load		
Web Address:	www.oakmark.com	Management Fee:	1.00% max./0.85% min.		
Inception:	08-05-91	Actual Fees:	Mgt 0.93%	Dist: ——	
Advisor:	Harris Associates	Expense Projections:	3Yr: $34	5Yr: $59	10Yr: $131
Subadvisor:	None	Avg Brok Commission:	—	Income Distrib: Annually	
NTF Plans:	Fidelity, Jack White, Fidelity Inst., Schwab	Total Cost (relative to category)	Below Avg		

	Services
ACNielsen	Staples
Nabisco Hldgs Cl A	Financials
⊕ Old Republic Intl	Industrials
⊕ Stanley Works	Health
Sybron Intl	Durables
Bandag Cl A	Industrials
Geon	Services
GC	

		Rel	
	32.5	-11.50	2.12
	59.6	-4.42	1.66
	7.0	-30.20	1.54
	20.6	-3.51	1.38
	21.1	-5.29	1.34
	—	—	0.52
	8.9	31.71	0.51
	—	-19.50	0.16

Current Investment Style

	Stock Port Avg	Relative S&P 500 Current Hist	Rel Cat
Price/Earnings Ratio	22.8	0.63 0.81	0.86
Price/Book Ratio	3.7	0.41 0.58	0.74
Price/Cash Flow	13.4	0.56 0.80	0.81
3 Yr Earnings Growth	11.5	0.71 0.80	0.92
1 Yr Earnings Est%	18.2	0.99 —	1.19
Med Mkt Cap $mil	8,300	0.1 0.3	0.33

Style: Value Blend Growth
Size: Large Med Small

Sector Weightings	% of Stocks	Rel S&P	5-Year High Low
Utilities	0.0	0.0	5 0
Energy	0.0	0.0	10 0
Financials	10.7	0.7	29 11
Industrials	27.2	2.3	27 12
Durables	11.7	5.4	18 2
Staples	19.8	2.5	29 5
Services	22.2	1.6	33 8
Retail	0.0	0.0	6 0
Health	5.7	0.5	20 0
Technology	2.7	0.1	8 0

Special Securities % assets 08-31-99

Restricted/Illiquid Secs	0
Emerging-Markets Secs	0
Options/Futures/Warrants	No

Market Cap

Giant	8.4
Large	35.8
Medium	55.0
Small	0.6
Micro	0.2

Composition % assets 08-31-99

Cash	9.3
Stocks*	90.8
Bonds	0.0
Other	0.0
*Foreign (% stocks)	0.0

- the 36-month performance rank
- the average price-earnings ratios of the fund's portfolio
- the volatility ratings of the fund compared to the market
- the five-year after-tax return with dividends reinvested
- the name of the portfolio manager and the number of years running the fund
- the percentage of cash held in the fund's assets, as well as the ten largest holdings
- the top ten new buys and the top ten new sells

The graphs also show the performance of the fund versus the S&P 500 during the past five years. Such information allows the interested investor to make some sort of intelligent comparison among the myriad of funds offered. Similar information is available from Morningstar and other reporting services. Figure 4–2 is an explanatory chart that is a regular feature of *Investor's Business Daily.* Figure 4–3 is an example of a Morningstar profile of one fund.

Information tables on open-end mutual funds are published daily in both *Investor's Business Daily* and *The Wall Street Journal.* (See Figure 4–4.) The published prices are the bid and offer charges, which include any load or sales charge. The bid in the quotation is the net asset value of the fund (NAV). This is the value of each share of the mutual fund and the price the investor receives when selling shares. The cost to purchase shares is known as the offer price, which includes any load. Some offering prices have the letters NL indicating this is a no-load fund and the bid and offer are the same.

Figure 4–4. Mutual Fund Tables.

36 Mos. Performance Rank	Mutual Fund	1998 % Chg	52 Wk % Chg	5 Yr After Tax Rtn	Net Asset Value	N.A.V. Chg
	Thursday, December 10, 1998					
	– A –					
	AAL Mutual A $4.7 bil			800–553–6319		
	Balanced A b	11.27	– .09
E	Bond A	+ 7	+ 8	+ 18	10.20	+ .02
A+	Capital Gr A	+20	+21	+138	31.15	– .51
C+	Eq Inc A	+ 8	+11	14.04	– .19
	High Yield Bd A	– 3	– 2	9.22	– .01
D	International A	+ 8	+ 7	10.89	+ .05
E	Mid Cap Stk A	– 7	– 7	+ 60	13.52	– .24
D	Muni Bd A	+ 6	+ 8	+ 23	11.79	+ .01
	Small Cap Stk A	– 9	–10	11.35	– .20
	AAL Mutual B $ 9 mil			800–553–6319		
	Balanced B m		11.22	– .10
	Capital Gr B	+19	+20	30.71	– .50
	Eq Inc B b	+ 8		14.01	– .19
	High Yield Bd B b	– 3		9.22	– .01
	International B b	+ 7	+ 6	10.72	+ .05
	Mid Cap Stk B	– 8	– 7	13.30	– .24
	Small Cap Stk B	–10	–10	11.18	– .20
	AARP Investment $16.5 bil			800–322–2282		
C+	Bal Stk & Bd	+ 5	+ 6	21.03n	– .12
	Bd for Inc	+ 7	+ 7	15.38n	+ .02
A	Capital Gr	+16	+16	+106	60.50n	– .98
	Div Inc Gr	+ 7	+ 7	16.45n	– .04
	Diversified Gr	+ 7	+ 7	18.31n	– .11
	Glbl Gr	+ 9	+10	19.63n	– .05
D–	GNMA & US Tres	+ 7	+ 7	+ 20	15.28n
B+	Gr & Inc	+ 4	+ 4	+112	54.19n	– .51
E	Hi Ql Sht Trm Bd	+ 5	+ 6	+ 18	16.28n	+ .02
E	Insd Tx Fr Genl	+ 5	+ 6	+ 20	18.78n	+ .02
	Intl Gr & Inc	+ 8	+ 7	17.75n	+ .15
	Small Co Stk	–10	–11	17.88n	– .22
	US Stk Ind	+22	+22	22.09n	– .34
	ABN AMRO Funds $970 mil			800–443–4725		
E	AsianTiger Com	–10	–13	6.82n	+ .03
B–	Balanced Com	+ 7	+ 8	+ 60	12.13n	– .12
D	Fixed Inc Com	+ 7	+ 9	+ 23	10.59n	+ .01
A–	Growth Com	+20	+19	+112	16.73n	– .21
C	Intl Eq Inv Com	+21	+21	+ 69	18.40n	+ .03
E:	IntlFixdIncCom	+16	+16	+ 19	11.21n	+ .09
D–	Intmd FxdInc Cm	+ 9	+ 9	+ 21	10.40n	+ .02
	LatinAmEqCom	–34	–30	8.50n	– .03
D	Sm Cap Gr Com	–14	–12	+ 45	11.28n	– .17
E	TxExmpFixdCom	+ 6	+ 8	+ 22	10.62n	+ .02
B+	Value Com	+ 4	+ 4	+ 94	14.28n	– .23
	Accessor Funds $758 mil			800–759–3504		
A+	Growth	+35	+34	+164	28.43	– .48
C	Intl Eq	+12	+11	16.57	+ .02
D	Intrmd Fxd Inc	+ 9	+10	+ 22	12.61
D	Mortgage Sec	+ 6	+ 7	+ 26	12.70	+ .01
E	Sh Intl Fxd Inc	+ 7	+ 7	+ 18	12.51	+ .01
A–	Small Cap	+ 4	+ 5	+101	22.02	– .24
A	Value & Income	+ 8	+ 9	+109	22.17	– .29
	Balanced C b	+ 6	+ 7	27.09	– .25
	Blue Chip C m	+21	+21	38.23	– .58
	Cap Devlpmnt C m	– 5	– 5	13.52	– .21
	Charter C m	+16	+15	14.25	– .21
	Constellation C m	+ 7	+ 5	28.05	– .52
	Glbl Agg Gr C m	– 2	– 2	16.36	– .06
	Global Gr C m	+14	+13	18.64	– .15
	High Yield C b	– 7	– 7	8.84
	Int Govt C m	+ 7	+ 8	9.61
	Intl Equity C m	+ 9	+ 7	17.81	+ .04
	Value C m	+21		38.50	– .44
	Weingarten C m	+19	+18	23.15	– .42
	AIM Global Theme $3.7 bil			800–347–4246		
	Cons Prod&SvcA b	+14	+15	24.31	– .21
	Cons Prod&SvcB m	+13	+14	23.79	– .21
B+	Finl Svcs A b	+ 6	+ 5	18.37	– .10
B	Finl Svcs B m	+ 5	+ 5	17.99	– .10
E	Glbl Res A b	–36	–40	10.65	– .07
E	Glbl Res B m	–37	–41	10.45	– .06
B–	Health Care A b	+11	+ 9	+ 78	22.02	– .36
C+	Health Care B m	+10	+ 8	+ 73	21.16	– .34
D	Infrastructure A b	0	+ 1	14.90	– .05
D	Infrastructure B m	– 1	0	14.56	– .04
D	Telecom A b	+ 8	+10	+ 32	17.74	– .11
D	Telecom B m	+ 8	+10	+ 28	17.16	– .10
	Alger Funds A $ 80 mil			800–992–3863		
	Capital Apprec A	+25	+23	30.46	– .50
	Growth A	+33	+32	13.44	– .23
	MidCap Grwth A	+18	+16	22.89	– .47
	Small Cap A	0	–	9.57	– .18
	Alger Funds B $ 1.5 bil			800–992–3863		
B–	Balanced m	+24	+24	17.87	– .17
B	Capital Apprec m	+24	+22	30.00	– .49
A–	Growth m	+32	+31	+131	13.22	– .23
C+	MidCap Growth m	+17	+15	+122	22.52	– .46
E	Small Cap m	– 1	– 2	+ 49	9.42	– .18
	Alger Retirement Fds $ 82 mil			800–992–3863		
	Cap Appr Ret		10.25	– .14
	Growth	+37	+36	13.66	– .24
	MidCap Growth	+24	+22	9.61	– .22
	Small Cap	+11	+ 9	18.17	– .33
	Alliance A Capital $9.7 bil			800–221–5672		
C	Alliance Fund b	–11	–12	+ 50	5.98	– .08
B–	Balanced A b	+12	+12	+ 57	14.85	– .14
D	Corporate Bond b	0	+ 1	+ 19	13.29
	Glbl Dollar Gvt b	–23	–20	5.89	– .05
	Glbl Str Inc A b	+ 2		10.40
	Global Envir A b	–12	– 9	8.35	– .12
D+	Global Sml Cap b	– 3	– 4	+ 41	10.89	– .04
E	Govt Bond b	+ 9	+10	+ 15	7.75	+ .02
A	Growth b	+20	+21	+133	51.59	– .66
A	Growth & Inc b	+14	+14	+106	3.59	– .07
C+	Growth Inv A b	+20	+19	16.09	– .10
	Hi Yld Inc A b	– 2		10.32	+ .01
D–	Insured Mu CA b	+ 6	+ 8	+ 23	14.31	+ .01
D	Insured Muni b	+ 5	+ 7	+ 23	10.32	+ .01

PROS AND CONS

There are a number of factors that you should consider when investing in any particular mutual fund. The dynamics of the stock market have been dramatically changed by the influx of money into mutual funds. The tremendous growth of the mutual fund industry has substituted the collective judgment of millions of individual investors for that of a relative handful of professional managers. These professional managers mostly invest in the same large capitalization stocks because these are the only issues large enough to absorb the money flow and the managers perceive these stocks as having greater liquidity when they wish to exit a position. The individual investor must look to the attitude and trading style of the individual fund manager.

The greatest irony of most mutual fund purchases is the desire of the individual investor to be a long-term holder at the same time that the professional manager is interested in turning over the fund's portfolio in order to show performance results. In addition, trading strategies of the professionals and even the timing of the investor's purchase of shares can have drastic and unforeseen tax consequences. Investors should consider whether the fund's investment policy is tax neutral or whether large capital gains will be passed through. During the summer of 1998 many mutual fund investors were shocked by the notification of large capital gains even as the value of their shares was going down. This resulted from managers locking in long-term gains against the decline in the market.

The demographics of the baby boom continue to work in favor of continued cash inflows into mutual funds and will continue to do so until 2010 when the first of the baby boomers begin to retire. Nevertheless, specific dangers do exist for mutual fund investments. Mutual funds are valued for the diversity of investment, yet many investors make the mistake of investing in several different funds that all invest in the same types of stocks. Diversity in this situation is better served by investing in different *groups* of funds, i.e., large

capitalization blue chips, small capitalization stocks, mid-capitalization growth stocks, corporate or government bonds, and perhaps foreign stocks or global growth.

INDEX FUNDS

A relatively new and growing force in the world of mutual funds has been the rise of the index mutual fund.

John C. Bogle of the Vanguard Group of investment funds and creator of the Vanguard 500 Index fund, is generally considered the father of index investing. In dealing with the concept of efficient market theory, Bogle's thesis is that the gross returns earned by investors collectively must equal the gross returns earned by the entire stock market, and that the net returns of the collective group of all investors, after advisory and other investment fees, will fall short of the returns of the entire market by the amount of the costs expended. And on a historical statistical basis this efficient market theory would appear to be correct.

A passively managed fund (also known as an "index fund") seeks to match the investment performance of a specific index. Unlike active management who actively trade in an attempt to beat the market, a passive manager simply holds all or a representative sample of the securities in the index.

Beginning with the Vanguard 500 Index Fund, this segment of the mutual fund industry has come to represent over 23% of the funds available covering numerous indices well beyond the most commonly known, such as the DOW 30, S&P 500, and NASDAQ 100.

The *benefits* of passive fund management include: 1) *relative predictability* because the fund's performance should mirror that of the index less operating expenses, 2) *tax efficiency,* because the index portfolios do not turn over very often, a passive manager is not required to trade with great frequency and as a result tends to

distribute modest, if any, capital gains, which means a lower tax lia-
bility for shareholders, 3) *lower costs* because index funds have
lower management fees because they are not active which incurs
lower brokerage and transaction fees resulting in passive manage-
ment operating expenses far less than for an actively managed fund.

DRAWBACKS OF PASSIVE FUND MANAGEMENT

Limited returns. A passively managed fund cannot expect to outper-
form the market and generally does only as well as the index it tar-
gets. With an actively managed portfolio, the investor can identify a
fund that can outperform the target index. *(Historically however,
over time, the average passively managed fund has tended to outper-
form the majority of actively managed funds.)* Rates of return fluc-
tuate from year to year, but during the late '90s, index funds tended
to outperform actively managed funds by a substantial margin as
massive cash flows into index funds by investors just interested in
buying and holding the market averages directed nearly 32% of new
money into index funds during the period July 1998–July 1999.
Managers forced to buy index stocks drove up the prices. However,
during the first nine months of 1999, 50% of actively managed diver-
sified funds exceeded the S&P 500's return of 13%, and the outper-
formance tended to be substantial, i.e., Vanguard 500 did 16% YTD
return to December 9, which was beaten handily by a growth fund
showing 156%, an internet fund showing 178%, and a global tech
fund at 176%. Investors tend to chase the hottest performing sector
out of greed and fear of being left behind, rather than staying with a
disciplined buy and hold investment policy, which over the long term
has usually outperformed switching from one hot performing sector
to another.

 Rigid portfolio requirements. An actively managed fund can
buy or sell specific securities, or go to cash, in times of market volatil-
ity. Passively managed funds are bound by the terms of their charter
to maintain certain proportional ownership in the stocks that make

up the index fund and to remain fully invested, and accordingly can be expected to perform badly during market downturns.

Alternatives to index funds are index shares which trade on the major exchanges and represent proportional ownership in the particular index tracked. Most investors are familiar with the index shares which track the Dow 30 Index (DIA), the NASDAQ 100 (QQQ), and the S&P 500 (SPY), but other indices track utilities, tech stocks, and bio-techs to mention but a few. Because they are proportional shares, i.e., 1 SPY share equals 1/5 of the S&P 500 basket, the shares may be too high priced for individuals, and index shares do not provide for reinvestment of dividends which are settled in cash. The costs, however, are lower as only a standard brokerage commission is paid at time of purchase and sale without any other management fees or trails.

There's More Than One Market

Barter, the earliest form of commerce, is defined as the exchange of commodities or services for other commodities or services, rather than for money. The earliest societies relied on barter for the exchange of the goods and services necessary for human existence. As trade expanded, the use of money became the norm, and later the concept of the corporation developed. The corporation is an improvement over other forms of business organization because it enjoys unlimited life. (It can be destroyed only by act of law.) Furthermore, corporations provide their owners (shareholders) with limited liability. (The shareholders stand to lose only those assets committed to the corporation.)

WALL STREET—WHERE IT ALL BEGAN

Securities are traded in a variety of forms and in diverse trading places. Wall Street is where it all began, but you will see that the nation's financial marketplace today bears little resemblance to its origins there.

According to historians, prior to the Revolutionary War, New York City's leading merchants met daily under a buttonwood tree located at what is today the corner of Wall and Broad Streets. These

early merchants traded in commodities such as furs, tobacco, and currencies, and provided services, such as insuring ships' cargoes.

As companies were organized to conduct different types of commercial activities such as banking, retail trade, or shipping, an informal market in shares of these companies developed among the merchants who controlled them. Twenty-four of these early merchants, or stockbrokers, as they came to be called, entered into a formal agreement on May 17, 1792, to trade only among themselves and to maintain agreed-on commission rates. This marked the founding of what is today the New York Stock Exchange.

The 24 stockbrokers decided that meeting under the buttonwood tree wasn't always a good idea, so they took to meeting at a coffeehouse. This was common in those days, with coffeehouses often specializing in different sorts of patrons. The merchants came to meet at a multistoried coffeehouse, where they traded different goods on different floors. After outgrowing this arrangement, they rented space in various locations on Wall Street. By the middle of the 1800s, they settled on the corner of Wall and Broad Streets, where the present home of the New York Stock Exchange (opened in 1903) stands.

THE NEW YORK STOCK EXCHANGE

The New York Stock Exchange (NYSE) is a centralized exchange. This means all trading is supposed to occur at the Exchange itself. Nowadays, many companies trade NYSE-listed stock over phone lines, by means of computers, and away from the floor of the Exchange, which has been further facilitated by the removal of NYSE Rule 390.

Another aspect of this Exchange is that only certain stocks would be traded. Those that did not make the grade would be traded by other exchanges. This meant that certain standards would have to be met for a stock to be traded on the Exchange. Today these

listing requirements apply to a company's earnings history, asset value, amount of shares outstanding, and trading volume on other exchanges. Figure 5–1 is a compilation of the current NYSE listing standards. It must be remembered, however, that each case is decided on its own merits and that NYSE decisions are not simply based on mathematical measurements.

Figure 5–1. Minimum Qualifications
for Listing a Stock on the New York Stock Exchange.

CRITERION	INITIAL LISTING
1. Earning Power	*Either* $2.5 million pretax for the most recent year and $2 million for each of the preceding 2 years *or* an aggregate of $6.5 million in the last 3 years, with minimum in most recent fiscal year of $4.5 million (all three years must be profitable)
2. Net tangible assets	$40 million
3. Aggregate market value of common stock publicly held	$40 million
4. Publicly held shares	1.1 million
5. Number of shareholders	2,000 round-lot holders, or 2,200 total shareholders with an average monthly trading volume of 100,000 shares for the most recent 6 months, or 500 total shareholders with an average monthly trade volume of 1,000,000 shares for the most recent 12 months

These listed securities are traded by people and by companies. However, only those with a membership or *seat* can actually trade

on the floor of the Exchange. There is a limited number of seats, and the price varies with the times. Prices have been up to $2,000,000 to less than $500,000. Trading is done for the public by the members of the Exchange and through Exchange computers.

One of the key players in a trade is the *specialist*. This person, or more likely company, specializes in making sure that a particular stock can trade. It is the specialist's duty, as regulated by the various federal securities acts. Profits as well as losses come with this duty.

Not just any firm can decide it wants to be a specialist. A company has to apply and be approved by the Exchange in order to call itself a specialist. Upon becoming a specialist, a company is assigned a stock in which to trade. While a specialist will have more than one stock of which to be in charge, there is only one specialist per stock. This makes the specialist the exclusive market maker for a company's stock.

The specialist is found at a *post*. It is here that other traders will gather when they want to buy or sell that particular stock. The specialists provide an orderly and liquid market for their stocks, buying when the price is falling and selling when the price is rising. Specialists are like auctioneers who buy and sell from their inventory; they will act when no one else wants to in order to try to smooth out market excesses.

The specialist firm is also in charge of "running the book" in the stocks assigned by the Exchange. *Running the book* refers to the specialist entering on a computer those buy-and-sell orders that are not at the current trading price. (This can be done automatically.) When and if the price is reached, the order is executed. Because of their position, specialists have access to highly significant information: the numbers of shares and prices at which orders are awaiting execution. In other words, they know the supply and demand for a particular company's stock and to some degree predict the direction in which the stock's price is headed. This is another reason why the specialist is regulated by the government and by the Exchange.

Historically the specialist's role has proven very profitable. The job can be very risky as well, since the specialist has to act contrary to the trend. This means a specialist needs a substantial amount of capital. Considering the high volume of stocks traded today, this is especially true.

Other trading personnel on the floor include registered traders and floor brokers. *Registered traders* are independent traders. Originally used to help maintain liquidity, their role has diminished over the years. *Floor brokers* work for brokerage firms with the job of acting as agents of buyers and sellers of stocks. In the past they were busy filling all orders that reached the floor of the Exchange, but nowadays many of their duties have been augmented by computers.

The NYSE has an order-entry system known as *Designated Order Turnaround (DOT)*. Orders are entered by a brokerage firm and electronically routed to the computers of the Exchange. These orders are sent to a specialist's electronic book and stored or are executed. This allows brokerage firms to confirm the execution of some trades while still on the phone with the customer. With DOT many discount brokerage firms also allow customers to enter their trades using their home computers. Once the trade is made, the price, volume, and time are recorded and disseminated throughout the world.

This computerized order-entry system is useful to the large investor as well as to the small one. Large investors are often called *institutions or institutional investors*. These investors are brokerage firms, insurance companies, mutual funds, as well as private and public retirement funds. What all institutions have in common is that they trade in large amounts of blocks because they have so much money. While the individual may think in terms of hundreds or thousands of shares, the institution is trading in hundreds of thousands or millions of shares. Almost half of all the block shares traded in 1990 were traded by institutions. In order to protect the small investor, the *Small Order Entry System (SOES)* was established, giving priority to trades of 1,000 shares or less.

While the computerized entry system helps expedite large and small trades, it also has had a part in creating trading strategies that can have a large impact on the market. This is because many orders can be placed to be executed at the same time. To profit from changes in the stock market, many firms have combined the computerized order execution with computerized trading strategies. A common strategy is known as program trading.

Program trading is a way for large "players" to take advantage of market relationships. This type of strategy uses the stock market, as measured by certain indices, and plays it off against the stock index futures market. This sort of strategy requires that when certain price relationships arise, a participant should buy or sell stock as one part of the transaction. The other half of this transaction is on the other market.

This strategy has such a large impact because the stocks that are bought or sold are the market leaders. Another reason why program trading has an affect is that many firms use this strategy because it can be quite profitable.

Because of the volume program trading creates, it has the ability to move the market up or down. In order to stem this volatility, the NYSE has established price limits called *trading curbs*. If the market moves a certain amount in one direction or the other, these program trades are not allowed. This happens in an up market as well as in a down market. These limits were put in place to reassure the individual investor and others not involved with program trading.

To truly begin to understand the changes that have taken place in the United States financial markets, it is only necessary to look at the numbers for the NYSE. During the 20-year period from 1979 to 1999, the number of stocks traded rose from 1,580 to over 3,100 stocks (preferreds included) of approximately 2,600 companies. The number of foreign companies listed rose from 37 to 380. The average daily trading volume rose from 28 million shares per day to over 674 million shares per day, with a record set in 1998 of 1.3 billion shares traded in a single day!

THE AMERICAN STOCK EXCHANGE

Many investors refer to the American Stock Exchange (AMEX) as the "Curb Exchange" because it began as an informal group of stockbrokers and dealers who conducted their business on the curb in front of the New York Stock Exchange and from the windows and doorways of the surrounding buildings. By the late 1890s, the American Stock Exchange had been organized and moved indoors to its own building. In the late 1950s, the AMEX moved to its present location behind Trinity Church, just blocks away from the NYSE.

Though the AMEX has recently merged with the NASDAQ, it will retain its trading floor. The requirements for listing a corporation on the AMEX are substantially less stringent regarding assets, earnings, and number of stockholders. The AMEX has traditionally been the trading place for shares of the smaller and newer of the nation's public companies as well as the shares of natural resource companies. A pattern has been that as a company grew in assets, showed a proven record of sales and earnings, and gained greater public recognition, it met the standards for listing on the NYSE and moved over to that exchange.

The reasons for switching to the NYSE have much to do with the added recognition and liquidity that many investors and corporate managers feel a NYSE listing gives a company. However, if you run down the names of the AMEX-listed companies, you will find a number of familiar names and companies of substantial size. For that matter, many companies have been listed on the AMEX for 40 or 50 years; the idea of switching exchanges does not appeal to all company managements.

The mechanical process of executing orders on the AMEX is effectively the same as on the NYSE. The specialist, floor broker, registered trader, and operational staff play the same roles and have similar importance as on the NYSE.

However, some important differences exist between the two exchanges. For one thing, the volume of trading on the AMEX is much less than that on the NYSE because institutions find that many

of the stocks listed on the AMEX do not meet their investment criteria. The AMEX has historically been, and continues to be, the investment domain of the small investor.

Second, the prices of stocks listed on the AMEX tend to be lower and the price action more volatile than those of NYSE-listed stocks. Many companies listed on the AMEX are smaller and more subject to economic downturns and competition. The AMEX has proven to be aggressive in developing and marketing new investment products such as options. It was the AMEX that first developed an option trading program in New York.

REGIONAL STOCK EXCHANGES

Regional stock exchanges were developed to meet the need for trading places for the stocks of local companies. Companies can be listed on more than one exchange as long as they meet the respective market's listing requirements. Dual listings are common on the regional exchanges, where transactions are usually based on current NYSE or AMEX prices. While the Boston, Philadelphia, Midwest, Cincinnati, and Pacific Stock exchanges still exist, as time passed, the New York Stock Exchange, American Stock Exchange, and the over-the-counter market (described later) came to account for approximately 90 percent of all trading activity. This pattern appears likely to continue in the future. Regional exchanges, however, help to increase the overall liquidity of the marketplace. Some of the larger regional exchanges have been linked by computer to the NYSE and AMEX, providing a truly national listing for many stocks.

THE OVER-THE-COUNTER MARKET

The over-the-counter (OTC) market got its name from the manner in which securities were bought and sold: Buyer and seller passed

securities over the counter in a brokerage house, rather than trading them on the floor of an exchange. Today, however, there is no counter in over-the-counter.

As an investor, you should be familiar with the differences between an exchange market and the OTC market. As mentioned, the exchange market uses the specialist system. In the over-the-counter market there are competing specialists who are called *market makers*. These market makers are broker/dealer firms that have an inventory of stocks and orders. There is not one "book" over which one market maker has control. While the specialist is in one centralized locale, the market makers are located throughout the country and are connected to each other with phone lines and to a central computer.

The exchange market is an auction market. A security is traded in a bidding process where the specialist is the auctioneer offering a stock to be bought or sold. The over-the-counter market is considered a negotiated market because one broker/dealer can call another to make a trade rather than appealing to an entire group, but recent changes have leveled the playing field further by requiring firm offers of bid and ask prices by each market maker of a security. In the future, Electronic Commerce Networks (ECN) may replace or create alternative markets. Already several companies have filed with the SEC to become electronic exchanges that will compete directly with the established markets.

What kinds of companies are traded in the over-the-counter market? The OTC has a marketplace for just about any size company. The smallest, most speculative companies to the largest computer hardware and software companies such as Intel and Microsoft trade OTC. What makes this possible is that there is a different market for companies with differing liquidity or trading volume.

There are no listing requirements for the OTC. Any stock that is not listed on an exchange and any transaction that does not occur on an exchange can be considered OTC. In fact, the OTC is not limited to stocks; we could say that the government bond market, the

mutual fund market, and others are part of the OTC because they are not listed on an exchange or traded in a centralized location. It is important to remember, however, that there are volume-based listing requirements, similar to those maintained by exchanges, for companies that want to be part of the NASDAQ or NMS levels of the OTC (discussed later in this section).

Companies that do not trade very often or in large volumes are part of the "pink sheet" market. Pink sheet stocks are called that because quote information about the stocks comes out once a week on pink paper. This information is the bid and offer prices from a market maker for that particular stock. The quote is an *indication* of prices, not a price at which a trade has been done. The NASD has developed an electronic system known as the OTC Bulletin Board, which for the most part has superseded the pink sheets except for all but the smallest of companies.

Some companies that trade on the OTC Bulletin Board are highly speculative and belong to the ranks of the "penny stocks." This type of stock can be like swampland—once you are in a stock, it is tough to get out. There are, however, also growing domestic companies and strong foreign companies that just do not receive a lot of trading interest in the United States. These may be foreign banks and other companies considered blue chip on their home turf.

In fact, there are many foreign companies that trade OTC. This can allow you to add a global dimension to your stock portfolio without ever leaving home: 440 foreign companies are found OTC. They account for approximately 9 billion shares' worth of volume every year. This is roughly equal to the average two-week share trading volume OTC.

Another level of the OTC belongs to the NASD automated quotation system or NASDAQ. The NASD is the governing organization of the OTC; the AQ (automated quote) is the centralized computer where market makers send their bid and ask prices on a particular company's stock. The computer sends out the best bid and ask prices based upon those it has received. This becomes the

NASDAQ quote. The best bid or buying price would be the highest, the best offer, the lowest sell price. Because of the introduction of the automated system, the differences in bids and offers from different market makers have decreased. This is considered to be a good sign of competition among the market makers.

With the advent of the National Market System (NMS), investors can receive trading information about a particular stock just as if it were trading on an exchange. The NMS rules require that market makers report their trade with the price and the volume within 90 seconds of the trade. Computers make this easy. The NMS has a computerized order entry system for large and small trades. The Small Order Execution System (SOES) guarantees automatic execution of up to 1,000 shares at the best price. The system can also do limit order matching. Price and volume of trades are automatically recorded with this system.

Because of these advances, institutions are almost as prevalent in the OTC world as they are at the NYSE. In 1998 the NASDAQ saw institutions make up over 50 percent of all block trades and own a trillion dollars of stock.

This added attention has made the OTC a very active market in recent years. There were 5,400 companies that were part of NASDAQ that traded over 202 billion shares during 1998, with a daily average of over 800 million shares traded. Nine trading days were over a billion shares each according to the NASD, which means the system had over 50 percent of the total shares traded in the United States.

THE CHICAGO BOARD OPTIONS
EXCHANGE

The exchanges discussed thus far provide marketplaces for trading stocks and bonds. The Chicago Board Options Exchange, commonly referred to as the CBOE, provides a marketplace for trading stock *options*. Prior to the establishment of the CBOE in 1973, bro-

kerage firms referred all their stock-option business to the Put and Call Dealers Association. All option dealers were members of the dealers association and all options—whether *calls* (rights to buy) or *puts* (rights to sell)—were created (written) to fit the needs of the particular customer. The sole function of the member firm was to guarantee that the dealer writing the option was financially capable of fulfilling the option's terms.

This system changed when the CBOE came into existence. For the first time, an active marketplace was available for trading put and call options on the majority of listed stocks. Options trading was no longer relegated to an obscure corner of the investment picture; rather, the volume of options trading on the CBOE has grown so much in recent years that the NYSE, AMEX, and certain of the regional exchanges voted to permit options trading on their respective trading floors.

Institutional investors have also become a major force in options trading, and a number of brokerage firms and investment advisors have developed sophisticated computer-based trading strategies for options. Orders are processed on the CBOE in much the same fashion as stock orders are processed on the exchanges (as described earlier), and the specialist, floor broker, registered trader, and operational personnel play much the same roles.

FUTURES EXCHANGES

Commodity trading is one of the most volatile areas of the financial marketplace. Because of the need to offset risk in agricultural products, the commodities market has evolved to include precious metals, petroleum, and financial instruments such as treasury bonds and stock index futures.

Dealers in commodities buy and sell *futures* contracts—agreements to make or take delivery of a commodity at a specified future time and price. The terms *commodities* and *futures* can be used interchangeably.

You can trade commodities with a small amount of money down (usually a 5% *margin* deposit); this leverage attracts many people to commodity trading. But leverage (discussed in Chapter 6) is a two-edged sword that can magnify losses as well as gains. In commodity trading, like options trading, fortunes can be made or lost in a matter of minutes.

The method of order execution and the players on the futures exchanges are much the same as on the other exchanges, except that futures exchanges do not have specialists. Also, commodities exchanges place an artificial cap called a *limit* that sets a maximum day-to-day variation in price. The limit is simply the greatest price change permitted by the Exchange for any particular commodity during the trading day.

The different futures exchanges and their various product concentrations are shown in Figure 5–2.

Figure 5–2. Futures Exchanges.

EXCHANGE	PRINCIPAL CONTRACT
Chicago Board of Trade	grains financial futures
Chicago Mercantile Exchange	livestock financial futures
Commodity Exchange, Inc. (NYC) New York Mercantile Exchange	metals petroleum potatoes metals
New York Cotton Exchange	cotton orange juice
New York Coffee, Sugar, and Cocoa Exchange	coffee sugar cocoa
Kansas City Board of Trades	grains stock indexes

(continued)

Figure 5–2, *cont'd.*

EXCHANGE	PRINCIPAL CONTRACT
Mid America Commodity Exchange	("mini" contracts in:) grains gold financial futures
Minneapolis Grain Exchange	grains
New York Futures Exchange	financial futures

Source: *Handbook of Investment Products and Services,* 2nd ed., by Victor L. Harper (New York: New York Institute of Finance, 1986).

Implementing Your Investment Goals

For many people, an investment program begins and ends with a stock tip. The tip may come from a friend who works for a company that developed a new product, obtained a government contract, or is experiencing rapid growth. Or it may come from a conversation overheard in a barber shop, restaurant, or on the subway. The first purchase of common stock is often the result of just such a tip. Tips do not usually pan out, but instead, result in the loss of a substantial portion if not all of the money invested.

Why is investing on the basis of a tip usually destined to fail? This approach to investing puts the cart before the horse. Before purchasing stocks, bonds, real estate, or any of the investment products now available, investors should decide what their long-range goals are. Once long-range goals have been determined, it is easy to decide whether the purchase of a particular stock fits into the overall plan. Long-range plans also force investors to come to grips with how much risk they are willing to live with to obtain specific rewards (risk/reward ratio) and to decide whether they want to make their own investment decisions or prefer that professional management handle their investments.

In this chapter, some of the long-range goals and objectives of typical investors are explored and defined. Included are discussions

of some of the alternative ways to reach these long-range goals and the trade-offs necessary along the way.

INVESTMENT OBJECTIVES

Starting with an objective (a goal) makes it easier to formulate a long-range plan for achieving that objective.

Two basic investment goals are, first, the *accumulation of assets* and, second, the *derivation of income from accumulated assets.*

Most people occupy themselves throughout their working lives with the accumulation of assets and never really recognize it as an investment goal. Typically, the first asset a person accumulates is a savings account and for some people this continues to be their core asset throughout their working lives. Many people never progress to the second stage in the accumulation of assets, which is typically the purchase of a home. Along the way, the majority of people acquire some luxuries, such as an expensive car, a VCR, jewelry, and so on. Most people reading this book are concerned with the third stage in accumulating assets: the accumulation of *financial* assets. The starting point for the accumulation of financial assets is a systematic program for setting aside a portion of an individual's after-tax income in order to build up the capital that is the core of any investment program. Most people falter at this stage, either because of life's many pressures or because there are many attractive alternatives to the dull chore of saving and accumulating capital.

How can you accumulate the necessary capital to begin an investment program? The easiest way is to have a portion of your salary directly deposited with a savings institution so that you never actually see the money. Also, money that comes to you as a surprise in the form of a tax refund, or an inheritance, could provide the core capital you need to begin an investment program.

Once you have accumulated this basic core capital, you are ready to initiate a program to accumulate financial assets. Most of this book is concerned with describing and explaining the nature of the financial investments available today. Before you can select from the alternatives available to you, however, you must answer a number of questions about yourself.

Some of these questions relate to your own personality and how much uncertainty and risk with which you can live. A later section of this chapter helps you answer this question, to find what professional investors refer to as your *risk/reward ratio.* Another question you have to answer for yourself is, "Why are you seeking to accumulate financial assets?" Do you want to provide for your retirement or for a college education for your children, or simply to accumulate the money for its own sake and for the luxury and power that might come with it? You must answer this question so that you have a time frame in which to operate, that is, you need to know how much time you have to accumulate the specific dollar amount you need to fulfill the designated goal. Knowing the dollar figure and the time frame makes it easier to select particular financial products (stocks, bonds, real estate, and so on).

Once individuals have accumulated the needed financial assets and have used them to meet their aims or goals, they typically turn to a second investment objective—deriving income from accumulated assets. This does not mean that people never seek income from their financial assets during their working lives, but most people can meet their goals only through substantial capital appreciation—not simply from investment income. (Leverage—increasing return without increasing investment—is the key here and is discussed in greater detail later in this chapter.)

As an investor gets older, emphasis typically shifts from seeking capital gains and growth in financial assets to preserving capital and maximizing the return from the assets accumulated over a working lifetime. To meet the needs of an aging population, investment professionals have developed a number of products that meet this need

for a stable and predictable income stream. Portions of this book identify and explain the nature and character of these income-producing products, particularly the nature of bonds. Older investors should be cautious: They may tend to be more vulnerable if they are trusting and they do not have a lifetime to replace assets lost through bad or fraudulent investments.

THE RISK/REWARD RATIO

The *risk/reward ratio* is a new term applied to an old concept. Without consciously thinking about it, most people realize that to achieve a given return on an investment they have to be willing and able to assume some degree of risk. The risk/reward ratio focuses attention on the process of evaluating risk. What is meant by risk is the certainty of return. An investment with a low certainty of return is considered to be high risk; an investment with a high certainty or probability of return on investment is considered to be a low risk. That uncertainty can be influenced by many factors, many of them related to the financial fundamentals of the investment. Many companies are sold on the hope of future earnings but not the certainty.

The risk/reward ratio relates the level of risk a particular investor is willing and/or able to accept, to the reward achievable from such an investment. For example, let's assume that an investor, Mary Richards, is seeking to obtain a 200% return on her money in one year. Mary might best be described as a high-level *risk-taker*. Investments that could yield such a high return over a one-year period would be highly speculative, including perhaps low-priced "penny stocks," new issues, and issues of companies on the verge of bankruptcy or just coming out of bankruptcy. To achieve such a high return, an investor must be willing to live with the possibility that all the money placed into such investments could be lost. Investors who will not take more than minimal risks confine their investing to savings accounts, T bills, and similar financial products and are described as *risk-avoiders*. Most people fit somewhere

between these two extremes and will accept a moderate degree of risk for a moderate return on their investment.

What makes a particular individual a risk-taker or a risk-avoider? To answer this question, a number of academic studies on individuals' risk tolerance have been conducted that lead to the following conclusions. First, the level of risk an individual is willing to assume is directly related to personality traits and age. Some individuals are uncomfortable with any risk in their investment life. Persons who lie awake at night worrying about their investments have obviously chosen ones that are inappropriate for them. On the other hand, some people thrive on the excitement and challenge of the marketplace.

The same studies found that most older investors tended to be risk-avoiders because they believe that they could not recover from investment losses and are concerned about not having an adequate retirement fund. Further, these studies found that *net worth* (assets minus liabilities) has a bearing on the level of risk with which a person is comfortable. Typically, a wealthy individual will accept a greater degree of risk than will an investor with moderate income and net worth. This fact is attributed to the wealthy individual's concern for the tax consequences of investment strategies. Many individuals acquired wealth because they were willing to take chances and accept risks.

How can you as an investor make use of the risk/reward ratio in making investment decisions? Rather than make an investment and then try to determine its anticipated return, you should calculate the risk/reward ratio before you make any investment. As an investor, you must be satisfied that the return you may derive from a particular investment is in line with the attendant risk and fits your investor profile as a risk-taker or risk-avoider.

LEVERAGE

Leverage is another name for borrowing in today's world of investing. Leverage has been elevated to a high art form. Every year *Forbes*

magazine publishes a list of the nation's wealthiest individuals. If you examine the business history of most of these individuals, you will find that they accumulated their wealth by using other people's money, that is, by knowing when and under what circumstances to use leverage.

To understand how leverage, the use of borrowed funds, works for such individuals and can work for you, you should understand the concepts of concentration and diversification. If you seek to reduce your risk of loss (thereby also reducing your possibility for gain as well), you must *diversify* your portfolio; in effect, spread your risk around. The concept of diversification is the cornerstone of the mutual fund industry. Diversification has merit for the individual who seeks an average return from an investment portfolio and is unwilling or unable to assume a high degree of risk. Chapter 4 discusses mutual funds and explains how they fit into an investment program.

Concentration is the flip side of the coin. *Concentration* is a term that describes an investment pattern in which substantial assets are committed to one or a small number of investments. Professional investors call this type of investment "betting the ranch." Many people who made the *Forbes* list bet the ranch on a single idea, concept, or industry. First-time investors usually overdiversify by buying a few shares of a number of companies, often based on the "stock tip of the day." As an individual investor, you should avoid this approach to investing; if you err, err on the side of concentrating your investments.

MARGIN ACCOUNT TECHNIQUES

When investing, the first leverage technique you will probably encounter is the *margin* account. Utilizing a margin account enables you to make your dollars work harder for you by financing your securities transactions. For example, a 50% margin requirement is currently in effect for the initial purchase of all stocks listed on the New York Stock Exchange, American Stock Exchange, and for cer-

tain qualifying over-the-counter securities. To purchase $10,000 of such securities, in a margin account, you need only $5,000; the remaining $5,000 is financed by the brokerage firm that maintains the customer's account. Interest is charged on the outstanding balance at a rate slightly above the prevailing prime rate. (Margin accounts are explained more fully in Chapter 8.)

However, you should be familiar with some other aspects of the margin account. A customer will receive a maintenance call if the stock purchased in the account drops substantially in price. A maintenance call requires the customer to put up additional cash or securities to bring the account into balance; that is, at least to the 25% equity position. In the case of corporate or government bonds, less money is required "up front" because the brokerage firm is allowed to finance more of the transaction.

The majority of small investors is not aware of another aspect of stock-secured or collateralized borrowing. This is the nonpurpose loan. A *nonpurpose loan* allows you to borrow against your fully paid-for securities to finance a venture, such as a real estate transaction, a new business, or an educational expense. Commercial banks make such nonpurpose loans at rates substantially below the rates charged on conventional consumer loans and generally lend between 70% and 90% of the market value of all fully paid-for securities. However, many commercial banks place restrictions as to the size of such a loan (usually a minimum of $25,000) and the type of securities required as collateral (for example, government or corporate bonds or listed stocks selling above a certain price). Obviously, the nonpurpose loan is a useful tool for getting more mileage from your assets.

From the foregoing discussion, you can see how margin works to magnify losses as well as gains. Margin allows you to purchase a greater number of shares because you are able to finance a portion of the transaction. If the stock you purchased on margin increases in value, you will be building *buying power* in your account. This allows you to buy additional shares of the same security or any

other security as the equity in your account increases. But margin is something you should handle with the respect due any form of borrowing—use it but don't abuse it.

WARRANT TECHNIQUE

The purchase of a *warrant* represents another way that you can make your investment dollars work hard for you.

A warrant does not represent an actual ownership position in a company as does a share of common stock. Rather, a warrant represents the right to purchase a specified number of shares of a company's common stock at a certain price for a designated period of time. As a nonowner, the holder of a warrant has no say in the company's management and is not entitled to any dividends. Typically, warrants have a life span of at least two years, although they can be extended, and some perpetual warrants do exist. Warrants are a source of potential capital to the issuing company. When an investor exercises a warrant, the stock is issued by the company and the proceeds go to the company itself.

For what reasons do companies issue warrants? Besides providing a source for potential new capital for the company, warrants are frequently used as "sweeteners" of stock and bond offerings. By attaching a warrant to its debt or preferred stock offering, a company may stimulate the market for it and reduce the rate it must pay to borrow the funds. Many small start-up companies find that the only way they can go public is through the offering of units consisting of common stock and warrants. Many of the warrants in existence today were "spun off" from companies coming out of bankruptcy as managements sought to compensate their creditors and stimulate interest in the reorganized company.

How do warrants fit in as a leverage device? When you find a company you want to invest in, you should consult one of the standard financial reference sources (Standard & Poor's or Moody's) to determine if the company has any warrants outstanding and what

their terms are. The purchase of a company's warrants enables you to control a greater number of shares for the same number of dollars. Warrants provide a way to leverage your capital and make it work harder.

For example, at the time of this writing, the common stock of Fleet Financial Group, a major commercial banking firm listed on the New York Stock Exchange, is selling at $44 3/8 per share. The purchase of 100 shares of Fleet Financial's common stock would cost $4,437 plus brokerage commissions. Fleet Financial also has a warrant outstanding that entitles the holder to purchase two shares of Fleet Financial common stock at $21.94 per share. At the time of this writing, the warrant is selling at $45.00. Thus, for approximately the same dollars it costs to purchase 100 shares of Fleet Financial's common stock, you can purchase 100 warrants, each representing the right to purchase two shares of Fleet Financial's common stock at the aforementioned price of $21.94 per share.

From this example, you can see how the warrant, for the same dollar amount, lets you control a greater number of shares. By purchasing a warrant as opposed to the underlying common stock, you can magnify your gain if the stock appreciates in price or your loss if it declines.

Before you rush out and invest in every available warrant, be aware of some of their negative aspects. First, warrants tend to be more volatile than the underlying stock they represent because the typical purchaser of a warrant is a short-term trader who reacts quickly to any change in the company's stock price or earnings picture. Second, because warrant holders are not owners of the company, they have no standing in the event of the company's bankruptcy or liquidation.

Options Technique

The packaging and marketing of options as investment products has been a very significant development on the investment scene. Years

ago, options were traded exclusively through the Put and Call Dealers Association. If you wanted to purchase a call option on IBM common stock (the right to purchase 100 shares of IBM common stock at a specified price for a designated period of time, usually ranging up to one year), you would have had to arrange through the brokerage firm that the particular call be written by the Put and Call Dealers Association. Likewise, an investor who wished to purchase a put on IBM (the right to sell 100 shares of IBM stock at a specified price for a designated period of time) would have had to follow the same procedure.

Such a system presented a number of problems. Because each trade was "custom made," there was little liquidity in the marketplace for put and call options. Each transaction was handled on a negotiated basis, with no set fees. For these reasons, options were viewed by most professional investors as a somewhat shady part of the investment business best left to the small-time speculator and trader. It was unheard of for institutions to trade in options.

All this changed in 1973 with the founding of the Chicago Board Options Exchange (CBOE), which marked the development of a centralized marketplace for option trading. Each option was no longer a separate item, but a uniform set of fees, expiration dates, and stocks on which options were written. Clearing procedures were established and implemented.

Options are now actively traded on all the principal exchanges, and the number of stocks on which options are written grows day by day. Institutions are active in the option market, and sophisticated computer programs have been developed to analyze and devise option-trading strategies.

How can options be used as a leverage tool by the small investor? As with warrants, options enable you to leverage your limited capital by enabling you to control (for a limited time) a larger amount of a company's common stock than if you purchased the underlying stock. For example, at the time of this writing, Intel is selling at 127, or $12,700 to own 100 shares, but a call allowing the

options buyer to purchase 100 shares of Intel at any time within the next three months at a price of $125 per share is currently trading at 12, or $1,200 to control 100 shares of Intel for the next three months.

Essentially options are "time instruments." Since they are issued with varying expiration dates, they are considered "wasting" assets. For this reason, the option buyer must guess the direction of the overall market, as well as forecast the stock's price movement in a particular amount of time. If his or her timing is off, the buyer can lose his or her entire investment, but no more.

Although more and more small investors trade in options, their results are often not profitable. This is because most small investors buy the longest term options looking for large price appreciation. Often, they are merely buying the "time value" of the option, which can only decrease as the option moves to expiration. Historically, 80 percent of options buyers lose money on the transaction while 80 percent of options sellers make money.

Options may be used conservatively by selling a *covered call* either to enhance yield through the additional income represented by the options premium, or as a form of portfolio discipline to set defined sell points. The sale of the call is described as "covered" because the seller of the option already owns the underlying shares against which the option has been sold and may deliver if the stock price rises and the call is exercised.

Before you invest in options, become familiar with the overall operations of the securities marketplace and find an investment advisor in whom you have confidence. Options are not for the unsophisticated and unknowledgeable investor.

MARKET AVERAGES

The stock market and its performance ranks high as a popular topic of conversation these days. In newspapers and on television you hear frequent references to the dramatic swings in the market aver-

ages (Dow Jones and Standard & Poor's 500) that have occurred with increased frequency over the past few years. *Just what are these averages and how much weight should you give them in making your investment decisions?*

The market averages we hear of today trace their existence to the late 1800s and to the work of Charles H. Dow, one of the founders of Dow Jones Company and the first editor of the *Wall Street Journal*. Dow thought that a market "average" of a group of selected stocks could be used to gauge the level and trend of stock prices.

Initially, he created an average that would be a proxy for the market and the economy as an entirety. This was the Industrial average. At the time, it was composed of 30 industrial companies. Today, however, it is made up of large corporations many of which are not industrial, such as Microsoft, Hewlett Packard, and Coca-Cola. This change has been made to reflect the less industrial nature of the economy and the companies trading in the market.

Along with an Industrial average, Dow created other performance measures—the Utilities and, at the time, the Railroad averages. The latter has, of course, been changed to the Transportation average.

The Dow Jones Industrial Average (DJIA) is an average of the market prices of the selected group of 30 stocks. It is calculated by adding all of the prices together and dividing by a factor. This factor, or divisor, changes over time to account for stock splits and changes in the companies within the average. Because of this divisor, the average itself does not change due to these events. This sort of average is known as price-weighted.

Some criticism of the DJIA relates to its being a price-weighted average: Movements in the average are influenced by different prices. The argument has been made that the DJIA is not representative of the entire marketplace because it is heavily weighted toward the higher-priced well-capitalized companies, that is, blue chips, as opposed to the lower-priced stocks of smaller companies.

In response to these criticisms, new indexes have been developed. The Standard & Poor's 500 Index is value-weighted. This type of index derives the value of all the stocks used in the series; this figure is then used as a "base" and assigned a value of 100. A new market value is calculated continuously and compared with the base to determine the percentage change in the value of the index. The S&P 500 Index includes stocks traded on the American Stock Exchange, as well as OTC stocks, and uses this weighting concept to eliminate the dominance of the blue chips and to obtain a better gauge of the price trend of the overall market.

Averages and indices may give you a feel for the general condition of the marketplace, but do not depend too heavily on their data for plotting your investment goals.

WHAT CAUSES MARKET MOVEMENTS?

The typical first-time investor makes a purchase of a particular common stock based on a feeling about the company's management, its products, or the stock's performance. The professional investor takes the opposite approach, focusing first on the overall economy, then on the particular industry, and finally, selecting a company in which to invest.

How do you as an investor keep yourself informed about economic indicators? The financial pages of most daily newspapers feature changes in economic indicators and devote substantial space to analyzing the indicators and their implications for the overall economy. The Federal Reserve Bank, as well as many of the major money-center banks, publishes monthly newsletters analyzing economic indicators.

Professional investors utilize economic indicators to signal changes in the direction of the economy. For this reason, indicators have been divided into three categories: leading, lagging, and coincidental. *Leading indicators* usually reach peaks or bottoms before

the rest of the economy. Analysts and professional investors place the greatest emphasis on leading indicators and find them the most useful. Common stock prices and the money supply in constant dollars are examples of two leading indicators. *Lagging indicators* have their peaks and troughs after the peaks and troughs actually occur in the overall economy. *Coincidental indicators* have their peaks and troughs at the same time or coincidentally with the economy.

How accurate are economic indicators in predicting turns in the overall economy? These indicators, no matter how refined and mathematically sophisticated, cannot predict turns in the overall economy in all instances. One reason lies with the *variability* of the leads and lags. On the average, a particular economic indicator may lead or lag the economy by five or six months, but the range may vary over the years from two to ten months. Another limitation on the accuracy of such indicators is related to the difficulty of gathering the data and revising them. Also, they were developed in the 1950s to indicate the direction of the economy of that time. The reason indicators are so widely relied on despite their inaccuracies is that they are the only game in town and, in a general sense at least, point the direction in which the economy is headed.

Another important factor in the economy that is closely watched by professional investors is the Federal Reserve Bank. The Fed, as it is called, has the job of keeping the economic growth on an even keel. This means it has the responsibility of stimulating the economy during recessions and acting as a moderating influence during times of strong economic growth and high inflation.

What investors follow is the kind of policy the Fed is pursuing. During recessions the Fed is engaged in an easy-money policy to stimulate growth through low interest rates. So the important trends to watch are the actions of the Fed. Lower interest rates eventually encourage economic growth; higher rates lead to an economic slowdown. It is a maxim of the market, "Don't fight the Fed." Historically, three interest rate cuts by the Federal Reserve, signalling monetary easing, lead to a higher stock market six months

after the last cut. Antithetically, three interest rate hikes, or "steps," lead to a "stumble" or slowing of the economy and a decline in the stock market.

The first action in any investment plan is to determine the direction of the economy. From this decision about whether the economy will improve or decline flow a number of other decisions, including the decision whether to invest any money at all in the equity or bond markets at this time. If you do decide to invest, the economic outlook you foresee will influence the size and timing of your investments. Rational investing requires economic projections.

CHOOSING YOUR INVESTMENTS

INDUSTRIES

If you have decided that the time is suitable for you to invest in common stocks, the next question that confronts you concerns the choice of industries in which to invest.

Like people, industries pass through stages. The first stage of the industrial life cycle is referred to as the pioneering stage. This stage is characterized by rapid growth in sales and earnings, followed by increased competition as more and more companies recognize the possibilities of the industry and enter it. Networking, the linking together of computers at diverse work locations, is an example of an industry in its pioneering stage.

The investment maturity stage, which follows the pioneering stage, is characterized by the domination of the industry by a relatively few companies. The investment maturity stage can be relatively long in duration (running into the decades) and characterized by mergers and consolidation. Cable television would be an example of an industry in the maturity stage. While the rewards of investing in industries in the investment maturity stage are less than the rewards of investing in industries in the pioneering stage, so are the risks.

The final stage in the industrial life cycle is the stabilization stage, which can last for many decades. Most of the nation's companies are in this stage of industrial development. It is characterized by a slowdown in the rate of growth of sales and earnings and by the actual bankruptcy of some of the weaker companies.

Now that you are familiar with the industrial life cycle, you probably wonder how to identify industries in their pioneer and investment maturity stages so that you can choose investments in industries that will grow and expand. Identifying industries in these stages of growth is time-consuming for professional investors and security analysts. There are some basic guidelines to identify such industries, but no method is foolproof.

One technique for identifying such industries requires you to follow scientific breakthroughs closely, looking for the industries that emerge from such developments. Other individual investors as well as professional investors are constantly on the lookout for such developments; therefore such developing industries rarely stay undiscovered for long. Professional investors also rely on computer techniques to survey industries, looking for industries whose sales and earnings are growing at an above-average rate. Further, financial institutions employ technologists on an ongoing basis to visit and examine numerous industries and companies, looking for what may be the next IBM or Xerox.

Where does this leave the individual investor? For the most part, unless you have some insight into a particular industry or you are buying professional research from a company such as Standard & Poor's or Value Line, you are probably better off having your investment advisor formulate ideas and suggestions about pioneering or growth industries. But you should keep informed so that you can properly evaluate and act on the information supplied by your advisor. Information is readily available from newspapers such as the *Investor's Business Daily* and the *Wall Street Journal* as well as a myriad of daily television programming covering virtually all aspects of the markets and the economy. The rapid growth of the Internet has

made accessible research literally a mouse click away. (This investment avenue will be covered in greater detail in Chapter 13.)

COMPANIES

Once you have selected an industry to invest in, the next question you face is which *company* in that industry is suitable for your investment.

Chapter 10 of this book is devoted to the analytical tools security analysts utilize to select the "right" company. As a matter of fact, the analyst usually selects a specific company first, then uses these analytical tools to determine its investment merits. Therefore, in this chapter I describe the different categories most companies fit into, rather than discuss specific techniques.

Most investors, both individual and professional, spend their time trying to discover growth companies and the stocks they represent. A *growth stock* is simply one in which the growth rate of sales and earnings is well above the norm. Note that emphasis is placed on both sales *and* earnings, because a major increase in sales is significant only if the results are brought down to the bottom line— earnings. Likewise, for a stock to qualify as a growth stock, the pattern must continue for a period of time rather than appear as the result of a one-time event or accounting "adjustments."

Why is it so difficult to identify growth stocks? Growth stocks are difficult to identify because you are competing with the whole world. Many of these other investors have capabilities and contacts that are not available to you.

What are the dangers in investing in growth stocks? When you invest in growth situations, you must realize that frequently such stocks sell at a high *price-to-earnings ratio*. Such a high ratio may already include a substantial portion of future growth. Also, many growth stocks are heavily owned by institutional investors who plan to liquidate their positions if growth in earnings and sales is less than outstanding. Thus, the price movements of growth stocks can

be particularly volatile. This is not to say that growth stocks are not suitable for the individual investor, but you must be sure that you are buying into a growth situation "early on."

Cyclical stocks and the companies they represent are another important category. The term *cyclical stocks* refers to companies in such industries as auto and steel. Investing in companies in these industries is a matter of timing. To be successful in this area, you need a knowledge of or a feeling for industry and economic cycles and a willingness to be a *contrarian,* that is, to invest in what no one else wants at this particular time and wait until business and market climates change. In effect, investing in cyclical stocks means buying them at the bottom of the business cycle and selling them at the top. Many individual investors have done well in this area of investing because they have more staying power than institutional investors.

Defensive stocks and the companies they represent are another important category. Defensive stocks are stocks of companies such as tobacco, liquor, and food, which perform well in an economic downturn. (Such companies are thought of as supplying the necessities of life and continue to perform well in terms of sales and earnings during economic downturns because people cannot live without their products.) Again, these investments are a matter of timing. Individual investors tend to dominate this area both in terms of interest and ownership.

A final area where you might concentrate your research effort is in the area of *low price-to-earnings (P/E) stocks.* Low P/E stocks represent the orphans of the marketplace. Stocks selling at P/Es of ten or below fall into this category and represent stocks and companies in which few individual investors and institutions have an interest. Typically, such companies are not followed by security analysts and for the most part are not heavily owned by institutional investors. Many of these companies are "thinly traded," meaning that few shares are held in public hands and financial information is not readily available. But a number of studies have shown that low P/E stocks have outperformed many of the so-called growth (high

P/E) stocks. Some analysts have turned their attention to what is called "bottom fishing," that is, to looking for such marketplace orphans. But the small investor can still prosper in this area by devoting the time and effort necessary to research such companies and by holding such stocks until developments, either internal or external, change the market's perception of their real worth.

Certain general observations can be made about approaches to deciding in which companies and industries you should invest. First, it is generally held that the worst company in an industry that is performing well will perform better in the marketplace than the best company in the worst industry. If you decide to invest in an industry performing poorly, however, have patience and select a company with the financial capability to survive the downturn. Second, after you have analyzed the numbers, but before you invest in a company, read and learn as much as you can about the management. Management plays a key role in the success or failure of any company. Third, see if the company and the stock have "sponsorship," that is, the interest of nonretail investors. Many companies remain undiscovered because they have no institution or analyst sponsorship. Although buying stocks that have no following may prove profitable, it is always worthwhile to figure out who might buy the stock from you and why it is undiscovered.

The Brokerage Firm
and You

You can buy and sell many things—even "big ticket" items such as cars—without the professional advice of a salesperson, lawyer, or accountant. Although it is not advisable to do so, people sometimes even buy or sell real estate without the aid of an agent or lawyer. People are free to buy and sell almost anything without involving professional salespeople, but legal problems may arise.

So it is with securities: You may buy and sell stocks and bonds without a lawyer or salesperson (that is, a broker or "stockbroker")—there's no law against doing so—but you run into many difficulties if you try.

WHAT THE BROKERAGE FIRM
DOES FOR THE INVESTOR

If you were to buy a stock without going through a brokerage firm, you would have to deal with these questions:

- How do you get in touch with someone who owns the stock in the quantity you want to buy and who is willing to sell at or below the price you want to pay?

- How do you execute the transaction? Do you arrange for a meeting with the seller, at which time you exchange your pay-

ment check for the stock certificates? If a meeting is not possible, do you mail a check to the seller, who waits for it to clear before sending you the stock?

- How do you verify that the stock certificate is bona fide or that the seller is the rightful owner?

- Where do you keep your stock so it is safe from fire and theft?

- If the certificate is lost or destroyed, how do you prove that *you* are the rightful owner?

When you were ready to sell the stock, you would have to go through a similarly troublesome procedure. Obviously, if every investor had to conduct transactions in this way, the stock market could not be so large or active as it is.

ORDER EXECUTION AND CLEARANCE

A brokerage firm handles all these matters for you. In fact, most investors are totally unaware of such services except when an occasional error is made. For the most part, once you have an account with a brokerage company, all you have to do is call your stockbroker and explain what transaction you want to make. Usually within minutes, the broker returns your call, confirming execution of your order. You buy or sell stock, but all you are aware of is that brief conversation with the salesperson. Your part in the actual trade is as easy as that. (Of course, the decision to buy or sell is not so easy. Questions about whether the market is going up or down, where it is headed tomorrow or next week, which stock to purchase, what price is "right," and when to sell are dealt with in other chapters.) Perhaps you do not even wish to talk to an order taker. Today it is possible to trade on the Internet at greatly reduced commission (and with some substantial dangers) without ever talking to another human being.

When you place an order with the stockbroker, you generally don't see how much behind-the-scenes activity takes place. As the bro-

ker receives your order, an order ticket is filled out. After you hang up, the order is passed to the firm's order room, whose staff executes it. From that point, a series of clearing operations takes place, whereby the stock is paid for and the new owner's name recorded. The actual stock certificates are sent to the new owner or held by the brokerage firm. All the paperwork is handled in compliance with federal and other regulations, out of the customer's sight. By providing order execution, clearing, and other services, brokerage firms enable millions of investors to participate in the stock market every day. Because investors can buy or sell so readily, stocks are considered *liquid* investments, that is, stock owners can convert their stocks into cash quickly and easily by selling them in this very active marketplace.

HOW THE BROKERAGE FIRM OPERATES

For the services provided to investors, the brokerage firm charges a *commission,* which is usually a percentage of the total dollar amount of the transaction. For example, let's say that you've told your stockbroker to buy 100 shares of ABC stock, and the order is executed at $17 per share. You have just spent $1,700 ($17 times 100 shares). The brokerage firm might charge you a 2.5% commission for execution and clearing; that comes out to $42.50 ($1,700 times .025). The total cost of the purchase and commission is $1,742.50 ($1,700 purchase price plus $42.50 commission).

From the brokerage firm's point of view, individual investors like yourself represent "retail" clientele, as opposed to their "institutional" customers. Investors' commissions—or *retail* commissions—represent only part of a brokerage firm's revenues. Other earnings come from the purchase and sale of stocks and other securities on behalf of the firm itself. When a firm executes a trade on behalf of a customer (retail or institutional), it is said to be acting as a *broker* or *agent*—the two words mean the same thing. When the firm buys and sells for its own account, it is acting as a *dealer* or as *principal*—again, these two terms are synonymous. Most firms,

large and small, act in both capacities; so you might hear them referred to as *broker/dealers.*

In both roles, the broker/dealer is said to be acting in the *secondary market,* the market you hear about on the nightly newscast and read about in the daily newspaper. Stocks (and other securities) trade hands in this secondary market every day.

What, then, is the primary market? This market is where stocks (and bonds) first become available to the public. When a corporation wishes to raise money, one way to do so is to *issue* stocks or bonds in what is known as an underwriting. In an *underwriting,* the brokerage firm buys the new stock or bond issue and resells it at a higher price to investors, thereby earning a profit. In this process (whereby capital is raised for American businesses), the brokerage firm is said to be acting as an *investment banker.* Underwritings are usually handled by groups of firms, rather than just a single firm, who all act as investment bankers. In this way, the underwriters dilute the risk and facilitate the sale (or *distribution)* of the issue. Once the issue is sold (distributed), it is traded in the secondary market.

These roles—agent, principal, and investment banker—are assumed by the brokerage firm. As an individual investor, your investment dollars, along with those of millions of other investors, become part of the American investment marketplace, or *capital market.* Your dollars help to finance business if you invest in corporate securities and to finance government if you buy U.S. Treasury or state authority bonds. In the process, you stand to gain if the value of your investment rises, and the brokerage firms can gain by earning commissions on your trades and profits on their own.

WHAT THE STOCKBROKER
DOES FOR YOU

At one time, the term *stockbroker* was perfectly appropriate for describing the sales representative of a brokerage house. The repre-

sentative acted as a broker for the firm's customers and dealt for the most part in stocks only. Earnings came from the commissions that the firm shared with the representative. The stockbroker was therefore also called the "customer's man."

Nowadays that same person may be called a *registered representative* (because registration with the National Association of Securities Dealers is required), an *account executive* (AE), a *financial counselor,* or a *financial advisor or consultant*—the titles vary from firm to firm. All the titles, however, reflect a greater responsibility than just brokering stock. Sales representatives are now more like financial advisors than ever before: Their role is not merely to execute orders on behalf of their clients, but to become sufficiently familiar with their clients' financial situations to plan for them, or at least to make intelligent, informed recommendations.

To function as representatives in the securities industry, salespeople must possess a working knowledge of a broad array of investment products. They must also be sensitive to the requirements of all regulatory bodies, such as the Securities and Exchange Commission (SEC), the National Association of Securities Dealers (NASD), or the exchanges—to name just a few. Everything they do as registered representatives (or account executives) is subject to stringent regulations.

To assure a minimum level of competence among these financial professionals, the SEC requires all would-be representatives to take a vigorous examination, prepared by the New York Stock Exchange and administered by the NASD. Passing the examination entitles reps to deal with customers, but it is only the beginning of the learning process. Once in practice, they must continually learn what they can about investment products, old or new, and about their clients' needs and objectives.

The account executive's job is not easy. Earning a living means doing all the things that other successful salespeople do: constant prospecting, asking for referrals, servicing accounts, and so on. Yet all this must be done in an environment that is laced with regulation

upon regulation. A false step, however unintended, can incur penalties from fines to loss of job or even imprisonment.

Another aspect of the AE's job makes it more difficult than those of most other financial professionals: When you engage the services of a lawyer or accountant, you don't necessarily have to understand why you must sign a document placed before you or how your tax return was calculated. The AE who recommends an investment to you, however, is responsible to be certain that you understand the nature of the investment, its risk, and its potential return. You have to "own" the investment decision because *you* initiate the order, not the broker. If you enter into an investment that is unsuitable for you, and the AE lets you do so, the sales representative and/or the firm can be held responsible for any losses you incur. As a result, part of the AE's task is to educate you, the client. Your responsibility, of course, is to learn the language and business of the securities industry. This book will help you get started on that learning process.

FULL-SERVICE AND DISCOUNT FIRMS

You pay for what you get. For most of the U.S. stock market's history, commission rates were fixed. No brokerage house was permitted to charge less than industry-wide minimums. Then came May Day, or May 1, 1975. On that day, commission rates became *negotiable*. That is, brokerage firms could charge as low or as high a commission rate as the competition or profit margins allowed. With negotiated commission rates, firms could charge a higher or lower commission rate, depending on the services they rendered to the investor. In this regard, brokerage firms are broadly classified as either full-service or discount brokerages. The following describes the basic differences in the services provided by each.

FULL-SERVICE FIRMS

A *full-service firm,* as its name implies, provides its clients with considerable assistance, generally in the form of the following five types of service:

1. *Investment research.* Analysts are employed by the firm to watch the markets, seek out good investments, and furnish research reports to the sales staff, who use the information in making recommendations to their clients.

2. *Asset management.* A number of brokerage companies offer cash management accounts, which serve as savings accounts, checking accounts, and investment accounts—all in one. As an example of this type of cash management, suppose you sold some stock but are not sure where to place the sales proceeds. You can "park" the money in the firm's money market account and earn moderate interest income while you make up your mind.

3. *Investment advice.* The research department's analysts make recommendations in general, but only your account executive can give you advice to suit your individual financial goals and personality. The full-service AE, in touch with a number of investment products and markets, is responsible for giving you the best advice possible for your situation and objectives.

4. *Order execution.* As you will see in Chapter 9, the brokerage firm is set up to execute your order for the best available price in the appropriate market. Most orders can be executed in minutes.

5. *Clearing.* Every order execution has a long paperwork "trail," most of which is necessary for legal reasons.

Full-service firms fall into several categories.

Wire houses are very large, diversified firms whose names are generally familiar even to noninvestors: Merrill Lynch, Morgan Stanley Dean Witter, Prudential, and Smith Barney.

As large as these firms are, they still try to expand their retail business (that is, open accounts for individual investors). They are the department stores of the investment world, offering the investor a wide range of investment products and the means to keep checking, savings, and investment monies all in one account.

In contrast to wire houses, *specialized firms* deal in only one type of product, for example, U.S. government or municipal bonds. Perhaps the best-known specialized firm is Lebenthal & Co., specialists in municipal bonds. Other specialty firms are not so familiar to the general public.

Another type of firm is the New York-based house, whose clients are well-heeled and very sophisticated in investment matters. Firms such as Morgan Stanley Dean Witter, Donaldson Lufkin & Jenrette, and Bear Stearns are sometimes referred to as *carriage trade houses* (a reference to the "limousines" of the past). These companies offer especially well-developed research reports, savvy representatives, and extremely personalized service. In addition, as one of their clients you would have the opportunity to purchase new issues of stocks and bonds (the primary market).

This type of firm is not nearly so interested as the wire house in the typical investor's account. The clientele of carriage trade houses is upscale, and you generally need a reference from one of the firm's own clients to open an account. Besides, these houses do not usually provide the range of overall financial services you can get elsewhere.

Firms such as Gruntal, Wheat First Butcher Singer, and Advest offer characteristics of both the wire houses and the carriage trade houses. These firms provide all or most of the products and services of the large wire houses, but cater to the small- and medium-sized investor in a more personalized way. For want of a better term, they are called *boutique firms*.

Regional houses also seek retail accounts. They are not so large as the wire houses, but they offer personalized service that makes doing business a pleasure. Although their research staffs are limited in size, they often "discover" local companies that are good investments.

Discount Firms

Discount brokerage firms are exactly that—all they do is brokerage. What makes them different from the large wire houses or broker/dealers is that the only thing they do is fill orders that originate from the customer and take care of clearing the transactions. You do your own research and security analysis, picking your investments without the help of the firm. They do not get involved in syndicates, which bring new issues of stock to the market. They do not have sales reps who spend their days soliciting customers. Their registered reps are paid a salary to take orders from incoming calls and confirm execution. The back office of the company takes care of clearing the transaction.

When discount firms first came on the scene they simply executed a stock order and processed a transaction for a commission that was less than that of the wire houses. While there are still firms today that do only this, the discount segment of the retail business has two levels: discount and deep-discount (which includes electronic Internet trading). The difference between the firms is the commission rates the firms charge. This gap between rates has widened and reflects the different levels of service available from the firms.

Figure 7–1 shows a relative comparison among types of brokers, but does not include Internet commissions where a battle is being fought for the bottom.

Figure 7–1. Comparison of Deep-Discount, Discount, and Full-Service Firms' Commission on Stock.

NUMBER OF SHARES	DEEP-DISCOUNT	DISCOUNT BROKER	FULL-SERVICE
100	$25–$29	$ 49–$ 55	$ 84
300	$25–$47	$ 82–$107	$207
500	$42–$55	$ 97–$127	$190–$310
1000	$48–$75	$128–$166	$314–$507

New York Stock Exchange. Listed stocks are minimum $.03 per share. Trades subject to minimum commissions.

There are just a few major discount firms: among them are Fidelity, Charles Schwab, and Quick and Reilly. These companies heavily advertise the extra services that the deep discounters eschew. Some of those services are 24-hour service, money market accounts with check writing and charge cards, and the ability to invest in mutual funds as well as in government, corporate, and municipal bonds along with stocks and options. Among other services they provide is the ability for investors to place their orders over the computer. These firms also offer additional services to differentiate themselves from their competitors.

The deep-discount brokers only execute orders and strive to do so at the lowest prices. While they may have the ability to invest in mutual funds, stocks, and options, they are basically no-frills firms. One reason firms are able to offer their services at such a low rate is due to computerized order entry for the various exchanges. (This will be discussed later.) Generally, discounters' rates are about a quarter to two-thirds lower than full-service firms.

Discount commissions generally take two forms:

1. *A percentage of the share's price.* For example, if you sold 100 ABC stock at $20.50, you would pay a commission that represents a percentage of the total sale price: 100 ABC at $20.50 equals $2,050, times a commission rate of 1.1%, equals a commission of $22.55.

2. *A dollar amount based on the number of shares traded.* For example, if you bought 100 shares of ABC (at any price), you would pay a fixed amount per share, such as 20 cents. In this case, the commission would be $20 (100 shares times 20 cents).

FULL-SERVICE VS. DISCOUNT BROKER

In deciding whether to go with a full-service house or a discounter, the chief consideration is obvious: *How much help do you need in*

making your investment decisions? If you are confident of your own research and analysis, then a discounter is probably appropriate. If, on the other hand, you need assistance in these areas, as well as the personalized counseling of a representative, then full-service might be the better choice.

A "dollar-wise" argument may make the choice clearer. If you save commission dollars on a purchase executed by a discounter, the return on your investment would not have to be so great as if the order had been placed with a full-service house. For example, compare a purchase made through both types of firms:

| | Commission | |
| | Full-Service | Discounter |
Purchase	(2.5%)	(1.1%)
100 shares of ABC at $30: $3,000	$75	$33

If you add the cost of the commission to the price of the stocks, here's what you would actually pay:

	Full-Service	Discounter
Price: $3,000 divided by 100 shares	$30.00	$30.00
Commission divided by 100 shares	$ 0.75	$ 0.33
Total	$30.75	$30.33

The stock purchased through the full-service house must rise $0.75 in value before you start to gain. The discounter-purchased stock needs to rise only $0.33. Given that information, the question you must answer is whether you can pick a stock whose value will appreciate sufficiently without professionally conducted research and investment advice. See Chapter 13 for special considerations to be given to electronic daytrading.

YOUR RELATIONSHIP WITH YOUR ACCOUNT EXECUTIVE

If you opt for a full-service house, the next step is to develop a relationship with a suitable account executive. (A discount firm will simply assign an AE to your account.) Finding an AE who meets your personal and financial needs requires an active search, because the AE/client relationship must meet the needs of both parties. For example, suppose you intend to periodically purchase stock for several thousand dollars and to hold it long term (for five years or more). Suppose also that your risk tolerance is low (that is, you prefer low-risk investments). If you were to open an account with an AE whose clients buy and sell more actively and who deal in relatively high-risk investments, your account might not get the attention it requires. To avoid this kind of situation, you should discuss your finances and aims openly and make certain that you understand what kind of account the AE is accustomed to handling. (Chapter 8 describes in detail how to search for a brokerage firm and an account executive that are right for you.)

How Much Does the AE Need to Know?

The need for compatibility between client and AE raises the question of how much the AE needs to know about you personally, about your financial status, and about your financial goals. Questions your prospective AE would ask include:

- How much money do you earn a year?
- Do you have any savings?
- How much do you owe?
- Have you ever purchased stocks or bonds before?

You are not asked such questions every day; the answers are generally—and rightly—considered to be solely your business. Giving out

this type of information can make a person uncomfortable or embarrassed, but the account executive is going to ask this much and more about your financial situation.

Does the AE really need all this information? Yes, to give you sound advice, the AE should be completely informed about your financial situation and objectives. Without a clear picture of your finances—your income, savings, other investments, and so on—an AE can only guess at what investments best suit your goals and how able you are to absorb possible financial loss.

At worst, customers who represent themselves as being "better off" than they really are can find themselves over their heads in investments that require more disposable cash than they have. At best, the AE may recommend investments that simply don't do what these customers want. It only makes sense to give your AE all the information required *(full disclosure)*.

The burden of full disclosure rests on the account executive or sales representative as well as on you. Rule 405 of the New York Stock Exchange is known as the "know your customer" rule. This rule obliges the account executive to get the information needed to provide proper service. (A more detailed explanation of this information is covered in Chapter 8.) Full disclosure is so important that if you refuse to supply some or all of the information required, the brokerage firm may lawfully refuse to open an account for you.

This time-tested analogy explains the need for full financial disclosure: When you go to a doctor for an ailment, you serve your best interest by telling the doctor as much as you can about the problem. If you refuse to do so, the doctor may—and probably should—refuse to treat you. Information from you is needed to choose the proper treatment. The doctor who does not insist on full disclosure can easily do you more harm than good by treating you. Your relationship with the account executive is a professional one, as it is with a doctor, lawyer, or accountant. In fact, if an AE is ready to take your order before getting a complete accounting from you, you

should consider whether his or her aim is to render a long-term professional service—or just to make a commission.

Does full disclosure give the AE the right to know whether you have accounts with other brokerage firms? You are not legally bound to tell the AE, but generally, both you and the AE can benefit by sharing this knowledge. If you feel that other account executives are especially suited to handling parts of your investment program, say so. By being open, you give all the AEs involved a greater insight into your financial situation. They can thus make recommendations that better suit your objectives and waste less of everyone's time. In the worst case, if you do not inform your AEs about your other accounts, one advisor who doesn't know about the other's activities may unknowingly counteract them. So be fully candid with everyone. No feelings should be hurt if you are dealing with professionals.

Even when dealing with a discounter, you must still fill out certain disclosure forms, and the AE is subject to the "know your customer" rule. Should you place an order that seems inconsistent with the information on the disclosure forms, the discount broker is obliged to make certain that you are not undertaking an investment position that is beyond your financial capabilities. Because the discount AE is serving more like a stockbroker and less as a financial advisor, however, more of the burden of prudence and discretion falls on your shoulders.

WHAT TO EXPECT FROM THE AE

Full-Service Firm When you pay for full service, you should get it. Some investors, however, abuse their right to consultation with the AE—they call to chat or to get information that is readily available in the financial news. If you call the AE without a sound business reason, you only waste everyone's time and create a nuisance.

On the other hand, when you are calling for a legitimate purpose, the AE is obligated to take your call or return it. If your messages are not returned or your requests for information are ignored,

don't stand for such treatment. Insist on proper service and, if you don't get it, take your business elsewhere. An effective client/AE relationship must work both ways.

When the relationship becomes unsatisfactory for either party, often the cause is a lack of communication. For example, if you make a purchase of stock but do not have the financial means to make any other transactions for six months, make that fact known to the AE. You will spare yourself the awkward experience of having continually to reject the AE's recommendations during that period. The AE, in turn, will not waste time making recommendations to you and will not have to wonder what recommendation, if any, *will* be acceptable to you. Your openness can prevent such difficulties.

Another element of a healthy relationship is mutual consideration: The AE should be sensitive to your need to feel comfortable with your investments, and you have to be considerate of the AE's need to use time efficiently. It's no secret that the time salespeople spend on nonsales-related activities is time taken away from selling activities. Time is an extremely precious thing to anyone who sells for a living, and the AE, whose commissions and professional evaluation depend on sales generated, is no exception. In fact, the AE who habitually stays on the phone with you, talking about nonbusiness matters, is probably not doing what an AE is supposed to be doing—solving other clients' problems, reviewing research, and, above all, selling. If you expect considerate treatment from AEs, remember what time means to them.

You can handle some routine matters without having to go through the AE by working with the *sales assistant* (SA) at the brokerage firm. This person is sometimes the AE's personal assistant, but more likely the AE shares the services of a pool of such assistants. These people can be extremely helpful. For example, if you are waiting on an overdue check, want to make an address change, or have some other routine administrative matter, ask to speak with the assistant. In fact, get to know the SA's name; you can get many things done through this "office specialist." (By law, an assistant may not discuss

an investment with you, much less express an opinion about a stock or the market. Generally, assistants are not registered and therefore are not permitted to advise clients. Even if an SA is registered, the brokerage firms usually prohibit everyone but their registered salespeople from making recommendations or rendering financial advice. So don't put the assistant on the spot by expecting such advice.)

On the other hand, obviously it is in the interest of your account executive to stay in touch with you and with your investments. Professional representatives gladly spend time with their clients to discuss a particular purchase or sale, a change in investment goals, or any question concerning their clients' financial situation. Investment advice is the primary service offered by the representative of the full-service firm. By all means, take full advantage of that service—but not of the AE. Before dialing the AE, ask yourself two questions:

1. Is the purpose of the call to obtain investment advice?
2. If the answer to the first question is no, can or should a sales assistant help me?

If using this kind of discretion makes you feel that you aren't "getting your money's worth," remember that you are actually making the best use of your time and the AE's. In the long run, the time you do spend in consultation with the AE will be far more fruitful and your relationship more beneficial for you both.

Discount Firm With a discounter, don't forget that what you are paying for is only to have your order executed and the transaction cleared. You are not paying for research, asset management, or investment advice. You may therefore reasonably expect the AE to:

- take your order accurately and courteously,
- enter the order for execution, and
- confirm the execution to you by phone.

In addition, if a mistake is made, the AE should work with you to correct it promptly and satisfactorily.

Don't be surprised if you change AEs several times before staying with one. New investors often try a number of AEs and/or brokerage firms before finding the person and company that meet their needs. At some time you will probably break off with one account executive and start an account with another. How to do this and what to do if you feel you've been wronged are explained in Chapter 12.

When dealing with a brokerage firm and its account executive, your comfort level is important. You must understand the language and phrasing that the AE uses in making proposals, and you must know what to expect when you speak with an AE or place an order. After you finish this book, you will be more knowledgeable about the mechanics of investing, and you will be more comfortable when you pick up a phone and call *your* account executive.

Opening an

Account

After you have reviewed your personal financial situation, determined your financial goals, and decided that securities investment may be right for you, you are ready to select a brokerage firm and open an account.

CHOOSING A BROKERAGE FIRM

The purposes and types of brokerage firms were discussed in Chapter 7. You must decide what services you need to achieve your goals and then choose a firm that meets your needs.

Finding the appropriate brokerage firm requires a little research on your part. The first step is to ask a friend, business associate, your lawyer, or tax advisor if they know a reputable firm and/or broker. Such recommendations may be worth following up.

Once you have a name or names to work with, you must do a little reading on your own. Read professional opinions of these firms or brokers. Go to the library and research back issues of magazines like *Financial World*, *Forbes*, *Money*, *Money Maker*, and *Barron's*. Articles on top-ranking brokers may give you additional insight into performance records, success routes, and success rates of firms with which you may want to do business. Other sources of information

include *Investor's Business Daily's* strong coverage of mutual funds and *The Wall Street Journal's* weekly column "Heard on The Street" which heavily quotes brokers and fund managers, and the December issue of *Financial World,* which usually lists the year's top ten brokers.

The third step involves reading advertisements for brokerage firms in the financial pages of newspapers. Pay close attention to members of the New York Stock Exchange, as they are subject to strict regulation and surveillance.

The fourth and final step in choosing a brokerage firm is to telephone the most likely candidates from your list. Tell them your name, who recommended you to them, and the amount of money you have available to invest at this time. Find the one who is most interested in helping clients within your income and net worth group.

Also consider the following questions:

- What is the range of their services?
- Will you be matched to a broker specializing in your needs? (If not, or if you feel you are being "turned off," pursue another firm.)
- How long has the firm been in business?
- Is research available to you?
- What products (stocks, bonds, options) do they deal with?
- What is their margin rate?
- Does the firm underwrite new issues of stocks or bonds and make them available to their customers?
- Has anyone in the firm ever been censured by an official regulatory agency?
- Do you feel pressured? (Never allow yourself to be pressured into acting immediately with this first call.)

Based on the feedback you receive from these calls, choose a firm with whom you feel comfortable doing business.

CHOOSING AN ACCOUNT EXECUTIVE

The *worst* way to select an account executive is to respond to a cold call and buy an investment product in a *single* phone conversation. Any legitimate sales representative who calls should be *glad* to answer your questions because they signal that you are interested enough to want to know more. Be very suspicious of any cold-calling salesperson who

- asks leading questions, such as "As the provider for your family, you want to do the very best you can for them—don't you?";
- promises you quick, large profits (No one can make that guarantee.);
- hurries you to make a decision before you "miss out on this great opportunity";
- will not agree to talk with your accountant and/or lawyer;
- does not seem interested in knowing about you and your finances before opening an account or accepting an order for you (The AE is bound *by law* to make sure your investments suit your financial capabilities and investment goals.); or
- gives you cagey answers.

 Ask these questions of any salesperson who calls:

- Where did you get my name?
- Will you send me a prospectus, an investment proposal, and/or risk disclosure statements?
- If I am interested in the investment, are you willing to speak with my lawyer/accountant?
- What risks are involved?
- Which regulatory agency governs your firm?
- Is the investment traded on a regulated exchange?

- When can I meet with you?
- May I get references from your firm's bank or attorneys?
- What happens if I want to get out of the investment?

If the caller answers your questions forthrightly, agrees to be checked out, and arranges to meet with you, you're probably dealing with a legitimate firm and representative. The next question is whether the investment is the right one for you, and an honest account executive will help you with that decision too.

One last note about being cold-called: The likelihood is all but nil that a perfectly suitable account executive is going to call you. More likely, you will have to actively search for the AE who will meet your personal and financial needs.

PROSPECTING

One way to start the search for an account executive is to ask your friends about their AEs. Don't be content with a blanket recommendation like, "My account executive is John Smith. He's great. You ought to try him." John Smith might be the perfect advisor for your friend but totally unsuitable for you because your investment goals may differ from your friend's. For example, in the next ten years you may need cash for your children's education, while a childless couple about to retire would be looking ahead to monthly income payments from their investments. These differing investment goals entail different investment products and perhaps varying levels of risk. The same account executive might be able to handle both objectives and, therefore, your account as well as your friend's. Such is not always the case, however, and you may have to look further for an AE. Here are some questions to ask about a friend's AE:

- What are your investment goals?
- How have your advisor's recommendations helped you to achieve your goals?

- Is the AE responsive? Are your calls returned? Do you receive information you requested?
- Have you changed advisors many times?
- Is the firm prompt and accurate in executing orders?
- Do you get a confirmation by phone from the AE? Is the confirmation by mail prompt and accurate?
- Is your monthly statement on time and accurate?
- Does the firm correct its mistakes without your having to constantly follow up?
- Do you think your AE would be able to handle my investment goals?

If you cannot get a recommendation from a friend, then you have to do some prospecting, that is, you must call and screen a number of brokerage firms. (Before making any calls, however, be sure that you are aware of the wide selection of investments, the types of accounts available to you, and, most important, your own investment goals.) Each call should enable you to determine whether a face-to-face interview with the AE is worthwhile for both of you.

INTERVIEWING YOUR ACCOUNT EXECUTIVE

Whenever the phone conversation leads you to believe that a meeting with the AE might be beneficial, set up an appointment.

Once you have chosen a firm, it is a good idea to meet with the account executive (AE), broker, or registered representative who will be handling your account.

A face-to-face meeting between yourself and your prospective broker or AE helps to ensure that the two of you get along and understand each other. *You* must understand how the AE will handle your account, what will be done with your money, and whether you will be notified in the event of a mistake or if a quick decision must be made. The *broker* must be clear about your overall finan-

cial picture—not just the amount you are investing, your risk tolerance, and your understanding of the industry and how it works. Avoid an AE who is patronizing or condescending, promises to make you rich, claims to be an expert in *all* areas of finance, or doesn't take time to discuss your financial goals or the amount of risk you are willing to take.

SUPPOSE IT DOESN'T WORK OUT?

Despite everyone's best efforts, sometimes the relationship between broker and customer simply does not succeed. Perhaps the AE is not helping you achieve your goals. Perhaps your goals or financial status have changed and require the services of an AE with different qualifications. Perhaps your AE has moved to another firm, and you don't want to change accounts. Or perhaps the two of you just don't see eye to eye.

Whatever the reason, the decision to change AEs is yours to make whenever you feel it's necessary. However, first ask yourself whether the AE or the firm is at fault. Assuming that the firm's other services—execution, clearing, and so on—are satisfactory, consider changing to another AE within the firm.

You can make this change simply by finding a new account executive and authorizing the release of assets and information from your current AE. Your new AE does everything else. This procedure is the same whether you change AEs within a firm or change from one firm to another.

TYPES OF ACCOUNTS

The process of opening a brokerage account is similar to that of opening a bank account or a charge account. However, the two basic types of accounts—cash accounts and margin accounts—have different requirements.

CASH ACCOUNT

A *cash account,* in which all transactions are settled on a cash basis, is the most popular type of account opened by a new investor. Several forms must be filled out, but these may differ among brokerage firms. The new account application asks for your name, address, social security number, occupation, citizenship, and at least one bank reference. (See Figure 8–1.) Other information that may be required is your marital status, your spouse's name and occupation, and the names of both your employers as well as financial information and investment goals.

Depending on the firm and the types of investments you are making, you may have to fill out (1) a *trading authorization* (if someone other than yourself will be giving orders in the account); (2) a *client agreement* (that allows the designated AE to act as your broker); and (3) a *limited trading authorization* (that allows the AE to exercise trading discretion over your account, but not to withdraw securities and funds).

Additional forms are also required for the following types of accounts which have specific ownership characteristics:

Joint Account with right of survivorship allows any of the joint owners to act independently.

Uniform Gift to Minor Account allows transfer of assets to a child's name and social security number. There may only be one trustee for each UGMA, and the child automatically owns the assets upon reaching majority. Special considerations to be considered before using an UGMA are the maturity of the child and the effect such gifts will have on college scholarship funding, which looks to the child's assets first in determining need.

Trust accounts, corporate accounts, and sole proprietorship accounts all require additional documentation indicating beneficial ownership and trading authorization.

Options and futures accounts require additional documentation indicating the investor's level of experience and economic tolerance for risk. These forms are to protect both the investor and the brokerage house through full disclosure in order to insure that the

investor is accepting an appropriate risk level in accordance with the stated investment goal.

Street Name accounts where shares purchased for an individual are held in the broker's name (street name) also require a separate form which allows your broker to lend your shares. These forms are for your protection as well as the firm's. Any changes in your situation or specifications must be documented and endorsed.

MARGIN ACCOUNT

Margin accounts can be opened instead of or in addition to regular cash accounts. In a margin account, you may buy or sell securities by paying only part of their cost—the broker pays the rest by loaning you the money. Buying on margin can be a tempting way and profitable way to increase your holdings through leverage. The Federal Reserve Board, the various exchanges, and the individual brokerage houses all have independent margin requirements with regard to what kinds of investments are marginable and to what degree.

The Federal Reserve requirement—as set forth in Regulation T—currently allows up to 50 percent of the purchase price of marginable stocks to be borrowed from the brokerage house. Effectively this allows the investor to buy twice the number of shares which can greatly magnify profits in a rising market, but which can prove dangerous in a down market when declining prices may force a *margin call* where the investor must make additional equity deposits to the account in the form of cash or securities in order to avoid having his or her positions sold to meet minimum borrowing requirements under the margin agreement. To open a margin account, you must complete the same forms as for a cash account, as well as additional agreements, including: (1) a *margin agreement* or *hypothecation agreement* that explains the terms and conditions under which a brokerage firm will finance your transactions (see Figure 8–2); (2) a *loan consent agreement* that allows the broker to use your securities as collateral for loans from banks; and (3) a *credit agreement* that specifies how and when interest is charged on your account.

Figure 8–1. A Typical New Account Information Form.

LaSalle St. Securities, Inc.

New Brokerage Account Application

SPECIMEN

ACCOUNT REGISTRATION

(Custodian)
Name: _____ U.S. Social Security No. or U.S. Tax ID No. _____

Date of Birth _____

(Minor)
Joint Tenant (if any) _____ U.S. Social Security No. or U.S. Tax ID No. _____

Date of Birth _____

If this is a joint account, it is the express intention of the undersigned that ownership of this account be vested in them as (Check one):

☐ **Joint tenants** with rights of survivorship and not as tenants in common or as tenants by the entirety. In the event of the death of either or any of the undersigned, the entire interest in the Joint Account shall be vested in the survivor or survivors on the same terms and conditions as theretofore held, without in any manner releasing the undersigned or their estates from the liability provided for in this Agreement.

☐ **Tenants in common.** In the event of the death of either or any of the undersigned, the interests in the tenancy shall be equal unless otherwise specified immediately below.

If interests are not to be equal, designate the percentage interest of each tenant.

_____ % _____ % _____ %
Name Name Name

*If you do not choose, the account will be registered as Joint Tenants with Rights of Survivorship.

Please indicate your investment interests:

☐ Income ☐ Safety ☐ Growth/College/Retirement ☐ Taxes ☐ Speculation ☐ **Estate Planning**

The customer is responsible for notifying LaSalle St. Securities, Inc. of changes in objectives and financial position.

Type of Account ☐ Cash ☐ Margin (Margin agreement must be completed.) ☐ Option (Option agreement must be completed.)

CUSTOMER

Address

Mailing Address Number / Street _____

City _____ State / Zip _____

*(If using a P.O. Box must indicate your legal street address below)

Legal Address
(if different than mailing address)

*Number / Street _____

City _____ State / Zip _____

Telephone Numbers

Daytime (_____) _____ Evening (_____) _____

Citizenship

❑ U.S. ❑ Resident Alien ❑ Non-Resident Alien

If Non-Resident Alien, Indicate Country _____ & Passport No _____

Employment

Employer _____

Type of Business _____ Position / Title _____

Number / Street _____

City _____ State / Zip _____

If you are not currently employed, please provide the amount and source of your annual income here:

Amount _____ Source _____

Bank Reference

Name of Bank _____ Account No. _____

Branch / City _____ State / Zip _____

For internal use only

X _____ _____
 Approval Office Manager Date

X _____ R.R. # _____ _____ _____
 Registered Representative Signature Date Account Number

Figure 8-1, *cont'd.*

JOINT TENANT

Address
Mailing Address Number / Street _____
State / Zip _____
City _____
*(If using a P.O. Box must indicate your legal street address below)

Legal Address
(if different than
mailing address)
*Number / Street _____
City _____ State / Zip _____

Telephone Numbers
Daytime (____) _____ Evening (____) _____

Citizenship
☐ U.S. ☐ Resident Alien ☐ Non-Resident Alien
If Non-Resident Alien, Indicate Country _____ & Passport No. _____

Employment
Employer _____ Position / Title _____
Type of Business _____
Number / Street _____
City _____ State / Zip _____

If you are not currently employed, please provide the amount and source of your annual income here:
Amount _____ Source _____

Bank Reference
Name of Bank _____ Account No. _____
Branch / City _____ State / Zip _____

SPECIMEN

Annual Income
Approximate annual income from all sources: (For joint account check your combined income.)
☐ Under $25,000 (please state amount $ _____) ☐ $25,000-$50,000 ☐ $50,000-$100,000 ☐ over $100,000

Estimated Net Worth:
(exclusive of home and farm)
☐ Under $50,000 (please state amount $ _____) ☐ $50,000-$100,000
☐ $100,000-$500,000 ☐ $500,000+

Estimated Liquid Net Worth:
(including cash and securities)
☐ Under $50,000 (please state amount $ _____) ☐ $50,000-$100,000
☐ $100,000-$500,000 ☐ $500,000+

Tax Bracket: ☐ 15% ☐ 28% ☐ greater than 28%

Affiliations and Acknowledgments

I am affiliated with, or work for: _____ ❑ a bank, trust, or insurance company
❑ a stock exchange or a member firm of an exchange or the NASD

(If so, notification your intent to open an account will be sent to your employer in accordance with current regulation.)

I am a ❑ director, ❑ 10% shareholder, ❑ policymaking executive officer of a publicly traded company.

(If so, provide name of company) _____

If you have checked any of the above, please supply account number(s) of other accounts you or members of your immediate family have with us.

Power of Attorney

Have you granted trading authorization to someone other than the account owner(s)? ❑ Yes ❑ No
If so, please attach the trading authorization unless you have previously provided it to us.
Please indicate the relationship between you and your agent (e.g., investment advisor, family member, trustee, etc.)

Account Service Instructions

Puchases
❑ Hold Securities
❑ Send me certificates

Sales
❑ Send me proceeds
❑ Sweep proceeds into Capital Reserves Fund

Dividend/Interest
❑ 1. Pay Weekly
❑ 2. Pay Monthly
❑ 3. Hold/Reinvest Mutual Fund Div.
❑ 4. Hold/Sweep to Money Market
❑ 5. Pay Semi-Monthly
❑ 6. Pay Quarterly

Registration

❑ ADM - Administrator
❑ EXEC - Executor
❑ TRU/A - Trust (Under Agreement)
❑ UF - Joint Usufruct
❑ PC - Professional Corporation

❑ CM - Committee
❑ IC - Investment Club
❑ TRU/W - Trust (Under Will)
❑ J - Joint with Rights of Survivorship
❑ SP - Sole Proprietorship

❑ CP - Corporation
❑ I - Individual
❑ COM/P - Joint Community Prop.
❑ PT - Partnership
❑ UA - Unincorporated Association

❑ UGMA - Custodian (Gifts to Minors)
❑ TIC - Joint Tenants in Common
❑ PR - Personal Representative
❑ Other _____

❑ UTMA - Custodian (Transfer to Minors)
❑ TIE - Joint Tenants in Entirety
❑ PA - Professional Association
❑

Duplicate
(only if different address than "customer" sect.)

❑ CONFIRMS Sent to _____

❑ STATEMENTS _____

Figure 8-1, *cont'd.*

Convenient payment for your purchases

Automatic Trade Settlement Authorization

Complete this section if you wish to link your brokerage account with one of the following Money Fund Accounts:

(please check one)

SPECIMEN

☐ CAPITAL RESERVES: MONEY MARKET PORTFOLIO
☐ CAPITAL RESERVES: U.S. GOVERNMENT PORTFOLIO
☐ CAPITAL RESERVES: MUNICIPAL MONEY MARKET PORTFOLIO

Please be sure that you have read the fund prospectus for the fund of your choice. Please read the Automatic Trade Settlement section of the Customer Agreement for more information.

Notice to National Financial Services Corporation

This is to advise you that I (we) have instructed LaSalle St. Securities, Inc. to establish, in my (our) behalf, and as my (our) agent an account with you. I (we) have appointed LaSalle St. Securities, Inc. as my (our) exclusive agent to act for and on my (our) behalf with respect to all matters regarding my (our) account with you, including but not limited to the placing of securities purchase and sale orders and delivery of margin and option instructions if authorized, for my (our) account. A copy of my (our) agreement with LaSalle St. Securities, Inc. is delivered to you herewith. I (we) acknowledge that no fiduciary relationship exists. You shall look solely to LaSalle St. Securities, Inc. and not me (us) with respect to such orders or instructions; and you are hereby instructed to deliver confirmations, statements, and all written or other notices including margin maintenance calls, if applicable, with respects to my (our) account to LaSalle St. Securities, Inc. Any such communications delivered to LaSalle St. Securities, Inc. shall be deemed to have been delivered to me (us) I (we) agree to hold you harmless from and against any losses, costs or expenses arising in connection with the delivery or receipt of any such communication(s), provided you have acted in accordance with the above. The foregoing shall be effective as to my (our) account until written notice to the contrary is received by you and LaSalle St. Securities, Inc.

Please read the customer agreement and sign your name

To LaSalle St. Securities, Inc. and National Financial Services Corporation

I am at least 18 years of age and am of full legal age in the state in which I reside. In consideration of your accepting one or more accounts, I hereby acknowledge that I have read, understood and agreed to the terms set forth in the Customer Agreement herein. I understand that LaSalle St. Securities, Inc. will disclose my name to issuers of securities if securities are held in my account so that I can receive important information unless I do not consent to disclosure and I will notify LaSalle St. Securities, Inc. if I do not consent. I certify under penalty of perjury (1) that the Social Security or Taxpayer Identification Number provided above is correct, and (2) that the IRS has never notified me that I am subject to 20 percent backup withholding, or has notified me that I am no longer subject to such backup withholding. (Note: if part (2) is not true, please strike out that part before signing.) I understand that telephone calls to LaSalle St. Securities, Inc. may be recorded and I hereby consent to such recording. Reports of executions or orders and statements of my account shall be conclusive if not objected to in writing within five (5) days and ten (10) days respectively, after transmitted to me by mail or otherwise.

I REPRESENT THAT I HAVE READ THE TERMS AND CONDITIONS GOVERNING THIS ACCOUNT AND AGREE TO BE BOUND BY SUCH TERMS AND CONDITIONS AS CURRENTLY IN EFFECT AND AS MAY BE AMENDED FROM TIME TO TIME. THIS ACCOUNT IS GOVERNED BY A PRE-DISPUTE ARBITRATION AGREEMENT WHICH IS ENCLOSED. I ACKNOWLEDGE RECEIPT OF THE PRE-DISPUTE ARBITRATION AGREEMENT.

X _____

Signature / Date

X _____

Signature of Joint Tenant (if any) / Date

Account Carried by National Financial Services Corporation.

MEMBER SIPC

Figure 8-2a. A Typical Customer Margin Agreement/Loan Consent Form (front).

Supplemental Application for NFSC Margin Account Privileges

Essentials

Name _____

SPECIMEN

Name of joint tenant _____
(If applicable)

Your Brokerage Account Number _____

Annual Income

This information must be provided in accordance with Securities and Exchange Commission requirements.

Annual income of Customer(s).

□ Less than $15,000 □ $15,000 — $25,000 □ $25,000 — $50,000 □ Over $50,000
Please state amount $ _____

Estimated Net Worth: □ Under $50,000 □ $50,000-$100,000 □ $100,001-$500,000
(exclusive of home and farm) □ Over $500,000 Please state amount $ _____

Investable Assets: □ Under $50,000 □ $50,000-$100,000 □ $100,001-$500,000
(including cash and securities) □ Over $500,000 Please state amount $ _____

Tax Bracket: □ 15% □ 28% □ 31% □ 36% □ 39.6%

Affiliations and Acknowledgments

☐ I am affiliated with, or work for a stock exchange or a member firm of an exchange or the NASD

(Please indicate name of firm)

(Notification of your intent to open an account will be sent to your employer in accordance with current regulation.)

I am a ☐ director, ☐ 10% shareholder, ☐ policymaking executive officer of a publicly traded company

(If so, provide name of company)

If you have checked any of the above, please supply account number(s) of other accounts you have with us.

Please be sure to sign the reverse side of this application.

For Office Use Only

_____ _____
Principal Approval Date

_____ _____
Registered Representative Date

Please be sure to sign the reverse side of this application ▶

NF MO (11/98) 65549
P6-016-939

1

Figure 8–2b. A Typical Customer Margin Agreement/Loan Consent Form (back).

Margin Account Agreement

To: My Broker/Dealer and National Financial Services Corporation ("NFSC" or "you") Introducing Broker/Dealer: _____

1. I agree as follows with respect to all of my brokerage accounts, in which I have an interest alone or with others, which I have opened or will open in the future, with you through my Broker/Dealer for the purchase and sale of securities. I hereby acknowledge that I have read, understand and agree to the terms set forth below. Upon acceptance of my application(s), I understand my Broker/Dealer will maintain an account for me at NFSC, and my Broker/Dealer may buy or sell securities or other products according to my instructions. All decisions relating to my investment or trading activity shall be made by me, my Broker/Dealer or my duly authorized representative. Any information provided in this brokerage account application and agreement will be subject to verification, and I authorize you or my Broker/Dealer to obtain a credit report about me at any time. Upon written request, NFSC or my Broker/Dealer will provide the name and address of the credit reporting agency used. I authorize NFSC or my Broker/Dealer to exchange credit information about me. My Broker/Dealer and you also may tape record conversations with me in order to verify data concerning any transactions I request, and I consent to such recording. I also understand that my brokerage account(s) is carried by NFSC, and that all terms of this Agreement also apply between me and NFSC. I have carefully examined my financial resources, investment objectives, tolerance for risk along with the terms of the margin agreement and have determined that margin financing is appropriate for me. I understand that investing on margin involves the extension of credit to me and that my financial exposure could exceed the value of securities in my account. I agree to notify my Broker/Dealer in writing of any material changes in my financial circumstances or investment objectives.

2. I am of legal age in the state in which I reside and represent that, except as otherwise disclosed to you in writing, I am not an employee of any Exchange or of a Member Firm of any Exchange or the NASD and that I will promptly notify you if I become so employed. I am not employed as a director, 10% shareholder, or policy making executive officer of a publicly traded company and I will promptly notify you if I become so employed.

3. All transactions are subject to the constitution, rules, regulations, customs, and usage's of the exchange, market or clearinghouse where executed, as well as to any applicable federal or state laws, rules and regulations.

4. Any credit balances, securities, assets or related contracts, and all other property in which I may have an interest held by you or carried for my brokerage accounts shall be subject to a general lien for the discharge of my obligations to you (including unmatured and contingent obligations) and you may sell, transfer, or assign such assets or property to satisfy a margin deficiency or other obligation whether or not you have made advances with respect to such property. Without notice to me, such property may be carried in your general loans, and all your securities may be pledged, repledged, hypothecated or rehypothecated, separately or in common with other securities or any other property for the sum due to you or for a greater sum, and without retaining in your possession and control for delivery a like amount of similar securities or other property. At any time in your discretion, you may, without notice to me, apply and/or transfer any securities, related contracts, cash or other property, interchangeably between my brokerage accounts, whether individual or joint, from any of my brokerage accounts to any brokerage account guaranteed by me. You are specifically authorized to transfer to my cash account, on the settlement day following a purchase made in that brokerage account, excess funds available in any of my brokerage accounts, including, but not limited to, any free balances in any margin account, sufficient to make full payment of this cash purchase. I agree that any debit occurring in any of my brokerage accounts may be transferred by you at your option to my margin account. In return for your extension or maintenance of credit in connection with my brokerage account, I acknowledge that the securities in my margin account, together with all attendant rights of ownership, may be lent to you or lent out to others. In connection with such loans, you may receive and retain certain benefits to which I will not be entitled. In certain circumstances, such loans may limit, in whole or in part, my ability to exercise voting rights of the securities lent.

5. I will maintain such margins as you require in your discretion at any time and will pay on demand any debit balance owing on any of my brokerage accounts. If any brokerage account is liquidated in whole or in part by you or me to satisfy the debt, I will be liable to you for any deficiency and shall make payment of such deficiency on demand. Whenever in your discretion you deem it desirable for your protection (and without the necessity of a margin call), including but not limited to extreme market volatility or trading volumes, an instance where a petition in bankruptcy or for the appointment of a receiver is filed by or against me, or an attachment is levied against my brokerage account, or in the event of my death or incapacity, or in compliance with the orders of the Exchange, you may, without prior demand, tender, and without any notice of the time or place of sale, all of which are expressly waived, sell any or all of securities or related contracts that may be in your possession, at your selection, or which you may be carrying for me, or buy any securities, or related contracts relating thereto of which my brokerage account or brokerage accounts may be short, in order to close out in whole or in part any commitment on my behalf. You may also place stop orders with respect of such securities and such sale or purchase be made at your discretion on any exchange or other markets where such business is then transacted, or at public auction or private sale, with or without advertising, and neither any demands, calls, tenders or notices which you may make or give in any one or more instances nor any prior course of conduct or dealings between us shall invalidate the aforesaid waivers on my part. You shall have the right to purchase for your own account any or all of the aforesaid property at such sale, discharged of any right of redemption which is hereby waived.

6. In the absence of a specific demand, all transactions in any of my brokerage accounts are to be paid for, securities delivered or required margin deposited, no later than 2 p.m. Eastern Time on the settlement date, and I agree to deliver my securities that I have in my possession in sufficient time to be received by my Broker/Dealer one day before settlement date. My Broker/Dealer and NFSC reserve the right to cancel or liquidate at my risk any transaction not timely settled. Margin calls are due on the date indicated regardless of the settlement date of the transaction. For most stocks and bonds, the settlement date is the third business day following the trade date. Settlement dates for U.S. government issues vary. Options settle on the next business day. Interest will be charged on any debit balance which remains in my brokerage account past the settlement date as explained in the Disclosure of Credit Terms on Transactions section of this Agreement.

7. I agree to be charged interest on any credit you extend to or maintain for me for purchasing, carrying or trading securities. The annual rate of interest which will be charged on average debit balances will be calculated by a formula based on the rate for brokers' call money published in The Wall Street Journal (or substitute publications) and, therefore, is subject to change without notice in accordance with changes in the brokers' call money rate. With the exception of credit balances in the short account and income account, all other balances in all of your accounts are combined to determine the daily balance and interest is charged to the margin account based on the average of any resulting daily debit balance. Interest is computed monthly on the average daily debit balances during the month. If rates change during the month, separate charges will be shown for each interest period under the different rate. Calculated by computer, the interest on combined balances from all cash and margin accounts is arrived at by multiplying the average debit balance by the effective rate of interest divided by 360, times the number of days a daily debit balance was maintained during the interest period. You may request additional collateral in the form of marginable securities or cash whenever you deem it necessary or advisable in your sole discretion, or if there is a decline in the market value of securities in the margin account. All securities in any of my brokerage accounts are collateral for debit balances in this brokerage account, and a lien is created by these debits to secure the amount owed you. This means securities in these brokerage accounts can be sold by you to redeem or liquidate any debit balances in this brokerage account. You reserve the right to increase maintenance requirements and to request additional collateral at any time at your discretion. The Federal Equal Credit Opportunity Act prohibits creditors from discriminating against credit applicants on the basis of race, color, religion, national origin, sex, marital status, age (provided the applicant has the capacity to enter into a binding contract); because all or part of the applicant's income derives from a public assistance program, or because the applicant has, in good faith, exercised any right under the Consumer Credit Protection Act. The Federal agency that administers compliance with this law concerning this creditor is: Securities and Exchange Commission, 450 Fifth Street NW, Washington, DC 20549.

8. I agree that, in giving orders to sell, all "short" sale orders will be designated as "short" and all "long" sale orders will be designated as "long" and that the designation of a sell order as "long" is a representation on my part than I own the security and that I have delivered or will deliver by settlement date such security to you.

9. Communications by mail, telegraph, messenger or otherwise sent to me at the address of record listed on the application or any other address I may give my Broker/Dealer in writing, are presumed to be delivered and received by me, whether actually received or not. A statement of all transactions will be mailed to the address of record, monthly or quarterly, depending on activity. I understand that I should promptly and carefully review the transaction confirmations and periodic brokerage account statements and notify my Broker/Dealer of any errors. Information contained on transaction confirmations and periodic brokerage account statements is conclusive unless I object in writing within five and ten days respectively, after transmitting to me.

10. I am liable for payment upon demand of any debit balance or other obligation owed in any of my accounts or any deficiencies following a whole or partial liquidation, and I agree to satisfy any such demand or obligation. Interest will accrue on any such deficiency at prevailing margin rates until paid. I agree to reimburse my Broker/Dealer and NFSC for all reasonable costs and expenses incurred in the collection of any debit balance or unpaid deficiency in any of my brokerage accounts, including, but not limited to, attorneys' fees.

11. My Broker/Dealer and NFSC are not liable for any losses caused directly or indirectly by government restrictions, exchange or market rulings, suspension of trading, war, strikes or other conditions beyond their control, including, but not limited to, extreme market volatility or trading volumes.

12. No waiver of any provision of this Agreement shall be deemed a waiver of any other provision, nor a continuing waiver to the provision or provisions so waived.

13. No provision of this Agreement can be amended or waived except in writing signed by an officer of NFSC. This Agreement will remain in effect until its termination by me is acknowledged in writing by an authorized representative of NFSC; or until written notice of termination by you shall have been mailed to me at my address last given to you. I will remain responsible for all charges, debit items, or other transactions initiated or authorized by me, whether arising before or after termination.

14. This Agreement and its enforcement shall be governed by the laws of the Commonwealth of Massachusetts; shall cover individually and collectively all brokerage accounts that I may maintain with NFSC; shall inure to the benefit of my Broker/Dealer's or your successors and assigns whether by merger, consolidation or otherwise and my Broker/Dealer and you may transfer my account to my Broker/Dealer's or your successors and assigns; and shall be binding on my heirs, executors, administrators, successors, and assigns.

15. If any provision of this Agreement is or at any time should become inconsistent with any present or future law, rule or regulation of any entity having regulatory jurisdiction over it, that provision will be superseded or amended to conform with such law, rule or regulation, but the remainder of this Agreement shall continue and remain in full force and effect.

16. If the undersigned shall consist of more than one brokerage account holder, their obligations and liabilities under this Agreement shall be joint and several and may be enforced by my Broker/Dealer or NFSC against any or all brokerage account holders.

17. I understand that you may deliver margin calls and other notices to my Broker/Dealer for the sole purpose of collection of my obligations under this Agreement. I agree to the foregoing and further understand that my Broker/Dealer may act on your behalf with respect to margin calls in your discretion.

18. I represent that I have read and understand the Disclosure of Credit Terms on Transactions. I further understand that they may be amended from time to time.

19. YOU ARE HEREBY AUTHORIZED TO LEND, HYPOTHECATE OR REHYPOTHECATE SEPARATELY OR WITH THE PROPERTY OF OTHERS, EITHER TO YOURSELVES OR TO OTHERS, ANY PROPERTY YOU MAY BE CARRYING FOR ME ON MARGIN. THIS AUTHORIZATION SHALL APPLY TO ALL MY BROKERAGE ACCOUNTS YOU CARRY AND SHALL REMAIN IN FULL FORCE UNTIL YOU RECEIVE FROM MY BROKER/DEALER WRITTEN NOTICE OF MY REVOCATION AT YOUR PRINCIPAL OFFICES.

I REPRESENT THAT I HAVE READ THE TERMS AND CONDITIONS CONCERNING THIS ACCOUNT AND AGREE TO BE BOUND BY SUCH TERMS AND CONDITIONS AS CURRENTLY IN EFFECT AND AS MAY BE AMENDED FROM TIME TO TIME. THIS ACCOUNT IS GOVERNED BY A PRE-DISPUTE ARBITRATION CLAUSE WHICH APPEARS ON PAGE 4. I ACKNOWLEDGE RECEIPT OF THE PRE-DISPUTE ARBITRATION CLAUSE.

SPECIMEN

Account Holder Signature / Date

Joint Account Holders (if any) / Date

Joint Account Holder Signature (if any) / Date

Joint Account Holders (if any) / Date

Bar Code (inserted as part of the form)

Account carried with National Financial Services Corporation. **Member NYSE/SIPC**

— 2 —

Special Miscellaneous (Memorandum) Account

A *special miscellaneous account* (SMA) is established to allow you to make use of paper profits or excess deposits without disturbing the security position in your margin account. This account can be viewed as a credit line that costs nothing if unused and, if used, increases your *debit balance.*

Cash Management Account

A *cash management account* (CMA), also called an umbrella account, an active assets account, a financial management account, and other names, provides a variety of different services depending on the firm with which you deal. This type of account requires a minimum deposit ranging from $1,000 to $20,000. Some of the services it provides include: checking privileges, automatic reinvestment of interest or dividends, interest on credit balance, and a credit card. A money market fund account is similar to this type of brokerage account except that a money market account requires a smaller minimum deposit and excludes a credit card. Appropriate forms are needed to open this type of account.

The Mechanics
of Trading

HOW AN ORDER IS EXECUTED

When you contact your brokerage firm to buy or sell a listed security, your AE or broker places the information on an order form, or *office ticket,* and it is entered on a computer in the *order department.* The order is then sent to the floor of the exchange via telephone, teletype, or computer, where clerks transfer some of the information onto a *floor ticket.* Federal law and exchange rules determine the information required on both kinds of tickets. Only members of the exchange are permitted to execute orders, so the clerk on the exchange floor contacts an available *commission house broker* or *two-dollar broker* to actually execute the order.

When the execution is completed, the trade information is sent back to the firm's order department. From there, the pertinent information is sent to the *purchase and sales department* (P&S) for recording the order, figuring the monies due, comparing the order with the broker on the other side of the transaction, and confirming the trade with the customer. The cashiering, accounting, and stock record departments are also notified of the trade. Though a paper trail is maintained, virtually all record keeping is now handled by computer entry. (Generally, the broker on the floor will not notify

you to confirm the execution of your order. Instead, the AE will notify you by telephone that the trade took place and at what price the stock was bought or sold. If you do not get a call from the AE by the end of the day, call him or her for verbal confirmation.)

A couple of days after the execution, you should receive written confirmation of your transaction in the mail. The confirmation usually shows the following information (see Figure 9–1):

1. trade date

2. settlement date

3. quantity

4. price

5. point of execution

6. method of execution

7. customer name and address

8. commission charges

9. applicable taxes and fees

10. money required (if any)

Figure 9–1. An Illustrative Confirmation Notice.

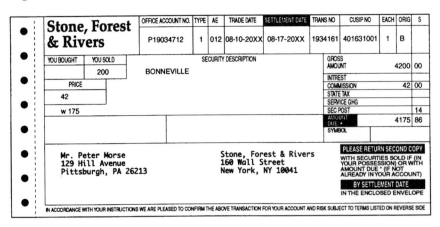

UNITS OF TRADING

Most stocks trading on the NYSE are bought and sold in 100-share units called *round lots*. A trading unit less than a round lot (for example, 1 to 99 shares) is called an *odd lot*. In some cases, orders for a combination of an odd lot and a round lot (for example, buying 150 shares of a stock) require two order tickets.

TYPES OF ORDERS

Three major types of orders are market, limit, and stop orders.

MARKET ORDER

A *market order* is an order to buy or sell at the best available price as soon as the order reaches the floor. Usually, this type of order is executed at a price reasonably close to the quote obtained before the order was taken. A broker who fails to follow such instructions due to negligence is responsible for *missing the market,* and reimburses the customer for any loss. Missing the market rarely occurs but can happen if an order is misplaced, or if the broker accepts too many orders for different securities at the same time.

LIMIT ORDER

A *limit order* is entered when you or the broker sets a maximum price you will pay as a buyer or a minimum price you will accept as a seller. Your order must not be executed until the established price is reached. Such a price limitation includes an understood "or better" instruction. Therefore, to avoid missing the market, the broker should execute the order immediately if the limit or better is obtainable.

Stop Order

A *stop order* is an order that is temporarily suspended. In effect, a stop order is a memorandum that will become a buy order or a sell order if and when the market price equals or passes through the price stated in the memorandum. For example, if you bought a stock at $30 and it is currently selling at $28, you might want to place a *sell stop order* at $25. If trading in the stock touches or drops below $25, your order is activated and becomes an order to sell *at-the-market,* generally limiting your loss to $5 per share plus commissions, except in very fast markets. Remember that a stop order becomes a market order once the stop price is breached.

SPECIAL INSTRUCTIONS

Market, limit, and stop orders can be supplemented with time instructions, such as a *good-till-cancelled* (GTC) order. This instruction keeps a buy or sell order valid until it is executed or canceled by the customer (unlike day orders, which are effective only for the trading day on which they are entered). Other instructions (defined in the glossary) are also used to supplement market, limit, and stop orders, such as *not held* (NH), *all or none* (AON), *fill or kill* (FOK), and *immediate or cancel* (IOC).

SELLING SHORT

Usually, investors buy securities before they sell them. (Such positions are said to be *long*.) In a *short* sale, however, investors sell securities that they do *not* own and incur the obligation to buy the securities sometime in the future to "cover" the short position. Investors sell short because they anticipate a decline in price. Fundamentally, selling short is an inversion of the buy-low/sell-high principle: sell high (now, without delivering right away) and buy low (later, to repay the shares borrowed). (See Figure 9–2.)

Figure 9–2. How a Short Sale Works.

DIVIDENDS

When you invest in common or preferred stock (as discussed in Chapter 2), you are entitled to *dividend* returns on the stock you purchased. (Dividends are that portion of the after-tax earnings that the corporation's directors declare and pay to the shareholders.)

Several key dates apply to dividend payment; as an investor, you should understand their importance. For example, suppose investor Bill Brown knows that his dividends on a particular stock arrive around August 3 or 4. He buys 100 additional shares, but gets no extra dividend. When he calls his broker for an explanation, Bill discovers that he must have owned the newer shares of stock on July 1 (record date) to be eligible to receive the August dividend on them.

Susan Ryan sells 100 shares of the same stock on July 24, but still expects to receive the dividend. She is surprised when no dividend arrives because she owned the stock when the dividend was declared, but she sold prior to the ex-dividend date.

These and similar situations occur frequently because many investors are confused about the different critical dividend dates involved in a transaction. To determine whether the buyer or seller is entitled to the dividend, it is necessary to understand the following:

- *Trade date:* The day on which the trade is executed.
- *Settlement date:* The day on which money is due the broker for a purchase, or the certificate is due the broker for a sale.
- *Declaration date:* The day on which a corporation's board of directors meets, decides on the amount of the dividend, and makes the public announcement.
- *Ex-Dividend date:* The day on which a security begins to trade without the value of the dividend belonging to the purchaser. Because almost all securities contracts are settled *regular way* (this means the settlement date is three business days after the trade date), the ex-dividend date is usually the second business day before the record date.
- *Record date:* The day on which a corporation closes its register of securities holders to determine the recipients of a previously announced distribution. This date is set by the directors of the issuing corporation.
- *Payment date:* The day on which the corporation makes payment of the dividend to previously determined holders of record.

Whether or not you are entitled to a dividend payment depends largely on the date you purchased or sold your stock and its relation to the record date. Since the record date is set by the cor-

poration's directors, it may seem that you have little control over your dividend acquisition. The concepts behind dividend dates can be very confusing to the novice investor; the knowledge and experience of your AE will probably come in handy at this time. However, a good rule to remember is this: If the settlement date is any day up to and including the record date, the buyer is entitled to the dividend. If settlement date falls after the record date, the dividend belongs to the seller.

ACCRUED INTEREST

Accrued interest is the interest on a bond from the last payment date to settlement date. Accrued interest is paid by the buyer to the seller; but the buyer's expense is only temporary. When the corporation next pays interest on its debt, the purchaser collects the entire amount accumulated during the normal six-month period. Part of this amount is reimbursement for the earlier payment to the previous bondholder. The other part of the interest payment is due because the buyer now has the status of a creditor of that concern.

YOUR MONTHLY STATEMENT

Whether you are an active investor, or one who only periodically enhances or changes your holdings, the accounting department of most brokerage firms handles the maintenance of your account and sends you a statement of your transactions. Under federal law, if there has been any transaction activity, security position, or money balance in an account within the preceding calendar quarter, the customer must be given a statement of account. Many firms comply by sending their customers (particularly margin account customers) monthly statements instead of the mandatory quarterly report.

Whether monthly or quarterly, the statement summarizes all that has occurred in your account during the period. All purchase

expenses are debited to the account, and sales proceeds are credited. However, each purchase and/or sales transaction is posted on contract settlement date, whereas all other activities are posted on the day they occur.

For example, a check received from a customer is credited to the account on the day it is received, and money delivered out of the account is debited on the actual day of reimbursement. But a regular-way trade of a corporate security on June 28 is not posted until July 1, three business days later. This difference is often a point of confusion for customers, especially toward the end of the month when they receive their statements of account without the trade posted on it.

Despite the best efforts and intentions of the accounting department, mistakes do occur. Perhaps an issue is not carried forward to the following month's position listing, or duplicate entries are processed accidentally and both items are posted in the account. A typical customer statement therefore contains a self-protective legend, "E & OE," which means, *errors and omissions expected.* This statement allows the brokerage firm an opportunity to correct the mistake without legal liability.

The statement may also carry a legend advising customers of financial protection afforded them under SEC Rule 15c3-3. Free credit balances must be maintained in a "special reserve bank account for the exclusive benefit of customers," a rule that denies the brokerage firm the right to use those funds in the speculative conduct of its own business. The accounting department, employing a formula approved by stock exchange or NASD authority, supervises firm compliance with this rule and ensures that customer money is used only for customer purposes.

Entering an order is perhaps the easiest part of investing, but it can be a source of many a misunderstanding between you and your brokerage firm. To minimize such problems, make certain that you are communicating clearly. State the details of your order slowly and distinctly, and even have the account executive repeat them to you.

When you get the call-back confirming the execution of the order, listen carefully. Even if there was an error in execution, the damage can be held down by correcting the error promptly.

Though it is rarely spoken of by account executives for fear of offending a customer, there is also a very real issue of trust between the account executive and the customer. In many trades substantial sums are being committed on the basis of a verbal order. Though many brokerages tape all customer calls, many do not, and the account executive has to be able to trust and rely upon the customer's word that payment will be made or stock delivered, or face the very real possibility that the brokerage firm will look to the account executive for reimbursement of any deficit caused by correcting a trade when a customer refuses to acknowledge that the order was placed.

Fundamental
Analysis

If you're like most individual investors, you sense an aura of mystery surrounding the world of security analysis. For many investors, security analysts and the tools and techniques of the trade seem remote, complex, and difficult to comprehend. In this chapter, I will try to show you that security analysis is simply the application of common sense—in conjunction with certain key mathematical ratios—to decisions to buy, hold, or sell particular stocks.

DEFINING A "SOUND INVESTMENT"

The late Benjamin Graham, credited by Warren Buffett, Peter Lynch, and other disciples as the most influential proponent of fundamental investing, stated in his seminal work *The Intelligent Investor* that "the habit of relating what is paid to what is being offered is an invaluable trait in investing." More simply stated, what is an investment really worth? Under the system of fundamental analysis as expounded by Graham, the ultimate aim was to determine what an investor would be willing to pay for the assets, i.e., buildings, inventory, machinery, sales lists, etc., for the entire company in a private sale. Graham's methodology requires a sound intellectual framework for making decisions and the ability to keep emotions from corrupting that framework.

To do this effectively, however, it is first and foremost necessary to understand what a "sound investment" is. As espoused by Graham, a stock is *not* a sound investment just because it can be bought close to its net asset value. A reasonable price/earnings multiple, strong financial position (a good balance sheet), and some degree of confidence that the earnings will be maintained going forward are also essential. For a stock to be a "true" bargain it must have an indicated value at least 50 percent greater than the market price as measured by two tests:

1. The appraisal method largely relies on estimating future earnings and multiplying it by a factor appropriate to the issue and industry.
2. The value of the business to a private owner pays more attention to the realizable value of the assets with particular emphasis on the net current assets or working capital.

Graham believed that market perceptions or inefficiencies created opportunities of undervaluation, usually caused by currently disappointing results, protracted neglect or unpopularity, or the market's failure to recognize a company's true earnings or asset picture. He also understood from the extreme overvaluations of radio and other emerging technology stocks in the late 1920s that (1) the obvious prospects for physical growth do not necessarily translate into obvious profits for investors, and (2) experts have no dependable way of selecting and concentrating on the most promising companies in the most promising industries. This is a lesson that bears repeating and has been most recently demonstrated in investment bubbles in biotechnology, computer and software related, and Internet stocks.

THE IMPORTANCE OF ANALYSIS

If you plan to hire professionals to direct and advise you about your investments, you might wonder why you need an understanding of

security analysis at all. There are many reasons to have at least some knowledge. Most important, you should have a grasp of security analysis in order to find out how much research your investment professional has done on the stock he or she is recommending. With a working background you will be able to know whether your investment advisors are doing a good job for you and presenting you with good ideas and suggestions. You will be able to judge for yourself whether their research is good or poor.

Some of you may find that you enjoy doing your own research. In fact, in recent years, so many individuals have chosen this route that the American Association of Individual Investors was founded and has grown to over 100,000 members, the vast majority of whom view security analysis and investments as their hobby and/or part-time business. Very reasonable software programs for fundamental and technical analysis are available from the AAII, some of which rival the most expensive trading programs.

FUNDAMENTAL VS. TECHNICAL ANALYSIS

At the outset, you need to understand the distinction between the two principal schools of thought that dominate security analysis— fundamental and technical analysis. *Fundamental analysis* looks to the fundamentals of a company—its earnings, sales, assets, liabilities, cash flow, and rate of return on equity, to name just a few. Fundamental security analysts believe that these factors are important in deciding whether a particular stock represents a buy, sell, or hold position. Most professional security analysts believe in and practice fundamental analysis, although different analysts place differing amounts of emphasis on particular ratios and factors.

Technical analysis, on the other hand, focuses less on the fundamentals of a particular company's stock and more on what the market action says is occurring. Technical analysts spend their time

studying price and volume movements and from these studies determine the direction a particular company's stock is going—up, down, or sideways. (Technical analysis is discussed in Chapter 11.)

As a final step in analyzing a company, many fundamental analysts consult the brokerage firm's technical analysts to learn their feelings about a particular stock's trading pattern and price prognosis. Fundamental analysis is generally used to discover an appropriate stock; technical analysis is used to determine the right time to invest in that stock. Because a substantial number of investors subscribe to technical theories and follow the advice of technical analysts, technical analysis does indeed have an impact on the marketplace, and can tend to move the market in exaggerated ways as more and more day traders and institutional money managers rely on computer-generated trading programs to instantly flash and execute buy and sell programs.

THE BASICS

To introduce you to fundamental analysis, let us divide the universe of public companies into two categories—asset plays and growth situations. (There are also hybrids of these forms.) This breakdown into categories helps determine whether more emphasis should be placed on analyzing the company's balance sheet or its income statement and which numerical ratios have the most significance for the company.

Asset (Value) Plays

What is an asset play? An asset play is simply a company whose assets significantly exceed its liabilities. In the case of a pure asset play, the company's current assets (cash, cash equivalents, marketable securities, inventories, and receivables) may be many times more than the company's current liabilities. A particular company

may also have hidden assets, including such items as undervalued real estate, marketable securities carried at cost rather than current value, valuable consumer franchises and brand names, saleable subsidiaries and divisions, and/or excess funding in a pension plan. The point of asset plays is to find an undervalued company that will be purchased by another at a price that will recognize the company's true value.

How do you analyze an asset play situation? To analyze an asset play situation, you should concentrate your attention and effort on the company's *balance sheet.* Try to determine if the parts are worth more than the whole. You then apply certain key ratios to the particular company's balance sheet to determine if its stock does, in fact, represent an asset play. Figure 10–1 can be used for this exercise.

The Balance Sheet A balance sheet presents a company's accounts on a specific date, usually the final business day of the quarter or the year. One side of the balance sheet describes the company's *assets*—the funds the company has—in order of liquidity, from liquid assets (cash and cash equivalents) to illiquid assets (plant and equipment—assets that cannot readily be converted to cash). The other side of the balance sheet lists the company's liabilities and net worth. The *liabilities*—the funds the company owes—are presented in the order in which they come due. *Net worth*—the funds *owned* by the company in excess of the funds *owed* by the company—is displayed as a balancing figure below liabilities. The two sides of a balance sheet must always equal even if a company is insolvent (liabilities exceed assets); the equalization is expressed as a negative net worth. At this point, you should refer to Figure 10–1 to familiarize yourself with a sample balance sheet.

Key Ratios *What key ratios are used to determine if a particular company and its stock represent an asset play?* The key ratios in making this determination are referred to as liquidity ratios and include the current ratio and the quick ratio. The *current ratio* is defined as current assets divided by current *liabilities.* (Current

Figure 10–1. Income Statement and Balance Sheet.

INCOME STATEMENT
FOR THE YEAR ENDED DECEMBER 31, 20XX
($000)

Net Sales		200
Cost of Goods Sold	150	
Depreciation	10	
Selling, General, and Administrative Expenses	20	
		180
Net Operating Profit		20
Other Expenses	3	
Interest Expense	3	
Income Taxes	4	
		10
Net Income		10

BALANCE SHEET
OF XYZ CORPORATION DECEMBER 31, 20XX

Assets		Liabilities	
Cash/Cash Equivalents	80	Accounts/Notes Payable	40
Accounts Receivable	40	Accrued Liabilities	30
Inventory	40	Current Portion,	
Current Assets	160	Long-Term Debt	10
Fixed Assets (Plant &			
Current Liabilities	80		
Equipment)	100		
Less: Depreciation	(70)	Long-Term Liabilities	
Net Fixed Assets	30	(Funded Debt)	40
Other Assets	10	Total Liabilities	120
Total Assets	200		
		Shareholder's Equity	
		Capital Stock	20
		Retained Earnings	60
		Net Worth—	
		Stockholder's Equity	80
		Total Liabilities & Net Worth	200

assets are those that can be converted into cash within one year or less, and current liabilities are those that must be paid within one year.) The current ratio is essentially a measure of liquidity and should be compared with the company's past pattern as well as to the pattern of the industry in which the company operates. A 2:1 ratio is the norm for most companies and industries, while a current asset ratio of 5:1 or more may signal that the company represents an asset play. *The higher the current asset ratio, the more appealing a company becomes to companies and individual investors seeking to make an acquisition.* Refer to the balance sheet in Figure 10–1; the *current ratio* would be calculated as follows:

$$\text{Current ratio} = \frac{\text{Current assets}}{\text{Current liabilities}}$$

$$= \frac{160}{80} = 2:1$$

Norm: 2:1

Another ratio used to determine whether a company represents an asset play is the quick ratio, also referred to as the acid-test ratio. This ratio represents an even more stringent measure of liquidity. The *quick ratio* is calculated by adding cash, cash equivalents (for example, marketable securities), and accounts receivable, and then dividing by current liabilities. (The ratio can also be arrived at by subtracting inventory from current assets and dividing by current liabilities as shown here.) Refer to the balance sheet in Figure 10–1; the quick ratio would be calculated as follows:

$$\text{Quick ratio} = \frac{\text{Cash} + \text{Cash equivalents} + \text{Receivables}}{\text{Current liabilities}}$$

or

$$\text{Quick ratio} = \frac{\text{Current assets} - \text{Inventory}}{\text{Current liabilities}}$$

$$\text{Quick ratio} = \frac{120}{80} = 1.5{:}1$$

Norm: 1:1

Note that inventory is excluded from the asset calculation because it is considered the least liquid asset and the most subject to manipulation by corporate management. A ratio of 1:1 is acceptable for most companies, assuming that year-to-year comparisons reveal positive trends.

Calculating the quick ratio (acid-test ratio) brings into focus those companies that represent asset plays. To the professional analyst or the merger and acquisition specialist, a high quick ratio means that the company should be examined more closely. Thus, the quick ratio serves as a *screening device* that a professional analyst can use to rapidly identify those companies worth more of the analyst's time and effort.

Analyzing Current Assets When examining a company's current assets, pay special attention to the category referred to as marketable securities. *Marketable securities* represent stocks or bonds the company is holding for investment purposes. This category is frequently a "burying place" for hidden assets, so whenever you see marketable securities carried on a company's balance sheet, you should determine whether the number shown represents *cost* or *market value.* In many instances, companies show on their balance sheet the cost value for securities purchased years ago. In such cases, the true worth of the company—the value of the parts as opposed to the whole—may be masked unless the analyst considers the *current value* of the marketable securities owned by the company.

The Annual Report The question of cost versus market value in the case of marketable securities brings home the impor-

tance of examining the footnotes to a company's Annual Report. Most professional securities analysts read a company's Annual Report *from the back to the front,* because most analysts feel that any problems the company has will be buried in the footnotes. The number of footnotes attached to a company's Annual Report may also give an analyst a feeling about the quality of the particular company's sales and earnings figures. Did the company make use of every accounting rule to improve its earnings picture? Generally, the more footnotes attached to an Annual Report, the more closely the numbers—and management's management of these numbers—must be examined. The analyst also needs to know whether the outside accountants who prepared the annual report issued a *qualified opinion,* that is, an opinion based on certain assumptions and representations. If the opinion issued by the accountants is a qualified one, what is the significance of these qualifications? Finally, as an individual investor, you should look to the company's 10K for a complete picture. The 10K is the financial report that the corporation must file each year with the SEC and is available for inspection through the SEC. It can be accessed on the SEC website "Edgar," which contains all required filings on publicly held companies and is a wealth of information including requiring reporting on changes of insiders' holdings and quarterly reports called 10-Q filings. The Annual Report released to stockholders is a shortened form of the 10K, but contains virtually all information required to be filed with the SEC. Many corporations simply package the 10K in a glossy cover with graphic highlights of the company's annual progress and a letter from management and mail it to shareholders as the Annual Report.

Receivables and Inventory Receivables and inventory are not heavily emphasized when analyzing asset plays. I discuss them here, however, because receivables and inventory have considerable significance as tools for gauging the health of a company.

Receivables represent the money owed to the company by its customers. Receivables are self-liquidating because a company's customers will pay the money they owe to the company within a short

period of time—60 to 90 days. The following key ratios are utilized in analyzing receivables:

$$\text{Receivables turnover} = \frac{\text{Net annual sales}}{\text{Average receivables}}$$

The average receivable is the figure at the beginning of the year plus the figure at year end, divided by two. For purposes of this example, assume that at year end December 31, 20xx, receivables amounted to 45.

$$\text{Receivables turnover} = \frac{200}{(40 + 45)/2} = \frac{200}{85/2}$$

$$= \frac{200}{42.5} = 4.7$$

$$\text{Average turnover period} = \frac{\text{Number of days in the year}}{\text{Receivable turnover}}$$

$$= \frac{365}{4.71} = 77.49$$

These calculations indicate that receivables are generally collected in about 77 days.

What information about the health and viability of a particular company can you as an individual investor determine from the average turnover period of receivables? Before you can draw any conclusion about the significance of this number, you must first compare it with the prior year's number. Look for the trend in receivables, that is, whether the company collects the money owed it by its customers in a progressively longer or shorter period of time. Second, compare the pattern of the particular company's aver-

age turnover period with that of other companies in the same industry. Finally, look at who the company's customers are, that is, the *quality* of a company's receivables.

After you have considered all the foregoing factors, you should be able to determine if the company is having difficulty collecting its receivables. Problems in the area of accounts receivable are usually the first signal of imminent financial and liquidity problems. In this case, you should make an effort to determine how serious or significant the problem is.

Inventories are another area that should be examined when determining the health of a company.

The key ratio in this area is as follows:

$$\text{Inventory turnover} = \frac{\text{Net sales}}{\text{Average inventory}}$$

For the purposes of this example, assume that at year end December 31, 20xx, inventory amounted to 50.

$$\text{Inventory turnover} = \frac{200}{(40 + 50)/2} = \frac{200}{90/2}$$

$$= \frac{200}{45} = 4.44$$

As with receivables, you must look at the year-to-year trend to gauge the significance of this ratio. In addition, this number has significance only when compared with the ratios of other companies in the same industry. What might be a normal inventory turnover figure for one industry may be extremely high or low for another. You should consider the range the figure falls into: Too low a figure may mean that the inventory is dated or obsolete (for example, a garment manufacturer with an inventory of double knits); too high a figure

could mean that the company is not maintaining an adequate inventory to meet the growth in sales and may be losing sales because it is unable to meet demand.

In summary, the importance of inventory and receivable figures depends on the nature of the industry in which the company engages. Both figures should be used to gauge a company's health.

Analyzing Noncurrent and Hidden Assets Besides identifying asset-play companies by the cash or cash equivalents on their balance sheets, you can also identify such companies on the basis of their noncurrent or "below-the-line" assets.

What specific noncurrent assets should you concentrate on? Real estate is probably the most important item in this category. When looking at the real estate a company owns, you should consider a number of factors. First, to what degree is the property the company owns fully depreciated on its balance sheet? If a company's plant and offices are fully depreciated, then they were purchased years ago, at prices that today would represent a bargain. The same analysis can apply to department store chains and other retail operations that may have very lucrative lease arrangements in effect. The presence of such fully depreciated real estate on a company's balance sheet warrants further research. A major change that has occurred since the last revision of this book is the ever-increasing value of intellectual property assets, i.e., patents, copyrights, trademarks, and copyrights on software programs. In the postindustrial knowledge-intensive society we are living in, these intangible assets have taken on ever-greater value and often surpass in economic value the combined tangible assets of many corporations, i.e., Microsoft.

What other types of hidden assets should you look for? Other items that can be categorized as "below-the-line" or hidden assets include undervalued divisions or subsidiaries, trade names or consumer franchises, excess funding in a pension plan, and treasury stock and/or repurchase programs.

GROWTH SITUATIONS

With an asset play you concentrate on analyzing a company's balance sheet, whereas growth situations require you to take apart the company's income statement. Before proceeding further, review Figure 10–1, concentrating on the items comprising the Income Statement for the Year Ended December 31, 20xx.

Unlike asset plays, in which the emphasis is placed on what the company owns—its assets—the analysis of growth situations is more difficult because you are attempting to look into the future. You must discern *trends in earnings and sales* and, based on past performance, forecast what the future will bring for a particular company. In analyzing growth situations you must get a "reading" on *management's ability to achieve its defined goals* rather than simply analyze balance sheet items such as cash, marketable securities, and real estate. To complicate matters, many growth companies are characterized by weak or poor balance sheets simply because the company is straining its asset base to meet the demand for its products or services. To decide whether a particular growth company is an appropriate investment, you must calculate the return on equity and total assets, the growth rate in dividends and earnings *(g)*, and the price-to-earnings ratio.

Analyzing Sales, Earnings, and General Expenses The trend in a company's sales, earnings, and expenses is a crucial factor in deciding whether the company and its stock represent a growth situation. The emphasis is placed on the word *trend:* A sharp rise in sales and/or earnings between one year and the next does not confirm such a conclusion; there must be a *pattern* of such year-to-year growth. Most professional analysts look for the *five-year trend* to confirm that the company does indeed represent a growth situation.

Another area to concentrate on is what professional analysts call the *bottom line*. A yearly increase in sales is significant only if it

is reflected as growth in the company's earnings; that is, sales increases should be reflected in the bottom line or earnings figures. In examining a company's earnings figures, look behind the numbers to determine if the improvement is the result of some unusual event or a change in accounting practice.

Changes in accounting methods can greatly affect the bottom line. For this reason, most professionals concentrate their attention on the number and complexity of the footnotes incorporated into the report. Generally, a large number of footnotes indicates that you should examine the company's figures more closely. Because corporate secrets are often hidden in the footnotes, you can obtain much useful information from them. Most security analysts spend time reading and evaluating the footnotes before they look at the text itself. This is a good example to follow, and you should spend time understanding the footnotes and considering their impact on your evaluation of the company.

The independent accountants' report is the starting point in examining the footnotes to a company's annual report. Any qualification is considered significant, and you should take time to analyze and understand it. Likewise, if the company frequently changes its outside accounting firm—referred to as opinion shopping—you should scrutinize its numbers more intensely.

Beyond the sales and earnings figures, you should look to the pattern of the company's general and administrative expenses. In many instances, a company is able to grow at a rapid pace until it reaches a plateau in earnings and sales. Such a plateau frequently occurs when companies lose control of their general and administrative expenses. The purchase of a corporate jet and other perks often spells problems for a growth company, particularly one in the start-up stage when every dollar of capital is needed in the business. Therefore, you should keep track of the trend of such expenses.

A listing of some of the key ratios applicable to the area of sales, earnings, and expenses and a description of their significance follows.

1. Gross profit margin $= \dfrac{\text{Gross profit}}{\text{Net sales}}$

An examination of a company's gross profit margin over time tells you how able the company is to maintain and hopefully expand its position in its industry. The gross profit margin should be compared with industry figures to determine how the company's margin compares with those of other companies in the same industry.

2. Operating profit margin $= \dfrac{\text{Operating profit}}{\text{Net sales}}$

Radical swings in a company's operating profit margin are generally a good indication of the volatility of a particular industry.

3. Net profit margin $= \dfrac{\text{Net Income}}{\text{Net sales}}$

The net profit margin tells you how well a company keeps its tax liabilities down. This number, too, should be compared with the industry norm to determine whether the company is more or less profitable than are other companies in the industry.

Management This factor is perhaps the most crucial and difficult to analyze in any growth situation, because management capability (or the lack of it) does not lend itself to numerical analysis. Unlike an asset-play situation, in which management may simply function in the role of a caretaker preserving corporate assets, most companies in a growth situation are made or broken on the capabilities of their managements. This is particularly true in high-tech industries, where management must react almost daily to changes and net developments.

How can an individual investor evaluate a company's management? The best way is to have a personal and working knowledge of the industry in which the company engages. For this reason, some of the best investment selections are made by individuals working in the industry. Many computer programmers and engineers, for exam-

ple, have invested successfully in computer and software companies with which they are familiar and with which they deal on a daily basis. If you don't have this familiarity with an industry, you should read whatever is available that describes the company's management, goals, objectives, and track record. It can be difficult to evaluate the management of a growth company. Annual reports and strong public relations efforts can often obfuscate the true results of management's intentions. If a company is popular with the press, it can take a good deal of research to find solid clues to the management's true performance.

Return on Stockholders' Equity Beyond sales and earnings figures and management capability, you should look at the return on stockholders' equity (total assets) to determine if the company indeed represents a growth situation. The following equation is used to calculate return on equity (ROE):

$$ROE = \frac{Sales}{Total\ assets} \times \frac{Total\ assets}{Equity} \times \frac{Income}{Sales}$$

$$ROE = \frac{Total\ asset\ turnover \times Financial\ leverage}{Net\ profit\ margin}$$

To understand what return on equity is all about, consider each component of the preceding equation. The three components of a company's return on equity are: (1) total asset turnover, (2) financial leverage, and (3) net profit margin. This clearly brings home the point that ROE can be improved by greater asset efficiency (turning assets over more rapidly), by altering the company's capital structure (increasing the amount of money borrowed), and/or by increasing the company's net profit margin (increasing productivity and/or changing the company's product mix). By determining the significance of each of these factors when figuring a particular company's ROE, you are now able to answer a number of questions: where the

company's growth is coming from (asset turnover, leverage, or profit margin), how the company's ROE compares with that of other companies in the same or similar industries, whether this pattern of growth will continue in the future, and what steps the company can take to improve its ROE.

Because the return on equity (ROE) is so significant in determining the merits of a growth situation, the following is an example of how ROE is calculated for a particular company. Refer to Figure 10–1 and to the items comprising the Income Statement for the Year Ended December 31, 20xx.

From the Income Statement, you can obtain the following information:

$$
\begin{aligned}
\text{Sales} &= 200 \\
\text{Total assets} &= 200 \\
\text{Equity} &= 80 \\
\text{Income} &= 10
\end{aligned}
$$

Fitting the given factors into the ROE equation, the ROE for this particular company is as follows:

$$
\text{ROE} = \frac{200}{200} \times \frac{200}{80} = \frac{10}{200}
$$

$$
\text{ROE} = \frac{10}{80} = 12.50
$$

Now that you have calculated the ROE, you are probably asking yourself what significance it has for your investment decisions. The ROE tells you how much a company is earning on the equity, that is, the capital, available to it. For a company (and the stock that represents it) to be considered a growth situation, it must have a high ROE compared with other companies, and the trend of its ROE should be stable and rising.

The Growth Rate The growth rate *(g)* of a company and hence the market price of its stock depend on two factors: *The rate of return (ROE)* that is earned on the equity retained in the business and *the amount of earnings retained in the business.* This second factor is frequently referred to as the retention rate or RR.

What does the retention rate represent and what does it tell you about a particular company's growth track? A company's board of directors decides how much of a company's earnings is retained in the business. For example, the company described in Figure 10–1 had earnings of 10. In a true growth situation, management might decide to retain the full amount (10) and hence the retention rate would be 100%. Retaining all or nearly all (80% to 90%) of a company's earnings indicates that management believes it can earn the most money for its shareholders by investing in the company itself.

The growth rate of our sample company would be calculated as follows:

$$g = \text{ROE} \times \text{RR}$$
$$g = 12.50 \times 1.00$$
$$g = 12.50$$

Again, you should consider the five-year trend in *g* rather than a single year's results.

Price/Earnings (P/E) Ratio The price-to-earnings (P/E) ratio is calculated as follows:

$$\text{P/E} = \frac{\text{Market price of the stock}}{\text{Latest 12 months' earnings per share}}$$

In the example, the company earned 10 in its latest 12 months. Let us assume that the company has 10 shares outstanding and that the market price of the stock is $40 per share. Therefore, the P/E ratio would be calculated as follows:

$$P/E = \frac{40}{1} = 40$$

What does a P/E ratio of 40 tell you about a particular stock? The P/E ratio tells you something only when it is compared with the P/E ratios of companies in the same or similar industries and with the P/E ratio of the overall market. Second, the P/E ratio of a particular stock has significance only when it is compared with its own P/E ratios for the past few years. You should consider the P/E ratio simply an expression of market sentiment toward a particular company and its stock—in no way so important as ROE or g in measuring the worth of a company.

Recent studies have been made comparing the historic market performance of high vs. low P/E stocks. These studies found that, on the whole, low P/E stocks (those typically selling at 10 or below) performed better in the marketplace than high P/E stocks (those selling at 30 and above). A number of reasons were given for these findings. First, high P/E stocks typically have a high proportion of institutional ownership and consequently are more volatile because institutions tend to move more rapidly in and out of individual stocks. Second, a high P/E ratio may mean that the market has already discounted future growth; that is, the price of the stock already reflects future growth in sales and earnings. The results of these studies show that the individual investor should be careful when investing in high P/E stocks because they are more volatile and may already discount future growth.

VALUE VS. GROWTH

It should be clear by now that security analysis combines elements of an art with the science of a skilled profession. While number crunching simply requires some basic mathematical skills of an objective nature, security analysis demands you make a number of

subjective judgments. Evaluating the capabilities of management and the future prospects for a particular industry or company requires subjective judgments about future economic trends and developments. Growth situations are more difficult to analyze than asset plays because in a growth situation you must look into the future rather than analyze the present.

There is considerable debate concerning the merits of asset investing—synonymously referred to for the purposes of this discussion as *value investing*—versus growth investing. A short hand definition might be that the growth investor looks to the return *on* his or her capital, whereas the value investor often looks to the degree of risk and the likelihood of the return *of* his or her capital.

The growth investor is seeking a high rate of return and is willing to accept the attendant risks for high performance. In recent years, growth has been ascendant over value investing and has returned substantially higher returns. Growth stocks reflect high expectations for future appreciation, typically selling at above average prices in relation to earnings, dividends, and book value and may reasonably be expected to continue to outperform the general market because:

1. *Creativity pays.* In the current period of expanding economic and technological growth, many of the most successful growth stocks are based on technological, scientific, or marketing innovations which tend to be less tangible, but potentially far more profitable than capital intensive assets such as mines and factories.

2. *Taxes matter* and fast growing companies pay virtually no dividends and most of the appreciation is in the form of capital gains. If held long term, capital gains are taxed at a maximum rate of 20% compared to dividends which are taxed at the investor's ordinary income rate with a maximum of 39.6%.

3. *Reliable results.* The best of the growth firms have proven track records of providing consistent solid earnings growth.

Investors like this and have been willing to pay high P/E ratios to own these stocks. Periods of low inflation and low interest rates make growth stocks even more desirable by raising the current value that investors place on projected future earnings. This can be a two-edged sword as investors will hastily punish any stock that fails to live up to expectations.

The fallacy herein is that high P/E ratios anticipate many years of future earnings growth, but the rate of innovation and corporate start-ups makes it unlikely that all of today's growth favorites will be able to maintain their leadership. Existing companies are not going to reap *all* the benefits of continued growth. Accordingly, investors tend to extrapolate too far into the future and be too pessimistic on value stocks. This tendency tends to put the value investor on the right side of the risk equation and it may viewed as a form of contrarian investing (going against the crowd). Simply, value stocks have already been beaten down and therefore have nowhere to go but up if they perform better than expected, and provide less risk of loss during volatile markets.

Value stocks are often considered out of favor and have below average prices based on their earnings, dividends, and book value, but value stocks do not always lag the market. While large cap value stocks have lagged the growth stocks in the S&P 500, the value stocks of the Russell 2500, which measure performance of the next 2,500 largest stocks after the 500 largest, outperformed growth over the three- and ten-year periods ended June 30, 1999, while during the same periods, growth was well ahead of value among the S&P 500.

Among the reasons to expect value investing to return to favor:

1. Stock markets tend to revert to long-term norms. Periods of unusually high returns tend to be followed by periods of subpar returns, not only for the entire market, but for segments within it.

2. Value stocks as a group generally trade at lower prices because investors have modest expectations of future growth, but long-range forecasts of corporate earnings are notoriously poor and with expectations low, value stocks can pleasantly surprise and enjoy price appreciation.

3. Dividends still count. Even at historically low dividend rates, the S&P 500's value stocks returned 2% higher dividend rates than the growth stocks. Even during the incredible ten-year bull run measured to September 20, 1998, dividends accounted for about 30% of the S&P 500's cumulative return of 393%. In periods of static or falling stock prices, dividends provide the only positive source of returns.

HYBRID FORMS

This area requires just a few comments. While most companies can be classified as either asset plays or growth situations, you may conclude after analyzing a company's balance sheet and income statement that it fits neither of these categories. In fact, the company may appear to possess traits of both categories. In this case, determine which of the two categories the company more nearly fits and apply those specific analytical tools in evaluating the investment merits of the company. The utilization of the tools discussed in this chapter should assist you in deciding whether the company warrants your investment.

OWNERSHIP: THE MISSING LINK

While I have discussed the normal way an analyst might approach the study of an annual report, for most practical purposes, virtually the same information can be obtained from concise stock reports such as those from Standard & Poor's (S&P), which are reprinted on the following pages.

Figure 10–2a. The S&P Report on General Electric (page 1)

STANDARD
&POOR'S
STOCK REPORTS

General Electric

NYSE Symbol **GE**

In S&P 500

23-JAN-99 | Industry: Electrical Equipment | **Summary:** GE's major businesses include aircraft engines, medical systems, power systems, broadcasting, appliances, lighting and financial services.

S&P Opinion: Hold (★★★)	Recent Price • 97⅞ 52 Wk Range • 104⅞-69	Yield • 1.4% 12-Mo. P/E • 35.0

Quantitative Evaluations

Outlook
(1 Lowest—5 Highest)
• **NA**

Fair Value
• **94¼**

Risk
• **Low**

Earn./Div. Rank
• **A+**

Technical Eval.
• **Bullish** since 10/98

Rel. Strength Rank
(1 Lowest—99 Highest)
• **63**

Insider Activity
• **Unfavorable**

Earnings vs. Previous Year
▲-Up ▼-Down ▶-No Change

2-for-1

10 Week Mov. Avg.
30 Week Mov. Avg.
Relative Strength

1995 1996 1997 1998

VOL. MIL.

OPTIONS: CBOE

Overview - 14-OCT-98

Revenues are expected to rise 10% in 1998 from those of 1997, reflecting favorable trends in aerospace and financial businesses, and a continued emphasis on international expansion, acquisitions, and on broadening of the aftermarket repair and services businesses. The focus on service will be most visible in the aircraft engine, medical equipment and power generation businesses. At the original equipment end of the business, aircraft engines will benefit from a sharp increase in market share. NBC is expected to grow earnings by 20%, even with the loss of Seinfeld and professional football broadcasts. Financial services should continue to expand at a 15% to 20% annual rate, aided by aggressive marketing and acquisitions. GE's consolidated earnings should benefit from improved margins on greater volume, improved manufacturing efficiencies, and strong cost control programs.

Valuation - 14-OCT-98

We are maintaining our hold recommendation on the shares, based on price. While this diversified powerhouse has long established itself as a well managed company that delivers consistent earnings growth, we think that the price of the stock has reached levels consistent with the company's financial performance. While we still view the shares as a core long-term holding, we think that they will only be average performers over the next year, as the company's earnings catch up to its premium valuation. Substantial share repurchases and a rising dividend will improve the value of the stock over time, but we would defer additional purchases until a more reasonable P/E is reached.

Key Stock Statistics

S&P EPS Est. 1999	3.20	Tang. Bk. Value/Share	4.83
P/E on S&P Est. 1999	30.6	Beta	1.10
Dividend Rate/Share	1.40	Shareholders	493,000
Shs. outstg. (M)	3276.8	Market cap. (B)	$320.7
Avg. daily vol. (M)	4.576	Inst. holdings	49%

Value of $10,000 invested 5 years ago: $ 41,179

Fiscal Year Ending Dec. 31

	1998	1997	1996	1995	1994	1993
Revenues (Million $)						
1Q	22,626	20,157	17,098	15,126	12,657	12,900
2Q	25,070	21,997	19,066	17,809	14,768	14,761
3Q	24,136	21,991	20,021	17,341	14,481	14,858
4Q	28,637	26,695	22,994	19,752	17,791	18,087
Yr.	100,469	90,840	79,179	70,028	60,108	60,562
Earnings Per Share ($)						
1Q	0.57	0.50	0.45	0.41	0.35	0.32
2Q	0.74	0.65	0.57	0.51	0.46	0.19
3Q	0.69	0.60	0.53	0.48	0.42	0.35
4Q	0.80	0.70	0.62	0.56	0.49	0.43
Yr.	2.80	2.46	2.20	1.93	1.73	1.29

Next earnings report expected: early April

Dividend Data (Dividends have been paid since 1899.)

Amount ($)	Date Decl.	Ex-Div. Date	Stock of Record	Payment Date
0.300	Feb. 13	Mar. 05	Mar. 09	Apr. 27 '98
0.300	Jun. 26	Jul. 06	Jul. 08	Jul. 27 '98
0.300	Sep. 11	Sep. 28	Sep. 30	Oct. 26 '98
0.350	Dec. 18	Dec. 29	Dec. 31	Jan. 25 '99

Used by permission of Standard & Poor's. All rights reserved.

184

Figure 10–2b. The S&P Report on General Electric (page 2)

General Electric Company

Business Summary - 14-OCT-98

This diverse company has the highest market capitalization of any public company. GE's interests include a broad range of services, technology and manufacturing industries. GE's senior management has proven adept at defining broad themes which lower level managers implement. Key to GE's business plan is the requirement that businesses be first or second in market share in their industries. Businesses that aren't leaders are divested.

Six themes are currently being pursued: quality, globalization, service, information technology and consumer wealth accumulation and protection. Quality involves a company-wide initiative to boost quality and lower costs. The company believes that this should boost margins in 1998 and beyond as hundreds of projects underway mature. Globalization is the pursuit of rapid growth in overseas markets. Already more than 40% of GE's revenues (including exports) and 32% of profits are derived overseas. Service aims to capture a larger part of the recurring revenue stream tied to aftermarket service of manufactured products. This strategy is having the largest impact on aircraft engines, medical equipment, power generation and locomotives. Information technology is developing information services units such as GE's media and satellite leasing businesses, as well as applying information technology

in all units to improve their competitiveness. Consumer wealth accumulation addresses the growing demand for financial, insurance, health care and other needs of aging baby boomers.

Segment contributions in 1997 (profits in million $):

	Revs.	Profits
Aircraft engines	8.3%	$1,051
Appliances	7.1%	458
Broadcasting	5.5%	1,002
Industrial products & systems	11.6%	1,490
Materials	7.1%	1,476
Power generation	7.9%	758
Technical products/services	5.2%	828
Financial services	42.3%	4,422
Other	5.0%	3,558

Operations are divided into two groups: product, service and media businesses and GE Capital Services (GECS). Product, service and media includes 11 businesses: aircraft engines, appliances, lighting, medical systems, NBC, plastics, power systems, electrical distribution and control, information services, motors and industrial systems, and transportation systems. GECS operates 27 financial businesses clustered in equipment management, specialty insurance, consumer services, specialized financing and mid-market financing.

Per Share Data ($)

(Year Ended Dec. 31)	1998	1997	1996	1995	1994	1993	1992	1991	1990	1989
Tangible Bk. Val.	NA	4.69	4.09	4.88	4.40	4.53	4.08	3.44	3.54	3.33
Cash Flow	NA	3.67	3.35	3.02	2.67	2.25	2.08	2.09	1.92	1.71
Earnings	2.80	2.46	2.20	1.95	1.73	1.29	1.25	1.27	1.21	1.09
Dividends	1.20	1.08	0.95	0.84	0.74	0.63	0.58	0.52	0.48	0.42
Payout Ratio	43%	44%	43%	43%	43%	38%	46%	41%	39%	39%
Prices - High	103⅛	76½	53⅛	36⅝	27½	26⅝	21⅞	19½	18⅛	16¼
- Low	69	48	34⅜	25	22½	20¼	18¼	13¼	12½	10⅞
P/E Ratio - High	37	31	24	19	16	21	17	15	16	15
- Low	25	19	16	13	13	16	14	10	10	10

Income Statement Analysis (Million $)

Revs.	NA	90,840	79,179	70,028	59,316	59,827	56,274	59,379	57,662	53,884
Oper. Inc.	NA	NA	22,764	20,821	18,194	16,241	15,205	15,887	15,377	13,944
Depr.	NA	4,082	3,785	3,594	3,207	3,261	2,818	2,832	2,508	2,256
Int. Exp.	NA	8,384	7,904	7,327	5,024	7,057	6,943	7,504	7,544	6,812
Pretax Inc.	NA	11,419	10,806	9,737	8,831	6,726	6,328	6,508	6,229	5,787
Eff. Tax Rate	NA	26%	33%	33%	31%	32%	31%	31%	30%	31%
Net Inc.	NA	8,203	7,280	6,573	5,915	4,424	4,305	4,435	4,303	3,939

Balance Sheet & Other Fin. Data (Million $)

Cash	NA	5,861	64,080	43,890	33,556	3,218	3,129	1,971	1,975	2,258
Curr. Assets	NA	NA	NA	NA	NA	NA	NA	NA	NA	NA
Total Assets	NA	304,012	272,402	228,035	194,484	251,506	192,876	168,259	153,884	128,344
Curr. Liab.	NA	NA	NA	82,001	72,854	155,729	120,475	102,611	93,022	73,902
LT Debt	NA	46,603	49,246	51,027	36,979	28,270	25,376	22,602	21,043	16,110
Common Eqty	NA	34,438	31,125	29,609	26,387	25,824	23,459	21,683	21,680	20,890
Total Cap.	NA	93,374	91,651	90,972	70,418	60,859	54,719	49,392	47,746	41,544
Cap. Exp.	NA	8,388	7,285	6,447	7,492	4,739	4,824	5,000	4,523	5,474
Cash Flow	NA	12,285	11,065	10,162	9,122	7,685	7,123	7,267	6,811	6,195
Curr. Ratio	NA	NA	NA	NA	NA	NA	NA	NA	NA	NA
% LT Debt of Cap.	NA	50.0	53.7	56.1	52.5	46.5	46.4	45.9	44.1	38.8
% Net Inc.of Revs.	NA	9.0	9.2	9.4	10.0	7.4	7.7	7.5	7.5	7.3
% Ret. on Assets	NA	2.8	2.9	3.2	2.7	2.0	2.4	2.8	3.1	3.3
% Ret. on Equity	NA	25.0	24.0	23.5	22.7	18.0	19.2	20.6	20.6	20.0

Data as orig reptd.; bef. results of disc opers/spec. items. Per share data adj. for stk. divs. Bold denotes diluted EPS (FASB 128)-prior periods restated. E-Estimated. NA-Not Available. NM-Not Meaningful. NR-Not Ranked.

Office—3135 Easton Turnpike, Fairfield, CT 06431. Tel—(203) 373-2211. Website—http://www.ge.com Chrmn & CEO—J. F. Welch Jr. VP & Secy—B. W. Heineman Jr. SVP-Fin & CFO—D. D. Dammerman. Investor Contact—Mark L. Vachon (203-373-2816). Dirs—D. W. Calloway, J. I. Cash, Jr., S. S. Cathcart, D. D. Dammerman, P. Fresco, C. X. Gonzalez, G. G. Michelson, E. F. Murphy, S. Nunn, J. D. Opie, R. S. Penske, B. S. Preiskel, F. H. T. Rhodes, A. C. Sigler, D. A. Warner III, J. F. Welch Jr. Transfer Agent & Registrar—Bank of New York, NYC. Incorporated—in New York in 1892. Empl— 239,000. S&P Analyst: Robert E. Friedman, CPA

185

Figure 10–3a. The S&P Report on Northern Technologies International (page 1)

Northern Technologies Int'l

ASE Symbol **NTI**

23-JAN-99

Industry: Manufacturing (Specialized)

Summary: NTI makes corrosion-inhibiting products, used mostly as protective packaging, and sensing instruments that measure changes in dielectric properties of liquids and fibers.

Quantitative Evaluations		
Recent Price • 5⅞	Yield • 2.6%	
52 Wk Range • 9⅛-5	12-Mo. P/E • 9.2	

Outlook (1 Lowest—5 Highest)
• NA

Fair Value
• NA

Risk
• High

Earn./Div. Rank
• B+

Technical Eval.
• Bullish since 10/98

Rel. Strength Rank (1 Lowest—99 Highest)
• 33

Insider Activity
• Favorable

Earnings vs. Previous Year
▲=Up ▼=Down ▶=No Change

10 Week Mov. Avg. – –
30 Week Mov. Avg. ····
Relative Strength —–

Business Profile - 14-DEC-98

Although sales improved in FY 98 (Aug.), the gain did not translate to the bottom line. Results have been hurt by lower net earnings from joint ventures in foreign countries, due to the strengthening U.S. dollar and lower sales volumes at certain Pacific Rim operations. NTI added three new joint ventures in FY 98 and expects to continue to expand its joint venture program to other foreign countries in the future. Changes in the product mix reduced gross margins in the past year, but management anticipates that NTI's gross margins in FY 99 will not vary significantly under the company's current pricing structure.

Operational Review - 14-DEC-98

Sales rose 15% in the fiscal year ended August 31, 1998, on increased sales of corrosion inhibiting products to new and existing customers. Despite a less favorable product mix, profitability improved on a decrease in personnel related expenses and well controlled research costs; operating income climbed 61%. However, comparisons were hurt by a reduction in joint venture income and fees due to negative currency translations and the economic downturn in the Pacific Rim region. Following lower interest and other income, and taxes at 33.5%, versus 31.5%, net income was essentially unchanged at $2,619,315 ($0.63 per share, on 2.7% fewer shares), from $2,615,848 ($0.61).

Stock Performance - 22-JAN-99

In the past 30 trading days, NTI's shares have increased 2%, compared to a 5% rise in the S&P 500. Average trading volume for the past five days was 6,500 shares, compared with the 40-day moving average of 5,857 shares.

Key Stock Statistics

Dividend Rate/Share	0.15	Shareholders	600
Shs. outstg. (M)	3.8	Market cap. (B)	$0.023
Avg. daily vol. (M)	0.005	Inst. holdings	11%
Tang. Bk. Value/Share	2.31		
Beta	0.83		

Value of $10,000 invested 5 years ago: $ 22,529

Fiscal Year Ending Aug. 31

	1999	1998	1997	1996	1995	1994
Revenues (Million $)						
1Q	2.16	2.68	1.92	1.62	1.35	1.18
2Q	—	2.53	2.09	1.61	1.64	1.05
3Q	—	2.61	2.52	1.75	1.81	1.36
4Q	—	2.26	2.20	1.89	1.42	1.31
Yr.	—	10 08	8.73	6 87	6.21	4.91
Earnings Per Share ($)						
1Q	0.14	0.13	0.12	0.10	0 08	0.06
2Q	—	0.13	0.13	0.10	0.12	0.05
3Q	—	0.17	0.17	0.12	0.12	0.08
4Q	—	0.20	0.19	0.17	0.10	0.11
Yr.	—	0.63	0.61	0.49	0.42	0.30

Next earnings report expected: mid April

Dividend Data (Dividends have been paid since 1989.)

Amount ($)	Date Decl.	Ex-Div. Date	Stock of Record	Payment Date
0.150	Nov. 24	Dec. 02	Dec. 04	Dec. 18 '98
0.075	Oct. 29	Dec. 02	Dec. 04	Dec. 31 '98

Figure 10–3b. The S&P Report on Northern Technologies International (page 2)

Northern Technologies International Corporation

Business Summary - 14-DEC-98

Northern Technologies International Corp. develops, makes and markets corrosion-inhibiting products used primarily as protective packaging. The company also makes electronic sensing instruments that measure changes in dielectric properties of different liquids and fibers.

Corrosion-inhibiting products, marketed under the ZERUST name, are used in protective packaging servicing a wide variety of industries, such as transportation, nuclear power, electronics, aerospace, power generation, on and off-road automotive equipment, agricultural and metal processing; most are manufactured to customer specifications. Products include corrosion-inhibiting packaging films; chipboard, fiberboard and corrugated cartons; dunnage trays and bins; bubble cushioning and foamsheet; reinforced plastic scrim; corrugated and profile plastics; and pellets, tablets and capsules. Sales of ZERUST products accounted for 98% of total sales in FY 98 (Aug.).

All of the company's corrosion-inhibiting products utilize chemical formulations that emit an invisible and nontoxic vapor that is protective to metal surfaces. The emitted corrosion-inhibiting molecules, which diffuse throughout an enclosed air space saturating the atmosphere of the enclosure, are deposited on surfaces, and prevent humid and polluted atmospheres from initiating corrosion of the surfaces.

Electronic sensing instruments, which are based on the measurement of the change in dielectric properties of different liquids and fibers by means of capacitance sensors, include portable oil quality analyzers for on-site evaluation of oil and fluids, and instruments that provide for on- and off-line measurements of fiber denier and critical tubing measurements.

NTI also participates in a number of international joint-venture arrangements that manufacture, market and distribute corrosion-inhibiting products. Northern manufactures and supplies the proprietary ingredient that makes the finished product functional, although the actual manufacturing of the finished products takes place in the foreign country. During FY 98, the company formed ventures in three additional countries -- Poland, Indonesia and Thailand. Since 1987, NTI has formed joint ventures in 16 different countries in Europe, Asia and South America. In addition, during FY 98, the company made an investment in Ghana Development Fund Ltd., an entity formed to explore business opportunities in West Africa. Fees earned under licenses and technical support agreements with the joint ventures contributed significantly to results. Fees earned were $1.9 million and $2.2 million in FY 98 and FY 97, respectively. The decrease was attributable to negative currency translations and poor economic conditions in the Pacific Rim.

Products are marketed principally in the U.S. to industrial users by a direct sales force and through a network of distributors and sales representatives. Although one customer accounted for more than 10% of net sales in FY 96, o ne customer did represent approximately 16% and 14% of net sales in FY 98 and FY 97.

Per Share Data ($)

(Year Ended Aug. 31)	1998	1997	1996	1995	1994	1993	1992	1991	1990	1989
Tangible Bk. Val.	2.31	2.40	1.98	1.46	1.17	1.05	0.81	0.54	0.39	NA
Cash Flow	0.66	0.64	0.51	0.44	0.32	0.30	0.28	0.20	0.14	NA
Earnings	0.63	0.61	0.49	0.42	0.30	0.29	0.27	0.19	0.12	NA
Dividends	0.30	0.12	0.10	0.08	0.06	0.05	0.05	0.04	0.02	NA
Payout Ratio	48%	20%	20%	19%	20%	17%	19%	18%	12%	NA
Prices - High	10¾	12¾	7	8⅛	6⅜	3⅜	4	NA	NA	NA
- Low	5	5⅛	4¾	3¼	2⅜	2½	1⅞	NA	NA	NA
P/E Ratio - High	17	21	14	21	21	13	15	NA	NA	NA
- Low	8	9	10	8	8	9	7	NA	NA	NA

Income Statement Analysis (Million $)

Revs.	10.1	8.7	6.9	6.2	4.9	4.0	3.8	3.4	3.1	NA
Oper. Inc.	1.5	0.8	0.9	0.9	0.9	0.7	0.5	0.7	0.6	NA
Depr.	0.1	0.1	0.1	0.1	0.1	0.1	0.1	0.1	0.1	NA
Int. Exp.	Nil	Nil	Nil	Nil	Nil	Nil	Nil	Nil	0.0	NA
Pretax Inc.	3.9	3.8	3.2	2.7	1.8	1.3	1.1	1.2	0.8	NA
Eff. Tax Rate	34%	32%	34%	31%	30%	1.60%	2.20%	33%	37%	NA
Net Inc.	2.6	2.6	2.1	1.8	1.3	1.2	1.1	0.8	0.5	NA

Balance Sheet & Other Fin. Data (Million $)

Cash	2.2	3.9	3.7	2.8	2.2	2.3	1.6	1.2	0.8	NA
Curr. Assets	4.9	6.8	6.2	4.8	3.7	3.6	2.9	2.2	1.7	NA
Total Assets	9.3	11.2	9.3	6.8	5.4	4.6	3.7	2.9	2.1	NA
Curr. Liab.	0.3	1.0	0.9	0.5	0.4	0.2	0.2	0.3	0.5	NA
LT Debt	Nil	Nil	Nil	Nil	Nil	Nil	Nil	Nil	Nil	NA
Common Eqty.	8.9	10.1	8.3	6.2	5.0	4.4	3.4	2.3	1.6	NA
Total Cap.	8.9	10.1	8.3	6.2	5.0	4.4	3.4	2.3	1.6	NA
Cap. Exp.	0.1	0.1	0.7	0.1	0.2	0.1	0.0	0.0	0.0	NA
Cash Flow	2.7	2.7	2.2	1.9	1.3	1.3	1.2	0.9	0.6	NA
Curr. Ratio	14.2	7.1	6.8	9.2	9.7	21.7	12.2	7.7	3.6	NA
% LT Debt of Cap.	Nil	Nil	Nil	Nil	Nil	NM	NM	NM	NM	NA
% Net Inc.of Revs.	26.0	30.0	30.4	29.6	25.9	30.6	29.8	23.6	15.9	NA
% Ret. on Assets	25.5	25.5	25.9	30.2	25.4	29.6	34.7	32.0	NA	NA
% Ret. on Equity	27.6	28.4	28.8	33.0	27.1	31.4	39.6	40.2	NA	NA

Data as orig reptd.; bef. results of disc opers/spec. items. Per share data adj. for stk. divs. Bold denotes diluted EPS (FASB 128)-prior periods restated. E-Estimated. NA-Not Available. NM-Not Meaningful. NR-Not Ranked.

Office—6880 N. Highway 49, Lino Lakes, MN 55014. Tel—(612) 784-1250. Chrmn & Co-CEO—P. M. Lynch. Pres & Co-CEO—V. J. Graziano. CFO & Secy—L. M. Ehrmanntraut Dirs—S. Dworkin, V. J. Graziano, G. Hahn, D. A. Kubik, R. G. Lareau, P. M. Lynch, H. Rikuta, M.R. Vukcevich. Transfer Agent & Registrar—Norwest Bank Minnesota, South St. Paul. Incorporated—in Minnesota in 1970. Empl—22. S&P Analyst: J.W.H.

Case Study: General Electric and Northern Technologies International

As you can see from Figures 10–2a and 10–2b, virtually all the statistical information needed to analyze a company can be obtained from this report, including an outside analysis of the business. Calculations, however, in the General Electric example, are complicated by the lack of information on current assets.

Take a few moments to compare Figures 10–2a and 10–2b with Figures 10–3a and 10–3b that follow. Pay particular attention to the small boxes under the graphs labeled Key Stock Statistics.

I chose these two companies as comparative examples because of their similarities and the extremes. General Electric is the world's largest industrial company with a market capitalization in excess of 320 *billion* dollars and nearly 3.3 billion shares outstanding, whereas Northern Technologies has a mere 3.8 million shares outstanding and market capitalization of approximately 28.5 *million* dollars. Yet despite these extremes in valuation, on the basis of fundamentals, they are remarkably similar, with the statistical edge going to Northern Technologies.

By virtually every measure of fundamental analysis, Northern Technologies represents better value than General Electric. GE sells above 100 with a tangible book value of less than 5 dollars, in excess of a 20 to 1 price-to-book ratio, whereas Northern Technologies is trading at a 3.5 price-to-book ratio. Examine the years 1992 through 1997, the last year for which comparable figures are available, and you will note further discrepancies. During this six-year period, the tangible book value of Northern Technologies grew at a considerably faster rate than GE. During this period, both companies grew their revenues in excess of a 15% annual rate and the rate of net income growth was approximately the same. Yet in looking at the balance sheet, the most glaring discrepancies in valuation are obvious in examining the long-term debt, and the percentages of net income of revenues, return on assets, and return on equity. Northern

Technologies has no long-term debt, while GE's long-term debt is equal to 50% of its capitalization. Where GE's current ratio cannot be calculated, Northern Technologies shows an extraordinarily high 7.1 current ratio; in other words, it has current assets seven times its current liabilities. Both companies show approximately the same percentage return on equity, with a slight edge to Northern Technologies. GE has had a fairly consistent dividend payout ratio, while Northern Technologies is showing a rising payout ratio. The most glaring differences are the percentage net income of revenues and the percentage return on assets where the imbalance clearly favors Northern Technologies, indicating a greater degree of efficiency. Adding insult to injury, Northern Technologies is trading at a lowly trailing 12-month price earnings ratio of 9.2, while GE trades at a lofty 35 price earnings ratio.

By every normal standard of fundamental valuation, Northern Technologies appears to be a better fundamental value than GE, and it may well be, yet $10,000 invested five years ago in each company would have grown to $41,200 for GE compared with $22,500 for Northern Technologies. You may rightly ask "What accounts for this difference in return?"

The answer may well lie in the one area I have not yet discussed: the nature and evaluation of the company's ownership. Most security analysts emphasize the question of who owns the company's stock. Owners fit into any of three categories: *insiders* (corporate officers and directors), *institutions* (mutual funds, pension plans, and bank trust accounts), and *individual investors.*

To determine who the major holders or "players" are, you should calculate the stock's float. The *float* focuses on individuals who have significant holdings of the stock in question. The outstanding shares is a statistic that would definitely have an impact on an analyst's evaluation of the company. Where much of the stock is closely held, a takeover without management's cooperation is unlikely. Northern Technologies has a very "thin" float (relatively few shares outstanding) and a small number of shareholders with

only 11 percent held by institutions. The small capitalization makes the stock of little interest to institutions because they are unable to place a significant amount of money into the shares without driving up the price and accordingly the stock trades at a beta of .83, meaning that the stock price tends to be approximately 20 percent less volatile than the overall market. GE, on the other hand, is an institutional favorite in virtually every large cap manager's portfolio and trades at a beta of 1.1, or slightly more volatile than the overall market, but closely tracking it.

Typically the questions asked by buy side analysts include: (1) What will be the company's future growth pattern (assuming that the company's family ownership makes sale or liquidation unlikely)? (2) What do institutions see in the company's future prospects that warrants their substantial holdings of its common stock? (3) What price determines whether the stock is cheap compared with future prospects (its risk/reward ratio)?

Also, institutions have historically proven to be more fickle than the average investor, liquidating positions at the first sign of a downturn in quarterly earnings. Stocks discovered by institutional investors tend to sell at high price-to-earnings ratios (P/Es), making them more vulnerable to shifts in investor sentiment.

CONCLUSION

In review, it is important to remember the following:

1. When examining growth stocks, you are more dependent on the projection of future earnings and more possibility of serious miscalculation of error.
2. Among the factors affecting capitalization rate are:
 - general long-term prospects
 - management
 - financial strength and capital structure

- dividend record
- current dividend rate

3. The purpose of fundamental analysis is:
 - the orderly comprehensive and critical analysis of a company's income and balance sheet
 - the formulation of appropriate criteria for selection of well-protected bonds and preferred stocks
 - an approach to selection of common stock for investment purposes

Remember that asset situations concentrate on a company's balance sheet, whereas growth situations emphasize the income statement. Asset situations are easier to analyze because they call for more objective judgments and rely on numbers and "number crunching" rather than on the evaluation of a company's management and the inherent subjective aspect of any such appraisal. What both asset-plays and growth situations have in common is that they require investors to be consistent and logical in their approach to investing.

A FINAL NOTE

It is the long prevalent view that the fundamental investor first chooses the industry to invest in and then selects the best stocks within that industry. It is an old and sound principle of investing that if you cannot financially or emotionally afford to take risks, then you should be content with a relatively low yield on invested funds. It is also prudent to adequately, but not excessively, diversify your investment assets.

Technical

Analysis

The material in this chapter is divided into two parts. The first deals with the basics of technical analysis. While the vast majority of this material can now be retrieved mechanically, it is still necessary to know how and why technical analysis is used. The latter part of this chapter will describe various other technical and sentiment indicators that are regularly published and can provide quick resources for the individual investor.

BASIC CONCEPTS OF TECHNICAL TRADING

Fundamental analysis focuses on the supply and demand factors underlying price movements, and this approach is therefore said to study the *causes* of price movements. By contrast, technical analysis studies the *effects* of supply and demand—that is, the price movements themselves. In fact, technical analysis is also called *charting* since it is essentially the charting of actual price changes as they occur. The charting approach reflects the basic assumption of the technician that all influences on market action—from natural catastrophes to trading psychology—are automatically accounted for, or discounted, in price activity.

Given this premise, charting can be used for at least three purposes:

1. *Price Forecasting:* The technician can project price movements either in tandem with a fundamental approach or solely on the basis of charted movements.

2. *Market Timing:* Chart analysis is much better suited than the fundamental approach for determining exactly *when* to buy and sell.

3. *Leading Indicator:* If market action discounts all influences on it, then price movement may be considered as a leading indicator, and it may be used in two ways. First, the chartist may— without regard for why prices are moving in one direction or the other—buy or sell. Second, an unusual price movement can be taken as a signal that some influence or another on the market has not been accounted for in the fundamentalist's analysis and that further study is required.

The technician uses two working assumptions: (1) Markets move in trends, and (2) trends persist. The reasoning is that if market action discounts all influences, then prices move not randomly, but in trends. Identifying the trend at an early enough stage enables the trader to take the appropriate positions. The tool used to track price movements and thus to identify trends is the chart.

It is said that a picture is worth a thousand words. That is the thinking behind the use of the price charts. While an analyst could make lists of prices and study them, nothing makes trends and changes in them clearer than the chart. Although charts make past price movement clearer, there are many ways in which to interpret a chart for future price movement. This is why technical analysis may seem on the surface to be a very scientific endeavor. The tools that are used and how they are used reveal the subjective and "art" side of this method of analysis.

Two basic types of charts are available to the technician: the bar chart (Figure 11–1) and the point and figure chart (Figure 11–2). The bar chart is more common and has in it the element of time. The point and figure chart looks only at prices.

BAR CHARTS

A bar chart can be easily constructed on a graph that has a vertical and a horizontal axis. See Figure 11–3. The prices lie on the vertical axis within a range of the historical market price. It is important to include all relevant price increments. For a chart that covers daily or intraday movement, the smallest price increments need to be included. Longer term charts, however, can get bogged down in this detail.

The horizontal axis covers time. Here the investor has a choice. Most investors follow prices on a daily basis. This time length is important for following short-term trends. For long periods of time, such as five years, a weekly chart is probably more fitting. Weekly charts are used by those who are looking at longer term trends.

The bar chart includes the high, low, and the closing prices for the length of time covered. The high and low are represented by a vertical line, and the closing price is a hash mark or horizontal tic to the right of the bar. (A tic on the left side of the bar marks the opening price for the day.)

While you can create these charts yourself, it is possible to purchase charts ready-made or use a personal computer to capture the prices and create the charts. With so many chart services available, however, plotting one's own charts is often an unnecessary and unprofitable way to spend time.

TRADE AND TREND LINES

A trend is a series of price changes that collectively moves in one direction or another. An *uptrend* is a series of peaks and troughs that

Figure 11–1. A Bar Chart.

Figure 11–2. A Point and Figure (P&F) Chart.

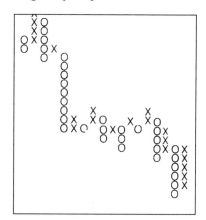

Figure 11–3. How a Bar Chart Is Constructed.

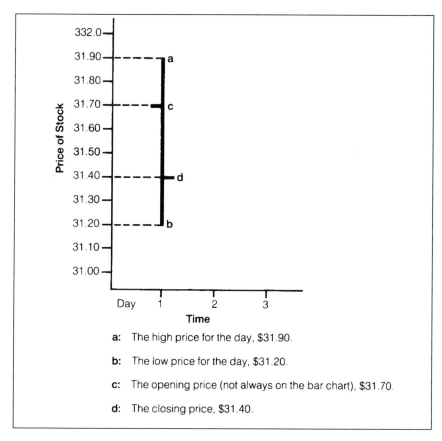

a: The high price for the day, $31.90.

b: The low price for the day, $31.20.

c: The opening price (not always on the bar chart), $31.70.

d: The closing price, $31.40.

rises on average. (See Figure 11–4.) A *downtrend* is a series that declines. (See Figure 11–5.) A series of price fluctuations that neither rises nor falls is *trendless,* and the market is said to be moving *sideways* or *horizontally.* (See Figure 11–6.)

Figure 11–4. An Uptrend.

Figure 11–5. A Downtrend.

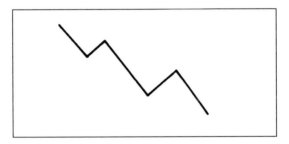

Figure 11–6. A Sideways, or Horizontal, Trend.

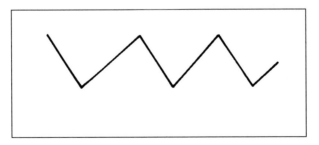

Trends are commonly classified according to their duration:

- *Secondary* trends last for one to three months.
- *Minor* trends persist for a few weeks or less.

On a bar chart, a trend is identified by drawing a *trend line,* which is a straight line connecting two or more successive high or low points in a series of price movements. An *uptrend line,* which rises from left to right, connects two or more low points so that all of the price activity is above the line. (See Figure 11-7.) A *downtrend line,* declining from left to right, connects two or more high points so as to keep all the movements below the line. (See Figure 11-8.)

Although either type of trend line can be drawn using only two points, at least one more point is needed to validate the trendlines. In Figure 11-7, for example, the major uptrend line is validated at points 1, 3, and 5. In Figure 11-8, the downtrend line is similarly validated.

Figure 11-7. An Uptrend and Channel Line.

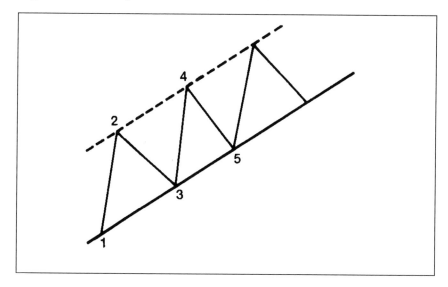

Figure 11–8. A Downtrend and Channel Line.

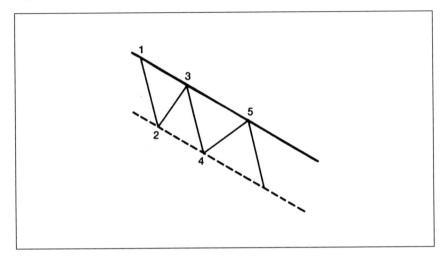

CHANNEL LINES

Sometimes prices trend within a clear-cut range between the main trend line and another parallel line, called a *channel* or *return* line. In an uptrend, the channel runs below the price activity and parallel to the uptrend line. (See Figure 11–9.) In a declining market, the channel runs above the price activity and parallel to the downtrend line.

The identification of both a trend line and channel is a potentially profitable piece of information. With it, the technician has advance notice of turning points in market price. In Figure 11–10, for example, points 2 and 4 would represent good buying prices, while points 1, 3, and 5 are good selling levels. Even when prices move outside the channel, the chartist can profit, since once a breakout occurs, prices typically travel a distance equal to the width of the channel. Once a breakout occurs, the chart user can measure the width of the channel and project that distance from the point of the breakout to calculate a buying or selling point. In Figure 11–10, after an upward breakout, prices are likely to move to point 7 before changing direction.

Figure 11–9. An Uptrend, Channel Line, and Breakout.

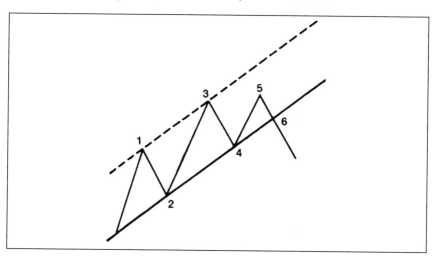

Figure 11–10. An Uptrend with an Upward Breakout.

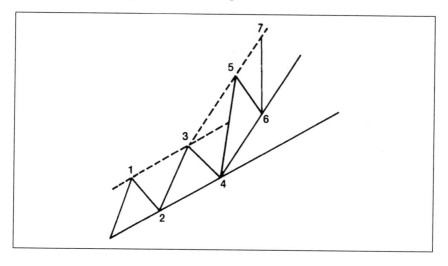

Trend lines and channel lines are two of the technician's simplest tools.

RETRACEMENT

In the course of any trend, prices will *countertrend;* that is, they move back against a portion of the current trend before resuming the original direction. These temporary countertrends are called *retracements.*

KEY REVERSAL DAY

Any day on which the market reverses is a potential key reversal day, also known as a *top/bottom reversal day* or *buying/selling climax.* (See Figures 11–11 and 11–12.) When does a reversal day become key? In an uptrend, a *top reversal* is a day on which a new high is established but the market closes lower than on the day before. In a *bottom reversal,* a new low in the downtrend is set but the market closes higher than on the prior day. In either case, volume is usually heavy. Also, if the high and low on the reversal day exceed the range of the previous day, forming what is known as an outside day, the reversal carries more weight. In many cases, however, a true key reversal day cannot be positively identified until long after prices have moved significantly past it.

Figure 11–11. A Key Reversal Day in an Uptrend.

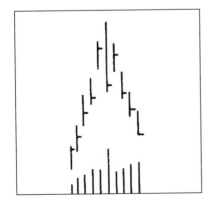

Figure 11–12. A Key Reversal Day in a Downtrend.

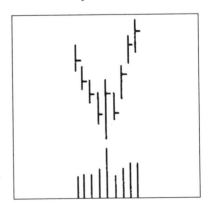

Sometimes a reversal takes two days to form and is called, appropriately, a *two-day reversal.*

PRICE GAPS

A *gap* is an area on a chart where no trading takes place. In an uptrend, the present day's low is higher than the previous day's high. The converse applies in a downtrend. (See Figures 11–13 and 11–14.)

There are four general types of gaps:

1. The *common gap,* the least important in charting, occurs in thinly traded markets or in the middle of horizontal trading ranges. Generally ignored by technicians, it reflects merely a lack of trading interest.

2. The *breakaway gap* usually occurs at the completion of an important price pattern on heavy volume and may signal the start of a significant market move. This gap is generally not completely filled by trading on ensuing days. In fact, the upper side of the gap often acts as a support level for subsequent trading. ("Support" is explained in the next section.) (See Figure 11–15.)

3. A *runaway gap* occurs on moderate volume, with the market trending effortlessly. It is a sign of strength in an uptrend but one of weakness in a downtrend. A move below a runaway gap in an uptrend is a negative sign. Like the breakaway, this type of gap is usually not filled.

 This information is also called a *measuring gap* because it commonly occurs about halfway through a trend. The distance from the beginning of the trend to the gap is the probable extent of the trend from the gap to its completion.

4. The *exhaustion gap* appears near the end of a market move, after all objectives have been achieved and after breakaway and runaway gaps have been identified. It is the "last gasp," so to speak, of the trend. When prices close under the last gap, the chartist can be quite sure that the exhaustion gap has made its appearance.

Figure 11–13. A Gap in an Uptrend.

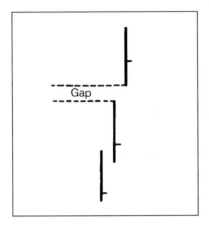

Figure 11–14. A Gap in a Downtrend.

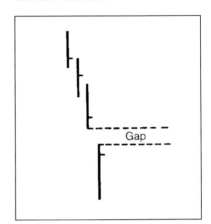

Figure 11–15. Various Types of Gaps.

ISLAND REVERSAL

When a trend reverses sharply, with gaps preceding and following the reversal period, the few days' or weeks' worth of price action between the gaps is referred to as an "island." (See Figure 11–15.) The significance of such a formation arises from the two gaps, not from the activity within the island itself. While the exhaustion gap signals that the trend is sputtering, the breakaway gap after the island presages a major move in the opposite direction.

RESISTANCE AND SUPPORT

Prices change direction for many reasons, not all of which can be identified, much less foreseen. Perhaps the greatest influence on price behavior, however, consists of the expectations and desires of the market participants, who fall into three basic categories:

1. The "longs"—those who own stock.
2. The "shorts"—those who have sold stock short.
3. The uncommitted—those who are not "in" the market at the moment. This is known as being *flat.*

Any of these types of participants can affect price movements. For example, with prices in an uptrend, the longs are delighted but wish they had bought more. The shorts are coming to the conclusion that they were wrong and would like to get out without losing too much. Of the uncommitted group, some never opened a position but wish they had, and others liquidated positions and wish they had not. All four of these groups are watching the market for a dip. If prices break downward, they are all liable to become buyers, that is, "buy the dip." As a result, should prices begin to drop for any reason, these would-be buyers respond by buying, thereby creating demand and forcing prices up again.

When declining prices meet with such demand and "bounce back," they are said to have hit *support*. The price dip as plotted on the chart is known as a *trough* or *reaction low*. Support is therefore a level or area below the market where buying interest is strong enough to overcome selling pressure.

Resistance is the opposite of support. It is a level, or area, above the market, at which selling pressure overcomes buying interest. In this case, the market is trending downward. The longs are looking for a chance to sell, while the shorts are waiting for the opportunity to increase the size of their positions. The uncommitted are likely to go short. Should the market turn upward, all these participants are primed to sell, thereby creating supply and eventually causing prices to turn downward again. (The upturn and drop in prices, once charted, are referred to as a *peak* or *reaction high*.)

Support and resistance often reverse their roles once they are significantly penetrated by price movements. Penetrated by upward movement, resistance becomes support. (See Figure 11–16.) Support, after being penetrated, becomes resistance. (See Figure 11–17.) What constitutes "significant" penetration, however, is arguable. Some chartists say 10%, others 3% to 5%. In practice, each technician must set an individual criterion for a "significant" penetration.

Figure 11–16. How Resistance Can Become Support.

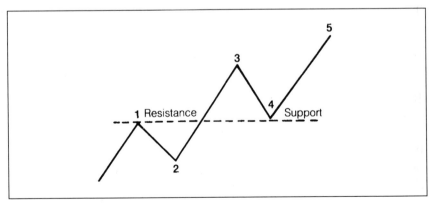

Figure 11–17. How Support Can Become Resistance.

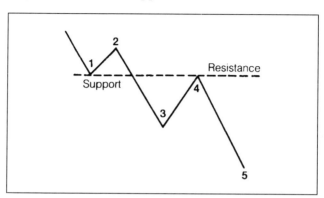

PRICE PATTERNS

In addition to trend lines and channel lines, technicians are able to identify a number of *price patterns*. These are price movements that, when charted, describe a predictable pattern. Some price patterns indicate a trend reversal, and they are therefore called *reversal patterns*. Others, called continuation patterns, reflect pauses or temporary reverses in an existing trend and usually form more quickly than reversal patterns.

Since the aim of this guide is only to introduce you to the basics of analysis, we will look at only one or two of each type of pattern. There are many good books available on technical analysis. If you choose to pursue this type of analysis, you should certainly study it further before basing investment decisions on your conclusions.

REVERSAL PATTERNS

Head and Shoulders Perhaps the best known of reversal patterns, the head and shoulders has three clear peaks, with the middle peak (or *head*) higher than the ones before and after it (the *shoulders*). (See Figure 11–18.) The *neckline* is the trend line drawn to con-

nect the two troughs between the peaks. A close below the neckline signals the completion of the pattern and an important market reversal. A breakaway gap at the point of penetration through the neck lends weight to the probability that a true reversal has taken place. The minimum extent of the reversal can be estimated. To do so, measure the distance from the head to the neckline and project the same distance from the breakthrough point in the neckline. A return move is likely, but it generally does not penetrate the neckline.

Figure 11–18. A Head and Shoulders Pattern.

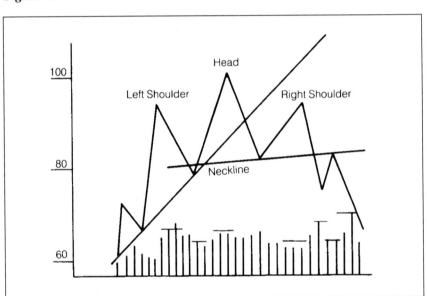

There are several variations of this type of pattern.

Saucers There are many other names for this pattern. In an uptrend, the pattern may be referred to as an *inverted saucer* or *rounding top*. During a downtrend, it can be a *rounding bottom* or *bowl*. (See Figures 11–19 and 11–20.) Regardless of its name, the pattern consists of a gradual turning of the trend on diminishing volume.

Figure 11–19. A Saucer Top.

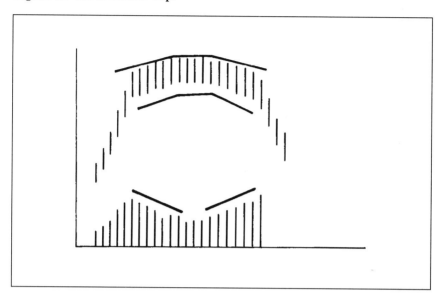

Figure 11–20. A Saucer Bottom.

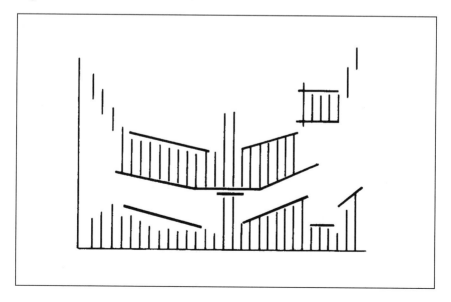

No precise measurement can be made of the extent of the reversal by means of a saucer. The duration and size of the prior trend have some bearing on the new trend, as does the time the saucer takes to form. Other criteria are the previous support and resistance levels, gaps, long-term trend lines, and so on.

CONTINUATION PATTERNS

As we know, continuation patterns represent not reversals in the making, but rather only pauses in the current trend.

Symmetrical Triangle Also known as a *coil,* this pattern forms, on diminishing volume, as a triangle that narrows evenly from left to right, with at least four reference points. (See Figure 11–21.) The trend may be expected to resume, with a closing price outside the triangle, sometime after one-half and three-quarters of the triangle's length are developed. Occasionally, there is a return move on light volume, but the penetrated trend line of the triangle acts as support in an uptrend or as resistance in a downtrend. In either direction, volume generally picks up as the trend resumes. The apex itself can also serve as longer-term support or resistance.

A couple of measuring techniques are associated with triangles. To project the minimum extent of the resumed trend, measure the height of the base (distance A–B in Figure 11–22) and extend a line of the same length from the breakout point (points C–D). Alternatively, draw a line from the top of the base (point A) that is parallel to the bottom line in the triangle.

Rectangle Also known as a *trading range* or *congestion area,* this pattern typically reflects a consolidation period before a resumption of the current trend. (See Figures 11–23 and 11–24.)

Because this formation closely resembles a triple top or bottom, the chartist must rely on volume to distinguish the two. If in an

uptrend the volume is heavier on the rallies than on the setback, then a rectangle is probable. In a downtrend, a rectangle is likely if the dips are accompanied by heavier volume than the rallies. Otherwise, a triple top or bottom could be in the making.

After the breakout, the extent of price movement can be gauged by measuring the height of the trading range and extending a line of the same length up or down from the point of breakout.

Figure 11–21. A Triangle.

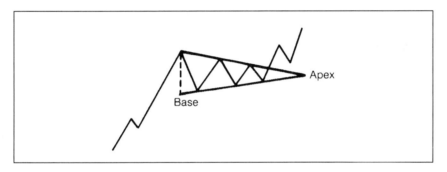

Figure 11–22. Measuring the Duration of a Breakout from a Triangle.

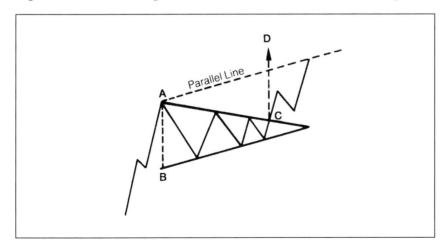

Figure 11–23. Upside Breakout from a Sideways Market.

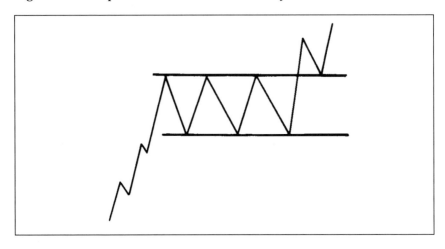

Figure 11–24. A Downside Breakout from a Rectangle.

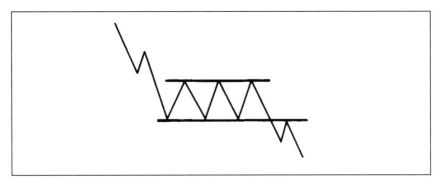

BLOWOFFS AND SELLING CLIMAXES

Sometimes at the end of a long advance or decline, sudden and dramatic market action will lead to a sharp reversal. When this occurs at the end of a prolonged uptrend, it consists of a great deal of buying, which causes prices to rise quickly, and is called a *blowoff*. In the case of a downtrend, it is called a *selling climax,* which is accompanied by much selling and, of course, sharp declines in

prices. In either case, as volume picks up, open interest drops off. Under these conditions, be on the lookout for an abrupt reversal.

MOVING AVERAGES

As you might have concluded by now, the technical approach can be a subjective practice, with two analysts in total disagreement over a pattern. Moving averages represent a step toward making chart analysis more scientific.

A *moving average* is an average of closing prices over a certain number of days. (Midpoint prices might also be used.) For example, a 10-day moving average includes the past 10 days' prices. It is "moving" because, as the latest day's prices are included in the average, the oldest day's prices are left out.

The moving average is a trend-tracking tool. Typically represented on a chart as a curving line laid over the price movements, the moving average "smooths out" the trend, enabling analysts to see whether prices are in or out of line. Thus, as a market follower, it signals whether a trend is still in effect or has reversed.

The responsiveness of a moving average to price movements depends on the number of days included in the calculation. Generally, the fewer the days included, the more closely the average tracks the price action. A 5- or 10-day average, for instance, would "hug" the market activity more closely than one of 40 days. (See Figure 11–25.)

The easily quantified and programmed moving average lends itself readily to today's computerized market-monitoring systems.

OSCILLATORS

An oscillator is a line at the base of a bar chart that is plotted around a midpoint line within a price range, whose boundaries are based on historical extremes. (See Figure 11–26.) The plotted line is a measure of price *momentum,* that is, how fast prices are changing. As the

momentum of price changes increases, the momentum line draws away from the midpoint line and toward one limit of the trading range or the other. As prices go up, the momentum line moves toward the upper, positive boundary; when they go down, the line moves into the negative range below the midpoint line. Like the moving average, a 5-day oscillator is more sensitive than a 10-day oscillator.

Figure 11–25. A Moving Average on a Bar Chart.

Figure 11–26. An Oscillator on a Bar Chart.

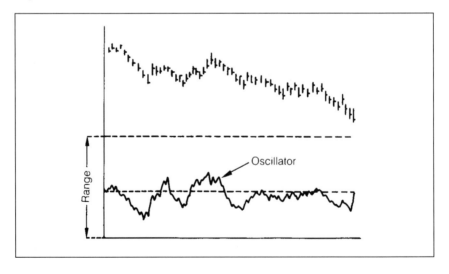

An oscillator tells the analyst whether a market is *overbought,* if the momentum line touches the lower one. For this reason, oscillators are particularly useful in sideways or horizontal markets. In addition, a divergence between price action and an oscillator in an extreme position is usually a warning that a price correction is imminent; the price has gone "too far, too fast." Some charts even use the crossing of the midpoint (or zero) line as a buy or sell signal—of course, always in conjunction with other technical considerations.

POINT AND FIGURE CHARTS

Unlike bar charts, point and figure (P&F) charts record only price movements; if no price change occurs, the chart remains the same. Time is not reflected on a P&F chart, although time reference points, such as a "10:00" for ten o'clock, are sometimes used. Volume is indicated only by the number of recorded price changes, not as a separate entity. Although traditionally ignored, gaps may be represented by empty boxes.

Nevertheless, point and figure charts have at least two major advantages over bar charts. First, they can be used on an intraday basis to identify support, resistance, and other price-related data—particularly congestion areas—that bar charts can miss completely. Second, P&F charts are more flexible than bar charts in that the analyst can vary the size of the box and the reversal criterion, either of which can drastically change the appearance of the formation.

BOX SIZE

In a P&F chart, a rising price change is represented by an X, a declining price movement by an O. Each X or O occupies a box on the chart. One of the first decisions in constructing a P&F chart, therefore, is how great a price change each box should represent. For example, a gold chart might have a box size of $1. On a less sen-

sitive chart, each box might equal $5; a more sensitive scale would be $.50 a box. Obviously, the smaller the value assigned to a box, the more detailed price action the chart can convey—and the more tedious it becomes to construct.

REVERSAL CRITERION

On a P&F chart, the analyst moves one row of boxes to the right each time the market reverses. The next question then is, what constitutes a reversal? Is a one-box change in direction a reversal? Or is it three boxes' worth of movement?

A P&F chart constructed with each box equal to one point and a three-box reversal criterion is a "1 × 3" chart. (See Figure 11–27.) The chartist can plot the same data differently—and make the chart less sensitive—by changing either the size of the box or the reversal criterion. For example, Figure 11–28 is the 1 × 3 cotton chart that was started in Figure 11–27, now plotted out for several hours' worth of trading. Compare it with Figure 11–29, which reflects the price changes but in a 2 × 3 format; that is, each box now represents two points, and the reversal criterion is still three days.

Figure 11–27. P&F Chart.

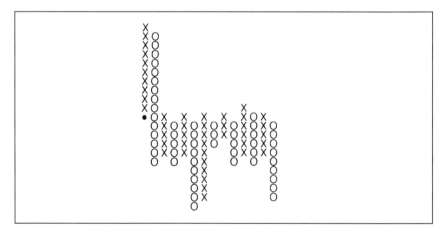

Figure 11–28. Continuation of the P&F Chart.

Figure 11–29. Price Changes from Figure 11–28 Plotted in a 2 × 3 Format.

THE HORIZONTAL COUNT

Whereas price objectives are determined by vertical measurements on a bar chart, they are obtained by what is known as a *horizontal count* on a P&F chart. On intraday, one-box reversal charts, the analyst measures the width of the congestion area and uses that number of boxes to measure the up- or downside target. Usually the column to count from is the one with the greatest number of X's and O's.

The point of a compass is placed at the extreme right of the area, and an arc is projected up- or downward once the width of the area has been measured.

POINT-AND-FIGURE PRICE PATTERNS

Although some patterns, such as gaps, flags, or pennants, are not evident on P&F charts, most formations can be seen. Their appearance, however, is sometimes different from the bar chart variety.

USING LONG-TERM CHARTS

Technical analysis techniques can be used in any time dimension. They apply not only to daily charts, but also to weekly charts (which contain up to five years of data) and to monthly charts (which can offer up to 20 years of price movements).

In fact, even though this chapter has focused on the daily chart, no analyst could get a broad enough picture of a market without referring first (and often) to longer-term charts. (See Figure 11–30.)

CONFIRMATION AND DIVERGENCE

Running through technical analysis are the two themes of confirmation and divergence. No one pattern, no one indicator can be

Figure 11–30. A Long-Term Bar Chart.

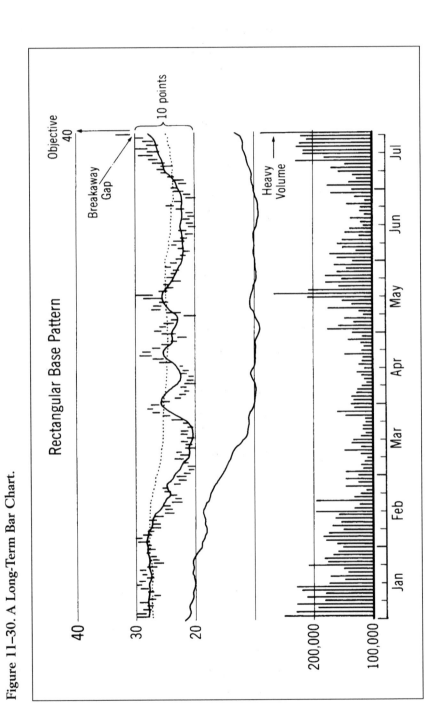

used in isolation. Instead, the chartist must take into consideration all the elements of the market, always seeking to test the signals given by the price movements. Two basic tests are confirmation and divergence.

- *Confirmation* is the comparison of all technical signals and indicators to ensure that most of them point to the same conclusion and thereby confirm one another.

- *Divergence* is a situation in which the indicators fail to confirm one another. Perhaps other delivery months or related markets are headed in a different direction from that of the one under study. Divergence is not necessarily a negative finding. It can be a valuable concept in market analysis and an early warning signal of an impending trend reversal.

The essential point is that charting price movements, considered by itself, usually does not provide enough information to make an intelligent investment decision. You must look at the stock itself, the economic conditions, the issuing company, and any other factors that might be influencing the market.

As I noted at the beginning of this chapter, virtually all of this type of technical charting has already been done on computerized programs that are for the most part freely available just by retrieving them from the Internet.

SENTIMENT INDICATORS

Technical charting is also used to follow trends in what are called the *sentiment* or *psychological indicators*. The aim of sentiment indicators is an attempt to forecast the short-term direction of the overall market based upon investor sentiment as reflected in the actual market internals, i.e., not merely what is being said, but how investors are voting with their money.

Some of the most commonly followed sentiment indicators are:

1. The *ratio of public to NYSE specialist short sales,* found by dividing the odd-lot short sales (presumed to be the small public investor) by the short sales of the NYSE specialists. The basis of this belief is that the public is usually wrong at critical times in the market. Therefore the higher the ratio, indicating heavy public short selling, the more likely the market is to rise. A ratio above .6 is deemed to be bullish, while a ratio below .35 is considered bearish.

2. The *ratio of price premiums in put options vs. call options* is believed to demonstrate the direction of implied volatility in the market and is often treated as a contrary indicator. For instance, a high price premium being paid for an increasing number of put contracts indicates more people believe the market will fall; but as a contrary indicator, it may be demonstrating that the market will in fact rise because too many people are negative and the market will do whatever it can to confound the greatest number of people.

3. *NASDAQ daily trading volume as a percentage of NYSE daily volume* is viewed as an indicator of public participation in the market as the public tends to be more directly active in the small and more thinly traded companies.

4. *Short interest ratio on the NYSE* is considered an indicator of market support since a high ratio of short sellers provide buying support to cushion any decline in the market and added fuel on any upside breakout as short sellers rush to cover their short sales.

5. *Percentage of bearish and bullish advisors* is one indicator I have personally found very reliable as a contrary indicator at market extremes. It is simply based on the concept that the majority, of necessity, must be wrong at turning points in the market in order to provide liquidity. A reading of less than 35

percent of investment advisors rating themselves bullish, or a reading of over 50 percent of investment advisors rating themselves bearish—especially occurring coincidentally—is considered to be a strongly bullish indicator. Conversely, a consensus of advisors over 55 percent bullish, or less than 20 percent bearish is considered extremely bearish for the market.

6. The *Tick* is a short-term sentiment indicator that is calculated simply by subtracting the number of issues that declined on the last trade from the number of issues that traded higher on the last trade. Negative 100 to positive 100 is generally considered neutral, whereas negative 500 would be very bearish, while positive 500 would be considered fairly bullish.

7. The *Arms Index* created by Richard Arms is also known as the *trin* or *trading index*. This is a short-term indicator intended to reveal buying or selling pressure. It is calculated according to the following formula:

$$\frac{\text{down volume/number of declining issues}}{\text{up volume/number of rising issues}}$$

If the result is between .9 and 1.1, it is considered neutral. Above 1.1 is considered bearish, while below .9 is considered bullish. A reading of .5 or below is very bullish, while above 1.5 is very bearish.

CONCLUSION

New chartists sometimes mistakenly regard technical analysis techniques as infallible—or nearly so. Their subliminal assumption is sometimes that, by drawing the trend lines associated with a pattern, they can "make" the projected price movement happen.

But perhaps the first rule in chart analysis is that there are no "rules" as such. A pattern will probably develop as anticipated, but it

is not certain to do so. That is why chartists use the word "indicator," not "rule" and surely not "guarantee."

That is also why confirmation is so important. Analysts must combine all they know and all they see before taking a position. They must bring to bear the findings of their fundamental studies, their awareness of the market and industry in general, and their willingness to constantly review indicators other than price. Only then can they reasonably expect to profit from their trading—most of the time.

Your Rights As
an Investor

In the process of investing, several questions may come to your mind. *What rights does ownership of a stock, bond, or any financial asset bring with it? How do I, as an individual investor, protect these rights? If I feel that I have been treated in an unfair or illegal manner, to whom do I turn and what can I expect in the way of compensation for my loss?*

Most public companies—and the brokerage community in general—are fair and equitable in their dealings with the investing public. Scrutiny by the media and 60+ years of state and federal regulation have contributed to this practice of fair dealing. This is not to say that individual investors have never been taken advantage of by unscrupulous or incompetent corporate officers, brokers, or financial advisors. As with any industry, the investment business has its share of "bad apples." Because the securities industry is so closely regulated, however, such individuals are eventually forced out. In this chapter, I will discuss your rights as a shareholder/investor and the mechanisms available for the redress of wrongs.

SHAREHOLDER RIGHTS

As a shareholder, whether you own one share or 5,000 shares, you are part owner of the public company whose shares you own. Bear in mind that the management of a public company "works for you" and is answerable to you as a shareholder.

What are your specific rights as a shareholder? First, the management of a public company is required by law to keep you informed about the progress of and general developments that affect the company. This disclosure requirement is mandated by the federal securities laws enacted by Congress in the mid-1930s and enforced by the U.S. Securities & Exchange Commission (SEC), which oversees the nation's financial markets and the brokerage community and applies equally to individual companies and mutual funds.

The concept of disclosure is at the heart of the federal securities laws: A public company must disclose (reveal) all the pertinent facts about itself to its shareholders. (You should understand that disclosure provides no guarantee against loss in an investment. The disclosure laws attempt to put every investor on an equal footing in terms of access to relevant information; however, the decision to buy, sell, or hold a particular stock or bond is yours alone.)

Disclosure takes several forms. As an investor in a public company you are entitled to receive an annual report, a quarterly report, and a proxy statement, and to be informed of any significant corporate development (such as replacement of a corporate officer, destruction of corporate property, or any offer to buy the company). All such information must be furnished on a timely basis and filed with the SEC before distribution to shareholders. The SEC reviews the information to determine if it meets disclosure requirements but *makes no judgment* regarding the information's significance. Information about public companies that is filed with the SEC is kept on microfilm at the SEC regional offices and is available for examination by the public either in person or by access through the

Internet. Many shareholders/investors are not aware of this source of information, but its usefulness is evident from the number of professional securities analysts who review it regularly.

If no errors, omissions, or false statements are uncovered after review by the SEC staff, companies mail copies of these reports to their shareholders. Chapter 10 explains the techniques you can use to analyze and evaluate the data available in a company's annual and quarterly reports, proxy statement, and other sources. In this section I will concentrate on the proxy statement—the document most concerned with your rights as a shareholder.

THE PROXY STATEMENT

In addition to receiving information, as part owner of a public corporation, a shareholder has the right to vote on an annual basis to select the company's officers and directors. The company must hold an annual meeting, at which the shareholders can voice their opinions and meet and speak with management. For the most part, the shareholders' rights with respect to the selection of management and the holding of the annual meeting are governed by the laws of the state in which the company is incorporated. However, all proxy statements must be filed with and reviewed by the SEC.

What is a proxy statement and what information does it contain? A proxy statement is simply a ballot sent to the shareholders of a public corporation whereby the corporation requests the shareholders' votes that its officers and directors continue in their positions. A proxy also provides for a negative vote: As a shareholder you are under no obligation to vote for the present management. It is extremely difficult, however, for individual shareholders to oust the existing management of a public corporation unless management has overtly abused its positions. The theft of corporate funds or the acceptance of kickbacks are examples of the instances in which shareholders might vote to throw out the current manage-

ment. Until the recent trend of mergers and acquisitions, it was not uncommon for a mediocre management to continue running a public corporation for a number of years, particularly if ownership of the company's shares was widely dispersed and fragmented, or concentrated in insider holdings.

A proxy may also be used to secure stockholders' approval of the selection of outside accountants as well as of changes in the corporation's *charter*. Such changes might include the addition of provisions to make a takeover of the company more difficult and expensive, a change in the state of incorporation, or the introduction of stock option plans to compensate management for superior performance.

Theoretically, proxy requirement and, hence, the annual election of officers and directors puts the individual outside stockholder on an equal basis with the institutional holder and with management. In reality, however, some individuals and institutions are "more equal than others." Unless you own a substantial amount of a public company's stock (5% or more), your best route, if you feel a company's management is incompetent or self-serving, is to "vote with your feet," that is, to sell your shares. Most professional investors and money managers use this strategy.

Although, as an individual shareholder, your ability to influence the company's management is limited, a proxy statement is important to you because it contains information you can use. The following highlights some of the more important information you can glean from a proxy statement.

First and foremost, the proxy provides information about the ages of the company's officers and directors and their business backgrounds. The fact that management is older may mean that the company is a likely candidate for sale or takeover. The proxy statement may also indicate that the company is beyond its growth stage and that management is more interested in preserving the status quo than in expanding and growing. Likewise, the absence

of outside directors, that is, directors not directly employed by the corporation, may leave you with the feeling that the corporation is too inbred and its focus and point of view too narrow. The proxy also tells you whether the company is a "family affair." If close relatives are waiting to step into the top positions, you might wonder whether the company is run on the basis of nepotism rather than on sound business judgment. Because such a company is viewed as an extension of the founding family rather than as a business, it is unlikely to be the subject of takeover attempts unless "family squabbles" arise. Finally, the proxy statement furnishes information about the level and nature of management compensation. The compensation management pays itself tells you whether management is interested in seeing the company grow or merely views it as a "cash cow" to be drained of its assets. The level of compensation management pays itself should be compared with the compensation paid by companies of similar size engaged in the same or similar business.

The Annual Meeting

Attending the annual shareholders' meeting is something few investors do although it is one of the basic rights that comes with ownership of stock in a public corporation. Every investor should attend at least one annual meeting, as it gives a real insight into how the affairs of the corporation are conducted. Looking at the pictures in an annual report or the numbers on a balance sheet or income statement never gives you a clear understanding of management's style, goals, or objectives. Particularly if you intend to invest a substantial amount of money in a company, you should make every effort to attend the company's annual meeting and meet management face to face. Your attendance also affords you the opportunity to meet with other shareholders and to appraise their backgrounds, to raise questions you feel are important, and to lis-

ten to management's responses to any questions raised. Most professional investors decide to invest in a company only after attending the annual meeting and speaking with senior management. Shareholders who attend annual meetings are generally surprised to find that a company with a thousand or more shareholders may have as few as ten in attendance. The fact that individual shareholders do not attend such meetings may encourage management's abuse of its position.

PRIORITY CLAIMS

In the event that a public company falls on bad times and is liquidated or files for reorganization under the bankruptcy statutes, the common stockholder's rights to share in the remaining assets of the corporation or to have a say in the company's reorganization are subordinate to those of secured creditors, bondholders, and preferred shareholders. Most bankruptcies wipe out the common shareholders, although they may be able to recover something of their investment in certain cases. As a common stockholder you should be aware that most state incorporation laws include a fairness provision, which specifies that a shareholder has the right to petition the state to bring in an outside appraiser if the shareholder believes the company is being sold (to outsiders or to the company's management) through a *leveraged buy-out* at a price that is out of line with the real worth of the corporation. In today's world, a company's management or outside investors can rarely "steal" a company, because institutional investors react quickly and are likely to sue any company that makes such an attempt. In addition, some law firms specialize in *stockholder derivative suits,* which are class-action suits brought on behalf of all shareholders when it is believed that management is taking advantage of them. Only if there are no institutional stockholders or if stock ownership is fragmented among a number of small and unsophisticated investors can management get

away with this type of abuse of its position. The federal and state regulatory authorities also discourage such practices.

PROTECTING YOURSELF AGAINST FRAUD

In the preceding section, you learned what your rights are as a shareholder of a public corporation. You also learned how best to utilize these rights to improve your ability to judge the merits of investing in a particular company. In this section, I will point out some common "scams"—tricks used to separate investors from their hard-earned money. Also discussed is where you can turn for help if you feel you have been wronged by someone in the investment community, or if you have fallen victim to one of these schemes.

About 99 percent of all scams (frauds) worked on individual investors start with a phone call. The caller most likely claims to be an employee of a major investment firm or a financial advisor with a long history of making clients rich. In most instances, the caller puts the person receiving the call on the defensive and pressures for quick action "before the opportunity of a lifetime passes by." The products offered may range from a tax-shelter offering a 10-to-1 write-off (meaning that for every dollar you invest in the shelter, you can write off ten dollars on your taxes; this is no longer permitted since the Tax Reform Act of 1986) to schemes involving currency futures and rare metals, participation in "government-sponsored" lotteries of oil and gas leases or Internet or broadcast or cable licenses, and investments in silver and gold coins and gems. What the caller offers for sale varies with what is currently in vogue in the news. These scams are particularly reprehensible because they are most effective with the elderly and with others who are least able to afford the loss. Because scams operate from out-of-town locations that change frequently (as do the corporate names), it is nearly impossible for small investors to recover any of their money. Trade

associations and regulatory bodies, as well as people who work in the securities industry, attempt to weed out con artists from the securities business, but individual investors must still be wary.

How can you avoid falling victim to such calls? First, you should always investigate before you invest. Since most fraudulent sales pitches appeal to human greed, you should always ask yourself if the return promised is totally out of proportion to anything you have seen before. Always ask yourself, *"If the deal is so good, why are the promoters not keeping it for themselves?"*

The following checklist includes questions you should ask a caller before you invest any money. As an investor you have the right to ask these questions and to obtain accurate answers.

INVESTOR CHECKLIST

1. *Where did you get my name?* No legitimate salesperson would hesitate to answer such a question; if the caller is vague or reluctant to reply to this question, invest your money elsewhere.

2. *Will I receive a prospectus or offering circular?* You should never commit any money until you have received and read a document that describes all aspects of your prospective investment.

3. *What are the risks involved?* Some investments are not suitable for particular investors; salespersons should fully explain all risks involved in the investments they recommend.

4. *How much commission must I pay to make this investment?* The level of commission paid to a salesperson tells a lot about the availability of buyers for an investment product.

5. *To what regulatory body or industry association does the firm you are selling for belong?* If the salesperson is vague or unwilling to answer this question, end the conversation. If the information is supplied to you, call the agency or industry body named to determine if the firm is indeed registered or a member.

6. *What happens if I decide to liquidate my investment?* Be sure the salesperson fully explains all the terms and penalties connected with a withdrawal from or liquidation of the investment.

7. *(for a stock or bond) Where is the security traded and who are the market-makers?* If you buy a highly speculative stock (referred to as a penny stock), you should be made aware of the risk it entails and given the opportunity to contact other market-makers in the stock to check that the price quoted to you is in line with the market. You should also be given the opportunity to research the stock before you enter a buy order.

8. *May I have a list of banks and other financial institutions that have dealt with you in the past?* Even when such references are given, you should contact the Better Business Bureau to determine whether the company or the individual has been the subject of complaints, and the nature of any such complaints.

9. *Can I refer you to my accountant or lawyer for any additional questions they might have?* This question is a good one to ask any cold caller. By all means let your accountant or lawyer speak to the salesperson before you commit any money.

10. *Will I have an opportunity to meet you face-to-face?* If this call or pitch is from a crooked firm, the caller will refuse to meet you because of the time involved and because the sales techniques of such firms work better on the telephone than in person. If the caller agrees to such a meeting, bring your lawyer, accountant, or financial advisor with you.

If you use this investor checklist, you should be able to successfully screen out the crooks from the legitimate salespeople. A key point to remember is that any legitimate salesperson will furnish all the information you request and will not put any time pressures on you or urge you to invest before the opportunity disappears. Do your investigating before you invest.

PREVENTING AND CORRECTING ERRORS

Most problems investors encounter fall into one of two categories. The first category consists of outright stealing of investors' money through some sort of scam or phony transaction. In the preceding section, I outlined the questions you should ask to protect yourself from being taken in by any of these schemes. If you *are* taken in, it is difficult if not impossible to recover your money. You should, however, contact the regulatory authorities immediately and describe the circumstances. In the case of a nonsecurity transaction, such as the purchase of gems, or gold and silver coins, contact the local district attorney's office. If you were contacted about the investment via a mail solicitation, you should notify the postal inspectors. If the investment was related to securities, you should contact the SEC, state securities officials, and the various industry associations. Any hope of recovering your investment depends on the speed with which you act.

The more common problems encountered by individual investors fall into a secondary category: disputes about the execution of a particular trade or about the way an account is handled. Problems related to a particular transaction may arise when the buy or sell order is entered. For example, you may be surprised to receive a confirmation in the mail for a particular trade because you believe that you never actually gave the order to the account executive (AE). Or a problem may arise if you believe an error was made in the way an order was entered or executed. The practice of placing orders over the telephone, rather than in person, increases the likelihood of error. For this reason, more and more brokerage firms—particularly discount brokers—make tape-recordings of all conversations between brokers and customers. The vast majority of individual brokers and firms active in the securities business are honest and fair in their dealings with the public; the errors that occur are simply that—with no intention to cheat the customer. These errors are gen-

erally corrected as soon as they are brought to the attention of the AE or the compliance department of the brokerage firm, and are typically caused by inaccurate data entry; for example, the transposition of an account number.

Select the Right Account Executive for You

How can you prevent such errors from occurring? First, take adequate time to select your account executives (AEs) or brokers before you do any business with them. Although Chapter 8 discusses this process in detail, I will review here some of the more important points.

The key to this selection process is *compatibility:* your personality, your goals, and your approach to investing must be compatible with those of your AE. Many of the problems that arise between customer and AE stem from incompatibility in these areas. Both you and your AE should understand each other's background and goals before entering into that first trade. Second, check out the brokerage firm that employs the AE. *Does the firm have a good reputation?* Third, ask the AE about previous employment. If an AE has been employed by a number of "marginal firms" (firms you have never heard of or whose principal business is the underwriting and sale of penny stocks), you should seriously consider whether it is appropriate for you, in your particular financial circumstances, to deal with such a person. Likewise, you might also be concerned that an AE who has frequently switched firms may have been terminated by these firms for any number of reasons.

How can you check out a particular AE and firm? Call or write the U.S. Securities & Exchange Commission, the registration sections of the various exchanges, and the National Association of Securities Dealers. (Refer to Appendix 2 for more information.) Although these agencies and self-regulatory bodies cannot endorse a particular AE or the firm employing such a person, they can tell you whether the AE or firm is, in fact, registered (that is, licensed to conduct a securities business). These organizations can furnish the names of the AE's past

employers and can inform you if the AE or the firm has been the subject of disciplinary actions. As in most business dealings, you must judge the character and honesty of the account executive and the brokerage firm before you do business with them.

Even if you take all the necessary precautions and check the credentials of all parties with whom you do business, the likelihood persists that an error or disagreement will occur in connection with your account. The first step in resolving such a problem is to discuss it directly with your AE. The majority of problems and errors are resolved at this level. If you and the AE cannot resolve the problem, however, the next step is to speak to the firm's office manager. The office manager is responsible to see that the AEs employed by the firm conduct business in an ethical and honest manner. Most brokerage firms require their office managers to review on a daily basis all trades that go through the branch office, looking for errors, questionable or unauthorized transfers of funds, and concentration of buying or selling in a security that is unfamiliar to the firm. This scrutiny enables the office manager to spot and correct most errors and irregularities before they reach a customer's account. The office manager (through years of experience) is usually able to spot "problem" AEs and warn or fire them if necessary. So if you are unable to resolve a matter directly with your AE, a meeting among yourself, the account executive, and the branch office manager will most likely bring about its resolution.

DEAL WITH THE COMPLIANCE DEPARTMENT

The majority of brokerage firms have compliance departments, which function as internal auditors. The compliance department is charged with the overall supervision of a firm's branch offices and branch managers and should know if a particular branch is poorly supervised and/or if its employees act in a dishonest manner. If you have a problem, the final level of appeal within a firm is to the compliance and/or legal department.

WHERE TO TURN FOR HELP

Most problems and difficulties between AEs and customers are resolved internally. However, Congress, the various states, and the securities industry itself provide additional means for customers who feel they have been treated unfairly to seek redress. These agencies and legal authorities want to know if the management of a public company uses its position to steal from the company, if individuals profit from using "inside information" about impending corporate developments, and/or if any organized attempt is made to manipulate the price of a company's stock. In this section, I will describe the various protections and defenses available to you as an individual investor and how to use them to assert your rights.

One of the first places individual investors consider turning in the event of difficulties with an AE or a brokerage firm is to the *Securities & Exchange Commission (SEC)*. The name of the SEC appears almost daily in the financial press in connection with actions against public corporations or brokerage firms. (The number of such actions is small, however, considering how many public companies and securities firms are operating today, and the number of people employed in the business.)

How can the SEC assist the individual investor seeking to redress a wrong? Most problems are presented to the SEC either in the form of a letter or a personal meeting between the investor and the SEC's representative. In many ways a letter is the better approach because it allows you to describe what occurred in your own words and in a logical and coherent manner. When sending such a letter, you should include *copies* of any correspondence, confirmations, or documents in your possession that relate to the transaction in question. (Always keep your originals in a safe place—you may need them.) On receipt of such a letter or after a complaint is presented in person, the SEC must determine if the federal securities laws have been violated. In making this determination, the SEC consults all parties involved in the transaction—the AE as well as the

customer. Many disputes among AEs, the firms who employ them, and their customers are resolved at this level. Most complaints involving transaction errors or failure to deliver securities or dividends are also resolved here. If it can be shown that the firm or the particular account executive has a pattern of dishonest and illegal activity, the SEC may bar the individual and/or the firm from the securities business and refer the matter to the U.S. Attorney's office for criminal prosecution.

Can the SEC recover money for an individual investor who has been defrauded? The answer to this question is no. The SEC is not a collection agency. However, an SEC action against an AE, a brokerage firm, or a public corporation can be used as the basis for a civil suit brought by the wronged investor. In instances where well-known brokerage firms are the subject of SEC action, the firms generally seek to make good to the investors, if for no other reason than to reduce the bad publicity that accompanies SEC action.

State authorities play a role similar to that of the SEC. The effectiveness of state securities authorities varies considerably from one state to another as well as from one administration to another. The state authorities use their power to regulate limited partnerships set up as tax shelters, or for specific purposes (such as to raise money to finance a Broadway show). Many state authorities actively pursue the promoters of con schemes worked on the residents of the particular state or locale. The state and local authorities work closely with the federal authorities in seeking to eliminate the "bad apples" from the securities business. Like the SEC, state authorities are not empowered to represent individual investors nor to recover money on behalf of such investors.

HOW TO RECOVER YOUR MONEY

If federal and state authorities cannot recover money you lost to a con artist or crooked brokerage firm, *what can you do to get your*

money back? Two basic mechanisms exist: arbitration and the use of private counsel.

ARBITRATION

During the past two decades, the securities industry has adopted a simplified uniform procedure administered by the National Association of Securities Dealers (NASD) for the processing and handling of cases in which investors seek to recover money from brokerage firms and even settle conflicts between brokerages or brokers and their own firm. NASD is the largest securities forum in the U.S. and handles over 6,000 arbitrations per year. Arbitration is viewed as a speedy and lower-cost method of resolving claims when compared to the judicial system. Disputes between brokerage firms and between brokers and their broker/dealers are *required* to be arbitrated, but the rules are different for the investing public.

Since the industry favors arbitration, virtually all accounts *other than cash accounts* carry a requirement that matters in dispute be subjected to arbitration and these clauses have been repeatedly upheld by the courts. In a cash account situation, it is the investor's option whether to proceed with arbitration or seek redress through litigation. Typically, an arbitration will be assigned to a single arbitrator if the matter in dispute is less than $5,000. For greater sums, a three-member panel is assigned consisting of an industry representative and two others from outside the securities industry. Usually, but not always, the panel members are attorneys with experience in the area of securities, or experienced securities practitioners.

What steps must you take to initiate an arbitration procedure? Three steps are involved in starting an arbitration procedure. First, you must file with the arbitration authority a typewritten or printed letter describing the nature of the claim. (Most securities industry organizations such as the NYSE, AMEX, and other regional exchanges have their own arbitration director, to whom you send this letter.) Second, you must deposit with the arbitration authority

a check or money order, in an amount prescribed by Section 2(c) of the Uniform Code. This requirement is intended to eliminate frivolous complaints; the final disposition of the deposit is left to the ruling of the arbitrator or panel. Third, the complainant must sign and return to the authorities a submission agreement, stating that the complainant will submit to the jurisdiction of the arbitration authority and will accept the decision it reaches.

The arbitration process itself is relatively straightforward and is conducted pursuant to the Code of Arbitration Procedure, usually in the city closest to the complainant's address. The arbitration authority appoints an arbitrator (usually an individual who is not associated with or employed by a brokerage firm or securities industry association) to look into the matter. The arbitrator (or panel for larger claims) examines the claim submitted by the individual investor and determines if the matter can be resolved to the satisfaction of all parties involved without going to an actual hearing. The complainant has the right to insist on an actual arbitration hearing; but in many cases the mere presence of an impartial arbitrator results in settlement without a hearing.

If the complainant requests it, or the arbitrator feels that the matter cannot be resolved on the basis of the letter and the submitted documents, a date will be set for a formal arbitration hearing. This hearing is similar to a regular court procedure, though considerably more informal and with generally greater latitude given to the claimant in presenting its case than might normally be allowed under the formal rules of evidence in a court proceeding. The arbitrator and witnesses are sworn in, and each party is given the opportunity to make an opening statement. The individual making the complaint presents a case using the relevant documents and the testimony of live witnesses, and the parties that are the subject of the complaint are allowed to present their side of the case. Counterclaims and closing statements conclude the arbitration proceeding. After all the facts have been presented, the arbitrator reviews the whole matter, reaches a decision, and advises the dis-

puting parties of the decision by mail. The arbitrator is empowered to order a brokerage firm to return money to an individual investor, and any decision is final as provided in the submission agreement.

This arbitration procedure has worked well and more often than not to the advantage of the small claimant when it involved a brokerage firm that was registered with the relevant authorities and was a member of the Securities Industry Association. However, if the individual or firm is a fly-by-night operation without any fixed location or address, it is virtually impossible to use this procedure to recover money. Therefore, you must check out individual salespersons and the firms that employ them before you enter into any transactions.

PRIVATE COUNSEL

If more than $5,000 is involved in a dispute, or if you feel that a court of law would provide a better forum for your case—and you have not obligated yourself to seek arbitration by signing a margin account form—you can retain legal counsel and sue the AE and the firm involved in the transaction. In recent years, a number of individual investors have brought such suits successfully and have been awarded large sums of money. The successful suits have had certain elements in common. First, the investors involved were able to show that they were relatively unsophisticated in the area of investing and that the trades in question were the first ones they entered into. The investors were also able to show that the disputed investments were totally inappropriate or excessive, considering the investors' ages or financial circumstances. For example, a court of law might find high-risk growth stocks or active option trading using complex strategies to be inappropriate investments for someone 85 years old. Many successful suits have shown that the AE used excessive influence in dealing with an older or infirm customer. But even in the most blatant instances, the costs of bringing such suits are high, and the party bringing the suit has no guarantee of success.

FINAL COMMENTS

As I noted earlier in the chapter, most disputes investors have with their account executives and brokerage firms relate to errors or mistakes in the execution of trades. Many of these complaints stem from mismatches between the personality and philosophy of the customer and those of the AE or the brokerage firm. The majority of these complaints, however, can be easily resolved. If you feel uncomfortable with or distrust a particular AE, the wise move is to look for another AE with whom you are more comfortable. Changing AEs (as discussed in Chapter 8) is an easy process.

Computers and
the Internet

Since the last edition of this book, the pace of change initiated by computer technology has accelerated dramatically.

There is no question that advancements in technology applications have greatly enhanced productivity and have changed many views concerning the underlying economy. For example, despite a slow start in the early 1980s, over one hundred billion dollars was invested by business to build up the personal computer and local area networks for an apparent return of only about one percent productivity gain. Yet as the learning curve for workers and businesses improved, along with the accelerating pace of technology and software improvements, the pace of productivity also began to accelerate to a point where at the end of the 1990s, the economy was faced with near full employment and worker shortages, without any signs of inflation that have historically tended to appear.

The speed of change is so swift and so pervasive that it is upon us before we even notice or have the opportunity to adapt. Before we master the latest changes, we are again confronted by a new technology. To understand how great this change has been, it is necessary to understand a bit of history and an analogy or two.

COMPUTER EFFICIENCY

Since the end of World War II, the pace of technological advancement has been accelerating and nowhere has it been more evident than in the changes in computer science. When ENIAC, the first true integrating computer was built at the University of Illinois at Champaign–Urbana in the late 1940s, the vacuum tube circuitry filled a room, eight feet by eight feet by ten feet. With the development of the transistor in 1956, circuitry size began to shrink as did the time for technology turnover. By 1970 and the introduction of integrated circuitry on a silicon chip, the period for technology turnover had dropped from twenty years to four and one half years, and the *ENIAC's circuits could be placed on a chip the size of a thumbnail.*

The development of the microprocessor, or a computer on a chip, again accelerated the pace of change to the point where the operating speed and Random Access Memory of the processor—that was 4.7 megahertz and 512 Kilobytes of RAM on the Motorola 8088—used in the first IBM PCs has been replaced with successive generations of microprocessors operating at nearly gigahertz speeds and RAM of 64 megabytes and higher, while the technology turnover has dropped to and at least temporarily stabilized at about eighteen months. That is the technical babble, *but what does it mean to you?* The most important aspect has been actual *deflation* in the cost of technology. Using the statistical rate of reduction in the cost of computer memory, operating speed, and storage costs, by relative comparison, if the airline industry had experienced the same cost efficiencies, it would be possible to build and operate a *1,000-passenger* airliner that would fly at *25,000* miles per hour on a *teaspoon* of fuel at a passenger ticket cost of under *one dollar!* The statistics are pesky, but the relative comparisons are real and only emphasize the incredible increases in productivity made possible by computer technology.

The trend is likely to continue as the increase in knowledge and research lead to new technological discoveries that only await com-

mercial applications. Regardless of the area, computers will play an ever-expanding role in human development, with most of the action taking place behind the scenes out of public view as in CADCAM (Computer Assisted Design Computer Assisted Manufacturing) and genetic modeling. Whether it is robotic welders in the automotive industry, the first MacIntosh plant where Apple made machines with little human labor input, or the Boeing 777—the first plane to go directly from computer modeling to production—the pace of technology will accelerate and the astute investor will look to the future, perhaps in the areas of nanomachines and genetically engineered drugs.

THE INTERNET AS AN INVESTMENT TOOL

The Internet was originally conceived as a research-sharing tool for academia and the government. Since approximately 1993, the commercial development of the Internet has exploded to over eight million Web pages of which the best of the search engines can catalogue only 15% to 25%, and the rate of development continues to explode.

For the determined initiate, the Internet offers remarkable amounts of freely accessible information that previously was available only to financial professionals at a relatively high cost. The egalitarian nature of the Internet levels the playing field between the individual investor and the professional. (*Note in passing:* All the research to update this book was retrieved from the Internet.)

Financial websites have become ubiquitous. Seemingly every mutual fund company, brokerage firm, media service, search engine, and investment advisor has a website where investors (potential clients) can find a variety of research including one click portfolios, charts, downloadable stock reports, earnings estimates, analysts' recommendations, and improved stock and mutual fund screening. These are mostly free of charge, but some are available as subscription services delivered over the Internet.

The greatest problem is not accessibility, but rather information overload. Anyone doing research on the Web must develop his or her own set of filters to sift the important from the trivial or repetitive. In addition, live chatrooms on the Web are constantly touting stocks, but how much is real and how much is hype insinuated into the discussions by the stock promoters?

The open nature of the Internet is a strength, but it also makes it very easy for scamsters to prey upon the gullible, with far more anonymity than was ever possible before.

TRADING ON THE INTERNET

During the period 1996 to 1999, the number of online trading accounts rose from 1.5 million to approximately 10 million. The percentage of equity trades made online, including retail and institutional, has risen during the same period from approximately 5% to nearly 18%. If only retail trades are considered, the percentage of trading done online rose to over 30%. Since the inception of online trading (around 1994), the number of online brokers has risen from one to over 100 and that number is expected to double again within the next two years.

For many of these online traders, cost is a primary consideration with the cost of an online trade dropping to an average of $15.75 during 1999. However, not all is as it appears, as studies indicate that at least 50 percent of the new online accounts are already discount brokerage customers who are switching the way they trade.

A major misconception among online traders is that they are in fact making their trades directly through a computer. This is not true! Virtually all trades entered by computer are filtered through the trading desk at the brokerage before being entered electronically.

As with any new technology, online trading has been plagued by its own special set of problems. The availability of information makes many new investors think they are more knowledgeable than

they are, which leads them into risky and speculative investments. The ability to trade with speed and at a low cost does not automatically translate into the ability to trade well or wisely. As often happens, progress in technology outstrips the ability to understand or regulate it, and accordingly the Internet has become rife with fraud not only in the form of offerings, but also in the modern version of the boiler room operation.

Nor have the technical problems been completely worked out as demonstrated by the numerous outages as brokerage servers become overloaded and crash during critical trading periods. According to one recent survey more than 11 percent of online traders said they were unable to access their online broker once a week or more. Other problems of concern deal with customer service and encryption protection. As hackers have repeatedly proved, no system is foolproof or hacker safe.

Online trading is particularly susceptible to other problems, usually human inspired, where the lack of an immediate fill or crossing messages has led to multiple fills of the same order committing traders to amounts far in excess of their original orders and exacerbating losses in fast-moving markets before the traders are even aware of the problem.

The SEC has established an Office of Internet Enforcement to deal with companies and individuals who mislead investors concerning pay arrangements with companies for touting their stock in online newsletters, message boards, websites, and junk e-mail (spam). Complaints can be e-mailed to enforcement@sec.gov.

INTERNET STOCKS AS INVESTMENTS

The explosive growth of the Internet has fueled a feeding frenzy for Internet stocks, or anything with a .com in its name. The frenzy has made instant multimillionaires of company insiders and early investors who got in, took at least some of their profits, and got out.

The frenzy was fueled early on by the relative dearth of available shares, creating a classic mania bubble.

As more and more .com stocks came to market, instant returns were and are to be made only on the strongest, with many new issues of Internet stocks actually ending their first trading day below the offering price. For speculators, primarily growth mutual funds and small day traders, the mania has proved to be heady with stocks that have no earnings and often no revenues, being driven to prices 1,500 times *sales*. But nothing lasts forever and many of these stocks have pulled back substantially, in many cases considerably below the IPO price. As many market observers have noted, the current Internet mania is most reminiscent of the stock mania in the late 1920s when investors went crazy for auto and radio stocks. Out of the thirty plus auto companies in 1928 only three exist today, and RCA, which reached $500 per share in late 1929, did not reach that split adjusted price again for nearly 50 years. It may reasonably be assumed that history will repeat itself with many, if not most, of the current batch of IPOs falling by the wayside, if for no other reason than the historical norm that between 80% and 95% of all new businesses fail within the first two years.

It is certainly true that the Internet has forever changed the way commerce is conducted both at the national and global level. Geographical and national borders and, in many cases, sales forces become invisible or irrelevant. The movement to Internet commerce is in its infancy with the dollar volume set to explode, and as with every new innovation will come dislocations in employment and money flows. Already various state government are eyeing ways to tax Internet commerce to make up for what they perceive will be a dwindling sales tax revenue. The development of electronic commerce has already produced a fundamental shift in the creation of new businesses and the way established businesses present themselves. It is forcing business to compete in new ways in order to avoid being swept aside; e.g., the movement of large retail brokerage firms into the arena of online trading or Barnes and Noble.com going head to head with

Amazon.com. Yet it does not necessarily follow that today's pioneers will be tomorrow's survivors. Does anyone today remember Bowmar or Commodore Electronics or Osborne Computer? How do you tell the pioneers? *They are the ones with the arrows in their back.*

Perhaps the central point to be stressed in evaluating an Internet company as an investment is that the Internet itself represents a form of *disintermediation,* simply, removing the middle man between the producer and the end user. Many of the current business models for Internet companies merely replace one form of intermediation, i.e., the retail store, with another form of sales outlet, usually selling at a discount because of the reduced overhead that has not been invested in bricks and mortar; but this model relies almost solely on shopping convenience and price. The Internet itself changes the playing field when the consumer can search for the best price using a shopping robot. Those companies that fill a certain niche, provide a value-added service, or increase direct contact between producer and end user will be those that survive. Even in its infancy, the business model has begun to change. Search companies such as Yahoo! make the major part of their income from advertising on their website, but advertising renewals have been mixed as advertisers find that merely being on a hot website is no guarantee that surfers will click on their advertisement. The new model is being formulated by GoTo where advertisers pay only for actual hits on their advertising and can bid for positioning by what they are willing to pay per hit.

As businesses adjust and redirect their efforts toward e-commerce, it is rapidly becoming clear that as with any new technology, companies will adapt and prosper or fail. It is equally clear that a less risky investment in the Internet is to be found in those companies that supply and build out the infrastructure of e-commerce such as Cisco and Lucent. Think of Levi Strauss who began his fortune selling pants, dry goods, and mining tools to all the prospectors who came to seek their fortunes during the California gold rush. He never did any prospecting, but 150 years later, we are still wearing Levi's blue jeans.

DAY TRADING

I was hesitant to mention day trading since it is so clearly speculating rather than investing. However, the enormous growth of day trading and its effect on the overall market deserve some serious consideration even if admonitory.

Day traders quickly buy and sell stocks throughout the day in the hope of making quick profits for the seconds to minutes they own the stock and generally close out their positions by the end of the day. They usually trade on borrowed money (margin) hoping to gain larger profits through leverage, but also accepting the risk of higher losses as well. Most individuals do not have the wealth, time, or temperament, nor can they accept the possibly devastating losses that accompany day trading. Yet the ranks of those willing to take their shot at the fabled life of easy living continue to grow, prompting concern at both the markets and regulatory authorities.

Day trading firms provide the means for their customers to trade their own accounts and promote and facilitate a particular type of trading. Customers may trade through equipment at the firm's offices or on their own computers equipped with the firms special software.

In a report from the NASAA (North American Securities Administration Association) Project Group on Day trading dated August 19, 1999, the forward stated the hope that this report "may also serve as a word of caution for those who believe that day trading offers a viable career opportunity, or that frenetic trading is an alternative to prudent, diversified, long term investing."

The report identifies 62 active day trading firms with a total of 287 branches and cites the Electronic Traders Association estimates that 4,000–5,000 people trade full time through day trading brokerages making 150,000–200,000 trades a day which represent nearly 15% of daily NASDAQ volume. It goes on to point out that the turnover of these traders is very high with fresh players constantly

being needed to keep the trading brokerages in business. It compares day trading to gambling, and indicates that futures and options may be more effective speculative trading vehicles than stocks.

A better analogy is made to retail futures trading where trading by retail customers is generally unsuccessful, with industry leaders acknowledging that 80–90 percent of individual customers lose money. One principal of a day trading firm has been quoted as saying that day trading is like any other business and like most businesses, 95% will fail during the first two years.

The problems observed by the NASAA project group included:

1. deceptive marketing, including inadequate risk disclosure,

2. violation of suitability requirements,

3. questionable loan arrangements including promotion of loans among firm customers and loans to customers by brokers,

4. abuse of discretionary accounts where brokers have day traded customer's account,

5. encouragement of unregistered investment advisor activity through customers trading the funds of third parties,

6. failure to maintain proper books and records,

7. failure to supervise.

In a warning memo from the SEC, the following points were emphasized:

1. Day traders typically suffer severe financial losses during their first months of trading and many never attain profit making status.

2. Day traders do not "invest," but try to ride the momentum of a stock and get out before it changes direction. True day traders do not carry any positions overnight because of the high risk that prices may change radically by the next day.

3. Day traders have high expenses, paying their firms large amounts in commissions for training and computers. It is an extremely stressful form of work and a day trader should calculate ahead of time how much they will have to make in order to cover expenses and break even.

4. Day trading relies heavily on margin and day traders should understand how margin works, the time to meet margin calls, and the potential for sustaining heavy losses.

5. Do not believe the claims of easy profits. Watch out for hot tips from newsletters and websites catering to day traders. And that "educational seminars" may not be objective, but rather forwarding the views and objectives of the trading firm.

6. Use common sense and check out the trading firm with your state securities regulator.

7. Seventy percent of professional day traders lose money. You need the ability to lose money and be OK with that.

As with any other trading vehicle or system, it pays to investigate first.

GLOSSARY

Account Executive (AE) A brokerage firm employee who advises clients and handles orders for them. The AE must be registered with the National Association of Securities Dealers (NASD) before taking orders from clients. Also known as registered representative (RR) or financial consultant.

Accounting Equation A formula used in totaling balance sheets:

Total assets = Total liabilities + Shareholder's equity.

The formula may be restated in terms of shareholder's equity or in terms of total liabilities as follows:

Total assets – Total liabilities = Shareholder's equity or
Total assets – Shareholder's equity = Total liabilities.

Accounts Receivable Any money due a business for merchandise or securities that it has sold or for services it has rendered. This is a key determinant in analyzing a company's liquidity.

Accrued Interest (1) The amount of interest due the seller, from the buyer, on settlement of a bond trade. (2) Prorated interest due since the last interest payment date.

Acid Test Ratio The value of cash, cash equivalents, and accounts receivable (the quick assets) divided by current liabilities. A measurement of corporate liquidity. Also known as quick asset ratio or liquidity ratio.

All-or-None (AON) Order An order to buy or sell more than one round lot of stock at one time and at a designated price or better. It must not be executed until both conditions can be satisfied simultaneously.

Alternative (Either/Or) Order An order to do either of two alternatives such as either buy at a limit or buy stop for the same security. Execution of one part of the order automatically cancels the other part.

Annual Report A formal statement issued yearly by a corporation to its shareowners. It shows assets, liabilities, equity, revenues, expenses, and so forth. It is a reflection of the corporation's condition at the close of the business year, and the result of operations for that year.

Arrearage Undeclared and/or unpaid dividends due holders of cumulative preferred stock.

As Agent The role of a broker/dealer firm when it acts as an intermediary, or broker, between its customer and another customer, a market-maker, or a contrabroker. For this service the firm receives a stated commission or fee. This is an "agency transaction." *See* As Principal.

As Principal The role of a broker/dealer firm when it buys and sells for its own account. In a typical transaction, it buys from a market-maker or contrabroker and sells to a customer at a fair and reasonable markup; if it buys from a customer and sells to the market-maker at a higher price, the trade is called a mark-down. *See* As Agent.

Ask-Bid System A system used to place a market order. A market order is one the investor wants executed immediately at the best prevailing price. The market order to buy requires a purchase at the lowest offering (asked) price, and a market order to sell requires a sale at the highest (bid) price. The bid price is what the dealer is willing to pay for the stock, while the ask price is the price at which the dealer will sell to individual investors. The difference between the bid and ask prices is the spread. *See* Bid-and-Asked Quotation.

Assets Everything of value that a company owns or has due: cash, buildings, and machinery (fixed assets), and patents and goodwill (intangible assets). *See* Equity.

Authorized Stock The maximum number of shares that the state secretary permits a corporation to issue.

Balance Sheet A condensed statement showing the nature and amount of a company's assets, liabilities, and capital on a given date. It shows in dollar amounts what the company owns, what it owes, and the ownership interest (shareholders' equity).

Bar Chart In technical analysis, a chart used to plot stock movements with darkened vertical bars indicating price ranges. Most charts are issued daily, weekly, or monthly.

Barter To trade by exchange of commodities.

Bear Market A securities market characterized by declining prices. *See* Bull Market.

Bear Raiders Groups of speculators who pool capital and sell short to drive prices down and who then buy to cover their short positions—thereby pocketing large profits. This practice was outlawed by the Securities Exchange Act of 1934.

Bearer Bond A bond that does not have the owner's name registered on the books of the issuing corporation and that is payable to the bearer.

Best-Efforts Offering An offering of newly issued securities in which the investment banker acts merely as an agent of the corporation, promising only his "best efforts" in making the issue a success but not guaranteeing the corporation its money for any unsold portion.

Bid-and-Asked Quotation (or Quote) The bid is the highest price anyone has declared that he/she wants to pay for a security at a given time; the asked is the lowest price anyone will accept at the same time.

Block A large amount of securities, generally a minimum of either 10,000 shares or $200,000.

Blue Chip Stocks Common stocks of well-known companies with histories of profit growth and dividend payment, as well as quality management, products, and services. Blue chip stocks are usually high-priced and low-yielding. The term "blue chip" comes from the game of poker in which the blue chip holds the highest value.

Bond A certificate representing creditorship in a corporation and issued by the corporation to raise capital. The company pays interest on a bond issue at specified dates and eventually redeems it at maturity, paying principal plus interest due.

Branch Office Manager (BOM) The person charged with one or more of a member firm's branch offices. This person must meet certain requirements, such as passing a special exchange examination. Those who supervise the sales activities of three or more account executives must also pass the branch office manager examination.

Breakout In technical analysis, the rise through a resistance level or the decline through a support level by the market price of a security.

Broker An agent, often a member of a stock exchange firm or the head of a member firm, who handles the public's orders to buy and sell securities and commodities, for which service a commission is charged. *See* As Agent; As Principal.

Bull Market A securities market characterized by rising prices. *See* Bear Market.

Buying Power The dollar amount of securities a customer could purchase without depositing additional funds and continue to meet the initial margin requirements of Regulation T of the Federal Reserve.

Call Feature (1) A feature of preferred stock through which it may be retired at the corporation's option by paying a price equal to or slightly higher than either the par or market value. (2) A bond feature by which all or part of an issue may be redeemed by the corporation before maturity and under certain specified conditions.

Capital Gain (Loss) Profit (or loss) from the sale of a capital asset. Capital gains may be short-term (12 months or less) or long-term (more than 12 months). Capital losses are used to offset capital gains to establish a net position for tax purposes.

Cash Account An account in a brokerage firm in which all transactions are settled on a cash basis.

Cash Cow A colloquial term for any business that generates an ongoing cash flow. These businesses have well-known products and pay dividends reliably.

Cash Dividend Any payment made to a corporation's shareholders in cash from current earnings or accumulated profits. Cash dividends are taxable as income.

Certificate of Deposit (CD) A negotiable security issued by commercial banks against money deposited with them for a specified period of time. CDs vary in size according to the amount of the deposit and the maturity period, and they may be redeemed before maturity only by sale in a secondary market.

Charter A document written by the founders of a corporation and filed with a state. The state approves the articles and then issues a certificate of incorporation. Together, the two documents become the charter and the corporation is recognized as a legal entity. The charter includes such information as the corporation's name, purpose, amount of shares, and the identity of the directors.

Clearance (1) The delivery of securities and monies in completion of a trade. (2) The comparison and/or netting of trades prior to settlement.

Commission A broker's fee for handling transactions for a client in an agency capacity.

Commission House Broker A member of the NYSE executing orders on behalf of his/her own organization and its customers.

Commodity A bulk good that is grown or mined, such as grains or precious metals. *See* Futures.

Common Stock A unit of equity ownership in a corporation. Owners of this kind of stock exercise control over corporate affairs and enjoy any capital appreciation. They are paid dividends only after preferred stock. Their interest in the assets, in the event of liquidation, is junior to all others.

Conversion (1) A bond feature by which the owner may exchange his/her bonds for a specified number of shares of stock. Interest paid on such bonds is lower than the usual interest rate for straight debt issues. (2) A feature of some preferred stock by which the owner is entitled to exchange preferred for common stock, usually of the same company, in accordance with the terms of the issue. (3) A feature of some mutual fund offerings allowing an investor to exchange shares for comparable value in another fund with different objectives handled by the same management group.

Convertible Bond Bond that can be exchanged for a specified number of another security, usually shares, at a prestated price. Convertibility typically enhances the bond's marketability.

Convertible Preferred Stock *See* Conversion (2).

Corporation A business organization chartered by a state secretary as a recognized legal institution of and by itself and operated by an association of individuals, with the purpose of ensuring perpetuity and limited financial liability.

Credit Agreement A document containing the complete terms and arrangements by which financing will be conducted in a customer's account. It emphasizes when and how interest is charged for the lending service provided.

Crowd *See* Trading Crowd.

Cumulative Preferred Stock A preferred stock that accrues any omitted dividends as a claim against the company. This claim must be paid in full before any dividends may be paid on the company's common stock.

Current Market Value (1) According to Regulation T of the Federal Reserve Board, the latest closing price (or quotation, if no sale occurred). (2) According to NYSE rules, the up-to-the-minute last sale price of a security.

Current Ratio Current assets divided by current liabilities. Also known as working capital ratio.

Current Yield The annual dollar interest paid by a bond divided by its market price. It is the actual return rate, not the coupon rate. Example: Any bond carrying a 6% coupon and trading at 95 is said to offer a current yield of 6.3% ($60 coupon ÷ $950 market price = 6.3%).

Customer's Agreement A document that explains the terms and conditions under which a brokerage firm consents to finance a customer's credit transaction. Also known as margin agreement or hypothecation agreement.

Cyclical Stock Any stock, such as housing industry-related stock, that tends to rise in price quickly when the economy turns up and fall quickly when the economy turns down.

Date of Record The date set by the corporate board of directors for the transfer agent to close the agency's books to further changes in registration of stock and to identify the recipients of a forthcoming distribution. Also known as record date. *See* Ex-Dividend Date.

Dealer An individual or firm in the securities business acting as a principal rather than as an agent.

Debenture An unsecured debt offering by a corporation, promising only the general assets as protection for creditors. Sometimes the so-called "general assets" consist of only goodwill and reputation.

Debit Balance The balance owed by a customer in his/her account as reflected on the brokerage firm's ledger statement of settled transactions.

Debt/Equity Ratio The ratio of long-term debt to shareholders' equity.

Debt Instrument A bond or bond-like security—a nonequity.

Declaration Date The day on which a corporation's board of directors announces a dividend.

Default The failure of a corporation to pay principal and/or interest on outstanding bonds or dividends on its preferred stock.

Discount Bond A bond that sells in the marketplace at a price below its face value.

Distribution The sale of a large block of stock, through either an underwriting or an exchange distribution.

Diversification (1) Spreading investments and contingent risks among different companies in different fields of endeavor. (2) Investing in the securities of one company that owns or has holdings in other companies. (3) Investing in a fund with a portfolio containing many securities.

Dividend Payout The percentage of dividends distributed in terms of what is available out of current net income.

Dividends Distributions to stockholders declared by the corporate board of directors.

Dividends Payable A current liability showing the amount due to stockholders for dividends declared but not yet paid.

Dow-Jones Average A market average indicator consisting (individually) of (1) thirty industrial, (2) twenty transportation, and (3) fifteen public utility common stocks. The composite average includes these 65 stocks collectively.

Dow Theory A theory predicated on the belief that the rise or fall of stock prices is both a mirror and a forecaster of business activities.

Equity (1) The ownership interest in a company of holders of its common and preferred stock. (2) The excess of value of securities over the debit balance in a margin (general) account.

Escrow Assets in a third-party account to ensure the completion of a contract by all parties.

Ex-Dividend (Without Dividend) Date A date set by the Uniform Practice Committee or by the appropriate stock exchange, on which a given stock will begin trading in the marketplace without the value of a pending dividend included in the contract price. It is closely related to and dependent on the date of record. It is often represented as "X" in the stock listing tables in the newspapers.

Execution Synonym for a transaction or trade between a buyer and seller.

Expiration Date The date an option contract becomes void. The expiration date for listed stock options is the Saturday after the third Friday of the expiration month. All holders of options who wish to exercise must indicate their desire to do so by this date.

Farm Credit Bank Bank set up to deal with the specific financial needs of farmers and their businesses.

Federal Home Loan Banks (FHLB) A government-sponsored agency that finances the home-building industry with mortgage loans from monies raised on offerings of bond issues; interest on these bonds is free from state and local income taxes.

Federal National Mortgage Association (FNMA) A publicly owned, government-sponsored corporation that purchases and sells mortgages insured by the Federal Housing Administration (FHA) or Farmers Home Administration (FHA); or guaranteed by the Veterans' Administration (VA). Interest on these bonds, called Fannie Maes, is fully taxable.

Fill-or-Kill (FOK) Order An order that requires the immediate purchase or sale of a specified amount of stock, though not necessarily at one price. If the order cannot be filled immediately, it is automatically cancelled (killed).

Floor The securities trading area of an exchange. *See* Ring; Trading Post.

Floor Broker A person who works on the exchange floor executing the orders of public customers or other investors who do not have physical access to the area.

Floor Order Tickets Abbreviated forms of order tickets, used on the floor of the exchange for recording executions.

Fundamental Analysis A method for analyzing the prospects of a security through the observation of accepted accounting measures such as earnings, sales, assets, and so on. *See* Technical Analysis.

Futures Short for futures contract, which is an agreement to make or take delivery of a commodity at a specified future time and price. The contract is transferable and can therefore be traded like a security. Although futures contracts were once limited to commodities, they are now available on financial instruments, currencies, and indexes. Noncommodity futures contracts often differ from their predecessors in important respects; for example, "delivery" on an index is irrelevant.

Going Public A private company is "going public" when it first offers its shares to the investing public.

Good-till-Cancelled (GTC or Open) Order An order to buy or sell that remains valid until executed or cancelled by the customer. *See* Limit; Stop; Stop Limit.

Growth Company (Stock) A company (or its stock) that has made fast gains in earnings over the preceding few years and that is likely to keep on showing such signs of growth.

Immediate or Cancel (IOC) Order An order that requires immediate execution at a specified price of all or part of a specified amount of stock; the unexecuted portion has to be cancelled by the broker.

Indenture A written agreement between corporation and creditors containing the terms of a debt issue, such as rate of interest, means of payment, maturity date, terms of prior payment of principal, collateral, priorities of claims, trustee.

Individual Retirement Account (IRA) Under certain circumstances, individuals not enjoying a qualified retirement plan at their place of employment may qualify to deduct from their federal taxable income an amount, as specified by the prevailing tax law, and set that amount aside for their retirement.

Investment Banker A broker/dealer organization that provides a service to industry through counsel, market making, and underwriting of securities.

Issue (Issuance) (1) Any of a company's class of securities. (2) The act of distributing securities.

Issued-and-Outstanding Stocks That portion of authorized stock distributed among investors by a corporation.

Joint Account An account including two or more people.

Junk Bond Any bond with a Moody's or Standard & Poor's credit rating of BB or lower. Such bonds, usually issued by companies without long track records, can produce high yields.

Keogh Plan Initiated under the provisions of the Self-Employed Individuals Tax Retirement Act of 1962, this term applies to programs that enable an individual to defer payment of any income

taxes on either a percentage of annual earned income or $30,000 until the individual retires and begins to withdraw funds from this accumulated pool of capital.

Leverage (1) In securities, increasing return without increasing investment. Buying stock on margin is an example. (2) In finance, the relationship of a firm's debt to its equity, as expressed in the debt-to-equity ratio. If the company earns a return on the borrowed money greater than the cost of the debt, it is successfully applying the principle of leverage.

Leveraged Buy-out Taking over a controlling interest in a company using borrowed money.

Limit The greatest price change permitted by the Chicago Mercantile Exchange in any particular commodity during the trading day.

Limit Order An order in which a customer sets a maximum price he/she is willing to pay as a buyer and a minimum price he/she is willing to accept as a seller. *See* Market Order; Stop Order.

Limit Price A modification of an order to buy or sell. With a sell limit order, the customer is instructing the broker to make the sale at or above the limit price. With a buy limit order, the customer is instructing the broker to make the purchase at or below the limit price.

Limited Trading Authorization *See* Power of Attorney (2).

Liquidation The voluntary or involuntary closing out of security positions.

Liquidity (1) The ability of the market in a particular security to absorb a reasonable amount of trading at reasonable price changes. Liquidity is one of the most important characteristics of a good market. (2) The relative ease with which investors can convert their securities into cash.

Listed Stock The stock of a company traded on a securities exchange and for which a listing application and registration statement have been filed with the SEC and the exchange itself.

Long Position The ownership of securities.

Margin The amount of money or securities that an investor must deposit with a broker to secure a loan from the broker. Brokers may lend money to investors for use in trading securities. To procure such a loan, an investor must deposit cash with the broker. (The amount is prescribed by the Federal Reserve System in Regulation T.) The cash represents the equity, or margin, in the investor's account.

Margin Call A demand on the customer to deposit money or securities with the broker when a purchase or short-sale is effected.

Margin (General) Account An account in which a customer uses credit from a broker/dealer to take security positions.

Marketable Security (1) A security that may be readily purchased or sold. (2) A U.S. government bond freely traded in the open market.

Market-Maker (1) An options exchange member who trades for his/her own account and risk. This member is charged with the responsibility of trading so as to maintain a fair, orderly, and competitive market. He/she may not act as agent. (2) A firm actively making bids and offers in the OTC market.

Market Not Held Order An order to buy or sell securities at the current market with the investor leaving the exact timing of its execution up to the floor broker. If the floor broker is holding a "market not held" buy order and the price could decline, he/she may wait to buy when a better price becomes available. There is no guarantee for the investor that a "market not held" order will be filled at a better price than if the order were not marked "not held."

Market Order An order to be executed immediately at the best available price.

Market Price (1) The last reported sale price for an exchange-traded security. (2) For over-the-counter securities, a consensus among market-makers.

Market Value The price that would be paid for a security or other asset.

Maturity (Date) The date on which a loan, bond, or debenture comes due; both principal and any accrued interest due must be paid.

Missing the Market The failure by a member of the exchange to execute an order due to his/her negligence. The member is obliged to promptly reimburse the customer for any losses due to the mistake.

Money Market The market for dealers who trade riskless, short-term securities: T-bills, certificates of deposits, banker's acceptances, and commercial paper.

Money Market Fund Name for an open-ended investment company whose portfolio consists of money market securities.

Moody's Investors Service One of the best-known bond rating agencies, owned by Dun & Bradstreet. Moody's Investment Grade assigns letter grades to bonds based on their predicted long-term yield (MIG1, MIG2, etc.). Moody's also rates commercial paper, municipal short-term issues, and preferred and common stocks. Another publication is a six-volume annual, with weekly or semiweekly supplements, giving great detail on issuers and securities. Publications include *Moody's Bond Record* and *Moody's Bond Survey*. Moody's investment ratings are considered the norm for investment decisions by fiduciaries.

Mortgage-Backed Certificate (Security) A security (1) that is issued by the Federal Home Loan Mortgage Corporation, the Federal National Mortgage Association, and the Government National Mortgage Association, and (2) that is backed by mortgages. Payments to investors are received out of the interest and principal of the underlying mortgages.

Municipal Bond (Security) Issued by a state or local government, a debt obligation whose funds may either support a government's general financing needs or be spent on special projects. Many municipal bonds are free from federal tax on the accrued interest and also free from state and local taxes if issued in the state of residence.

Mutual Fund An open-end investment company, a mutual fund offers the investor the benefits of portfolio diversification (that is, owning more different shares to provide greater safety and reduce volatility).

National Association of Securities Dealers (NASD) An association of broker/dealers in over-the-counter securities organized on a non-profit, nonstock-issuing basis. Its general aim is to protect investors in the OTC market.

National Association of Securities Dealers Automated Quotation System (NASDAQ) A computerized quotations network by which NASD members can communicate bids and offers. *Level 1* Provides only the arithmetic mean of the bids and offers entered by members. *Level 2* Provides the individual bids and offers next to the name of the member entering the information. *Level 3* Available to NASD members only, enables the member to enter bids and offers and receive Level 2 service.

Net Asset Value (NAV) per Share (1) Net assets divided by the number of outstanding shares. (2) For an open-end investment company, often the net redemption price per share. (3) For a no-load, open-end investment company, both the net redemption price per share and the offering price per share.

Net Profit Margin The ratio of net profit divided by net sales.

New Issue (1) Any authorized but previously unissued security offered for sale by an issuer. (2) The resale of treasury shares.

Nominal Yield The annual interest rate payable on a bond, specified in the indenture and printed on the face of the certificate itself. Also known as coupon yield.

Nonpurpose Loan A loan involving securities as collateral that is arranged for any purpose other than to purchase, carry, or trade margin securities.

Normal Trading Unit The accepted unit of trading in a given marketplace: On the NYSE it is 100 shares (round lot) for stocks and $1,000 par value for bonds. In some relatively inactive stocks, the unit is 10 shares. For NASDAQ-traded securities, it is 100 shares for stocks and $10,000 par value for bonds. *See* Odd Lots; Round Lots.

Not Held (NH) Order An order that does not hold the executing member financially responsible for using his/her personal judgment in the execution price or time of a transaction.

Odd Lot An amount of stock less than the normal trading unit. *See* Round Lot.

Offer The price at which a person is ready to sell. *See* Bid-and-Asked Quotation (or Quote).

Offering Circular (1) A publication that is prepared by the underwriters and that discloses basic information about an issue of securities to be offered in the primary market. (2) Sometimes used to describe a document used by dealers when selling large blocks of stock in the secondary market.

Office Order Tickets Transaction order forms filled out in great detail at each sales office of member firms. *See* Floor Order Tickets.

Option A contract wherein one party (the option writer) grants another party (buyer) the right to demand that the writer perform a certain act.

Order Department A group that routes buy and sell instructions to the trading floors of the appropriate stock exchanges and executes orders in the OTC market for trading accounts of both firms and customers.

Over-the-Counter Market (OTC) A securities market, conducted mainly over the telephone, made up of dealers who may or may not be members of a securities exchange. Thousands of companies have insufficient shares outstanding, stockholders, or earnings to warrant listing on a national exchange. Securities of these companies are therefore traded in the over-the-counter market between dealers who act either as agents for their customers or as principals. The over-the-counter market is the principal market for U.S. government and municipal bonds and for stocks of banks and insurance companies.

Paper Loss/Profit An unrealized loss or profit on a security still held. Paper losses and profits become actual when a security position is closed out by a purchase or sale.

Par Value The face or nominal value of a security. (1) A dollar amount assigned to a share of common stock by the corporation's charter. At one time, it reflected the value of the original investment behind each

share, but today it has little significance except for bookkeeping purposes. Many corporations do not assign a par value to new issues. For preferred shares or bonds, par value has importance insofar as it signifies the dollar value on which the dividend/interest is figured and the amount to be repaid upon redemption. (2) Preferred dividends are usually expressed as a percentage of the stock's par value. (3) The interest on bonds is expressed as a percentage of the bond's par value.

Partnership A type of business organization typified by two or more proprietors.

Pass-Through Security (P/T) A debt security representing an interest in a pool of mortgages requiring monthly payments composed of interest on unpaid principal and a partial repayment of principal. Thus the payments are passed through the intermediaries, from the debtors to investors.

Payment Date The day a corporation makes payment of dividends to its previously determined holders of record.

Penny Stocks Colloquial term for—but not limited to—low-priced, high-risk stocks that usually sell for less than $1 per share. These shares usually require a special margin maintenance requirement, and purchases are often limited to unsolicited orders.

Pink Sheets A list of securities being traded by over-the-counter market makers, published every business day by the National Quotations Bureau. Equity securities are published separately on long pink sheets. Debt securities are published separately on long yellow sheets.

Point (1) In stocks, $1. (2) In bonds, since a bond is quoted as a percentage of $1,000, a point equals $10. For example, a municipal security discounted at 3 1/2 points equals $35. It is quoted at 96 1/2 or $965 per $1,000. (3) In market averages, it means simply a point—a unit of measure.

Point and Figure (P&F) Chart In technical analysis, a chart of price changes in a security. Upward price changes are plotted as X's, and downward prices are plotted as O's. Time is not reflected on this type of chart.

Portfolio Holdings of securities by an individual or institution. A portfolio may include preferred and common stocks, as well as bonds, of various enterprises.

Power of Attorney (1) The legal right conferred by a person or institution upon another to act in the former's stead. (2) In the securities industry, a *limited power of attorney* given by a customer to a representative of a broker/dealer would normally give a registered representative trading discretion over the customer's account. The power is limited in that neither securities nor funds may be withdrawn from the account by the representative. (3) In the securities industry, an *unlimited power of attorney* given by a customer to a representative of a broker/dealer would normally give a registered representative full discretion over the conduct of the customer's account.

Preferred Stock Owners of this kind of stock are entitled to a fixed dividend to be paid regularly before dividends can be paid on common stock. In the event of liquidation, claims to assets are senior to those of holders of common stock but junior to those of bondholders. Holders of preferred stock normally do not have a voice in management.

Preliminary Official Statement (POS) Also known as the preliminary prospectus, the preliminary version or draft of an official statement, as issued by the underwriters or issuers of a security, and subject to change prior to the confirmation of offering prices or interest rates. It is the only form of communication allowed between a broker and prospective buyer before the effective date, usually to gauge the interest of prospective purchasers. Offers of sale are not accepted on the basis of a preliminary statement. A statement to that effect, printed in red, appears vertically on the face of the document. This caveat, required by the Securities Act of 1933, is what gives the document its nickname, "red herring."

Preliminary Prospectus *See* Preliminary Official Statement (POS).

Premium (1) The amount by which the price paid for a preferred security exceeds its face value. (2) The total price of an option, equal to the intrinsic value plus the time value premium. (3) The market price of a bond selling at a price above its face amount. For example,

"trading at 101" means that, for $1,010, one could purchase a bond that would pay $1,000 principal at maturity. *See* Discount Bond.

Price/Equity Ratio The ratio of the market price of a common share to the book value of a common share.

Price-to-Earnings (P/E) Ratio A ratio used by some investors to gauge the relative value of a security in light of current market conditions.

$$R = \frac{Price}{Earnings}$$

Principal Value The face value of an obligation that must be repaid at maturity and that is separate from interest. Often called simply "principal."

Private Placement The distribution of unregistered securities to a limited number of purchasers without the filing of a statement with the SEC. Such offerings generally require submission of an investment letter to the seller by all purchasers.

Proprietorship (Individual) A type of business structure consisting of one owner, who is personally responsible for all debt liabilities but who also can manage the business as he/she sees fit.

Pro Rata According to a certain rate, in proportion.

Prospectus A document that contains material information for an impending offer of securities (containing most of the information included in the registration statement) and that is used for solicitation purposes by the issuer and underwriters.

Proxy (1) A formal authorization (power of attorney) from a stockholder that empowers someone to vote on his/her behalf. (2) The person who is so authorized to vote on behalf of a stockholder.

Proxy Statement Material information required by the SEC to be given to a corporation's stockholders as a prerequisite to solicitation of votes.

Public Offering (Distribution) The offering of securities for sale by an issuer.

Purchase and Sales (P&S) Department The department in operations responsible for the first processing of a trade. Responsibilities include the recording of order executions, figuring monies due and payable as a result of trades, preparing customer confirmations, and making trade comparisons with other brokers.

Put Option A privilege giving its holder the right to demand acceptance of his/her delivery of 100 shares of stock at a fixed price any time within a specified lifetime.

Qualified Legal Opinion A conditional affirmation of a security's legality, which is given before or after the security is sold. An unqualified legal opinion (called a clean opinion) is an unconditional affirmation of the legality of securities.

Quick Asset Ratio *See* Acid Test Ratio.

Rate of Return (1) In fixed income investment, *see* Current Yield. (2) In corporate financing, *see* Return on Equity.

Record Date *See* Date of Record.

Redemption (1) For bonds, the retirement of the securities by repayment of face value or above (that is, at a premium price) to their holders. (2) For mutual funds, the shareholder's privilege of converting his/her interest in the fund into cash—normally at net asset value.

Registered Bond An outstanding bond whose owner's name is recorded on the books of the issuing corporation. Legal title may be transferred only when the bond is endorsed by the registered owner.

Registered (Floor) Trader A member of the NYSE who buys and sells stocks for his/her own account and risk.

Registered Representative *See* Account Executive.

Registrar Often a trust company or bank, the registrar is charged with the responsibility of preventing the issuance of more stock than authorized by the company. It insures that the transfer agent issues exactly the same number of shares cancelled with each re-registration of certificates.

Registration Statement A document required to be filed with the SEC by the issuer of securities before a public offering may be attempted. The Securities Act of 1933 mandates that it contain all material and accurate facts. Such a statement is required also when affiliated persons intend offering sizable amounts of securities. The SEC examines the statement for a 20-day period, seeking obvious omissions or misrepresentations of fact.

Regular Way Contract The most frequently used delivery contract. For stocks and corporate and municipal bonds, this type of contract calls for delivery on the third business day after the trade. For U.S. government bonds and options, delivery must be made on the first business day after the trade.

Regulation T A federal regulation that governs the lending of money by brokerage firms to its customers.

Repurchase Agreement (Repo) (1) A Federal Open Market Committee arrangement with a dealer in which it contracts to purchase a government or agency security at a fixed price, with provision for its resale at the same price at a rate of interest determined competitively. Used by dealers in government and municipal securities to reduce carrying costs. This transaction is not legal for nonexempt securities. (2) A method of financing inventory positions by sale to a nonbank institution with the agreement to buy the position back.

Resistance In technical analysis, an area above the current stock price where the stock is available in abundance and where selling is aggressive. This area is said to contain what chartists call a resistance level. For this reason, the stock's price may have trouble rising through the price. *See* Support.

Resistance Level *See* Resistance.

Retirement of Debt Securities The repayment of principal and accrued interest due to the holders of a bond issue.

Return on Equity A corporation's net income divided by shareholder's equity.

Ring The circular trading area in a commodity exchange. Also called the pit.

Round Lot A unit of trading or a multiple thereof. On the NYSE, stocks are traded in round lots of 100 shares for active stocks and 10 shares for inactive ones. Bonds are traded in units of $1,000. *See* Normal Trading Unit; Odd Lot.

Savings Bond Bond issued through the U.S. government at a discount and in face values from $50 to $10,000. The interest is exempt from state and local taxes, and from federal tax until the bond is redeemed.

Secondary Market (1) A term referring to the trading of securities not listed on an organized exchange. (2) A term used to describe the trading of securities other than a new issue.

Securities & Exchange Commission (SEC) A government agency responsible for the supervision and regulation of the securities industry.

Sell Stop Order A memorandum that becomes a market order to sell if and when someone trades a round lot at or below the memorandum price.

Settlement (Delivery) Date The day on which certificates involved in a transaction are due at the purchaser's office.

Share A stock certificate—a unit of measurement of the equity ownership of a corporation.

Shareholders' (Stockholders') Equity The financial interest of the stockholders in the net assets of a company. It is the aggregate of the accounts of holders of preferred and common stock accounts, as depicted on a balance sheet.

Short Market Value The market value of security positions that a customer owes to a broker/dealer (short in the account).

Short Position (1) The number of shares in a given security sold short and not covered as of a particular date. (2) The total amount

of stock sold short by all investors and not covered as of a particular date. (3) A term used to denote the writer of an option.

Short Sale The sale of a security that is not owned at the time of the trade, necessitating its purchase some time in the future to "cover" the sale. A short sale is made with the expectation that the stock value will decline, so that the sale will be eventually covered at a price lower than the original sale, thus realizing a profit.

Short-Stop (Limit) Order A memorandum that becomes a limit order to sell short when someone creates a round-lot transaction at or below the memorandum price (electing sale). The short sale may or may not be executed since the rules then require that it be sold at least one-eighth above the electing sale as well as high enough in value to satisfy the limit price.

Special Miscellaneous (Memorandum) Account (SMA) An account defined under Regulation T used to record a customer's excess margin and buying power. Excess funds arise from sales proceeds, market value appreciation, dividends, or cash.

Specialist A member of the NYSE with two essential functions. First, to maintain an orderly market, insofar as is reasonably practicable, in the stocks in which he/she is registered as a specialist. To do this, the specialist must buy and sell for his/her own account and risk, to a reasonable degree, when there is a temporary disparity between supply and demand. To equalize trends, the specialist must buy or sell counter to the direction of the market. Second, the specialist acts as a broker's broker, executing orders when another broker cannot afford the time. At all times the specialist must put the customer's interest before his/her own. All specialists are registered with the NYSE as regular, substitute, associate, or temporary.

Specialized Companies Investment companies that concentrate their investments in one industry, group of related industries, or a single geographic area of the world for the purpose of long-term capital growth.

Standard & Poor's (S&P) Corporation A source of investment services, most famous for its *Standard & Poor's Rating* of bonds and

its composite index of 425 industrial, 20 transportation, and 55 public utility common stocks, called *Standard & Poor's Index.*

Stocks Certificates representing ownership in a corporation and a claim on the firm's earnings and assets; they may pay dividends and can appreciate or decline in value. *See* Authorized Stock; Common Stock; Issued-and-Outstanding Stock; Preferred Stock; Treasury Stock.

Stop Limit Order A memorandum that becomes a limit (as opposed to a market) order immediately after a transaction takes place at or through the indicated (memorandum) price.

Stop Loss Order A customer's order to set the sell price of a stock below the market price, thus locking in profits or preventing further losses.

Stop Order A memorandum that becomes a market order only if a transaction takes place at or through the price stated in the memorandum. Buy stop orders are placed above the market, and sell stop orders are placed below it. The sale that activates the memorandum is called the electing (activating or triggering) sale. *See* Market Order; Sell Stop Order.

Street Name When securities have been bought on margin or when the customer wishes the security to be held by the broker/dealer, the securities are registered and held in the broker/dealer's own firm (or "street") name.

Subscription An agreement to buy a new issue of securities. The agreement specifies the subscription price (the price for shareholders before the securities are offered to the public). This right is called the subscription privilege or subscription right.

Support In technical analysis, an area below the current price of the stock where the stock is in short supply and where the buyers are aggressive. The stock's price is likely not to go lower than this level, which is called a support level. *See* Resistance.

Support Level *See* Support.

Sweetener A special feature in a securities offering, such as convertibility, that encourages the purchase of the security.

Technical Analysis An approach to market theory stating that previous price movements, properly interpreted, can indicate future price patterns.

Tennessee Valley Authority (TVA) A government-sponsored agency whose bonds are redeemable from the proceeds of the various power projects in the Tennessee River area. Interest payments on these bonds are fully taxable to investors.

Ticker (Tape) A trade-by-trade report in chronological order of trades executed, giving prices and volumes. Separate tapes exist for various markets. The mechanism used to be mechanical, but it is now some sort of electronic display.

Trade Date The date a trade was entered into, as opposed to settlement date.

Trading Authorization The legal right conferred by one person or institution on another to effect the purchase and/or sale of securities in the former's account.

Trading Crowd Members of an exchange involved in the purchase and sale of a particular issue. They gather at the specialist's position.

Trading Floor The location of any organized exchange where buyers and sellers meet to transact business.

Trading on the Equity The situation that exists when the rate of return a company earns in its business is higher than the cost it pays for the money it borrows, that is, the rate of return is greater than the rate of interest paid on borrowed funds.

Trading Post Twenty-three locations on the floor of the NYSE that were seven-foot-high, horseshoe-shaped structures with an outside circumference from 26 to 31 feet. The one exception is a table-like structure, Post 30, in the garage, where most inactive preferred stocks are traded in multiples of 10 shares. The posts have been replaced by a round structure with a lot of electronics display.

Transfer Agent An agent of a corporation responsible for the registration of shareowners' names on the company records and the proper re-registration of new owners when a transfer of stock occurs.

Treasury Bill A federal bearer obligation issued in denominations ranging from $10,000 to $1 million with maturity dates usually of three months to a year. A T-bill is fully marketable at a discount from face value (which determines the interest rate).

Treasury Stock Shares of stock reacquired by a corporation through purchase, and occasionally by donation, that are treated as authorized-but-unissued stock for purposes of calculating dividends, voting, or earnings.

Trend Movement, up or down, in a security's market price or in the market itself, for a period of six months or more.

Two-Dollar Broker A member of the New York Stock Exchange who executes orders in any security for any organization, in return for a brokerage fee. The fee, which is negotiable, is actually larger than $2 per trade. These brokers are also known as independent brokers or agents.

Underwriter Also known as an "investment banker" or "distributor," a middleman between an issuing corporation and the public. The underwriter usually forms an underwriting group, called a syndicate, to limit risk and commitment of capital. He/she may also contract with selling groups to help distribute the issue—for a concession. In the distribution of mutual funds, the underwriter may also be known as a "sponsor," "distributor," or even "wholesaler." Investment bankers also offer other services, such as advice and counsel on the raising and investment of capital.

Underwriting Agreement The contract between the investment banker and the corporation, containing the final terms and prices of the issue. It is signed either on the evening before or early in the morning of the public offering date (effective date).

Uniform Gifts to Minors Act A simplified law that enables minors to own property or securities in a beneficial fashion without need of trust instruments or other legal documents. Someone of legal age must serve as custodian for the minor's assets. In the securities industry, the term describes securities bought and sold under the provisions of this law.

United States Government Securities Debt issues of the U.S. government (Treasury Department), backed by the government's unlimited power of taxation, such as Treasury bills, notes, bonds, and Series EE and Series HH bonds. *See* Marketable Securities Savings Bond.

Vertical Line Charting A method of technical analysis in which the high and low for the period (usually a day) are shown as a vertical line on the chart, with the closing price shown as a small horizontal line.

Warrant An inducement attached to new securities in distribution giving purchasers a long-term (usually a five- to ten-year) privilege of subscribing to one or more shares of stock reserved for them by the corporation from its unissued or treasury stock reserve. *See* Subscription Right.

Watered Stock A corporation's issuance of additional shares without increasing its capital. Also called diluting the shares.

Wire House Any large exchange member firm with many branch offices.

Yield (Rate of Return) The percentage return on an investor's money in terms of current prices. It is the annual dividend/interest per share or bond, divided by the current market price of that security.

Yield-to-Maturity The calculation of an average rate of return on a bond (with a maturity over one year) if it is held to its maturity date and if all cash flows are reinvested at the same rate of interest. It includes an adjustment for any premium paid or discount received. It is a calculation used to compare relative values of bonds.

Zero-Coupon Discount Security A debt security that offers no payments of interest—only payment of full face value at maturity—but that is issued at a deep discount from face value.

Recommended

Reading

FUNDAMENTAL ANALYSIS

The Intelligent Investor by Benjamin Graham (Harper & Row)

Security Analysis: Principles and Techniques by Benjamin Graham and David L. Dodd (McGraw Hill)

TECHNICAL ANALYSIS

Technical Analysis of Stock Trends by Robert D. Edwards and John Magee (John Magee Inc.)

Stock Market Logic by Norman G. Fosback (Institute for Econometric Research)

OPTIONS

Options as a Strategic Investment by Lawrence G. McMillan (New York Institute of Finance)

COMMODITIES

How the Futures Markets Work by Jake Bernstein (New York Institute of Finance)

The Investor's Quotient, 2nd ed. by Jake Bernstein (John Wiley)

The Compleat Daytrader by Jake Bernstein (McGraw-Hill)

TECHNOLOGY AND THE INTERNET

Silicon Snake Oil by Clifford Stoll (Anchor Books)

Sources for Additional Information on Brokerage Firms

U.S. Securities and Exchange Commission
450 Fifth Street, NW
Washington, DC 20549
(202) 942-7040
Toll-free Investor Information Service (800) SEC-0330
Public Reference Room, Washington, DC 20549 (202) 942-8092

Order a copy of a brokerage firm's registration statement (Form BD). Also available on the Internet.

U.S. Securities and Exchange Commission
Office of Consumer Affairs and Information Services
Washington, DC 20549
(202) 942-7114

"Consumers Should Know" booklet, "Investigate Before You Invest" booklet, "How to Proceed with the Arbitration of a Small Claim" booklet.

Regional and Branch Offices
NORTHEAST REGIONAL OFFICE
7 World Trade Center, Suite 1300
New York, NY 10278
(212) 748-8000

BOSTON DISTRICT OFFICE
73 Tremont Street, Suite 600
Boston, MA 02108-3912
(617) 424-5900

PHILADELPHIA DISTRICT OFFICE
The Curtis Center, Suite 1005E
601 Walnut Street
Philadelphia, PA 19106-3322
(215) 597-3100

SOUTHEAST REGIONAL OFFICE
1401 Brickell Avenue, Suite 200
Miami, FL 33131
(305) 536-4700

ATLANTA DISTRICT OFFICE
3475 Lenox Road, N.E., Suite 1000
Atlanta, GA 30326-1232
(404) 842-7600

MIDWEST REGIONAL OFFICE
Citicorp Center
500 W. Madison Street, Suite 1400
Chicago, IL 60661-2511
(312) 353-7390

CENTRAL REGIONAL OFFICE
1801 California Street, Suite 4800
Denver, CO 80202-2648
(303) 844-1000

FORT WORTH DISTRICT OFFICE
801 Cherry Street, Suite 1900
Fort Worth, TX 76102
(817) 978-3821

SALT LAKE DISTRICT OFFICE
500 Key Bank Tower
50 South Main Street, Suite 500, Box 79
Salt Lake City, UT 84144-0402
(801) 524-5796

PACIFIC REGIONAL OFFICE
5670 Wilshire Boulevard, 11th Floor
Los Angeles, CA 90036-3648
(213) 965-3998

SAN FRANCISCO DISTRICT OFFICE
44 Montgomery Street, Suite 1100
San Francisco, CA 94104
(415) 705-2500

NASD arbitrations are handled at the following locations:

New York
NASD Regulation, Inc.
125 Broad Street, 36th Floor
New York, NY 10004-2193
(212) 858-4400
Fax: (212) 858-3974

Washington, DC—Satellite Office
NASD Regulation, Inc.
1735 K Street, NW
Washington, DC 20006
(202) 728-8958
FAX: (202) 728-6952

California
NASD Regulation, Inc.
525 Market Street, Suite 300
San Francisco, CA 94105
(415) 882-1234
Fax: (415) 546-6990

Los Angeles—Satellite Office
NASD Regulation, Inc.
300 S. Grand Avenue, Suite 1620
Los Angeles, CA 90071
(213) 613-2680
FAX: (213) 613-2677

Florida
NASD Regulation, Inc.
515 E. Las Olas Boulevard, Suite 1100
(954) 522-7391
Fax: (954) 522-7403

Illinois
NASD Regulation, Inc.
10 S. LaSalle Street, Suite 1110
Chicago, IL 60603-1002
(312) 899-4440
Fax: (312) 236-9239

Recommended
Websites

The following is a list of Internet sites that I have found to be particularly useful, and I have barely scratched the surface.

GOVERNMENT WEBSITES

SEC:
Office of Internet Enforcement
www.enforcement@sec.gov

Up-to-date SEC filings
www.edgar@ssec.gov
www.freeedgar.com

REGULATORY AGENCY WEBSITES

NASD
www.nasdr.com

MARKET WEBSITES

NYSE
www.NYSE.com

NASDAQ

www.Nasdaq.com

CBOE

www.cboe.com—educational materials on options trading from CBOE

General Research and News

Securities law

www.seclaw.cim—articles on securities law

www.gnn.com—contains information about or links to almost every type of site imaginable including several search engines, but not available on all servers

New York Times

www.nytimes.com/business

www.coveredcalls.com—information and valuation tables for valuing covered calls

Company profiles

www:dis.srath.ac.uk

Stockpoint

www.irnet.com

www.prnewsire.com—latest stories and press releases

www.investing.lycos.com—news stories

Morningstar

www.morningstar.net—excellent for funds and some stock reports

Hoover's

www.hoovers.com—company information, fairly sketchy capsules

www.icefi.com—closed funds index

www.stockresearch.com—stock research

www.marketguide.com—excellent site for snapshot of market daily performance

www.Ifn.com
www.freerealtime.com—free real time quotes
www.cbs.marketwatch.com—can access stories about the market going
 back months
www.biz.yahoo.com
www.bigcharts.com

Motley Fool

http://www.fool.com

Yahoo Finance

http://www.finance.yahoo.com

Quote.com

http://www.quote.com
www.investor.msn.com—Microsoft Investor with stock screening

Company Sleuth

http://www.companysleuth.com

Infobeat

http://www.infobeat.com

Marketplayer

www.marketplayer.com

WallStreetCity

www.Wallstreetcity.com

Marketguide

www.marketguide.com

S&P Personal Wealth

www.personalwealth.com

Quicken Investments

www.quicken.com/investments

Dividend Reinvestment Websites

www.netstockdirect.com—1,600 direct investment plans

www.stockpower.com—database of U.S. and foreign companies that offer
direct stock purchase and dividend reinvestment programs

www.dripinvestor.com—can order directory of corporate dividend rein-
vestment plans

Foreign Markets Websites

www.trustnet.co.uk—offshore funds

www.ino.com/charts/qwforex.html—up-to-minute quotes on foreign cur-
rency markets

Xhttp://www.asia1.com.sg/btstocks/—primarily Singapore issues, but has
much information on other Asian markets

www.netrus.net/useers/gmorles/—comprehensive look at most of the
Latin American markets

www.fe.msk.ru/infomarket/ewelcome.html—coverage of the Russian and
CIS markets (in Russian) (true, but here to see if you are awake)

Discount Brokers

www.sonic.net/donaldj—comprehensive listing of stock discount brokers

Small and Micro Cap Stocks

Global penny stocks

www.pennystock.com

SmallCap Financial

www.smcp.com

stockcentral.com/smallcap1.htm—Go2

Micro Cap stocks

www.microstocks.com

Small Cap Investor
www.smallcapinvestor.com

MicroCap World
www.microcapworld.com

FEE-BASED SITES

IBD
www.investors.com
www.dailygraphs.com

Silicon Investor
www.techstocks.com

INDEX

A

AAA rating, 43
AAII, *See* American Association of Individual Investors (AAII)
Account executive (AE), 121, 232, 251
 changing, 139
 checking credentials of, 233–34
 choosing, 136–39, 233–34
 compatibility between client and, 128–29, 233
 and full disclosure, 129–30
 interviewing, 138–39
 prospecting, 137–38
 questions asked by, 128–29
 relationship with, 128–33
 sales assistant (SA), 131–32
 what to expect from, 130–33
 discount firms, 132–33
 full-service firm, 130–32
Accounting equation, 251
Accounts, 139–52
 cash account, 140–41
 cash management account (CMA), 152
 margin account, 141
 special miscellaneous account (SMA), 152
Accounts receivables, 170–71
Accrued interest, 159
Accumulation/distribution rating, 33
Acid-test ratio, 168–69, 251
Advest, 124
Agent, 119
All-or-none (AON) order, 156, 251
Alternative (either/or) order, 251
American Association of Individual Investors (AAII), 164

American Stock Exchange (AMEX), 90–91, 103, 110, 237
 compared to NYSE, 90–91
 trading floor, 90
AMEX, *See* American Stock Exchange (AMEX)
Analyzing, 174–76
Annual meeting, 227–28
Annual report, 169–70, 251
Annual reports, 27
Arbitration, 237–39
Arms, Richard, 221
Arms Index, 221
Arrearage, 252
As agent, 119
Ask-Bid system, 35
As principal, 119
Asset-liability interrelationship, 1–2
Asset management, full-service firms, 123
Assets, 7, 166, 252
Asset (value) plays, 165–80
At-the-market, use of term, 156
Attorney, and will, 5
Authorized-but-unissued shares, 28
Authorized stock, 252

B

Back-end load funds, 70–71
Balance sheet, 166, 252
Bar charts, 194–95, 205–10, 253
Barron's, 134
Barter, 253
BB rating, 43
Bearer bonds, 42, 253